CREAM 3

CONTEMPORARY ART IN CULTURE

10 CURATORS

100 CONTEMPORARY ARTISTS

10 SOURCE ARTISTS

CONTENTS

PREFACE

'Is there life after Conceptual art?' This is a question asked in one of the texts in *Cream 3*, and might serve as a theme running through much of the art presented here. In this, the third book in Phaidon's 'biennale' of new artists, one senses a set of shared interests uniting much of the work, perhaps more noticeably than in the previous two. As with the earlier *Cream* (1998) and *Fresh Cream* (2000), Phaidon asked ten contemporary art curators, all known for their integrity and expertise in staging presentations of new art on an international level, each to select ten important new artists. These 100 artists have either emerged internationally over roughly the past five years, or are still relatively unknown. No limitations as to age, geography or media were imposed.

In the resulting disparate and worldwide grouping of artists, one is surprised to discover that references to 1960–70s Conceptual art abound, whether in terms of technique, style or in the literal citing of such key Conceptualists as Martha Rosler, Dan Graham and Joseph Beuys. Examples range from Mexican artist Maruch Sántiz-Gómez's text-and-image works, to Walid Raad/the Atlas Group's subtle use of documentary presentation, to Fatimah Tuggar's literal recreation of Rosler's groundbreaking feminist video, *Semiotics of the Kitchen* (1974). Together, they suggest Conceptual art as the post-war movement with the greatest longevity of influence among new artists (closely followed by the related Performance/Body art, with its overlap into social activism). This is perhaps due to Conceptualism's connection with politically motivated art; perhaps to the immense variety of its means of presentation; perhaps to the curricula of many of today's art schools.

Whatever the reason, the strength of Conceptualism's legacy today is to an extent confirmed in a new section introduced in *Cream 3*, entitled Source Artists. Here, each curator is asked to select and write about any artist from any previous generation whom they feel remains of key significance either to contemporary art at large or to their own thinking. Together, these texts form a small art history contextualizing today's practice. In the Source Artists section, leading Conceptualist On Kawara appears alongside artists loosely associated with the movement (Lygia Clark and Fabio Mauri), as well as Felix Gonzalez-Torres, whose post-Conceptual work has proved of central significance to art since the 1990s. The enduring relevance of such Conceptual 'masters' as Hans Haacke,

often referenced in the opening Internet conversation between the curators and myself, attests to the same preoccupation.

Another underlying theme through which readers might approach *Cream 3* is a recurring reflection on modernism, for example in the work of Martin Boyce, Sam Durant, Luca Frei, Julie Mehretu, Ana Maria Tavares, among many others. Modernism's purest medium, architecture, also figures prominently in *Cream 3*, with two selections, Atelier van Lieshout and LOT-EK, actively working also as architects/designers. Modernism – its art and architecture – is often reviewed by these artists with a certain nostalgia for the intensity of its convictions. From this perspective, Conceptual art seems like a kind of final chapter in the succession of modernist avant-garde movements, the last episode in a certain idealist, utopian genealogy of art history that now appears to have irretrievably disappeared. In fact, if one were to generalize even further and attempt to group, under a single idea, many of the themes addressed by artists in *Cream 3*, it would have to be that of failed utopias, whether architectural (Ana Maria Tavares), Marxist (Michael Blum), suburban (Tim Gardner), corporate (John Pilson), supernatural (Christian Jankowski), Debordian (Cerith Wyn Evans), Soviet (Vadim Zakharov) or American (Sean Snyder).

But contemporary art always defiantly resists any such convenient generalizations; one of its greatest attractions is its limitless ability to be contradictory, and to accommodate any variety of subject matter and practice, from the deadly serious to the shamelessly self-indulgent. And so it is in *Cream 3*; while many artists do indeed explore the themes suggested above (along with others such as the histories and uses of film, painting, photography and design), an equal number deny any such summary of their work, combining video, installation, sculpture, performance, photography and painting as well as a range of subjects to produce brilliant and indefinable, hybrid art forms.

Cream, *Fresh Cream* and now *Cream 3* together form a sort of growing paper trail of all these significant new voices, forms and ideas in art. Ideally these books function as an up-to-date source of exciting and reliable information for art lovers around the globe, as well as a springboard to prompt initiated and non-initiated readers alike to seek out and enjoy the living art around them.

Gilda Williams

10 CURATORS IN CONVERSATION

GILDA WILLIAMS

The exhibition Documenta 11 (Kassel, summer 2002) signalled for many a watershed moment, ushering in twenty-first-century curatorial practice. It marks the definitive return (after a brief waning) of politically motivated art with an emphasis on non-Western and other histories; the confirmation of the moving image as the predominant art form, often following documentary film tradition; and the institutionalization of the ideal architectural setting for such work: polished yet simple, monastic spaces. Popular culture, pleasure and all things erotic or sensual (including painting and sculpture) were largely absent. I confess that I missed them – even if I admired the curators for the thoroughness of their convictions, and agree that this severe mood accurately reflects the climate in which we're currently working.

Documenta 11 in some ways defined the artist as an informed 'medium' who excavates small, under-represented corners of history and writes these histories large – rather than, say, revealing the intricacies of her or his own autobiography, or inventing new visual forms. The curator, in turn, is required to take even more seriously her very public role, and the corresponding cultural responsibility for what curator Iwona Blazwick called in *Fresh Cream* (2000) 'accountability and representation'.

What are, if any, the 'real' effects of such politically charged artworks, i.e., have the films of William Kentridge made a difference in South Africa? What do you see as the spirit of Documenta 11, and the current position and content of contemporary art? How is this reflected, if at all, in your choice of artists in *Cream 3*, or in your role as a curator?

ADRIANO PEDROSA

First of all, one must bear in mind that while Documenta 11 encompasses multiple visions – those of the artists, the artistic director and the co-curators – it's just one possible exhibition project, and a very well carried-out one. I don't think it's reasonable to expect even a show as important as Documenta to embrace such different contents, forms, matters, as Gilda Williams suggests, and I suspect that 'popular culture, pleasure, and all things erotic or sensual' would have weakened the final exhibition. There are other shows doing that, and perhaps too many – the Venice

Biennale, for example, to mention another major European exhibition. What Gilda Williams didn't mention about Documenta 11, which I feel is quite distinct about it, is its platform structure. This extended the exhibition itself in terms of time, space and above all, disciplines, through conferences and events in Vienna, Berlin, New Delhi, Lagos and St Lucia, culminating with the show in Kassel. And one didn't even need to attend the various platforms to profit from them – books are being published on each conference.

I do think that Documenta 11 will prove to be a true lesson in curatorial practice, and we can already see this in the restructuring of the 2003 Venice Biennale, with director Francesco Bonami working with a team of curators,[1] as opposed to implementing a 'one-person show', as it were. Yet the conditions that Documenta can offer its curators and artists are quite exceptional in terms of time and money. Yes, it is severe, or perhaps rigorous, but in fact that's what I miss the most in contemporary art and exhibition projects these days. Some of those who made the trip from Kassel to the Basel Art Fair, held shortly after the Documenta opening, were surprised by the gap between the world's top art show and the world's top art fair – both in terms of structure and content, as the critic Peter Schjeldahl pointed out in his review of the exhibition in the *New Yorker*.[2] 'Today's institutional and commercial art worlds are separate solar systems', he writes. 'There are of course those few artists who manage to travel between the two but there are so many overrated artists in the commercial circuit that are not worth a penny on this side of the universe.' There seems to be something amiss here. On the other hand, can you really say that Documenta, or any other exhibition, can aspire to define what an artist is? It seems almost totalitarian, a position that I can't see any of the curators involved in the show assuming.

I conclude not with pop culture, but with a popular saying: 'Art can't change the world, but it can change the way people see it.'

RUBÉN GALLO

It seems to me that we have two pressing issues on the table: first, the question of how curatorial practice has evolved in recent years (with Documenta 11 as an example), and second – and this is a point that interests me a great deal – the tension between eros (what Gilda Williams referred to as 'pleasure and all things

erotic or sensual') and politics in contemporary art. I wish to comment on the latter point.

While Gilda Williams misses pleasure, Adriano Pedrosa doesn't see the need for it in a politically committed, international exhibition such as Documenta; both seem to suggest that pleasure and political commitment are mutually exclusive. There are many examples, however, of great artworks that integrate these two elements to achieve a compelling synthesis between eros and politics: think of an artist like Hans Haacke, whose work not only addresses political issues but also seduces the viewer with the pleasure of astonishingly beautiful objects. On Kawara's *Date Paintings* provide another good example. In thinking about pleasure and art, I find it useful to go back to Freud's text *Creative Writers and Daydreamers* (1908),[3] where he explores the question of why readers and art viewers experience pleasure in certain works. He argues that artists and writers 'bribe' their public with 'forepleasure', and claims that the success of an artwork can often be measured by the degree of pleasure it affords its viewers. Though he doesn't refer explicitly to political art, he does address the issue of the 'message' conveyed by art: he believes that forepleasure serves to smuggle the artist's message – almost like contraband – into the viewer's mind by temporarily shutting off his conscious defences. Haacke's work illustrates Freud's point well: it's the beauty of the work. Think of *Manet-PROJEKT '74*, the piece based on the provenance of Edouard Manet's *Bunch of Asparagus* (1880) – that helps convey the political message to the viewer. Far from being antithetical to politics, pleasure can be the perfect vehicle for political commitment. Framing the relationship between eros and politics in this way, we could arrive at a new reading of artists such as Kentridge.

ADRIANO PEDROSA

I don't disagree, and we could mention two of our other Source Artists here in terms of pleasurable yet 'messaged' works: Felix Gonzalez-Torres and Lygia Clark.

NANCY SPECTOR

As Rubén Gallo so insightfully points out, there is huge subversive potential in beauty and pleasure, and Gonzalez-Torres understood this. For him, the division between politics and aesthetics was entirely erroneous. Nothing is free from ideology. He said that 'the best thing about aesthetics is that the politics which permeate it are totally invisible … when we speak about aesthetics we are talking about a whole set of rules that were established by somebody. We were not born with a set of aesthetic rules in our hands, were we? Aesthetics are not about politics; they are politics themselves. And this is how the "political" can be best utilized since it appears so "natural". The most successful of all political moves are ones that don't appear to be "political".[4] In this sense, I find Gilda Williams' distinction between an art that foregrounds its sensual aspects and an art that directly addresses a specific world situation to be artificial and rather limiting as a way in which to understand the multitude of practices that constitute contemporary art today. I would also apply Gonzalez-Torres' refusal of cultural binarisms – agitprop/documentary art versus poetic/fine art – to our own curatorial vocation. Every act of selecting or commissioning or combining one artwork with another constitutes a 'political' gesture that says something about our relationship to the culture in which we operate.

It's a strange moment for me to be thinking about the transparency of the political, sitting here in New York on 11 September 2002, where the discussion about creating appropriate memorials is increasingly interrupted, or perhaps informed by, the rhetoric of war. It was enormously gratifying last year when the city approved and implemented a temporary memorial – two shafts of white light that reached up into the night sky as far as the eye could see – that was designed by the young artists Julian LaVerdiere and Paul Myoda. Here was an emphatically political statement, a truly public artwork about memory and survival that used the most minimal of means to communicate its message. Most people didn't even realize it was a work of art.

GILDA WILLIAMS

I too think Rubén Gallo makes a very good point when he says that pleasure or beauty and even humour don't necessarily exclude meaning, political or otherwise. A few other good examples would include works by Hélio Oiticica, David Hammons, Shirin Neshat's *Turbulent* (1998), William Kentridge's *History of the*

Hans Haacke, *Manet-PROJEKT '74*, 1974
10 panels with colour photo reproduction of Manet's *La botte d'asperges* (Bunch of Asparagus) with frame, in black frames under glass, each 52 x 80 cm

William Kentridge, drawing from *Felix in Exile* (detail), 1994
charcoal, pastel, gouache on paper, 120 x 160 cm

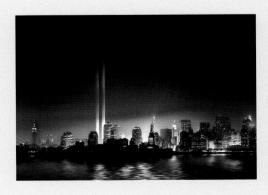

Julian LaVerdiere/Paul Myoda, *Tribute In Light*, 2002
light installation, New York City
with architects John Bennett, Gustavo Boneverdi, Richard Nash Gould and lighting designer Paul Marantz

Main Complaint (1996), Martha Rosler's *Semiotics of the Kitchen* (1974). I do think, however, that there was a sense of this mutual exclusion at Documenta 11, with very few exceptions (Walid Raad/the Atlas Group, Kutlug Ataman and Steve McQueen come to mind).

The immateriality and impermanence of Nancy Spector's example at the former World Trade Center site is a good instance of art verging on nothingness, connecting to Gonzalez-Torres' idea about invisibility. 'Making nothing' is a beautiful idea to think about, and perhaps one way completely to overcome the by-now obsolete distinction between form and content. Artists as different as John Cage, Maurizio Cattelan, Yoko Ono, Jeremy Deller, James Turrell, On Kawara, Marina Abramovic, Martin Creed, Tom Friedman, Robert Ryman and, of course, Marcel Duchamp, have 'done nothing' in very different and meaningful ways.

CHARLES ESCHE

I agree that it's rather too easy to describe Documenta as 'political' and contrast this with the erotic or sensual. The two are not exclusive categories; everything we already do has a political charge and art can, and perhaps should, deal with both aspects at once. The difficulty I have with Documenta is rather with the controlled nature of the exhibition itself, which perhaps led to a loss of connection between the erotic and the political. The works, with a few notable exceptions, deal with art in its reflective or analytical mode. Works that are more propositional, that act as an imaginative trigger or are even personally exposing, seem to have been mostly excluded (Thomas Hirschhorn, Isaac Julien and the Atlas Group being some exceptions). Thus, what's missing for me resides in the messy territory we call the 'social'. The so-called social works of the last ten years are significantly absent. This social territory is precisely the connective tissue that makes politics possible as a living discursive (erotic) dispute rather than a series of dogmas. So the lack of individualist erotics Gilda Williams perceives is for me a lack of collective discussion and exchange – which might lead to erotic moments of course.

Documenta 11 is simply too controlling a statement to allow for this uncertainty of discourse, even as it portrays itself as a platform for discussion. Therefore, though well made and a valuable attempt to deal with the cultural fall-out from current economic globalization, it partially fails for me as a tool to go on working as a curator. I can feel guilty as a representative of my society, or I can admire the political correctness of the inclusions, but it sends me away more shaking my head than prepared for action.

The Gwangju Biennale, which I curated with Hou Hanru in spring 2002, tried to propose a different model for a large-scale exhibition. It had its failures, but for us, it was an attempt to place the problematic of the social at the core of the exhibition, inviting artist groups from a variety of European and Asian cities and creating a series of differently choreographed exchanges. It has to be said that chaos was much more evident there than in Kassel.

YUKO HASEGAWA

I went to see the Gwangju Biennale on the day after the opening. I was very interested in the exhibition's structure and theme; it was an innovative show in terms of mixing Asian and European artists' groups and using alternative spaces. What was regrettable was that most of the artists disappeared after the opening day, and the audience was left with only the exhibition guides, who couldn't even explain how to access the data. They did not present a good interface for the audience. This type of exhibition requires artists as well as curators to stay at the exhibition site for at least a month. One representative from each group should have remained until the end of the exhibition period, so that they could communicate with the audience. In that sense, I had the impression that this exhibition didn't really function as planned.

CHARLES ESCHE

I would agree. We tried to persuade the Gwangju Foundation to support such longer residencies without success. This points out one of the problems of such biannual extravaganzas, in which bureaucratic organizers search for public and media impact on the opening days, rather than slowly unfolding an exhibition or seeking more substantial ways to connect with the audience. In those terms, the advantage with permanent institutions is that they can work over the long term and really try to affect the social and political culture in a particular location.

Martin Creed, *Work No. 200: half the air in a given space*, 1998
balloon installation, dimensions variable

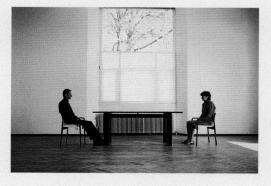

Marina Abramovic, *Nightsea Crossing*, 1982
one of a series of 22 performances lasting a total of 90 non-consecutive
days between 1981 and 1987, 2 chairs, 1 mahogany table (30 years old)
210 x 90 x 81 cm

Robert Ryman, *Winsor 6*, 1965
oil on linen, 192.5 x 192.5 cm

IGOR ZABEL

I think that when looking at a work of art with a clearly political content and intention, one almost inevitably asks a question similar to the one Gilda Williams posed about Kentridge: what is the actual effect of this art? Such a question is certainly not unjustified. A deliberately political work of art implies a political effect, and one should rightfully ask, what could such an effect be? Art is always political; better, it always has a political function. Even if it is intended to be pure and 'autonomous', it can be appropriated by the economic and political powers and made functional as a part of the 'ideological apparatus'. Therefore, the issue of the political impact of art cannot be merely academic. It can become a (sometimes very immediate) dilemma for artists, curators and other people involved in the arts. Repeatedly they're confronted with questions like, 'What is your position in the social system? What is your relationship to the systems of power, domination and exploitation? How can you act and react "meaningfully"?' 'Critical' or 'politically conscious' or even 'activist' attitudes are probably the result of such dilemmas. Artists want to be aware of their social position and deliberately active in it rather than just the passive 'objects' of ideological systems.

The decision to make political art, however, also involves something more. If the only goal were to make a real social impact, then one could find many other, more direct ways of doing it. One could be politically active as a citizen. One could also replace art with other, more effective, means of political propaganda and struggle (Socialist Realist painters, for example, were mere amateurs at 'engineering human souls' compared with contemporary PR experts). Art, therefore, has 'something more'. Haacke has been mentioned already, and he's a good example. Let's take his *Dyeing for Benetton* (1994), where he turned the controversial Benetton poster into a monument to all those anonymous exploited workers who have dyed the United Colours of Benetton with their own blood, so to speak. Here we can admire the precision of Haacke's shifts in meaning, the coherence of the conceptual structure of the work and its strong emotional charge. One cannot separate the poetic and the political in this work; this is why it's so strong. But this is also the reason why its political meaning could be suppressed and the piece

appropriated exactly by those structures of which Haacke has been critical in all his work. (Not necessarily Benetton, of course, but the cultural system through which the big capital tries to achieve its particular goals. What's important in Haacke's work, by the way, is that he never hides the fact that this system also determines the circumstances of his own work.)

There have been many discussions about the relationship between 'autonomous' and 'engaged' art in the past century (for example, in the period between the two World Wars, and in the 1960s). The reason for these controversies, which were never really resolved, was perhaps exactly the fact that art has its social and political function, while also being 'something more'.

Such discussions show that the nature of art in the modern era is deeply contradictory. It is determined by two aspects (embodied in 'autonomous' and 'engaged' art) that are each other's negation and, at the same time, each other's definition. Therefore, the function and the effect of art can never be unequivocal and given once and for all. Art can react to its social and political circumstances, but because it *is* art, it can be re-appropriated by the system, and then new strategies are needed to refresh its critical (and aesthetic) potential. (Here, it's important that not only the production, but also the presentation or reading of art can be political.) The real political effect of such works can, of course, be more or less direct. If the strategies of a work of art, its presentation or reading, manage to question and elucidate the established patterns of perception and thinking effectively, they are already successful. The ideological effect is exactly in assuming that certain forms or patterns are 'natural' and should be taken for granted. (The well-known slogan from Paris, May 1968, was: 'Let's be realists, let's demand the impossible!' The 'impossible' here is that which is, in the context of the dominant system, considered 'unnatural'.) In this potential of art, one can find an interesting parallelism between political and aesthetic strategies. In the work of Bertolt Brecht, the main political means is his deconstruction of the theatrical illusion through the principle of *Verfremdung* (Alienation). On the other hand, the Russian Formalists claimed that the basic effect of artistry is 'defamiliarization' or 'making strange'. The same strategy has thus both a poetic and a political value.

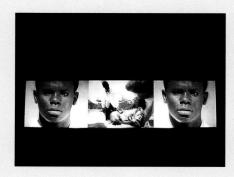

Isaac Julien, *Paradise Omeros*, 2002
triple video projection, 3 16 mm films transferred to
video, 20–25 min., black and white, colour, sound

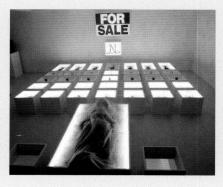

Arahmaiani Fiesal, *(EX)Change-2002*, 2002
Installation and performance, Gwangju Biennale, 2002

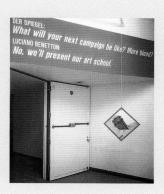

Hans Haacke, *Dyeing for Benetton*, 1994
elevator buttons, ashtray, emergency sign, light, Benetton
billboard poster with superimposed inscription: 250 x 340 cm
wall inscription: 90 x 135 cm; photo panel: 48 x 48 cm
Installation John Weber Gallery, New York, 1994

CHARLES ESCHE

I'd like to pick up on this comment about engagement and autonomy. Though I'm very sympathetic to Igor Zabel's point of view, I think we should strive to avoid such dialectical oppositions. Indeed, engagement could be seen more in terms of affirmation, while autonomy might provide some critique. That's why I've spoken elsewhere about 'engaged autonomy', a condition where art must necessarily be within the system while claiming a kind of tolerated second-order autonomy that is even welcomed by international capitalism. The question is not whether this situation is good or bad, but how to use it, either by wasting it on satisfying art-market desires or by practically and pragmatically constructing ways and works for thinking and seeing differently. At the same time, it is crucial to be aware that any effective proposal in this field will be co-opted, but that it may hold a residue of its intention even after this co-option. This state of 'engaged autonomy' is precisely why it's still possible to consider painting alongside social or economic interventions. Neither is by definition radical. The judgement has to be at the point of reception and after.

BEATRIX RUF

Like Nancy Spector and Igor Zabel, I feel that political art is not at its most effective when talking about this or that political question, or when it attempts to 'document' politically relevant themes. It is effective when aesthetic forms are made politically relevant. The artist Rirkrit Tiravanija is important in this context. His practice opens up a highly intelligent field that challenges the mechanisms of Western culture, the Western way of handling and understanding art. Even in exhibitions where the cultural 'other' is included in a 'politically correct' way – precisely when we're talking about forms of integration and opening up an expanded cultural discourse – we still always think in terms of 'us' and 'them'. Tiravanija critiques this situation while at the same time admitting the cultural relevance of something other than the formal superficialities by which we believe we can recognize art. Alongside many other aspects of his work, this might include qualities like communal action or hospitality. There's a more politically relevant cultural transfer – or cultural integration that doesn't create hier-

archies – taking place here than in most 'politically correct' attempts to integrate supposedly marginalized artists from supposedly marginalized cultural circles.

But the question of how art can be politically effective shouldn't be asked without first discussing the forms in which it can be made accessible. A curatorial setting isn't necessarily more democratic, more open, or even more politically correct, just because it involves a team or because it tries to deal with cultural blind spots. Perhaps such a setting is all these things if it succeeds in building its own positions and formal offers into what is chosen, if it manages to remain open to attack, discussion and variation. Though there have been failures, this is what I always hope to achieve in my own curatorial practice, even if the chosen form – solo exhibition, group exhibition, lecture, event – may look conventional at first glance.

Documenta 11 seemed to me to exclude any openness, disturbance, vulnerability or contestability of a personal viewpoint. So, for me, it had all the atmosphere of a high-security wing: highly professional, aesthetically and intellectually controlled, supermanaged and without any weaknesses, mistakes, vulnerable points, despite the choice of artists, which was highly problematic politically.

The complete absence of public space at Documenta 11 seems to be another aspect of this. It was missing on two levels. Firstly, the institutional framework didn't seem to be up for discussion, which meant that the art institution no longer represented a 'public' space. The second was that with the exception of a very small number of works by artists like Dominique Gonzalez-Foerster, Renée Green, Thomas Hirschhorn, Ken Lum, there were no uncontrolled situations outside the hermetic, aesthetically controlled and structured institutional statement that was the Documenta building. The platform structure looked interesting at first sight, but for me represented precisely the same withdrawal of public access: except for in Vienna, all the platforms were closed, 'invisible' events. Access via the publication is also dependent to a large extent on Western standards of purchasing power. Availability of information is a political issue too.

CAROLYN CHRISTOV-BAKARGIEV

I also feel that to pursue the discussion about the relationship between art that is pleasurable and art that is political is problematic – all good art and culture in general is pleasurable and all we do is political.

I disagree with Adriano Pedrosa that Documenta 11 proposes a new model of curatorial collaboration: working collaboratively is not a novelty in curatorial practice. There have been many collaborations over the last twenty years, such as Aperto '93 at the Venice Biennale.[5] Curators like Hans-Ulrich Obrist have always preferred collaborations – shows like 'Laboratorium', held in Antwerp in 1999 – it's so much more fun and mind-expanding. I found Documenta 11 to be an intellectually engaging, very ambitious endeavour, but I'm not sure it actually ushered in any new

Rirkrit Tiravanija
Installation Secession, Vienna, 2002

curatorial practice (or that it even aimed to do so). In my view, the curators adopted a very classical and traditional attitude towards curatorial practice and installation, which was less important to them than the political statement they wanted to make about problems in the world today. It seemed to me that the project was more about bringing into the already established spaces and paradigms of exhibition-making (the beautiful white cube, or the 1990s black cube) the work and ideas of cultural practitioners who are (or often have been) excluded or marginalized. Also, they seem to have wanted to use the vehicle of the exhibition to denounce injustices and human suffering in the globalized world. I'm refreshed by the presence of artists from so many parts of the world, who have been brought into the 'centre' of cultural discussion, thus broadening the range of issues and ideas one thinks about.

But we mustn't forget that this exhibition comes a long time after 1980s exhibitions like 'The Decade Show' or 'The Essential Black Art'.[6] And in so far as Documenta 11 is a show about bringing the outside 'in', I have some problems with it because it seems to simplify the politics of the world and of art practice. What are the implications of bringing us 'inside' the institution without also reflecting on the movement 'outside' of it? The only work that did reflect on this was Thomas Hirschhorn's installation *Bataille Monument*, a project in a Turkish neighbourhood that juxtaposed, for example, a sandwich bar with a reading room and other social spaces. Suddenly you felt the presence of globalization in the flesh – literally around the corner – and you were no longer in the 'aloof' space of the white cube, reflecting on problems in far off places. The one-sidedness of the project seemed to suggest that the exhibition was saying all the bad guys in the world are in one place and all the good guys are in another, and now is the time to storm the palace. Notions of exclusion/inclusion, centre/periphery are constantly altering according to how we define them. Most of the artists in Documenta 11, like the curators, are from America and Europe, even if they were born somewhere else and maintain important ties to their cultures of origin, and even if they do propose a non-Eurocentric perspective.

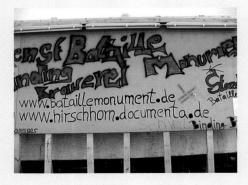

Thomas Hirschhorn, *Bataille Monument*, 2002
8 elements in the public space
Installation Documenta 11, Kassel, 2002

ADRIANO PEDROSA

There have of course been many other group-curated exhibitions in the past, yet this is something that I feel could be explored a good deal more in biennale-type exhibitions, which usually hinge on a single curator or curatorial vision. A notable exception is Manifesta, the European biennale, which has had three or four curators working together for each edition since it began in 1996. Yet there, I'm told, the curators often feel less connected to each other than they might, since they're appointed regardless of any cohesion between their areas of knowledge or choices. My point about the 'one-person show' (in terms of curators, not artists) touches upon the increasingly widespread figure of the 'chief curator' as the exhibition star. Documenta 11's platform structure was a definite innovation, particularly for such a traditionally Eurocentric show.

YUKO HASEGAWA

My perception of Documenta 11 is that it was an elaborately planned academic exhibition with few intellectual experiments. Okwui Enwezor's display was highly orthodox and functional, a well-organized white cube. The most significant question – and this hasn't really been mentioned here – was for whom was the exhibition planned, and how did it function for the audience (mostly young Germans)? Was it for 'society' or the abstract 'intellectual public'? It's far more important that people spend time at the exhibition site discussing art than to stage a historically successful 'blockbuster'.

UDO KITTELMANN

Yes, all the discussions about Documenta 11, which have been going on since the exhibition opened, have more or less concluded that this exhibition was probably the safest and most polished for decades. From the first moment, I said that it was one of the best *Grossausstellungen* (large-scale exhibitions) I've ever seen. And so far I haven't changed my mind.

But, like Gilda Williams, I too missed popular culture, pleasure and all things erotic or sensual; there was no blood, no sweat, no tears, with the exception of Tania Bruguera's sound installation/performance in a brewery, *Untitled (Kassel, 2002)*, the remarkable statement from the Atlas Group and, of course, Hirschhorn's project. Documenta has always been different from other large-scale exhibitions – more experimental, more risky, more surprising, more visionary, and on the look-out for remarkable 'outsiders'. In the past it always had its very own, unique position; it was made to be discussed, criticized, to confuse people about the state of art. This edition appeared to be a kind of retrospective exhibition. Everything was so familiar! The artists had all been seen in many other exhibitions and reviewed in many magazines over the past three years or so. Yes, it was a masterpiece of curatorial strategy and it reflected the climate in which we're currently working. But

what does 'the climate in which we're working' mean? Who is 'we'? Isn't it the climate that we, 'the Most-Wanted Curators', build up ourselves? ('What our city needs now is a biennial!'). How is the selection of artists influenced? There are, as we all know, only a few dozen curators, a few dozen critics etc. worldwide, and we're all connected in one way or another, like we're now connected via the Internet. Information about a specific artist can easily be e-mailed all over the world to different curators instantaneously, or one gets it by reading the art magazines every month. We all depend on the same information from the same group of a hundred people or so and use this information for our work.

The question I want to raise is: are we really free in our selections in a connected and somehow already manipulated art world like this? I doubt it. I guess that we're already living and working in the climate of a First Art World, in a new art economy. That was what Documenta 11 was about. That was – it now occurs to me – the reason why it looked so controlled. And so far I have no solution as to how to escape from this situation. Probably we should start to think about how we can rearrange the art world. Why not play dice? So this is what I did this time, when I was asked to select the artists for *Cream 3*. I wrote down twenty artists' names, put them all in my father's black hat, and picked out ten. And I was very satisfied with the result.

RUBÉN GALLO

Since we're all interested in the relationship between eros and politics, in the process of selection, perhaps we could use this forum to discuss how these concerns shape our curatorial practice. A good point of departure might be to explain how we arrived at our choice of artists for *Cream 3* – that's to say, how we put to practical use our own ideas about curatorial work. I liked Nancy Spector's account of how the synthesis between politics and pleasure has shaped her curatorial practice. When I work as a curator, I too aspire to bring together these two realms: to create a meaningful exhibition that also gives pleasure to all parties involved (the curator, the artists, the audience).

CHARLES ESCHE

For me, adding the social dimension to eros and politics gets closer to the position that I hope is represented by the artists I've selected for *Cream 3*. I tried to think about a network of individual artists that would manifest the kind of 'engaged autonomy' from their political situation I described earlier, through re-use/re-invention of existing conditions, through speculative proposals, by addressing the viewer at a tangent to the main issue, or personalizing the impact of economic change. The artists I've selected are mostly working on quite modest proposals but in ways that create space for the audience to take a different view, as Adriano Pedrosa says, to change the way the world is seen. I could cite Luca Frei's playful, open-ended works or Dan Peterman's recylced, community-based projects as examples of socially interactive strategies in art that can subtly change understanding.

I'd like to suggest possibility as a desirable condition in art – possibility in terms of imagining the world other than it is and therefore contributing to its change. Importantly, speculations that create possibility can be superficially formal or aesthetic exercises – such as, classically, Soviet Constructivism. I do believe art can change the world, though clearly not in causal, traceable, direct ways. If I stopped believing this I'd stop being involved.

BEATRIX RUF

The artists I chose for *Cream 3* all seem to offer in their own way a kind of political approach through the medium of their aesthetic space – they each present some kind of parallel autonomy in a variety of media and statements. Angela Bulloch, for example, creates starting-points and openings for inter-subjective public interaction of all kinds.

CAROLYN CHRISTOV-BAKARGIEV

What I find interesting is the prevalence of the documentary model in much current art practice around the world. One of the earliest artists to establish this area of work as a fulcrum was Willie Doherty from Derry in Northern Ireland, and his work provides a link between 1980s political/postmodern photography and contemporary practice. Many young artists today come from schools where Conceptual art marked the 'academic' norm. They are making a 'meta-Conceptual' art, what you might call a 'university-professor' art – in fact many also teach in colleges and

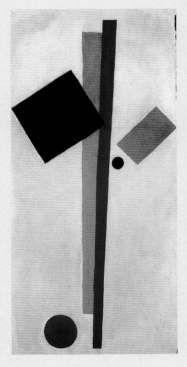

Kasimir Malevich, *Suprematist Composition*
*c.*1920–2, oil on wooden panel, 62 x 30 cm

universities themselves. I'm surprised that so few curators and artists are questioning the principles by which something is legitimized as 'truthful', and this is what's so interesting in the documentary mode. Why should we believe a documentary made by CNN more than one by an artist? How can we problematize this issue of truth/memory/history? This is why I'm interested in Walid Raad/the Atlas Group, whom I selected for *Cream 3*. By creating a totally false but truthful, plausible and non-ironic set of documents and data in his work, by becoming the different characters involved (researcher, witness, documentor, etc.), he analyses the relationship between events/media/collective memory/imagination/ projection /trauma and politics in a deeper way than most straightforward documentary artists today.

Omer Fast, too, explores the implications of documentary communication. In *Glendive Foley* (2000), for example, he contrasts images of suburban homes with views of himself acting as a foley artist, simulating the sounds for the image. I wish I'd seen more complex work like his in Documenta 11, but we all have different visions, knowledge and interests, so I'm not complaining. The works of my Source Artist Fabio Mauri, investigating memory, ideology, truth and deceit, are in a similar documentary mode and, though made in the late 1950s, still relevant today.

That said, I don't believe that 'documentary art' is the primary or sole mode of artistic practice today. I'm interested in very different practices, such as the work of young artists around the world who are engaging with modernism and/or modernity, like Sam Durant and Julie Mehretu – looking at issues of agency, form, composition etc. – moving away from postmodernist relativism.

YUKO HASEGAWA

Many of the artists in Documenta 11 presented their daily struggles to find a utopia in their actual lives, using the documentary form instead of creating art on the metaphysical level. The difference between documentary video and other kinds of work lies in its formation of memory. As soon as viewers walk out of the exhibition, oblivion begins to seep in. Video occupies them for longer, and, unlike abstract art, it shows a fragment of the real world. It's possible for viewers to comprehend the artwork in an instant, and

have it submerge as a memory in the deepest part of their subconscious. Instead of discussing what type of art is prevalent, it's important to think about how exhibitions can function as a memory device and a place for discussion.

As reflected in my selection for *Cream 3*, my interest lies in synchronistic senses, a new relationship between sound and vision, physical senses and intellectual ideas. There's a trend whereby artists are moving towards text and concrete poetry, or sound works, like those by Carsten Nicolai. Dance and the relationship between music and visual expression is also breaking through the cul-de-sac of saturated visual art and dogmatic meta-Conceptualism to create new expressions. This is why I selected On Kawara as my Source Artist. His work connects with the fresh generation of VJ (Video-Jockey) artists. I think the most intellectual and political experiment lies in the integration of pure senses and weightless representations.

NANCY SPECTOR

While thinking about Rubén Gallo's suggestion that we each share the rationale or criteria used to compile our selections for *Cream 3*, I've been musing over America's mania for list-making – from *People* magazine's 'most beautiful people of the year', MTV's 'sexiest videos', and Amazon.com's compilations of shoppers' personal obsessions, to (on a more grave note) the FBI's 'Most-Wanted' list and President Bush's infamous 'Axis of Evil' inventory. In relation to our discussion here about the political efficacy of art and, as Igor Zabel points out, our inability to circumvent dominant ideological systems, I can't help but think about our own involvement within a structure that much art pertains to resist/reject/critique. Our 'top-ten' lists provide exposure, institutional validation and fodder for the next round of market speculators looking for the 'new'. But this model is not specific to *Cream 3*. I suppose almost every aspect of our curatorial practice intersects with this (economic) reality. That said, there are compelling reasons to participate in a project such as this, namely that the *Cream* books reach a broad public and that hopefully more than a few members of that public will come to understand contemporary art differently – as a realm of possibility and provocation rather than an inscrutable or elitist entity.

GILDA WILLIAMS

I often sense in some (though not all) parts of the art community an instant suspicion of projects that bring contemporary art to a bigger and non-specialized audience, or are in some way connected with art's commercial side. This probably relates to the 'gap' that Adriano Pedrosa mentioned earlier between the often contradictory aims and intentions of contemporary art, as witnessed in the contrast between Documenta 11 and the concurrent Basel Art Fair. Many in the art world seem to feel the need to disassociate themselves from anything tainted by the selling of art. On the other hand, my experience tells me that most artists

Willie Doherty, *Fixed Parameter*, 1989
black and white photograph with text, 125.5 x 186 cm

are quite pleased to have their work sold. Certainly artists are most willing to be included in *Cream* and are very generous with their help in doing so – although not only for the commercial exposure, I think, but also for the acknowledgement that they're making a significant contribution to contemporary art. I do, however, sense that they're concerned when their work is treated as some kind of sideshow and not taken seriously as a life's work, which is a very different and valid complaint. And of course there's a depressing strain of artists who make work exclusively in response to the desires of the art market – although Andy Warhol comes to mind as an artist who could make even so extreme a compromise (say, with his portraits) and still produce some great art. In sum, I would hope one day to see an art world that's a bit more relaxed and honest about the simple fact that most of its members – artists, critics, curators, gallerists – are committed enough to art to want to make a living through it.

Regarding Nancy Spector's important point about list-making, I recall the theorist Irit Rogoff critiquing the first volume of *Cream* with an interesting comment about this project being immersed in a broader culture of list-making as a form of ordering knowledge.[7] Many strategies have been invented by the contemporary art world to avert or at least postpone this list-making process – for example, by producing such lists gradually, or collaboratively, or organically. But I still wonder, realistically, is there a genuine alternative – whether in putting together a group show, a museum or gallery programme, a magazine, a collection or a book-publishing programme like the Contemporary Artists series I'm involved with at Phaidon – to a list-making process? Is list-making, however odious and banal or creatively approached, somehow unavoidable in the presentation of new art? One of the ideas behind *Cream* is, in making it an open-ended project renewed every two to three years, to result in a kind of living, growing archive rather than a 'definitive 100', but I'm open to your comments as to whether or not this has succeeded.

RUBÉN GALLO

Nancy Spector's right to point out that many curatorial projects, magazine articles and publications such as *Cream 3* tend to degenerate into 'top-ten' lists, but I agree with Gilda Williams that there must be another way to conceive of projects such as this one. I'm reminded of something the artist Antoni Muntadas told me a few years back: *En la vida todo es editing* ('Life is all about editing'). Curating an exhibition and selecting artists for a publication are exercises in editing: our task is not limited to making a list (which is ultimately a mechanical endeavour), but calls for discovering interesting juxtapositions, contrasts and tensions among individual works. From the moment Gilda Williams invited me to take part in *Cream 3*, I thought the book could become a fascinating montage, and I believe the final product will be intriguing. Here's an example: one of the first artists I selected was Daniela Rossell, who photographs rich Mexican women posing in their ostentatious homes. I was also interested in Tim Gardner, who paints water-

colours of suburban jocks drinking beer. At first these seemed like two completely different (and, I feared, irreconcilable) bodies of work, but as I wondered if they could both fit into my selection for *Cream 3*, I started to discover certain similarities between them: both artists act as voyeurs, giving us a glimpse of a strange subculture; both grew up in the worlds they document, and both use their work to observe it from an outsider's perspective. One photographs a world of women, the other paints a world of men; Rossell equates femininity with extravagance, while Gardner associates masculinity with banality. The associations are endless, but I only began to discover them as I was drafting my 'list' for *Cream 3*.

NANCY SPECTOR

Despite my disparaging remarks about list-making and its concomitant activity-ranking, I have to say how much I enjoy the freedom it offers. Unlike the process generally required for making a group exhibition, in which your various choices should form a coherent whole, the selections for *Cream 3* can be made as individual decisions. Each artist can stand alone, judged on the merits or urgency of his or her own work. That said, I suppose there are certain connections among the ten artists whom I selected for the book. Many of them – Minerva Cuevas, John Bock, Trisha Donnelly, Michael Elmgreen & Ingar Dragset, Kai Althoff and Christian Jankowski – share a performative sensibility. This confluence reflects my own interest in art that is less engaged with pure object-making than with process. All ten artists produce work that can be thought of as subversive – whether it's playing with existing social structures (Cuevas, Elmgreen & Dragset, Jankowski, Fatimah Tuggar and Anri Sala) or art-historical conventions (Althoff, Manfred Pernice). My selections were really guided in every case by my own desire to know more about each of the artists, whose work has continually caught my attention. I see my participation in *Cream 3* as a very public research project.

IGOR ZABEL

It would be wrong to consider one's selection as the direct, simple result of a few basic principles. Like any curatorial decision, it's the outcome of many different circumstances and facts. Some of the considerations are pragmatic, others conceptual, still others very personal, maybe even beyond a rational explanation. To a great extent, decisions like this are the result of limitations. In this case, for example, there were many limitations given in advance, as the conditions and determinations of the book. But there are other, perhaps even more important limitations at work, too. My view is limited by my position, geographical, cultural, social and political. There are curators who have a much more panoramic and global view of contemporary art. Personally, I see my own position in this selection, too, as determined by a relatively limited field of vision.

A crucial factor is an attempt to be aware of, and to question, the social and political reality that determines the nature

and role of art in contemporary society. What social and political function do art and the art system have, and indeed what is my own role and position in this context? Looking at the list of artists I proposed, I see that all of them deal with the complex and antagonistic realities of the contemporary world, although I didn't have in mind any sort of 'engaged' selection. I find in the work of these artists an experience basically similar to my own: they're not distanced from the issues they deal with, nor do they present a sort of general knowledge in the form of works of art. Rather, they're right inside the situation, trying to orientate themselves within it. For them, politics is not so much a general theory or a rational action plan – although several of them, like Olaf Nicolai and Tadej Pogacar, consciously develop political and critical strategies – it's embedded in their most immediate experience. Roman Ondák's installation *SK Parking* of 2001 (old Skodas with Slovak licence plates parked for several weeks outside a Vienna gallery) could be used as an example. It deals quite obviously with the differences between East and West, yet it doesn't attempt a political analysis. Rather, it's a situation that stimulates an attentive observer to become aware of these relationships and start thinking about them. What is experienced as natural and what as foreign? How does a particular social system determine our everyday experience?

Another issue here is a situation with which I'm often confronted: that I'm, explicitly or implicitly, expected to function partly as a representative of a particular cultural essence, in my case the 'Eastern European' essence. (I don't want to say that in every case I'm invited as a token 'Eastern European', although sometimes it is so. Usually, however, I feel an obligation to represent Eastern European artists and thus support them, as much as I can, in entering the international art system more equally.) Thus, my decisions are usually also based on these considerations. I won't go into details about this complicated issue; I'll only indicate one point. Using a rough simplification I could perhaps say that Eastern European artists, curators etc. (as well as artists and curators from many other parts of the world) are considered as representatives of a particular cultural essence, while a Western artist can only 'represent' him- or herself. This situation is based on a mechanism of division and exclusion, which is probably not only cultural but also has to do with political and economic dominance. (I don't want to suggest that such a relationship is unchangeable; East–West relations in Europe have transformed in the past ten or fifteen years.) My dilemma is: to what extent should I try to oppose the mechanisms of representation and my role as a representative, and to what extent shall I accept this role and try to use it? This means not only extending the space of representation, but also aiming at deconstructing it in such a way that these artists will ultimately be recognized not as 'Eastern' artists, but simply as artists. (Such a deconstruction doesn't mean, of course, that their particular cultural and social context should be repressed and forgotten; quite the opposite, it should be clearly exposed.)

There's another elusive, immensely complicated and difficult question that one cannot avoid in making selections: the question of quality. The problem, of course, is that there is no generally valid measure of quality. Just as every artist, or even every work of art, demands a particular framework of interpretation, so it seems that quality can only be recognized each time anew in a process of negotiation between the work and the observer. (I don't believe that such judgements are necessarily completely subjective and coincidental. There are more general structures active here, but basically they function through a dialogical process.) Sometimes a work can be effective immediately; in other cases it demands long attention to display its richness and complexity. For me, a passing impression is often important, not necessarily in the sense that I find a work immediately attractive (although this is how it happened with Valery Koshlyakov, Kataryzna Kozyra and Ene-Liis Semper). Often, I stop at a work because I feel it somehow resists my gaze. I return to such works later, trying to approach their secret. Thus, something that is initially only coincidental, marginal and peripheral may later become of lasting importance. If I can, I try to include this aspect in my curatorial work. My interest in several of the artists included in my selection (Pawel Althamer, Luisa Lambri, Slaven Tolj) was initially based on this brief and passing encounter with their strangeness.

ADRIANO PEDROSA

I agree with these points about the process and conditions of choosing. A concrete limitation imposed early on in this project was that we were asked to avoid artists who had been in previous volumes of *Cream*, which in my case ruled out some with whom I've worked most closely, such as Ernesto Neto and Rivane Neuenschwander. Also, some artists whom I initially selected were chosen by other curators in this volume – such as Elmgreen & Dragset and Luisa Lambri. As Igor Zabel says, our choices were limited by our geographical location and, I would add, field of movement. In composing my 'list', I considered a number of cities/ scenes that I've been researching during the last few years – Rio de Janeiro, São Paulo, Buenos Aires, Mexico City, Caracas, Berlin, Lisbon, New York. My selection doesn't comprise a cohesive group, and my objective was simply to suggest those whose work I find strong in some way or another. The group reflects my interests and, if anything, that is what brings them together – from sculpture to architecture, from performance to landscape painting.

Like Nancy Spector, my interest was also in taking advantage of the context and the opportunity in order to suggest artists who wouldn't otherwise receive this exposure. I suspect we all feel the same way about this project: what is crucial here is the exceptional visibility that *Cream* brings to the artists. Working in Latin America, where there are fewer channels of visibility, this is very much a key issue for me. The group of artists is thus quite varied, ranging from successful names like Beatriz Milhazes and

Santiago Sierra, to younger ones who don't even work with galleries, such as Nuno Ribeiro from Lisbon and Carla Zaccagnini from São Paulo. Juan Araujo has never really shown outside Venezuela, while artists like Jorge Macchi from Buenos Aires and Franklin Cassaro from Rio de Janeiro have been exhibiting for some time, even internationally, yet their work deserves to be much more widely seen.

CHARLES ESCHE

The question of geography is an interesting one. I've just returned from Zagreb and Ljubljana where the conditions of possibility, which I referred to earlier, seem much greater than in many other cities. My initial impression is that there appears to be a desire for reviewing strategies from the socialist past in new ways, and for learning from the great failures of the twentieth century rather than wishing that history away. It was inspiring to hear these ideas, led perhaps by the theorist Slavoj Zizek's rich proposal to 'repeat Lenin under today's conditions'.[8] This could be a term applied loosely and speculatively to the artists I've selected for *Cream 3*. 'Repeating Lenin' means not to mouth the old battle-cries of Leninism but to revisit his 'concrete analysis of concrete situations' in respect to 2002. It means to speculate about changed economic, social and cultural conditions, something that the artists share, from the overt political optimism of Chad McCail's drawings and Sonia Abian's video, through Michael Blum's travelogues and Luca Frei's socially constructed game-playing to Silke Otto-Knapp's quiet watercolour re-imaginings of West Coast America.

GILDA WILLIAMS

Regarding the selection of your Source Artists, which has already been touched upon briefly, I think it's significant that no one chose an artist working before about 1960. Does earlier art history (say, prior to Jackson Pollock) have any real connection with contemporary work, other than when it's literally quoted as historically distant, for example in the work of John Currin, Yinka Shonibare, Matthew Barney or even William Kentridge? I wonder whether, some time in the second half of the twentieth century, art history in many ways succeeded in making the break with its own past, as attempted but not really achieved in modernism?

CHARLES ESCHE

I still find an incredible freshness and relevance in art from the early Soviet period. It's difficult to look at the claims that aesthetics can be revolutionary too without reminding ourselves of those early twentieth-century experiments. It's still amazing, in the light of current arguments about artists and their social responsibility, to read the small catalogue of *5x5=25*, a Russian avant-garde exhibition held in Moscow in 1921 that included works by Alexander Rodchenko, Liubov Popova and Alexander Vesnin. However, aside from this, it's clear that the break Gilda Williams speaks of is true and present in our selection of Source Artists.

IGOR ZABEL

If you call someone a 'Source Artist', he or she is probably more than just a great artist or someone who has been important for contemporary artists. I thought I should choose someone who has, beside that, strongly influenced my own understanding of art and its possibilities. Even though its members abandoned the field of art in 1971, and in spite of the fact that its work was not often exhibited, the OHO Group has remained the best example of an innovative, experimental and challenging spirit in Slovenian art. In fact, it has turned into something of a legend.

Referring to the question about the role of past art, it's no coincidence that I chose as my Source Artist a group from the 1960s, and that there are generally no older artists in the selection. I agree with Gilda Williams' thoughts about the break with the history of art in the mid-twentieth century. We've been following (and taking part in) a development of the concept of 'contemporary' art as different from 'modern' (i.e. modernist) art. Contemporary art is not only art produced today, but a particular experimental and critical line of art, to a great extent following the Conceptual and post-Conceptual models (in this sense, not all art today is 'contemporary' and not all 'contemporary' art has been recently produced). It has formed (to a large extent retrospectively) a particular tradition, and here the art of the 1960s plays a special role. We could perhaps say that the 'contemporaneity' of today actually began then. To go back to the OHO Group: its importance for the

John Currin, *SNO-BO*, 1999
oil on canvas, 122 x 81.5 cm

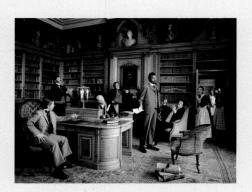

Yinka Shonibare, *Diary of a Victorian Dandy 14:00 hours*, 1998
poster, London Underground

1990s was much more than just that of a historical document. Contemporary Slovene artists recognized in the work of the group aims and approaches similar to their own. The result was that the lineage of avant-garde and experimental art, which had often been marginalized and even repressed in favour of the modernist line, took on new and strong importance.

Of course, the lineage of 'contemporary art' could go further back to art from the first half of the last century. But this is part of an accepted artistic and cultural canon, determining the general horizon for any cultural production today. It would be perhaps too obvious to choose Duchamp or Tatlin as Source Artists. This is also true for older art. Michelangelo cannot have the same immediate importance for contemporary art as Marcel Broodthaers, for example. This, however, does not mean that Michelangelo has no importance for it. Not only might many individual artists admire his work, it is an essential part of today's general cultural context and canon.

What I think is crucial in this context, too, is the idea that past artistic and cultural traditions are not something simply given, but should be re-conquered and re-appropriated, and thus made relevant to today. The philosopher Jurgen Habermas, in his famous essay 'Modernity – an Incomplete Project',[9] mentions a group of workers in Berlin during the 1930s who went regularly to the Pergamon Museum, discussing the works and making them relevant for themselves in a new way: 'Out of the resilient edifice of this objective mind, embodied in works of art which they saw again and again in the museums in Berlin, they started removing their own chips of stone, which they gathered together and reassembled in the context of their own milieu … These young workers went back and forth between the edifice of European art and their own milieu until they were able to illuminate both.'

NOTES

1. Carlos Basualdo, Daniel Birnbaum, Catherine David, Massimiliano Gioni, Hou Hanru, Molly Nesbit, Hans Ulrich Obrist, Gabriel Orozco, Gilane Tawadros in collaboration with Forum African Contemporary Art, Rirkrit Tiravanija, Igor Zabel

2. Peter Schjeldahl, 'The Global Salon', *The New Yorker*, Vol. LXXVIII No. 17, 1 July 2002, pp. 94–5

3. Sigmund Freud, *Creative Writers and Daydreamers*, 1908, Standard Edition, Vol. 9, Hogarth Press, London, 1959

4. Nancy Spector, *Felix Gonzalez-Torres*, Solomon R. Guggenheim Foundation, New York, 1995, p. 13

5. Curated by Antonio d'Avossa, Francesco Bonami, Nicolas Bourriaud, Kong Changan, Jeffrey Deitch, Mike Hubert, Helena Kontova, Thomas Locher, Robert Nickas, Rosma Scuteri, Berta Sichel, Matthew Slotover, Benjamin Weil

6. 'The Decade Show: Frameworks of Identity in the 1980s', 12 May–19 August 1990, co-organized and presented by the Museum of Contemporary Hispanic Art, the New Museum of Contemporary Art, The Studio Museum in Harlem; organized by Julia Herzberg (MOCHA), Sharon Patton (SNMH), Gary Sangster and Laura Trippi (TNM). 'The Essential Black Art', Chisenhale Gallery, London, 5 February–5 March 1988, touring to Laing Art Gallery, Newcastle, Huddersfield Art Gallery, Herbert Art Gallery, Coventry, Gardner Art Centre, Sussex University, Cooper Gallery, Barnsley; curated by Rasheed Araeen, featuring Rasheed Araeen, Zarina Bhimji, Sutapa Biswas, Sonia Boyce, Eddie Chambers, Allan de Souza, Mona Hatoum, Gavin Ganjes, Keith Piper

7. Irit Rogoff, *tate*, February 1999

8. Slavoj Zizek, *Repeating Lenin*, Bastard Books, Arzin/Zagreb, 2002

9. Jurgen Habermas, 'Modernity – an Incomplete Project', in Hal Foster (ed.), *The Anti-Aesthetic: Essays on Postmodern Culture*, Bay Press, Seattle, 1983

100 CONTEMPORARY ARTISTS

Born Posadas, Misiones, Argentina, 1966 Lives and works in Posadas

Selected Solo Exhibitions: 1999 'Paintings', Mensú Pub, Posadas 2000 'Samples', Recoleta Cultural Centre, Buenos Aires 2002 'The 1001 Argentinas', UnaM, University of Misiones, Posadas

Selected Group Exhibitions: 1992 'Coca-Cola in Art and Science', Recoleta Cultural Centre, Buenos Aires 1993 'Provincial Prize for Painters', Misiones Cultural Centre, Posadas 1998 'New Painters', touring throughout Paraguay 2001 'Networks, Contexts, and Territories', Goethe-Institute, Buenos Aires 2002 4th Gwangju Biennale; 'LRH 301', Town Council Museum, Posadas; 'Private Landscapes, Collective Prisons', Galería de Arte Ruth Benzacar, Buenos Aires

Selected Bibliography: 2000 Patricia Bertolotti, 'Mutant Universe', *Primera Edición Newspaper*, 15 October; Francisco Ali Brouchoud, 'Mosaic Work', *El Territorio*, 22 October 2002 Sonia Abian, 'Progress Must Not Stop, It Should Go Even Faster: Pause in Make', *Make*, Special Edition 92; Fernando García, 'Cultural Manifestations Inspired in Pot Demonstrations', *Clarín*, 18 June; Elena Maidana, *The Possible Gesture, An Ambulant Provocation: 4th Gwangju Biennale*; Santiago García Navarro, *Private Landscapes, Collective Prisons*, Galería de Arte Ruth Benzacar, Buenos Aires; Ximena Sinay, 'Politicians Words', *3 Points*, January

SONIA ABIAN

It is unusual for a single work of art, albeit a multi-dimensional one, to be sufficiently striking to establish an artist's career. In Abian's case, the uniqueness of her video/action *The Possible Gesture* (2001) is partly explained by her situation: she lives in the extremely poor north Argentinian city of Posadas. The economic and social conditions here are difficult, to say the least, but they are also the reason why she became an artist: she wished to comment on her political environment, and art affords her the rare opportunity to be heard.

Abian began as a painter but soon grew tired of the possibilities it afforded her. Deciding instead to embark on a form of direct, performative action, she printed a series of T-shirts with different quotations taken from the words of politicians on front and back. Often the two were contradictory, or at least plucked from either side of the illusory political divide. The quotations were drawn from statements made since 1983 by individuals still holding political office. They made absurd promises that have never been fulfilled, remaining only as theatrical gestures offered in the heat of the ballot and forgotten the moment they were enunciated. Abian was filmed wearing these shirts as she wandered around the city, even in those uncertain barrios that are still officially unnamed and unacknowledged. She also produced a series of small calling cards bearing photographs of her wearing the T-shirts. These were numbered like lottery tickets to give the appearance of random chance, and each corresponded to a dream that the artist had experienced. The cards were handed out by child beggars in lieu of the usual picture of a saint and biblical quotation with which they usually attempt to raise money. What becomes obvious from watching the resulting video is that Abian is not active in the creation of dialogues with other people in the city. Instead, she waits for them to approach, allowing them time to read the text on the T-shirt (sometimes they appear barely literate) and engage her in conversation. As she does so, she often pulls off her T-shirt in a gesture that at first appears erotic, only to reveal another set of quotations on a shirt beneath it.

This work expresses and provokes understandable political cynicism in a situation of desperate economic need. Seen through European eyes, it provides both touching and appalling proof of the ineffectiveness of any kind of democratic accountability once the World Bank and local corruption have taken control. Yet, if there is any element of redemption, it is in the humour and strength of the individual citizens, and the hope that the symbolic articulation of democratic failure can ultimately lead to something else.

Charles Esche

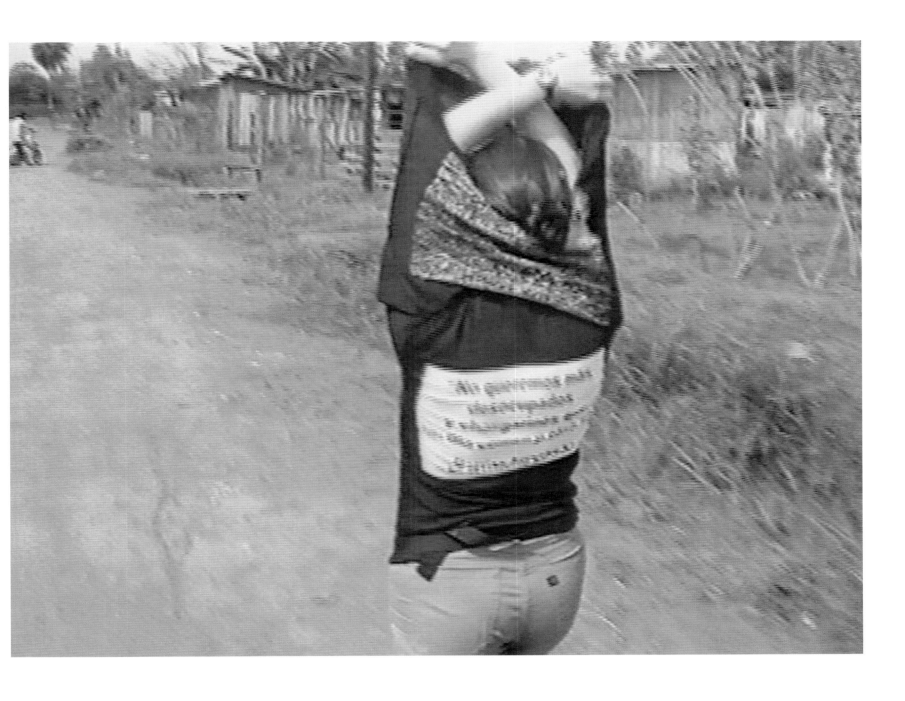

above and overleaf
The Possible Gesture, 2001
video/action, printed cards, 45 min., colour, sound

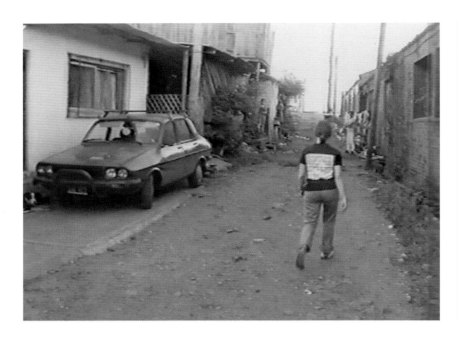
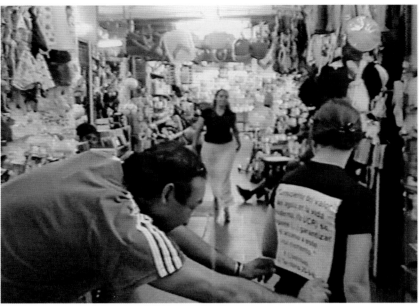
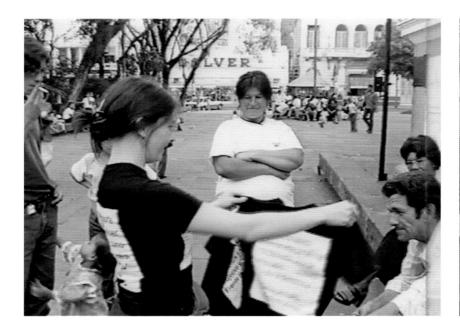
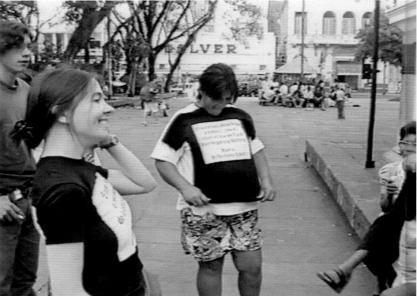

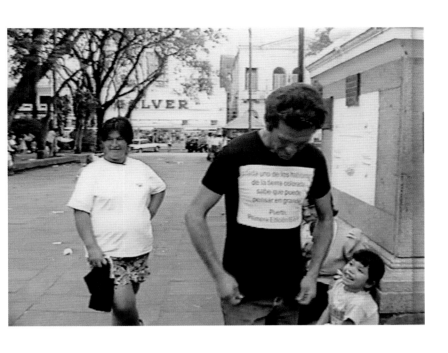

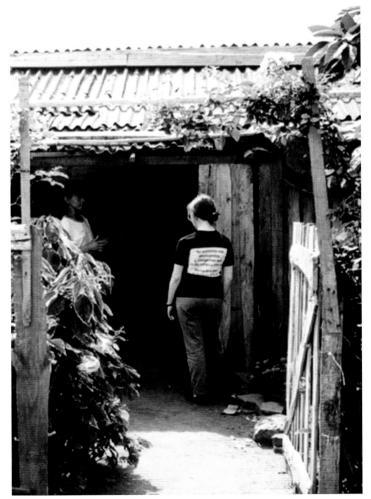

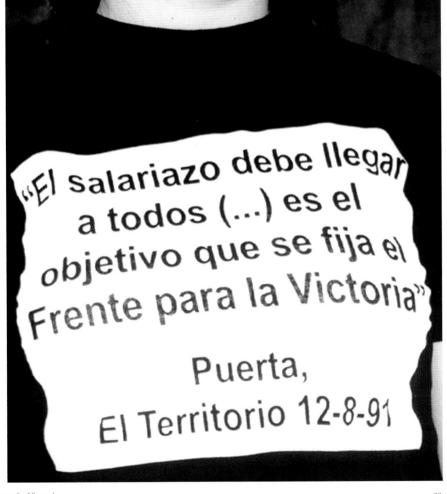

"El salariazo debe llegar a todos (...) es el *o*bjetivo que se fija el Frente para la Victoria"

Puerta,
El Territorio 12-8-91

T-shirt reads: 'The big wage increase should reach everybody (…) this is the objective established by the Front for Victory'

Born Ankara, Turkey, 1970 Lives and works in New York, USA

Selected Solo Exhibitions: 2000 'Coming Soon', Henry Urbach Architecture, New York 2001 'Blood Pressure', Deitch Projects, New York/Centre d'Art Contemporain, Geneva; 'Measure of All Things', P.S.1 Contemporary Art Center, New York/Kunst-Werke, Berlin; 'No Way Forward No Way Back', Aldrich Museum of Contemporary Art, Ridgefield 2002 'A Delicate Balance', Centro Nazionale per le Arti Contemporanee, Rome; 'Illusion of the First Time', Whitney Museum of American Art at Philip Morris, New York

Selected Group Exhibitions: 1998 'Selections', The Drawing Center, New York 1999 6th Istanbul Biennale 2000 'Strange Paradises', Casino Luxembourg, Forum d'Art Contemporain, Luxembourg 2001 'Animations', P.S.1 Contemporary Art Center, New York; 'Casino 2001', Stedelijk Museum voor Actuele Kunst, Gent; 'Painting at the Edge of the World', Walker Art Center, Minneapolis 2002 'Comic Release', Carnegie Mellon University, Pittsburgh; XXV São Paulo Biennale; 'Out of Site', New Museum of Contemporary Art, New York; 'Urban Creation', Shanghai Biennale 2003 'The Moderns', Castello di Rivoli, Museo d'Arte Contemporanea, Turin

Selected Bibliography: 2000 Julie Caniglia, 'Reviews', *Artforum*, May; Holland Cotter, 'Art in Review', *The New York Times*, 3 March; David Hunt, 'Coming Soon', *Time Out New York*, February; David Hunt, 'Overture: Haluk Akakçe', *Flash Art*, October; Bennett Simpson, 'Haluk Akakçe/Mart Noveau', *art/text*, August 2001 Douglas Fogel, 'Haluk Akakçe', *Artforum*, January; Max Henry, 'When Painting Meets Digital', *tema celeste*, May–June; Masanobu Sugatsuke, 'Haluk Akakçe – Superflat Syncronicities', *Composite*, May 2002 'Haluk Akakçe at the Aldrich Museum', *Sculpture*, Vol. 21, No. 3; Holland Cotter, 'Architectural Visions Keep Dreamers Awake', *The New York Times*, 12 July; Heather Waterman, 'Monitor: Haluk Akakçe', *RES*, January

⌐ HALUK AKAKÇE ¬

Haluk Akakçe is interested in change, transition and transformation. Through murals and video projections, sometimes combined with wall paintings, he explores the perception and mutation of shapes. He does this by creating a combination of cleanly contoured forms, reminiscent of the stylized graphics of some animation, and shapes that melt into one another through erotic and elastic rhythms. While re-engaging with high modernist experimental approaches to composition and painting, he is also acutely aware of our time – the digital age. Viewing his sinuous lines and shapes, we recall the fluidity of digital morphing and the optimistic sense of a renewed power over form that such a surge in technology allows. At the same time, we are made aware of our physical presence in the space of the painting or projection.

Akakçe moved to the United States from Turkey in 1995 and currently lives between London and New York. His earlier postmodernist works explored our relationship to technology and Virtual Reality at the birth of the Information Age. *The Measure of All Things* (2000), for example, was a combination of live-action video and digital animation that suspended allegorical figures in a neo-medieval game world. With *Delicate Balance* (2001), premiered at P.S.1 Contemporary Art Center in New York shortly after 9/11, Akakçe reduced his palette to black and white and created a completely abstract dance of falling black shapes, accompanied by Baroque music. This work, both dramatic and essential, is about the complexity of relationships and the interplay of elements and ideas. It is constructed around random configurations that infinitely multiply and separate – recalling both Abstract Expressionism and the decorative, organic aspects of Art Nouveau. Black shapes tumble down the vertical projection like rain, becoming increasingly thicker until the entire screen is black, and the process begins again. Behind these arabesques lies the memory of Islamic decorative arts, never quoted as something oriental and exotic, but still present in the artist's experience, along with forms of popular culture like science fiction.

Akakçe's recent works attempt to render even more absolute and essential the experience of perception and change. In *Untitled (Black on White and White on Black)* and *Untitled (White on White)* (both 2003), he returns to exploring the relationship between the projected image and the actual space of viewing. This merging of the projection and the space is achieved through the interplay of light and shadow, absence and presence in *Illusion of the First Time* (2002). Here, as in all Akakçe's works, painterly interests join cinematic strategies of unfolding and suggested narratives to create dynamic illusions of alternative worlds, recalling early modernist synaesthetic research into the abstract relationships between sound, movement and vision. Carolyn Christov-Bakargiev

The Measure of All Things, 2000
video, 8 min., 30 sec., loop, colour, sound
Installation 'The Measure of All Things', P.S.1 Contemporary Art Center, New York, 2001

Delicate Balance, 2001
multi-channel video projection, 6 min., loop, black and white, sound
Installation 'Delicate Balance', Centro Nazionale per le Arti Contemporanee, Rome, 2002

HALUK AKA

Blood Pressure, 2001
video, 6 min., 30 sec., colour, sound

Born New York, USA, 1966 Lives and works in New York

Selected Solo Exhibitions: 1995 'Follow the Bouncing Ball', VW2566, New York 1996 'Do You See What I See', Postmasters Gallery, New York 1998 'Spectral Paintings from COLOR-I-ME-TRY', Rove, New York 1998 'The Wave/Particle Project + Portals to Other Dimensions', Andrew Kreps Gallery, New York 2000 Van Laere Contemporary Art, Antwerp 2001 'Projects 74: Ricci Albenda', The Museum of Modern Art, New York; 'Tesseract', Andrew Kreps Gallery, New York

Gallery/Friedrich Petzel Gallery, New York 2003 'The Moderns', Castello di Rivoli, Museo d'Arte Contemporanea, Turin

Selected Group Exhibitions: 1999 'Continued Investigation of the Relevance of Abstraction', Andrea Rosen Gallery, New York 2000 'Elysian Fields', Centre Georges Pompidou, Paris; 'Glee: Painting Now', The Aldrich Museum of Contemporary Art, Ridgefield; 'Greater New York', P.S.1 Contemporary Art Center, New York 2001 'The Americans: New Art', Barbican Art, London; 'Casino 2001', Stedelijk Museum voor Actuele Kunst, Gent 2002 'From the Observatory', Paula Cooper Gallery, New York; 'Out of Site', New Museum of Contemporary Art, New York; 'Penetration', Marianne Boesky

Selected Bibliography: 1998 Ken Johnson, 'Ricci Albenda', *The New York Times*, 20 March 1999 Michael Cohen, 'Ricci Albenda', *Flash Art*, May–June; Jeremy Lin, 'Letter Press', *Surface Magazine*, June–July 2000 Tim Griffin, 'The Intangible Economy', *art/text*, August–October 2001 *The Americans: New Art*, Barbican Art/Booth-Clibborn Editions, London; Dike Blair, 'In the White Room', *Time Out New York*, 15–22 February; Tim Griffin, 'Spatial Forces', *Time Out New York*, 30 August; Laura Hoptman, 'Projects 74: Ricci Albenda', *The Museum of Modern Art*, November; Laura Hoptman, 'The Shape of Things to Come', *Flash Art*, May–June; Nadja Rottner, 'Ricci Albenda', *Flash Art*, March–April; Jerry Saltz, 'Psychitectural Digest', *Village Voice*, 27 February

RICCI ALBENDA

Ricci Albenda creates spaces suggesting heightened perception through which one can move. Whether creating these spatial environments or inventing a new typography, he is always intent on activating the viewer's visual awareness and interpretation.

Like that of the early utopian modernists Albenda's art is both experimental and interested in science, while at the same time reflecting the boom in technological development in our own age, with its new and almost fearsome ability to shape the world. His universe is an autonomous, floating realm of white walls and shapes, sometimes incorporating fragments of distorted lettering and words, which appear vaguely reminiscent of the commercial arena of communication – skewed, but still reminiscent of reality.

Though these works reference architecture, they are structures without function. In *Action at a Distance* (2000), for example, Albenda constructed a perfect white space in the dark, wet basement boiler room of P.S.1 Contemporary Art Center in New York, which used to be a school. Albenda's pristine, almost science-fictional 'white cube' contrasted in every sense with this practical, experience-laden boiler room located beneath a pavement.

These white spaces are made of tilted sheetrock walls and inclined floors, and often include strange, bulging, almost sexual-looking convex shapes, coupled by similar concave ones on the opposite walls. The artist calls these forms 'Portals to Another Dimension', building them into the walls themselves. What Albenda is proposing is a non-Euclidean geometry and different perspectival systems from those normally employed to depict three-dimensional space. In *Tesseract* (2001), he even attempted to sculpt a four-dimensional object (the mathematical term 'tesseract' describes a hyper- or four-dimensional cube).

Albenda's works act as perturbing points of reference in the white gallery space. Their highly physical nature suggests both a digitally shaped world and its reverse – a real space that grounds the body phenomenologically, not just in virtual reality, but in the actual world. One is therefore both *inside* these constructed, skewed shapes, and outside them, looking onto a model representation of them. In Albenda's fluid, complex universe of open-ended spaces, science and mysticism are continuous and simultaneous.

Carolyn Christov-Bakargiev

Action at a Distance, 2000
fibreglass, plaster, drywall, acrylic paint, dimensions variable
Installation 'Greater New York', P.S.1 Contemporary Art Center, New York, 2000

Far Room, 2001
fibreglass, plaster, drywall, acrylic paint, 3.9 x 5.1 x 1.6 m
Installation 'Tesseract', Andrew Kreps Gallery, New York, 2001

Portals to Another Dimension (Deborah)/Positive, 2001
fibreglass, plaster, drywall, acrylic paint, 127 x 173 x 24 cm
Installation 'Tesseract', Andrew Kreps Gallery, New York, 2001

Portals to Another Dimension (Morris)/Positive, 2000
fibreglass, plaster, drywall, acrylic paint, 122 x 137 x 20 cm

Portals to Another Dimension (Mersh)/Negative, 2000
fibreglass, plaster, drywall, acrylic paint, 103 x 102 x 15 cm

as installed left to right
trapezoid., 2001, fibreglass, plaster, drywall, acrylic paint, 43 x 163 cm
Portals to Another Dimension (Genevieve)/Positive, 2001, fibreglass,
plaster, drywall, acrylic paint, 229 x 305 cm
algae., 2001, fibreglass, plaster, drywall, acrylic paint, 91.5 x 302 cm
Installation 'Casino 2001', Stedelijk Museum voor Actuele Kunst, Gent, 2001

background left to right
wayfarer., 183 x 81 cm, **solid.**, 137 x 81 cm, **o'clock.**, 164.5 x 81 cm, 1998, acrylic paint on canvas
foreground **table**, 1998, wood and acrylic paint, 91.5 x 307 x 94 cm
Installation 'Spectral Paintings from COLOUR-I-ME-TRY', Rove, New York, 1998

Born Wigan, UK, 1971 Lives and works in London, UK

Selected Solo Exhibitions: 1997 Institute of Contemporary Arts, London; White Cube, London 1999 Galerie Max Hetzler, Berlin; The Renaissance Society, Chicago 2000 'Darren Almond: Traction', Chisenhale Gallery, London; 'Geisterbahn', The Approach, London; 'Transport Medium', Matthew Marks Gallery, New York 2001 'Air for up Coming', Matthew Marks Gallery, New York; De Appel, Amsterdam; Galerie Max Hetzler, Berlin; Kunsthalle Zürich 2002 'A', National Theatre, London/Yorkshire Sculpture Park, Leeds; 'Night as Day', Tate Britain, London

Selected Group Exhibitions: 1996 'Art & Innovation Prize'/'A Small Shifting Sphere of Serious Culture', Institute of Contemporary Arts, London 1997 'Delta', Musée d'Art Moderne de la Ville de Paris; 'Sensation: Young British Artists from the Saatchi Collection', Royal Academy of Art, London/Hamburger Bahnhof, Hamburg/Museum für Gegenwart, Berlin/Whitney Museum of American Art, New York 1998 'Art Crash', Arhus Kunstmuseum, Denmark; 'View Four', Mary Boone Gallery, New York 1999 'Chronos & Kairos', Museum Fridericianum, Kassel; 'Seeing Time', San Francisco Museum of Modern Art 2000 'Apocalypse: Beauty and Horror in Contemporary Art', Royal Academy of Art, London; 'Darren Almond, Mark Hosking', Kerstin Engholm Galerie, Vienna; 'Diary', Cornerhouse, Manchester; 'Geographies: Darren Almond, Graham Gussin, Anri Sala', Galerie Chantal Crousel, Paris; 'Inverse Perspectives', Edsvik, Sollentuna; 'Out There', White Cube², London 2001 2nd Berlin Biennale; 'Casino 2001', Stedelijk Museum voor Actuele Kunst, Gent; 'Deliberate Living', Greene Naftali Gallery, New York; 'Nature in Photography', Galerie nächst St Stephan, Vienna 2002 'Happy Outsiders from London and Scotland', Zacheta Gallery, Warsaw; 'Lila, weiß und andere Farben', Galerie Max Hetzler, Berlin; 'Melodrama Artium Centro', Museo Vasco de Arte Contemporáneo, Spain

Selected Bibliography: 1997 Francesco Bonami (ed.), *Delta*, Musée d'Arte Moderne de la Ville de Paris; Martin Herbert, 'Doing Time', *Dazed & Confused*, No. 29; *Sensation: Young British Artists from The Saatchi Collection*, Royal Academy of Art, London; Gilda Williams, 'Darren Almond at the ICA', *Art in America*, December 1998 Kate Bush, 'Doing Time', *frieze*, No. 42; Brian Muller (ed.), *UK Maximum Diversity*, Galerie Krinzinger, Vienna 1999 Francesco Bonami (ed.), *Common People. Arte Inglese Tra Fenomeno e Realta*, Fondatione Sandretto Re Rebaudengo per l'Arte, Turin; Martin Herbert, 'Darren Almond', *Camera Austria*, No. 67 2000 Jan Avgikos, 'Darren Almond: Matthew Marks Gallery', *Artforum*, September; Louisa Buck, 'UK Artist Q & A: Darren Almond', *The Art Newspaper*, March; Amy Cappellazzo/Peter Wollen (eds.), *Making Time: Considering Time as a Material in Contemporary Video & Film*, Palm Beach Institute of Contemporary Art, Florida 2001 Matthias Vogel, 'Wege zum Unfassbaren. Darren Almond in der Kunsthalle Zürich', *Neue Zürcher Zeitung*, 14–15 April

DARREN ALMOND

Were British artist Darren Almond assigned a belief system, it would probably be a cross between existentialism and Deism – an eighteenth-century rationalist belief that God, after setting the universe running like a clock, abandoned it, exerting no further influence over life and other natural phenomena. Summing up Almond's art is difficult. He is a sculptor and a video artist whose work, to all outward appearances, even when grouped according to medium, remains highly disparate. What distinguishes it thematically, however, is a fascination with time.

Almond's investigation of time neither aspires towards the purity of mathematics nor the poetry of metaphysics, but instead towards the existentialist mechanics of man-made time. It hardly matters, he suggests, if time is systematically differentiated into seconds, minutes, hours and days, or subjectively undifferentiated, as in the process of waiting or forgetting. Almond's subjects, be they as monumental as the Holocaust or as ineffable as boredom, all fall within the scope of the clock's indifference – whether a small one found on a hotel nightstand or the large one we call History.

According to Almond's work, time is the ultimate institution. He has captured this in *Schwebebahn* (1995), a backward-running video-portrait of an inverted train that shares a formal kinship with Fernand Leger's Cubist/Surrealist film classic *Ballet Mécanique* (1924); in sculptural works using digital clocks and ceiling fans; or in his real-time, live-feed videos. *A Real Time Piece* (1998), for example, was broadcast into the gallery direct from his empty studio, while the live setting for *H.M.P. Pentonville* (1997) was an empty prison cell.

In the video *Traction* (1999), Almond interviews his father while his mother listens in a separate setting. 'When was the first time you saw your own blood?', he enquires. This frightening question begins a recounting, delivered in a thick, working-class brogue, of Almond Senior's injuries, acquired both through his work as a miner in the North of England, and through play. His reflections recall Jean-Paul Sartre's famous statement in *Being and Nothingness* (1943) that the body is not so much the place of being as it is the alienated property of being. Almond Senior's body becomes a geographical site, each scar the landmark of an event.

Traction ultimately constitutes a mixture of tender mercies and hard knocks, as tales involving breaks, fractures and missing teeth are transmitted from father to son while the mother listens, alternately astonished and amused. Although Almond Senior's sounds like a hard life, *Traction* sets up a metaphor of life as a game, as if existence were akin to a harsh rugby match in which the players are inevitable losers against the game-clock of life.

Hamza Walker

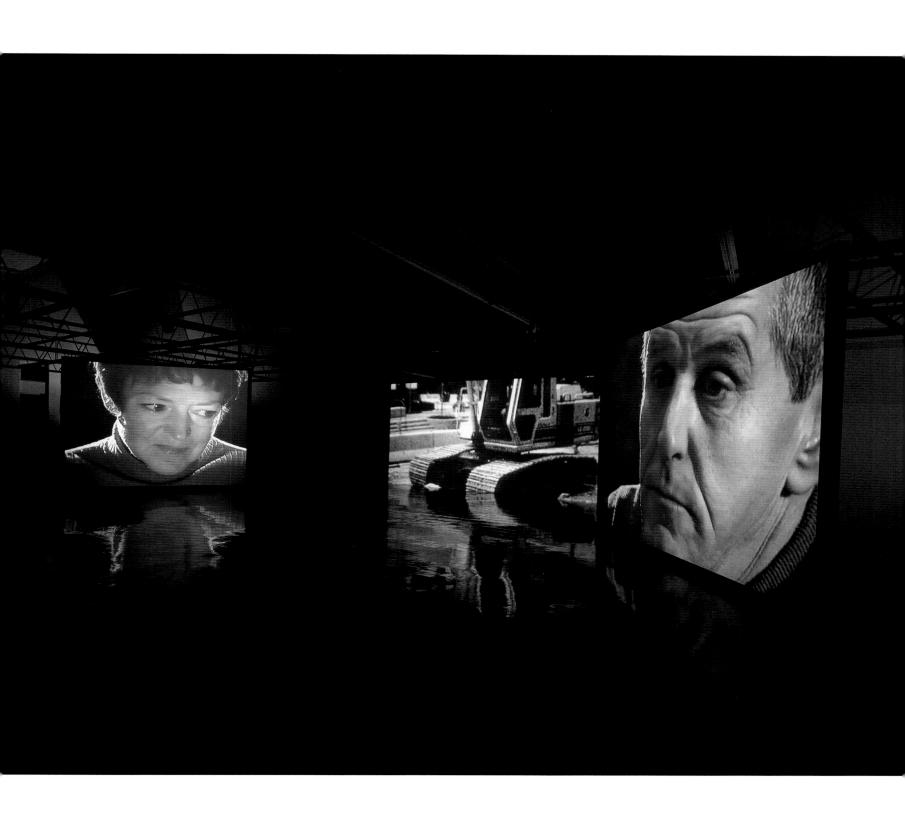

Traction, 1999
3-part video projection, 28 min., colour, sound
Installation The Renaissance Society, Chicago, 1999

Schacta, 2001
2-part video projection, 50 min., colour, sound
Installation Max Hetzler, Berlin, 2001

A, 2002
approx. 23 x 30.50 m, video, mini-DVD, BDSP, **A1**: 6 min., **A2**: 6 min., **A3**: 12 min., colour, sound
Outdoor projection, National Theatre, London and Yorkshire Sculpture Park, Leeds
Commissioned by Public Art Development Trust, London, 2002

H.M.P. Pentonville, 1997
video footage (1 hour, colour, sound) of live satellite link between Pentonville Prison and
Institute of Contemporary Arts, London, 1997

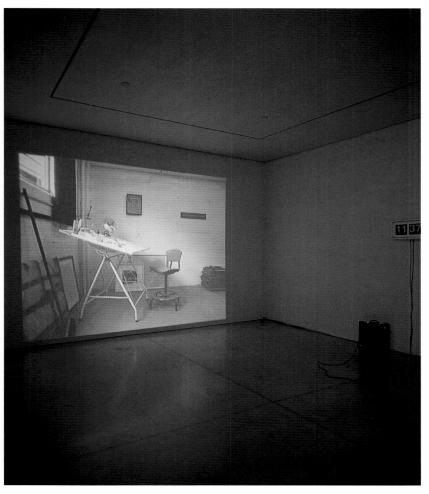

Time And Time Again, 1998
video projection with clock, colour, sound, duration variable

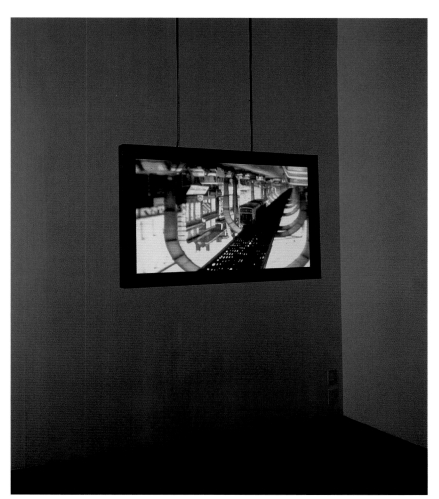

Schwebebahn, 1995
8 mm film, 12 min., colour, sound

Meantime, 2000
steel sea container, aluminium, polycarbonate, computerized
electronic control system and components, 3 x 2.5 x 12 m
Installation Matthew Marks Gallery, New York, 2000

Today, 2000
aluminium, steel, Perspex, paint, motor, 250 x 70 x 70 cm

Born Warsaw, Poland, 1967 Lives and works in Warsaw

Selected Solo Exhibitions: 1997 'Bródno', Cinema Tecza, Warsaw; Kunsthalle Basel 1998 Contemporary Arts Centre, Ujazdowski Castle, Warsaw 1999 'Untitled (A Tent)', Foksal Gallery Foundation, Warsaw 2000 'Bródno 2000', Warsaw 2001 'House on the Tree', Foksal Gallery Foundation, Warsaw; Museum of Contemporary Art, Chicago; 'Weronika', Amden 2002 'Le cinema itinerant/De rondreizende cinema', Belgium; 'Unsichtbar', Alexanderplatz, Berlin

Selected Group Exhibitions: 1997 Documenta X, Kassel 1998 'Parteitag', Galeria a.r.t., Plock 1999 'City Sleepers, Midnight Walkers', Amsterdam; 'Welcome to the Art World', Badischer Kunstverein, Karlsruhe 2000 'Amateur 1900–2000', Göteborgs Konstmuseum, Göteborg; Lyon Biennale; 'Endgame', Florence; Manifesta 3, Ljubljana 2001 'Ausgeträumt', Secession, Vienna; Galeria Vaclava Spaly, Prague; Jubilee Exhibition, Zacheta Gallery, Warsaw; OK Center, Linz; 'Museum unserer Wünsche', Museum Ludwig, Cologne; 'Neue Welt', Frankfurter Kunstverein, Frankfurt; 'Poetry Summer', Watou; 'Vi', Rooseum Centre for Contemporary Arts, Malmö 2002 'I Promise it's Political', Museum Ludwig, Cologne; 'The Collective Unconsciousness', Migros Musuem, Museum für Gegenwartskunt, Zürich

Selected Bibliography: 1996 Andrzej Przywara/Adam Szymczyk, 'Air Conditioning, Interview', *Pawel Althamer*, Foksal Gallery Foundation, Warsaw 1997 Andrzej Przywara, 'Ein Regisseur de Wirklichkeit', *In Freiheit – endlich. Polonische Kunst nach 1989*, Kunsthalle Baden-Baden; Andrzej Przywara, 'Spaceman', *Pawel Althamer*, Kunsthalle Basel, Basel; Adam Szymczyk, 'A Seemingly Innocent Subversion of Reality', *SIKSI*, Summer 2000 Dan Cameron, 'Manifesta 3', *Artforum*, No. XII 2001 Philipp Kaiser, 'Weronika, Pawel Althamer in Amden', *Kunst-Bulletin*, September; Michael Krajewski, *Museum unserer Wünsche*, Museum Ludwig Köln, Bonn 2002 Francesco Bonami, 'Requiem for a Dream: Interview with Pawel Althamer', *Flash Art*, March–April; Martin Prinzhorn, 'Looking back without being able to see', *Afterall*, May; Adam Szymczyk, 'The Annotated Althamer', *Afterall*, May

PAWEL ALTHAMER

In the millennial year, Pawel Althamer illuminated the windows of his large apartment block in Bródno, a suburb of Warsaw, to spell out a huge number '2000'. What made this work (*Bródno 2000*) so striking was the contrast between the everyday appearance of the building and the breathtaking display of brightly lit windows. This was perhaps Althamer's most spectacular work, and in this sense an exception, since he more often makes small, sometimes barely noticeable interventions. In *Motion Picture* (2000), for example, he employed ten people to act out the roles of ordinary people in the street for thirty minutes each, at the same time and place. The result was so close to invisible that many visitors who came to the square searched in vain for the 'performance'.

However, these two works have some essential elements in common. They are both interventions into everyday reality that make one suddenly see one's surroundings in a new way. They bring about shifts in our perception, making strange the reality we take for granted. We become newly aware not only of forms and appearances, but also of social and temporal structures. Fresh layers of ideas that shape both reality and our perception of it also come to light. The illuminated windows evoke utopian visions of social and technical progress, of a rationally structured and perfect society, on which the idea of such buildings was originally based. *Motion Picture* presented not individuals, but stereotypical social roles, appearing on the square as if on the stage of social life. Althamer often works with public spaces such as streets, squares and parks, where he observes and makes visible social relationships and patterns. Galleries and museums, too, are public spaces and highly specific social structures. Several of Althamer's works alter the established conditions and relationships within these spaces and thus our own relationship with them.

But Althamer does not only deal with social reality. For *Untitled* (2001) at Secession, Vienna, he transformed the nature of one social space – the gallery – by introducing into it elements from other such spaces (the subway station, the park). Homeless people who usually gather in public places spent a few hours a day in the gallery. But they were provided with strange white clothes, making them appear like visitors from the future. This poetic dimension, in which the weight of the present seems to be transcended, is active throughout Althamer's work.

Another basic aspect of his art is the tension between the personal and the public. While he observes and is active within social reality, often organizing large numbers of people in order to realize his projects, he also goes beyond it towards his very personal visions. In this sense, the sculpture *House on the Tree* (2002) should perhaps be understood not as a symbol of retreat from society, but as a materialization of the personal ideas and emotions that determine the artist's identity within the world. The tree-top house is perhaps a metaphor for the distanced position from which he can observe the world in new and unusual ways. Igor Zabel

Bródno 2000, 2000
Event organized with the participation of the inhabitants of Althamer's apartment block, Bródno, Warsaw, 2000

Motion Picture, 2000
Performance for Manifesta 3, Ljubljana, 2000

House on the Tree, 2002
bamboo construction, waterproof fabric, bed, chair, lamp, heating, approx. 2 x 2 x 1.5 m
Installation 'The Walk till the End of the World with Robert Walser', Foksal Gallery Foundation, Warsaw, 2002

Self-Portrait and Portrait of the Artist's Wife, 2002
metal construction, grass, plant fibres, wood, straw, animal intestines, mother of pearl, hair, cell phone, video camera, glass, tea bag, approx. 178 x 60 x 60 cm

Untitled, 2001
A gallery was painted a different colour every day by Althamer and his friend from the USA. In the adjacent room was a small exhibition of their memorabilia
Installation 'Untitled', Museum of Contemporary Art, Chicago, 2001

Born Cologne, Germany, 1966 Lives and works in Cologne

Selected Solo Exhibitions: 1993 Galerie Lukas & Hoffmann, Berlin 1994 'Zur Ewigen Lampe', Galerie Nicolai Wallner, Copenhagen 1995 'Modern wird lahmgelegt', Galerie Daniel Buchholz, Cologne 1997 'In Search of Eulenkippstadt', Robert Prime Gallery, London 1999 Galerie Hoffmann & Senn, Vienna; Galerie Christian Nagel, Cologne 2000 ACME, Los Angeles; 'Hau ab, Du Scheusal', Galerie Neu, Berlin; 'Stigmata aus grossmanssucht', Galerie Ascan Crone, Hamburg 2001 'Aus Dir', Galerie Daniel Buchholz, Cologne; Anton Kern Gallery, New York; Galerie Neu, Berlin 2002 Kunstverein Braunschweig, Germany

Selected Group Exhibitions: 1993 XLV Venice Biennale 1994 'Stonewall', White Columns, New York 1995 'Wild Walls' Stedelijk Museum, Amsterdam 1996 'Glockengeschrei nach Deutz', Galerie Daniel Buchholz, Cologne 1997 'Heetz, Nowak, Rehberger', Museum de Arte Moderno de São Paulo; 'Home Sweet Home', Deichtorhallen, Hamburg; 'Time Out', Kunsthalle Nürnberg, Nuremberg 1999 'Ars Viva 98/99', Portikus, Frankfurt; 'How Will We Behave?', Robert Prime Gallery, London; 'oLdNEWtOWn', Casey Kaplan Gallery, New York 2000 'Drawings 2000', Barbara Gladstone Gallery, New York; 'Premio Michetti, Museo Michetti', Francavilla al Mare, Italy 2001 'Musterkarte, Modelos de Pintura en Alemania 2001', Galeria Heinrich Erhart, Madrid; 'Neue Welt', Frankfurter Kunstverein, Frankfurt 2002 'Dear Painter, Paint Me …', Musée National d'Art Moderne de Paris/Centre Georges Pompidou, Paris; Schirn Kunsthalle, Frankfurt

Selected Bibliography: 1996 Eva Karcher, 'Kai Althoff Bilder vom Hoffen und Scheitern', *Art*, October 1997 Yilmaz Dziewior, 'Das Beste aller Seiten', *Texte zur Kunst*, March; Jorg Heiser, 'Bohemian Rhapsody', *frieze*, November–December; Ian Hunt, 'Kai Althoff', *Art Monthly*, May 1999 Isabelle Graw, 'Kai Althoff', *Berliner Tageszeitung*, 29 December 2000 Ascan Crane, 'Kai Althoff', *Flash Art*, Summer; Yilmaz Dziewior, 'Kai Althoff', *Artforum*, May; Renate Roos, 'Kai Althoff, Ein noch zu weiches Gewese der "Urain Bündne"', *Kunstforum*, January–March 2001 Michael Kimmelman, 'Kai Althoff', *The New York Times*, 23 November; Jerry Saltz, 'History Painting', *Village Voice,* 3 December

KAI ALTHOFF

In Kai Althoff's multi-disciplinary aesthetic universe, recollection and perception are in constant conflict. What is seen is almost always filtered through what is remembered. Althoff weaves ambiguous narratives in paint, drawing, sculpture and video that contemplate contemporary life using an array of anachronistic artistic languages including Northern Renaissance devotional art, Die Brücke's German Expressionist angst, Egon Schiele's sinuous, tortured subjects, and James Ensor's carnivalesque pageantry. To this mix he freely adds samplings from more current sources like Sigmar Polke and Martin Kippenberger, as well as a neo-primitive graphic sensibility derived from a certain type of religious publication in post-war Germany.

Althoff's drawings and figurative paintings (often done as watercolour and lacquer on paper adhered to canvas) have a folkloric quality. Some invoke a vague, nineteenth-century Prussian feeling. In *Untitled (scene in room with bed)* (2001), a man in riding boots stoops over a child lying in bed in an attic-like room. In *Untitled (scene in snow with dogs)* (2001), a helmeted soldier pauses on a snowy battlefield; the corpse lying near him is being preyed upon by wild dogs. And in *Untitled (two students)* (2001) a pair of young, uniformed men walk arm in arm in the night air while a threatening onlooker watches them go by. There are also renderings of Christ; one depiction of Jesus carrying the cross is encased in a block of clear resin studded with seeds.

At the other end of the spectrum, Althoff also creates intense, obdurate abstractions constructed from poured plastic and resin. When he references more contemporary life, which he often does in photo-based works, videos and installations, he depicts the cliques that thrive on the fringes of mainstream culture – subcultural communities, tribes of like-minded souls who make music, theatre, dance, fashion and/or film as subversive and liberating gestures. Althoff is himself a member of the experimental 'krautrock' group, Workshop, which recently released the album *Loving You and Your Physicality – a Freak*.

As opposed to much postmodernist pastiche, Althoff's appropriations and amalgamations of recognizable genres are not ironic or self-critical. Rather, they seem to be motivated by the artist's sincere enthusiasm for the communicative powers of myriad artistic vocabularies, as well as an understanding of how artificial and relative the differences among them are. His is a polymorphous aesthetic that shifts style and technique to invoke memories that speak, ultimately, about the present. Nancy Spector

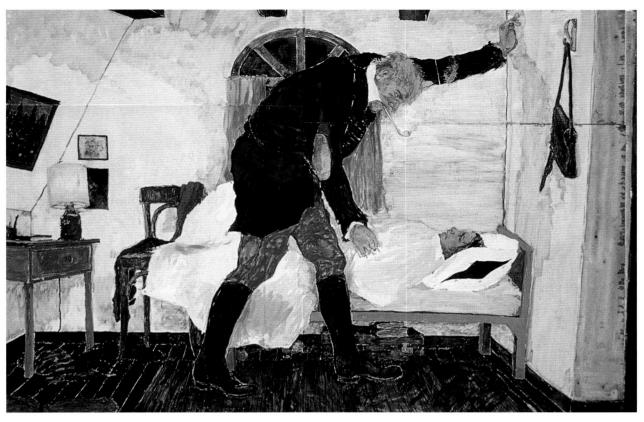

Untitled (scene in room with bed), 2001
lacquer, paper, watercolour, varnish, canvas, 40.5 x 60 x 4.5 cm

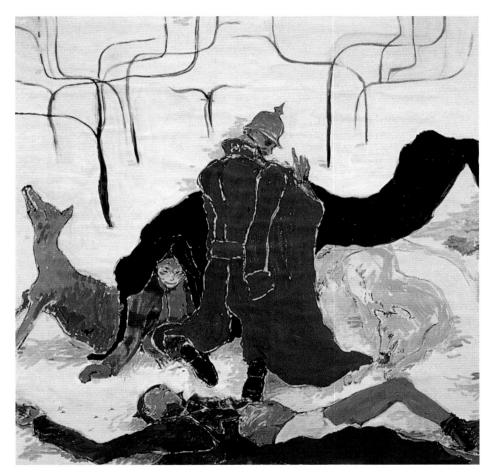

Untitled (scene in snow with dogs), 2001
lacquer, paper, watercolour, varnish, canvas, 40 x 40 x 4.5 cm

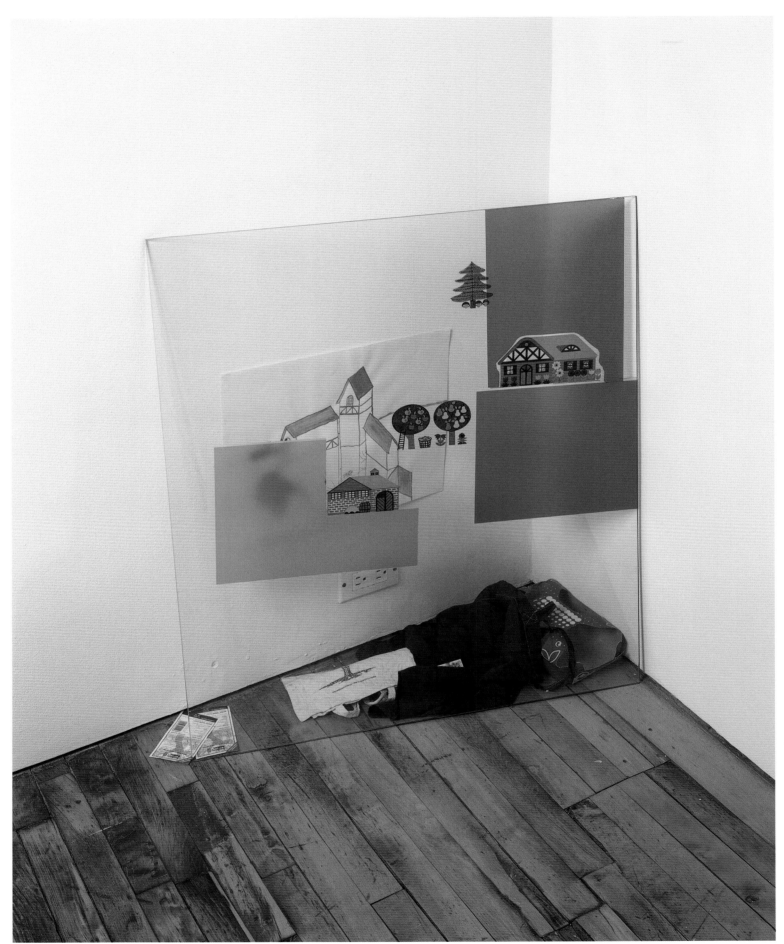

Untitled, 1997
1 drawing, 2 cloth bags, matchbox, 2 apple-juice game tickets, cardboard basket for apples, glass, dimensions variable
Installation 'Hilfen und Recht der äussern Wand (an mich)', Anton Kern Gallery, New York, 1997

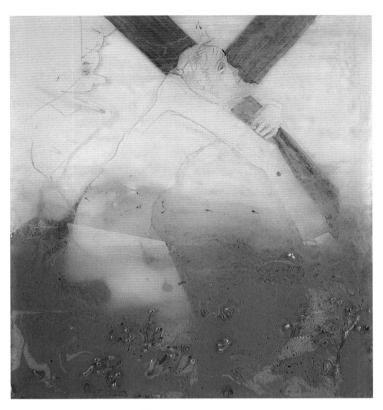

Untitled (resin with Jesus figure), 2001
epoxy resin, drawing, seeds, 70 x 64 cm

Untitled (green figure lying down), 2001
paper, chipboard, plastic foil, photography, plastic, 40 x 50 x 2 cm

Untitled (animal and man), 2001
paper, chipboard, plastic foil, photography, plastic, 47.5 x 34.5 x 2 cm

Untitled (two students), 2001
lacquer, paper, watercolour, varnish, canvas, 70.5 x 60 x 4 cm

Born Lausanne, Switzerland, 1972 Lives and works in Lausanne

Selected Solo Exhibitions: 1999 'Change is Good', Museum Fridericianum, Kassel; Kunsthaus Glarus 2001 'As Deep As Our Sleep, As Fast As Your Heart', Galerie Hauser & Wirth & Presenhuber, Zürich; 'Wouldn't it be nice', Extra Muros/Fri-Art, Fribourg 2002 'Lee's Season. Videofilm en fotowerken', Galerie Leyla Akinci, Amsterdam 2003 50th Venice Biennale; The Renaissance Society, Chicago

Selected Group Exhibitions: 1999 'Amnesic Cinémas', Galerie du Bellay, Haute-Normandie 2000 'Anticorps', Galerie Zürcher, Paris; 'Eidgenössische Preise für freie Kunst 2000', Kunsthalle Fri-Art, Fribourg; 'Only Connect', FRAC, Nord-Pas de Calais; 'Prophecies', Swiss Institute, New York; 'Pulsions', Centre Culturelle Suisse, Paris 2001 'Between Fantasy and Pleasure', The University of Arizona, Tuscon; 'Casino 2001', Stedelijk Museum voor Actuele Kunst, Gent; 'Digital Room', Photographic Center, Copenhagen 2002 'Alter ego artistes contemporaines', History Museum of Luxembourg; 'Flirt', SMART Project Space, Amsterdam; 'Imago 02', Centro de Arte de Salamanca; 'Non-places', Frankfurter Kunstverein, Frankfurt; 'Video Lounge', Fondazione Adriano Olivetti, Rome 2003 'Lust als Passion', Neue Galerie am Landesmuseum Joanneum, Graz

Selected Bibliography: 1998 *Seamless*, De Appel, Amsterdam 1999 Martine Béguin, 'Femmes et artistes en Suisse romande', *Art Suisse*, September; Urs Stahel, *New Photography in Swiss Art*, Christoph Merian Verlag, Basel 2000 Roy Exley, 'Anticorps (Antibodies)', *Contemporary Visual Arts*, No. 31; Jean-Paul Felley/Olivier Kaeser, 'Pulsions', *Attitudes*, September–October; 'No Comment', *Tribeca75*, March; '*Radiant Spirits. Les âmes soeurs*', Migros Museum for Contemporary Art, Zürich; 'The vanishing', *Tank*, May 2001 Sarina Basta, 'Emmanuelle Antille: Hauser & Wirth & Presenhuber', *Flash Art*, July–September; Maria Teresa Fiori, '*Milano Europa 2000. Fine Secolo. I semi del futuro*', Electa, Milan; Hans-Rudolf Reust, 'Emmanuelle Antille. Hauser & Wirth & Presenhuber', *Artforum*, November 2002 Lucca Cerizza, 'Emocionalmente suyo. Notas sobre le obra de Emmanuelle Antille', *Imago 2002 – Encuentros de Fotografía y video*, Centro de Arte de Salamanca; De Meurechy, 'Tell me: focuses on the use of language, text and narration in recent international video-art', M&M Gallery, Bornem, Belgium; Daniele Perra, 'Emmanuelle Antille', *tema celeste*, March–April; Nicolaus Schaffhausen, (ed.), *Non-Places*, Lukas & Sternberg, New York; Brigitte Ulmer, 'Emmanuelles Welt', *Bolero*, Zürich

EMMANUELLE ANTILLE

Emmanuelle Antille uses video installations, texts and photographs to address questions of identity and individual experience within both mediated and real spaces. She has been working since 1997 on a series of installations in which she creates spaces located between reality and dream, fact and fiction, using scenarios involving multi-channel video projections combined with ordinary furniture. Her works are set in private spaces: rented accommodation, detached houses, villas – places where social conventions infiltrate the intimate drama of our domestic lives. Her videos mirror and archive conventional social rituals whilst also potentially transforming them.

The characters in Antille's films are frequently speechless, seemingly searching for a sense of identity. Psyches and bodies slide from from activity to passivity, from speech to silence, from erotic intensity to asexuality, from loneliness to new encounters, from the interior spaces of the dream to the exterior spaces of social interaction. The skin of the architecture and the skin of the principal actors are presented as equally valid and sensitive meeting-places.

Often, Antille herself appears in the films as her own doppelgänger, or 'blood sister' as she calls it. *Until Nothing Can Reach Us* (1998), for example, is a three-channel video projection that intercuts slow, monotonous sequences filmed in a bare flat in a 1970s apartment block with views of the traffic on a busy city street. In the interior scenes Antille – either alone or manipulated by her double carries out a series of actions that are as somnambulistically robotic as they are helplessly clumsy, relating spatially to obscure elements of the architecture. A continuous tone unceasingly vibrates, suggesting both her inner and outer reality. These absurd games seem to express a loneliness incommunicable in language, through physical perception, as if she were attempting to maintain a grip on reality through her body.

Self-realization through physical contact is also a feature of Antille's more recent video works, here presented through the complex rituals of family systems. The family gathering in *Wouldn't it Be Nice* (1999) demonstrates ritualistic behaviour between men and women, the insistent repetition of which has aggressively secured conventions and made change impossible. The social rituals here eventually break into ambivalently erotic gestures.

In *Night for Day* (2000–1) an old lady who lives with a younger female companion, possibly her daughter, perform a series of specifically feminine rituals, based on cleansing and caring. Their physical relationship constantly shifts from affection to aggression, gentle comforting to manipulation. This suffocating exchange becomes a wild *folie à deux* in which the outside world is excluded. These two individuals are encapsulated within the narrow cells of their own reality, where only the somnambulistic parallel world of dream and sleep seem to present possibilities for transformation. Beatrix Ruf

As Deep As Our Sleep, As Fast As Your Heart, 2001
video, 15 min., colour, sound
Installation Galerie Hauser & Wirth & Presenhuber, Zürich, 2001

Yann and the dogs I, 2001
Ilforchrome print mounted on PVC, 100 x 150 cm

The Vanishing 1, 1999
Cibachrome print mounted on aluminium, 100 x 150 cm

Wouldn't it Be Nice, 1999
video, 14 min., colour, sound

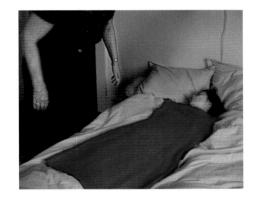

Night for Day, 2000–1
video, 26 min., 20 sec., colour, sound

Until Nothing Can Reach Us, 1998
video installation (3 projections), 10 min., 7 sec., colour, sound
Installation Rijksakademie van beeldende kunsten, Amsterdam, 1998

Born Caracas, Venezuela, 1971 Lives and works in Caracas

Selected Solo Exhibitions: 2000 'Batallas', Museo de Bellas Artes, Caracas 2002 'Holanda', Galleria D'Museo, Caracas

Selected Group Exhibitions: 1997 'La Invención de la Continuidad', Galeria de Arte Nacional, Caracas 1998 'II Bienal del Paisaje', Museo Mario Abreu, Maracay 1999 'IV Edición "Salón Pirelli"', Museo de Arte Contemporáneo, Caracas; 'Nuevas Aquisiciones', Galeria de Arte Nacional, Caracas; 'Perspective Visual', Galería de Arte Nacional, Caracas 2000 'Analogías y confrontaciones', Ateneo de Caracas; 'Litoral el lado anverso', Museo Alejandro Otero, Caracas 2001 'IV Edicións 'Jóvenes com FIA'', Ateneo de Caracas 2002 'Etnografia modo de empleo', Museo de Bellas Artes, Caracas; 'Paralelos', Museo de Arte Moderno, Rio de Janeiro

Selected Bibliography: 2000 Erik Feely, 'Little Paintings with Big Aspirations', *Weekend Newspaper Daily Journal*, 16 August; Yasmin Monslave, 'Las Huellas Pictoricas de Araujo', *El Universal*, 8 August; Luis Perez Oramas, *El Lugar del Paisaje*, Museo de Bellas Artes, Caracas; Edgar Alfonso Sierra, 'La Pintura Genera Problemas que Siempre han sido Conceptuales', *El Nacional*, 5 July 2001 Edgar Alfonso Sierra, 'Me Siento Como un Artista Pop', *El Nacional*, 27 July 2002 Luis Peréz Oramas, *Holanda*, Galeria D'Museo, Caracas; Edgar Alfonso Sierra, 'Libros de Pintura posan para Juan Araujo', *El Nacional*, 9 March

JUAN ARAUJO

'Every painting derives from another painting', claims the Venezuelan artist Juan Araujo. This seemingly straightforward statement is in fact doubly meaningful: on the one hand, painting seems forever doomed to address its own history and formal issues; on the other, the ancient medium may be regarded as nothing but a technique of fragmented quotations, a collage of citations.

Araujo's works are rife with images from other paintings, used in both celebratory and ironic ways. Yet what is at stake here is not merely postmodern appropriation with its infinite web of quotations. The art canon is full of European masters as well as some North Americans, but very few (if any) who originate from beyond the North Atlantic axis. Additionally, young painters in the South have little choice but to consume the Old Masters through illustrated books, most of them imported, some of them obsolete, some bearing poorly printed depictions of the grand works collected and exhibited elsewhere. Araujo's studio is filled with such books, as are his paintings, which feature landscapes and pastoral scenes, battles and seascapes, still lifes and interior views, and above all the pages from which they have been extracted.

Landscape is a key motif in the history of Venezuelan art (the white landscapes of modern master Armando Reverón, for example), and this is Araujo's central theme. The critic Luis Perez Oramas has written that his oeuvre constitutes a veritable 'atlas' of the genre. Taking classical European sources, he dilutes or revamps them, rendering them generic, painting them from memory, or blending them with bits and pieces of his own homeland. Here and there one finds fragments of the original mediating structures: the white space of the page where a caption or explanatory text was once printed, a picture frame with its barely legible imprint, the unequivocal squarish white borders of a Polaroid. One strategy is to paint in series, reworking each image, duplicating landscapes and seascapes again and again, and finally presenting them in a group that constitutes a single work. Formal games with abstraction are also present (a tradition perhaps taken up from Turner): the horizon, which in some cases coincides with an actual slicing of the wooden ground, at times divides crepuscular, hazy skies from solid monochromatic areas.

Painted on small rectangular pieces of wood or MDF, Araujo's works are very far from precious or slavish copies. They have a somewhat nonchalant, straightforward character, their surfaces and finish deliberately precarious, the brushstrokes exhibiting a carelessness that gives them an expressionistic painterly quality. It is as if Araujo wished to assert a certain disregard concerning the grand narrative of the European masters, which, nevertheless, he obviously adores.

Adriano Pedrosa

Vermeer Book, 2001
oil on paper on MDF, 17.5 x 11 cm

Page 267, 268, 269, 2002
oil on MDF, 28 x 63 cm

Subscription, 2002
oil on plywood, 28.5 x 21.5 cm

Ruysdael on the Plains, 2001
oil on MDF, 24 x 26 cm

JUAN AR

Palazzo Pitti, Sala della Alegoria, 2001
oil on MDF, 19 x 13.5 cm

Red Landscape No. 1, 2002
oil on wood, 25.5 x 30 cm

Imaginary Landscapes 2, 1999
oil on MDF, 15 x 27 cm

Joep van Lieshout born Ravenstein, The Netherlands, 1963 Lives and works in Rotterdam, The Netherlands

Selected Solo Exhibitions: 1990 Museum Boijmans van Beuningen, Rotterdam 1994 Gallery Roger Pailhas, Paris 1996 Jack Tilton Gallery, New York 1998 Gallery Gio Marconi, Milan 1999 USF Contemporary Art Museum, Tampa 2001 'AVL-ville', Rotterdam; P.S.1 Contemporary Art Center, New York 2002 Gallery Magazzino d'Arte Moderna, Rome

Selected Group Exhibitions: 1990 Stedelijk Museum, Amsterdam 1994 XXI São Paulo Biennale 1995 'Dutch Design Café', The Museum of Modern Art, New York 1996 'Model Home', Clocktower Gallery, New York 1998 'NL', Van Abbemuseum, Eindhoven 1999 'Expander 1.0', Galerie Jousse Seguin, Paris 2000 Expo Hannover; 'Milano Europa 2000', Milan 2002 1st Busan Biennale, South Korea; 'AREA', Galerie Schipper & Krome, Berlin; 'Expo 02', Biel

Selected Bibliography: 1985 *Der Wechsel Rotterdam–Düsseldorf*, Goethe Institute, Rotterdam 1986 *Perfo 4 D Rotterdam*, Rotterdam Kunststichting 1989 M. van Nieuwenhuyzen, 'Joep van Lieshout', *Arena International Art*, October 1990 D. Ruyters, 'Joep van Lieshout', *Forum International*, November–December 1991 A. Jourdan, 'Joep van Lieshout', *ART Press*, February 1995 'Klaar van de Lippe: Interview with J. van Lieshout', *Jong Holland*, Vol. 2 1997 B. van Lootsma/P. de Jonge/J. van Lieshout, 'A Manual', Museum Boijmans van Beuningen/NAI publishers/Atelier van Lieshout, Rotterdam 1999 I. Pollet, 'Kunstbeesten', *The Dummy Speaks*, Vol. 1 2000 M. Milgrom, 'Target: AVL', *Metropolis*, May 2000 B. Lootsma, 'Superdutch; New Architecture in the Netherlands', Thames & Hudson, London 2001 J. Allen, 'Up the organization', *Artforum*, April

┌ ATELIER VAN LIESHOUT ┐

Joep van Lieshout founded Atelier van Lieshout (AVL) in 1995. His work is truly diverse and far-reaching, going well beyond that of the traditional artist. He is also an inventor, 'manipulator', farmer, activist and architect.

As can be seen from his collaborations with Rem Koolhaas, van Lieshout's approach represents a departure from the traditional lingo of design and architecture. He proposes a new lifestyle with a survival theme but a sharp eye for the aesthetic. In 2001 he attempted to test the borders between society and the individual in a large project called *AVL-Ville*. This was the name he gave to his free state, which emerged in the harbour area of Rotterdam, had its own constitution, flag and currency, and was open to visitors while at the same time acting as home to AVL staff. There, works such as the mobile homes that AVL had exhibited over the years, equipped with showers, toilets and brightly coloured polyester furniture and bars, were put to actual use. Visitors from outside were able to dine in the Hall of Delights, and could even be treated at the fully equipped hospital. The AVL energy plant ran on waste and biogas. A biological city farm supplied AVL-Ville with its products. There was a distillery that made illegal alcohol, and weapons such as bombs and rifles were also manufactured there.

AVL-Ville could be called 'art' in the sense that almost anything was possible there, though life and art had merged into one. Van Lieshout was not proposing a utopia; he was presenting options for living. Information and technology for co-existing with the elements and ecosystems, necessary for the survival of society, were on display. The experiment came to an end after a year, but part of it has moved to Parc Middelheim in Antwerp, and the project continues in the form of AVL Franchise Units. Similar developments are also expected at other locations.

With the installation *Compostopia* (2002), van Lieshout focused on our obsession with the body, combining the various pieces of exercise equipment one would find in a gym with a vast mattress. On a platform reached by a flight of steps was a shower and a compost toilet.

A-Portable (2001) was a project conducted in collaboration with Dr Rebecca Gomperts, the founder of Amsterdam's Women on Waves. This group offers guidance to women and performs first-trimester abortions on international waters in order to prevent, albeit only in a small way, the tragic deaths that occur in countries that do not legally allow terminations. *A-Portable* was a mobile gynaecological clinic made from a shipping container, the inside of which was remodelled and fitted with medical equipment, which made it possible to conduct examinations and operations on boats and trucks. The boat that carried *A-Portable* was moored at the Arsenale in Venice, where abortions are forbidden by the Catholic Church. This project was not intended to highlight the issue of abortion, but was a geopolitical and intellectual test that demonstrated how to confront and challenge problems on a local level.

Yuko Hasegawa

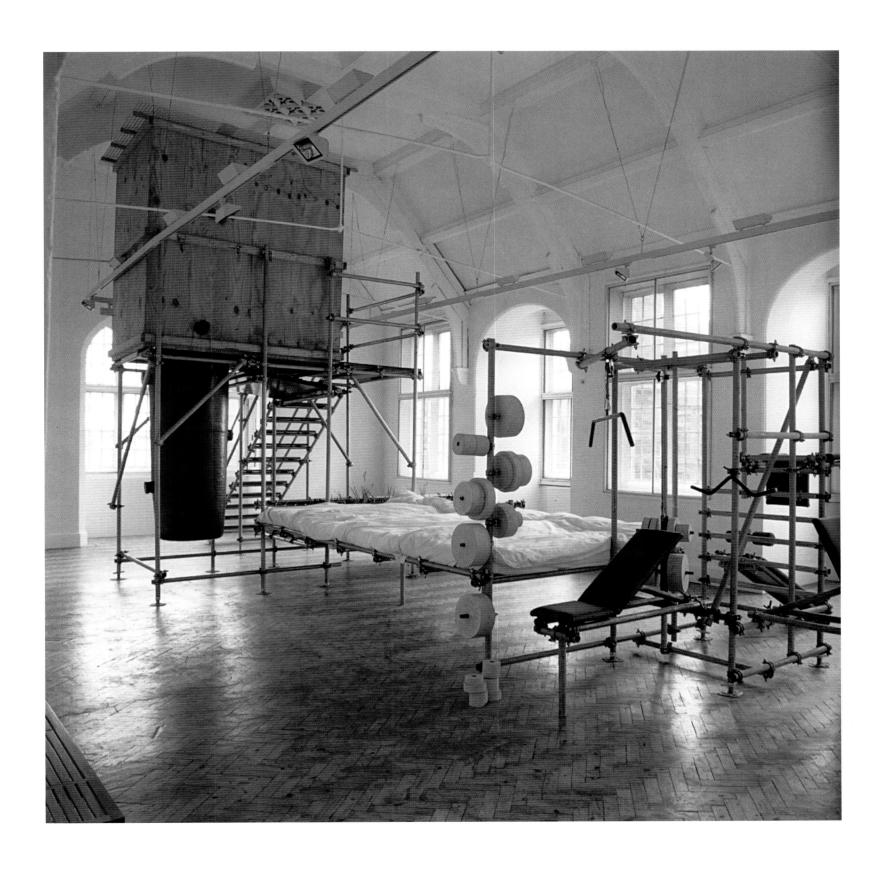

Compostopia, 2002
wood, steel, concrete, fibreglass, 5 x 10 x 4 m
Installation Camden Arts Centre, London, 2002

A-Portable (*exterior and interior*), 2001
steel container, fibreglass, medical equipment, 3 x 6 x 2.5 m

Maxi Capsule Luxus (*exterior and interior*), 2002
fibreglass, 1.5 x 3.5 x 1.2 m

ATELIER VAN LIES

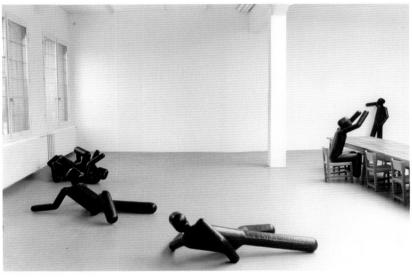

Utopian Dog House, 2002
fibreglass and polyurethane foam, 2.3 x 2.2 x 2 m
Installation 1st Busan Biennale, Korea, 2002

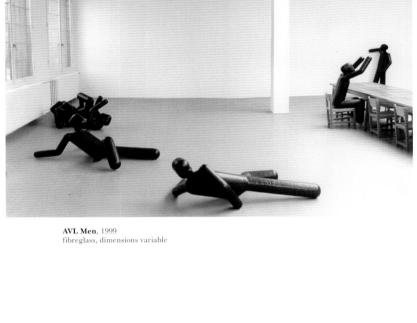

AVL Men, 1999
fibreglass, dimensions variable

Modular House Mobile (*exterior*), 1995–6
steel, wood, fibreglass, 2.15 x 3.1 x 7 m

Big Tongue, 2001
fibreglass and polyurethane foam, 75 x 130 x 80 cm

Clip-On (for Centraal Museum, Utrecht), 1997
fibreglass, 2.3 x 2.5 x 3.1 m

Born Afula, Israel, 1970 Lives and works in Amsterdam, The Netherlands and Israel

Selected Solo Exhibitions: 2001 Caermersklooster, Gent 2002 'Trembling Time', Beelden aan Zee Museum, Scheveningen, The Netherlands; 'Variables XYZ', Digital Art Lab, Holon

Selected Group Exhibitions: 2000 'Greater New York', P.S.1 Contemporary Art Center, New York; 'Open Ateliers', Rijksakademie van beeldende kunsten, Amsterdam 2001 'In the Meantime', De Appel, Amsterdam; 'Neue Welt', Frankfurter Kunstverein, Frankfurt; 'Open Ateliers', Rijksakademie van beeldende kunsten, Amsterdam 2002 4th Gwangju Biennale; Manifesta 4, Frankfurt; 'non-linear editing', De Paviljoens, Almere, The Netherlands; 'say hello wave goodbye', Galerie Hohenlohe & Kalb, Vienna; 'Tele-Journeys', MIT List Visual Center, Cambridge, Massachusetts; 'What? A Tale in Free Images', Brugge

Selected Film/Video Screenings: 2002 4th International Festival of Film and New Media, Athens; 5th International Manifestation of Video and Electronic Arts of Montreal; 48th International Short Film Festival, Oberhausen, Germany; 'e-photos: MediaForum2002', XXIV Moscow International Film Festival; International Film Festival, Rotterdam; International Short Film Festival, University of Texas, Austin; Microwave International Media Art Festival, Hong Kong; VIPER: International Festival for film, Video and New Media, Basel

Selected Bibliography: 2001 Barbara Clausen, 'Profile', *In the Meantime*, De Appel, Amsterdam; Alex Mar, 'In the Meantime …', *Metropolis M*, Summer; Vanessa Joan Muller, 'Yael Bartana/Sodatinnen', *Neue Welt*, Lukas & Sternberg, New York; Gabriele Nicol, 'Eine Frau Shießt per Video auf mannerfiguren', *Frankfurter Neue Press*, June 2002 Yael Bartana, 'Self-Portrait', *tema celeste*, May– June; Iara Boubnova/Martin Fritz/Nura Enguito Mayo/Stephanie Moisdon Trembley (eds.), *Manifesta 4*, Hatje Cantz, Ostfildern 2002 Dana Gilerman, 'To Whom Do We Salute?', *Ha'aretz*, 16 April; Jens Hoffmann, 'Passing Silhouettes', *Tele-Journeys*, Letter Perfect, Inc., Charlotte, North Carolina; 'Journeys of Youth', *Boston Sunday Globe*, 28 April; Wilma Klauer, 'Nonlinear Editing speelt spel met tijd', *Uitgelicht*, April; Verena Kuni, 'Manifesta 4, Frankfurt', *frieze*, No. 69; Cate McQuaid, 'At MIT "Tele-Journeys" to the Center of Globalism', *Boston Sunday Globe*, 26 May; Angela Rosenberg, 'Spot Light Manifesta 4', *Flash Art*, July–September; Geert van de Wetering, 'Couleur Locale', *De Volkstrant*, 5 May

YAEL BARTANA

'I am focusing on Israel in order to ask: "What is this place where I grew up? How long will this troubled nation continue to perpetuate this pattern of ignorance?"', the video artist Yael Bartana has explained. 'By manipulating form, sound and movement, I create work that triggers personal resonance. Personal, intimate reactions have the potential to provoke honest responses and perhaps replace the predictable, controlled reactions encouraged by the state.'

In her work, Bartana attempts something of a high-wire act. She articulates an ambivalent position to an extreme political situation, seeking, as an Israeli citizen, to express a nuanced and intelligent relationship to the state that acts in her name. Through specific attention to a national situation that has global repercussions, she implicates her viewers as witnesses and engaged participants in the constructed scenarios she unfolds.

Filmed from a high vantage point, *Trembling Time* (2001) depicts a busy four-lane highway. Layers of moving images slowly reveal cars coming to a halt and the occupants opening their doors, standing by their stationary vehicles, pausing and then slowly driving away. Today, in the perverse time we inhabit, the sight of stopped traffic suggests a grave situation. One wonders what catastrophe these drivers can see ahead of them, what has induced their paralysis. Is it fiction or reality, and, if fiction, how could a powerless artist arrest the flow of cars, goods and people? In fact it was filmed in Tel-Aviv on Soldier's Memorial Day, which is heralded by sirens blasting out across the country, triggering the ritual described above. Memorial Day forms part of a cycle of state-organized ceremonies and military events devised to define tradition and shape national identity. In most cases one experiences such situations as part of a collective, but Bartana's shift to slow motion, to the occasional close up and to the various responses of each driver highlights the individual within the mass. By observing from on high rather than being involved in these moments, she abstracts the emotions the state intends to foster. Instead of encouraging blind obedience, a space for possible change is opened up that is neither sympathetic nor critical but simply poses questions.

In *Disembodying the National Army Tune* (2001) a simple movement is again amplified and emphasized. Sliding up and down a four-metre pole, a loud speaker simulates the patriotic act of raising and lowering a flag. It is triggered into movement by the presence of the viewer, who also activates the sound – the Israeli National Army anthem vocalized by someone imitating the noise of a trumpet. The absurdity and feebleness of the sound can only be provocative in this context, yet nationalist feelings are still provoked by the tune, so that each listener is to some extent forced to adopt an individual position towards the expression of presumed collective will.

Profile (2000) uses a straight documentary film of young female Israeli soldiers during rifle training. The looped, sloweddown sequential movements of picking up, holding, aiming and shooting the gun become a visual choreography, accompanied by a carefully constructed soundtrack. The soldiers stand in line wearing headphones, as do we the viewers, watching the scenes on the monitor and listening to the soundtrack. Thus we re-enact the simulated confrontation with an enemy, experiencing the encounter from both a removed and implicated position, and cast in the unfamiliar role of soldier, law enforcer and potential killer.

Charles Esche

Disembodying the National Army Tune, 2001
loudspeaker, metal pole, motor, movement sensor, sound, 4 m
voice: Noa Frenkel, composition: Keren Rosenbaum

Trembling Time, 2001
video, 7 min., loop, colour, sound; soundtrack: Tao G. Vrhovec Sambolec
Installation 'Open Studio', Rijksakademie, Amsterdam, 2001

Profile, 2000
video, 3 min., colour, sound
Installation 'In the Meantime', De Appel, Amsterdam, 2001

Born Rome, Italy, 1966 Lives and works in Rome

Selected Solo Exhibitions: 2000 'Gymnasium', Centro per l'arte comtemporanea La Grancia, Serre di Rapolano, Italy 2001 'Day's End', Galleria Antonella Nicola, Turin; 'Fuga', La Folie de la Villa Médicis, Académie de France, Rome; 'In moto', Galleria Massimo De Carlo, Milan

Selected Group Exhibitions: 1999 'Fuori Uso', Ex Clinica Baiocchi, Pescara 2000 'Che c'è di nuovo?', Casina Pompeiana, Naples; 'Elisabetta Benassi, Federico Del Prete, Matthias Müller', Fondazione Adriano Olivetti, Rome; 'Mes rendez-vous', Galerie Michel Rein, Paris; 'Special Projects', P.S.1 Contemporary Art Center, New York; 'La Ville, le Jardin, la Mémoire', La Folie de la Villa Médicis, Académie de France, Rome 2001 2nd Berlin Biennale; 'Anstoss. Kunst, Sport und Politik', Kunst-verein Nürnberg, Nuremberg; 'Boom!', Ex Manifattura Tabacchi, Florence; 'Elisabetta Benassi, Lara Favaretto, Norma Jeane', Capsula Tellus, Rome; 'Sport Cult', Apex Art, New York; 'Unreal Presence', SMART Project Space, Amsterdam; 'Videorom', Valencia Biennale 2002 'De Gustibus', Palazzo delle Papesse, Siena; Manifesta 4, Frankfurt; 'You'll Never Walk Alone', Arnolfini, Bristol

Selected Bibliography: 1999 Paola Magni, 'Elisabetta Benassi', *Ars Medica. Fuori Uso*, Ex Clinica Baiocchi, Pescara 2000 Stefano Chiodi, 'Rilievi d'intenzioni: Elisabetta Benassi', *Espresso. Arte oggi in Italia*, Electa, Milan; Sergio Risaliti, 'Elisabetta Benassi', *Che c'è di nuovo?*, Casina Pompeiana, Naples 2001 Euridice Arratia, *Sport Cult*, Apex Art, New York; Elisabetta Benassi, 'What the crow says', *2nd Berlin Biennale*, Vol. 1, Oktagon, Berlin; Lorenzo Beneditti, 'Elisabetta Benassi', *Arte e Critica*, No. 28; Guido Curto, 'Elisabetta Benassi', *Flash Art*, No. 228; Daniela De Dominicis, 'Benassi, Del Prete, Müller', *Flash Art*, No. 226; Maria Luisa Frisa, "Fuga" in 'La folie di Villa Medici', *Il giornalino. Villa Mèdicis*, No. 20; Donatello Bernabò Silorata, 'Che c'è di nuovo', *Flash Art*, No. 226; Marina Sorbello, 'Partita doppia con Pasolini', *Il Manifesto*, 20 April; Marina Sorbello, 'Elisabetta Benassi', *tema celeste*, No. 86; Maria Rosa Sossai, 'Sconfinamenti', *Flash Art*, No. 226 2002 Gianfranco Maraniello, 'C'est un problème de temps. Notes sur l'art italien d'aujourd hui', *Art Press*, No. 279; Maria Rosa Sossai, *Artevideo. Storie e culture del video d'artista in Italia*, Silvana Editoriale, Milan; Maria Rosa Sossai, 'Declinazione video', *Flash Art*, No. 234

ELISABETTA BENASSI

Blending performance art, film and video, Elisabetta Benassi takes us on a journey through collective and personal memories, evoking emotions such as longing, desire, loss and love. Her art is at once restrained and emotionally engrossing.

You'll Never Walk Alone (2000) is a video loop in which Benassi appears as her alter ego Bettagol, wearing a leather jacket and riding a motorbike. She picks up Italian writer and filmmaker Pier Paolo Pasolini (played by an actor), takes him for a ride through the city of Rome, and ends up playing football with him in an empty stadium. The game, filmed in slow motion, becomes a dance composed of moments of fragile and elusive recognition. The film is soaked in nostalgia for an age during which intellectuals such as Pasolini were making history – expressing free thought, questioning ideology and bourgeois living in seminal novels and experimental films. As Bettagol and 'Pasolini' ride through the city, snippets from his film *Hawks and Sparrows* (1966) are woven in like flashes from another dimension of reality, a parallel world. There is something daring and empowering in deciding to juxtapose oneself with Pasolini, even if only in the space of a narrative fiction and for a few moments. Past and present overlap, and the two characters are brought into a tense relationship, meeting for the briefest moment when their gazes fleetingly cross.

As with the early twentieth-century modernists, the relationship with technology (the machine) is a recurring element in Benassi's art. The motorcycle, for example, crops up in other works, including *Timecode* (2000), a video featuring the same characters as *You'll Never Walk Alone*. In *Panoramicar* (2000), she modified a small van used to shuttle visitors back and forth to the art space Zerynthia, outside Rome. Upholstery, sound and video elements suggested an alternative journey, bordering on the exotic. There is an element of Romanticism in many of her works, a sense of the sublime and of solitude. In *Fuga* (2001), she placed a black piano inside an empty glass pavilion in a garden at night. The audience was outside, but through the glass architecture one could see the keys of the piano playing by themselves. Bettagol's red biker jacket hung from the limb of a nearby tree.

Increasingly, Benassi is joining sculpture and video in her works, creating ambiguous environments for viewing, places that blend with the aesthetic experience, and thereby prevent any detached, 'secure' perspective. In the installation *Day's End* (2000–1), for example, she built a projection cube that resembled an elevator, within which the audience watched a video loop. The footage was itself filmed in the elevator of the Empire State Building, and edited with an increasingly intense rhythm. The steadily mounting LED numbers, indicating the number of floors climbed, ultimately suggested ascension and epiphany.

Carolyn Christov-Bakargiev

Timecode, 2000
video, 3 min., 37 sec., colour, sound
with Elisabetta Benassi, Davide Leonardi
camera: Jacqueline Zünd

You'll Never Walk Alone, 2000
C-print on aluminium, 70 x 100 cm

You'll Never Walk Alone, 2000
video, 3 min., 40 sec., colour, sound
with Elisabetta Benassi, Davide Leonardi
camera: Jacqueline Zünd

Day's End (*exterior*), 2000–1
stainless steel, plywood, wood, DVD player, video projector, back-projection screen, loudspeakers, UV lamp, neon light
270 x 230 x 470 cm
Installation 'Boom!', Ex Manifattura Tabacchi, Florence, 2001

Day's End, 2000–1
video, 2 min., 30 sec., colour, sound

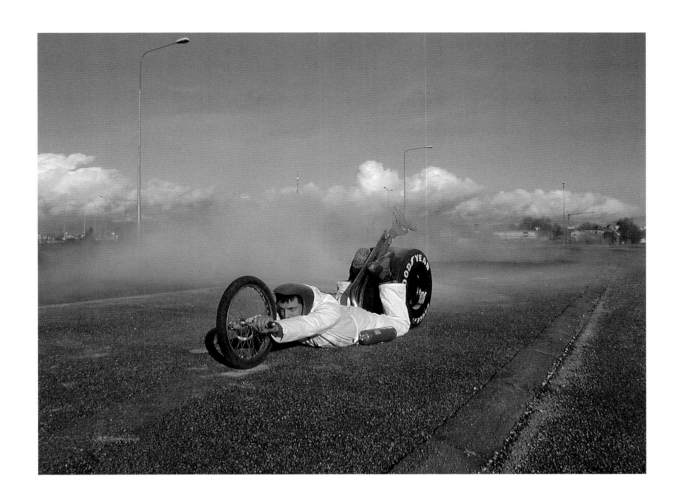

X-Men, 2002
Lambda print on aluminium, 30 x 40 cm

Born Jönköping, Sweden, 1973 Lives and works in Stockholm, Sweden

Selected Solo Exhibitions: 1996 'År du lik en känd person?', Galleri Service, Stockholm 1998 'Straight from the Hip', Ynglingagatan 1, Stockholm 1999 'Coming Up', 1419A, The Royal Academy of Art, Stockholm 2000 'Project for a Revolution', Galleri Flach, Stockholm 2001 'Keep on Doing', Sub Bau, Gothenburg; 'Where She Is At', Moderna Museet Project Room, Stockholm/Oslo Kunsthall 2002 'Where She Is At', Bild Museet, Umeå

Selected Group Exhibitions: 1997 'Party', Académie Royale des Beaux-Arts, Brussels 1998 'Gekko', Münchenbryggeriet, Stockholm; 'Performance, an Art Brothel', Herkulesgatan, Stockholm; 'Stuff It', Ynglingagatan 1, Stockholm 1999 'Eslövs Julsaga', Eslövs, Sweden; 'Light Show', Signal, Malmö 2000 'Lost in Space', Färgfabriken, Stockholm; 'Onufri "00" In and Out', National Gallery, Tirana; 'Swe.de', Riksutställningar Uppsala Konstmuseum; 'Viva Scanland', Catalyst, Belfast 2001 'Blick – New Nordic Film and Video', Moderna Museet, Stockholm/NIFCA, Helsinki; 'I'll Never Let You Go', Panacea Festival at Moderna Museet, Stockholm; 'Motstånd/The Path of Resistance', Moderna Museet, Stockholm; 'Projects for a Revolution', Le Mois de la Photo à Montréal; 'Vi/Intentional Communities', Rooseum, Malmö/CAC, Vilnius; 2002 4th Gwangju Biennale; 'Es is schwer da reale zu berühen', Kunstverein München, Munich; 'Room for Revolution', Deluxe Projects, Chicago

Selected Bibliography: 2000 Millou Allerholm, 'Generation 00', *Dagens Nyheter*, 12 August; Susanna Chan, 'Belfast', *CIRCA*, No. 93; Lars O Eriksson, 'Uppror ur unga ögon', *Dagens Nyheter*, 13 April 2001 Jan-Erik Lundström, 'Projects for a Revolution', *Le Mois de la Photo à Montrèal;* Åsa Nacking, 'De kollektiva som en möjlghet', *Rooseum Provisorium*, No. 2; Anne-Marie Ninacs, 'Just do it: on a few ethical models proposed by the practice of art', *Les Commensaux: When Art Becomes Circumstance*, Skol, Montreal 2002 Søren Grammel, 'Est is schwer das reale zu berühren', *Drucksache Kunstverein München*, Spring; Lisa Panting, 'The Innocence has Evaporated', *Untitled*, Autumn; Mats Sternstedt, *The Artist, the Individual and the Community*, Moderna Museet, Stockholm

JOHANNA BILLING

'It was our parents' generation who brought the revolution. They took care of all that for us and we were told that now everything had been done and it wasn't something we need be bothered with. We were to pursue a career and invest in our own lives.' This is Johanna Billing speaking in 2001 about the failure of her generation to reinvigorate social democracy in Sweden. Her work is imbued with her country's recent history and often touches on that sense of turning up after the party is over that preoccupies her peers.

Billing's best-known work, *Project for a Revolution* (2001), takes its inspiration from the opening sequence of Michelangelo Antonioni's *Zabriskie Point* (1969). By removing from her video version all the dialogue, passion and action, she delineates a stagnant time during which the protagonists wait for something to happen, without providing any clues as to what this might be.

In another video, *Missing Out* (2001), Billing uses the collective breathing exercises that she remembers from school as a vehicle to define the difficulties experienced by the individual within the group, the desire for conformity and its impossibility for some people. A young man tries to join in the activities of a group of people who lie stretched out on an institutional floor. Unable to settle, he gets up again as the film abruptly shifts to the interior of a car, then shows him standing on the street and later wandering around a supermarket. In each scene he appears more agitated than before. Eventually he returns to the bosom of the group and tries again to join in the simple exercise of communal breathing.

A third recent video called *Where She is At* (2001) also plays with the isolation of the individual in society. A woman paces nervously on a high diving board unable to decide whether to jump or not, neither too frightened to climb down nor brave enough to take the plunge.

The essential element in all these works is the emergence of ambivalence and indecision in the face of the pressure to conform. Perhaps this refers back to a critique of the institutionalized nature of Swedish social democracy, with its constant prioritization of consensus over conflict. However, Billing is not arguing here for the Anglo-American model as an alternative. By capturing these moments prior to the decisive act, she emphasizes the troubling nature of choice. To choose is to lose a potent zone of possibility, she seems to be saying. Neither the group nor the individual is paramount; neither social democracy nor the US monopoly capitalist model are the way forward. Rather than offering a programme of action, she conveys a strangely diffident curiosity about what else might exist beyond these choices.

Interestingly, alongside these video works focusing on inaction, Billing also runs an independent music label called Make it Happen, which successfully releases records and organizes concerts. This dichotomy perhaps points to a subtle understanding of effective contemporary action, making things happen at a local level while still keeping an eye out for art's potential as a broadly effective symbolic language.

Charles Esche

Missing Out, 2001
video, 4 min., loop, colour, sound
camera: Manne Lindwall

Missing Out, 2001
video, 4 min., loop, colour, sound
camera: Manne Lindwall

as installed left to right
Missing Out, 2001, video, 4 min., loop, colour sound
Project for a Revolution, 2001, video, 3 min., 14 sec., loop, colour, sound
Installation 'Intentional Communities', CAC, Vilnius, 2001

Where She is At, 2001
video, 7 min., loop, colour, sound
camera: Henry Moore Selder

JOHANNA B█

Project for a Revolution, 2001
video, 3 min., 14 sec., loop, colour, sound
camera: Johan Phillips

Where She is At, 2001
video, 7 min., loop, colour, sound
Installation 'Where She is At', Oslo Kunsthall, 2001

Born Jerusalem, Israel, 1966 Lives and works in Paris, France

Selected Solo Exhibitions: 1997 'Un rude hiver', Musée des Beaux-Arts et de la Dentelle, Calais; 'La salle des temps perdus', Le Grand Wazoo, Amiens 1998 'Tales Of Britain', Espace Culturel François Mitterand, Beauvais; 'Vacance', Venividi/Shopping centre, Ivry-sur-Seine 2000 'Homo Œconomicus', Stanley-Picker Gallery, Kingston University, Kingston-upon-Thames; 'PropagandaTM', Der Standard/Museum in Progress, Vienna 2002 '400 jaar zonder graf, dan heb je lang gezwegen', Oost-Indisch Huis/Upstream, Amsterdam

Selected Group Exhibitions: 1997 'Sous le manteau', Galerie Thaddaeus Ropac, Paris 1998 'Disquieting Strangeness', Centre for Freudian Analysis and Research, London 1999 'Visions Underground', Stalingrad Metro Station, Paris 2000 'I.C.I.', W139, Amsterdam; 'The Language Course', El Caracol, Mexico City; 'Public Inventions and Interventions', Temporary Services, Chicago 2001 '58 Films Cash', Musée d'art contemporain, Marseille; 'Take Two/Reprise, Ottawa Art Gallery 2002 'BIG Social Game, BIG Biennale', Turin; 'Bingo', Galerie Thaddaeus Ropac, Paris; 'Non-Places', Frankfurter Kunstverein, Frankfurt; 'La nuova agora', Fondazione Pistoletto, Biella/Shedhalle, Zürich; 'Telejourneys', MIT List Visual Arts Center, Cambridge, Massachusetts 2003 'Influence, Anxiety and Gratitude', MIT List Visual Arts Center, Cambridge, Massachusetts

Selected Bibliography: 2000 Michael Blum, *Homo Œconomicus*, IDEA Books, Paris/Amsterdam; Anita de Groot, 'Wandering Marxwards', *Worldwide Video Festival*, Amsterdam 2001 Michael Blum, 'Revolution', *Cabinet*, Summer; Sylvie Fortin, 'Take Two', Ottawa Art Gallery 2002 Elke Buhr, 'Im Transitraum', *Frankfurter Rundschau*, 12 March, Frankfurt; Jens Hoffmann, *Passing Silhouettes*, MIT List Visual Arts Center, Cambridge, Massachusetts; Verena Kuni, 'non-places', *frieze*, May

MICHAEL BLUM

If contemporary art is to have any purchase on shaping culture – rather than simply affirming it – it must be able to deal directly with the dominant ideas of our age. The monolithic presence of global, free-market capitalism is pushing every other concept of social organization into the shadows. Economic rationalism is presented more as a force of nature than a political and social choice, and to imagine different ways of doing business, exchanging culture or even surviving is increasingly difficult.

It is in the face of such rigid closure that Michael Blum's work operates. One of his earlier video works, *Wandering Marxwards* (1999), takes us on a journey through North American retail splendour to the accompaniment of a voiceover, spoken by the artist, who wonders how we can extract Marx from the trash-can of capitalist history. In the process, he seeks to uncover a poetic, even soulful, Marx from a supposedly dry economic text. Another video work continues to touch on economic globalism but this time in a more overtly personal and traumatic way. *My Sneakers* (2001) starts with a beautiful description of the artist suddenly glancing down at his sneakers in wonder at their absurd colour. From this epiphany, Blum embarks on a journey to Indonesia to find the people and conditions under which they were manufactured. This ultimately forlorn quest mutates into a process of education and dawning understanding. Meeting factory workers, especially women, whose relationship with sneakers is totally different from that of any European consumer, draws us close to the marginalized community that underpins Western affluence. The final sequence, when the sneakers are returned for recycling to the streets of Jakarta, is strangely moving, as though we are saying goodbye to an old friend.

It is not only in video that Blum explores the personal implications of globalization. His public work *400 years without a grave is a long time to shut up* (2002) is a simple gravestone to a somewhat forgotten Dutch explorer, Cornelius de Houtman. From speakers hidden inside, a deathly monologue echoes, as if Houtman were speaking from beyond the grave, telling of his bitterness about his lack of renown. Funny and arrogant, de Houtman emerges as the prototypical grey-suited CEO.

The element of historical research continues in other works such as the text installation *Piety, cleanliness and punctuality are the strength of a good business* (2002), and his collaged publication *potlatch.com*. The latter seeks to illustrate Bataille's description of potlatch (ritual gift-giving and destruction of goods by the leader of a tribe) with a collection of historical and contemporary images that was freely distributed in various waiting rooms in Amsterdam and Paris.

These and other works intercept and confront us with carefully controlled information about the unrecognized environment around us. It is this technique of disclosing images and signs from the underbelly of capitalism that marks Blum out as an artist working in the interesting field of engaged autonomy – locked into the system while using art as a way to provoke new ideas about its future.

Charles Esche

400 years without a grave is a long time to shut up, 2002
tombstone and sound system, 8 min., looped soundtrack
Installation Oost Indisch Huis courtyard, Amsterdam, 2002

Wandering Marxwards, 1999
video, 19 min., 23 sec., colour, sound

My Sneakers, 2001
video, 37 min., 30 sec., colour, sound

Born Gribbohm, Germany, 1965 Lives and works in Berlin, Germany

Selected Solo Exhibitions: 1997 'Das Gängelband der Kunstwohlfahrt', Klosterfelde Gallery, Berlin 1998 '1 Mio Knödel Kisses', Galerie der Stadt Schwaz, Tirol 1999 'Lombardi Bängli', Kunsthalle Basel; 'Maybe-Me-Be-Microworld', Anton Kern Gallery, New York; 'Zeitwenden Rückblick und Ausblick', Kunstmuseum, Bonn 2000 'Aller Anfang 1st Merz – Von Kurt Schwitters Bis Heute', Sprengel Museum, Hannover; Kunstverein Bremen; 'Projects 71', The Museum of Modern Art, New York 2001 'Ma'am Prociutto Crudo', Helga Maria Klosterfelde, Hamburg; 'Lehm, Lehm, Lehm', Regen Projects, Los Angeles; 'When I am Looking into the Goat Cheese Baiser', Anton Kern Gallery, New York

Selected Group Exhibitions: 1998 1st Berlin Biennale; 48th Venice Biennale 1999 'German Open', Kunstmuseum, Wolfsburg 2000 FRAC, Reims; 'Jacob Frabricus', Modenschau aus MoMA, Copenhagen; 'Koppel op Kop, Ars Viva', Kunstverein Freiburg 2001 '3-Person Group Show', Magasin 3, Stockholm; 'April is the Cruellest Month', Stella Lohaus Gallery, Antwerp; 'Hypermental Rampant Reality 1950–2000', Hamburger Kunsthalle, Hamburg; 'New Settlements', Contemporary Art Centre, Copenhagen 2002 Documenta 11, Kassel

Selected Bibliography: 1997 Ronald Jones, 'Openings: John Bock', *Artforum*, Summer; Roberta Smith, 'John Bock', *The New York Times*, 13 March 1999 *German Open 1999 – Gegenwartskunst in Deutschland*, Kunstmuseum, Wolfsburg 2000 Holland Cotter, 'Update on Berlin Since the Wall', *The New York Times*, 12 November; Yilmaz Dziewior, 'John Bock: The Receiver's Due', *art/text*, February–April; Massimiliano Gioni, 'John Bock', *InterVista*, Summer; Laura Hoptman, 'The John Bock Primer', The Museum of Modern Art, New York; Jerry Saltz, 'Ruff Trade', *Village Voice*, 30 May; Dieter Ronte/Walter Smerling (eds.), *Zeitwenden Rückblick und Ausblick*, Kunstmuseum Bonn 2001 Benjamin Meyer-Krahmer, 'The Quasi-me as Optimal Existoform', *nu: The Nordic Art Review*, Vol. 3, No. 5; Alexi Worth, 'John Bock – Anton Kern Gallery', *Artforum*, October

JOHN BOCK

John Bock has transformed sculpture into theatrical space, creating bizarre little hovels, cramped, multi-level hideaways and maze-like burrows inside which he performs manic, nonsensical dramas. Viewers have access to him only intermittently as he slithers through narrow channels, hides under floors and crawls over the jerry-built stages that comprise his installations. In some shows, particularly after the opening events have concluded, Bock is visible only on video monitors, his recorded antics serving to animate the eccentric architecture that has been left behind as a sculptural trace of the live action. But, ever the one to confound expectations, Bock occasionally blends the two – airing over live television-feed a performance done in some hermetic environment and then abruptly appearing in the exhibition space to confront his audience.

Bock's performance persona – part mad scientist, part clown, part lunatic pedagogue – is enhanced by outlandish knitted, stuffed and collaged costumes that often extend his body via soft, patterned prosthetics. His presence is further augmented by an assortment of nasty little props that populate and activate each event: cheese graters, eyelash curlers, calculators and the like, all laced together in a labyrinth of tangled wire and crumpled aluminium foil, a spinning Mixmaster strung with green peppers, and a stunning variety of viscous substances. Bock's performances – or 'lectures', as he prefers to describe them, in an allusion to Joseph Beuys' pseudo-scientific utopian project – are impossible to decode. Monologues spew forth in a dizzying array of German, French and English, their contents encompassing such wide-ranging topics as Hollywood cinema, Nazi Germany, agriculture, consumer goods, behavioural analysis, French literature and so on. Bock's method of stringing words together with a stream-of-consciousness-like cadence is exemplified in the following sequence from *Lombardi Bängli*, a lecture performed at the Kunsthalle Basel in 1999: 'I feel like MegaMeMind./am united aggressiveactiveactionmorph/I live out my Randy-Dandy/100 percent./The self lies out of the triangle-bush./Mr. Hyde smells like/NapalmDeathGeometer/The Self-Quasi-Me mutates into/Meech-fever-ether.' While delivering such utterances, Bock often draws diagrams and various other schema in a preposterous gesture towards explication of meaning.

The art-historical sources for Bock's particular brand of mad-abject-performance-clutter are plentiful, including Dada soir-ées, happenings, Viennese Aktionism, Beuys' ritualistic sermons, Vito Acconci's early libidinized architecture and Paul McCarthy's videotaped gross-out sessions. But the real impulse behind the work appears to be avant-garde theatre – a fusion, perhaps, of Bertolt Brecht's radical, distancing techniques with the Theatre of the Absurd, as exemplified in the work of Samuel Beckett and Eugène Ionesco. Bock's affinity with the theatrical was apparent in the 100-day performance he presented at Documenta 11 (*Gribbohm IIb*, 2002). Ensconced in an open field on the exhibition grounds, Bock and his collaborators invoked the communal spirit of a Commedia dell'arte troupe.

Nancy Spector

Untitled (Tent), 2001, mixed media, fabric, 305 x 91.5 x 427 cm
with **Wald**, 2001, video, 6 min., 30 sec., loop, colour, sound
Installation Anton Kern Gallery, New York, 2001

When I am Looking into the Goat Cheese Baiser, 2001
wood panels, video, car roof, glass, drinking receptacles, panels, ashtray, cigarette lighters, sugar packets, pills, cloth bags, staff with record and needle, staff with wire circle, dresser, toiletries, clothing, blow dryer, suitcases, food stuffs, chair, bucket, costumes, Anton Kern Gallery sign
3.5 x 12.5 x 3.3 m
Installation Anton Kern Gallery, New York, 2001

Gribbohm IIb, 2002
video-projection booth: wooden box, metal supports
Installation Documenta 11, Kassel, 2002

Gribbohm IIb, 2002
storage hut: objects, costumes, production materials, televisions
Installation Documenta 11, Kassel, 2002

JOHN

LehmLehmLehmLehmLehm, 2001
rotating wall, sawed chair, wood, metal, desk, ball of yarn, vacuum cleaner, paper towel, razor blade, foodstuffs, cordless drill, golf clubs,
dummies, diagram, clothing, trophies, vases, drawings on wood, dimensions variable
Installation Regen Projects, Los Angeles, 2001–2

Meech City, 2001
pills, cosmetics, boxes, bins, tables, slide projections, sculpture, television, video, drawings, dimensions variable
Installation Anton Kern Gallery, New York, 2001

Born Mexico City, Mexico, 1981 Lives and works in Mexico City

Selected Solo Exhibitions: 1998 'Foto Apertura', La BF.15, Monterrey; 'Photographic Works', Regina 51 3er Piso, Mexico City 1999 'Lighting', Zacatecas 89, Mexico City 2000 '607 W', Proyecto Zapopan, Guadalajara; 'Dark Room', Colima 385, Mexico City; 'Sala de Proyectos', Museo de Arte Carrillo Gil, Mexico City 2001 'Audiovisivi', Galeria Bordone, Milan 2002 'Photographic Views from a Wall', Galeria de Arte Mexicano, Mexico City

Selected Group Exhibitions: 1998 'Made in Mexico Made in Venezuela', Art Metropole, Toronto 1999 'Bad Photographer', Foro Encamera, Mexico City; 'Blind Spot', Art & Idea, Mexico City 2000 'Antes y Despues de Kraftwerk', X Teresa Arte Actual, Mexico City; 'Contra el Muro', Puerto Rico 00 (Paréntesis en la 'Ciudad'), San Juan 2001 1st Tirana Biennale; 'Locus Focus', Sonsbeek 9, Arnhem, The Netherlands; 'Short Stories', La Fabrica de Vapore, Milan; 'Vanishing Cities', Programa Art Center, Mexico City 2002 'Pictures of You', The Americas Society, New York; 'Zebra Crossing', Haus der Kulturen der Welt, Berlin

Selected Bibliography: 2000 Vanesa Fernández, 'Texto acerca de este texto', *Milenio Diario*, Mexico City; Ruben Gallo, 'Iñaki Bonillas', *Poliester*, Summer 2001 Mario Garcia Torres, 'Sala de proyectos La segunda Parte', *Complot*, April

IÑAKI BONILLAS

Iñaki Bonillas is one of the youngest and most perceptive members of a new generation of artists who have devoted their work to the rigorous investigation of photography. He appropriates many of the themes and strategies developed by Conceptual photographers such as Alan Sekula in the 1960s and 1970s, taking them as a starting point for mapping the boundaries of the medium. Most of his work plays on the documentary aspect of Conceptual photography.

For one of his earliest pieces, *Ten Cameras Acoustically Documented* (1998), for example, he recorded onto a number of CDs the sounds made by various cameras as their shutters were released, then installed them in a 'listening station' at a Tower Records in Mexico City.

In *Lighting (Photographic Documentation of 20 Lightbulbs)* (1999), he photographed all the different 'white' light bulbs he could find. As those who understand the technicalities of the light spectrum might expect, none of the resulting slides came out white, their hues ranging from a sleazy red to a peaceful blue.

For *Dark Room* (2000), Bonillas lit the gallery with red light and painted the wall black, transforming the gallery space from a white cube into a seedy interior reminiscent of those in red-light districts. Like many of the 1960s Conceptual artists who have inspired his work, Bonillas selects titles that describe in full detail the process by which the works are made: *Documentation of the 84 Exposure Combinations for the Vivitar 2000* (1998), *Documentation of 36 Photo Labs* (1998), *Photographic Archive of Three ASA-400 Films (Kodak, Fuji, Konica)* (1998).

Bonillas' investigations have much in common with the recent work of Alfredo Jaar, another artist who has explored the boundaries of photography. Like Jaar (whose *Real Pictures* of 1998 concealed photographs of Rwandan genocide behind texts describing these atrocities and thus forced the viewer to read instead of merely looking), Bonillas creates 'photographic' works that are devoid of images. In some cases – such as his acoustic documentation CDs – photography is no longer the medium but merely the subject of representation. *Library Project* (2001), a site-specific installation created for a recent group show in Mexico City, questions photography's longstanding primacy as the ideal medium for documenting artistic projects. The installation features a number of archival boxes containing files, press clippings, CVs and additional documentation pertaining to the other artists in the show. These textual materials provide a clearer and more detailed 'picture' of the works in question than could be achieved by a photograph.

Bonillas' projects are the fruit of a rigorous approach learned from Conceptual artists like On Kawara. Series such as *Photographic Archive of Three ASA-400 Films* evoke Kawara's work not only in style (the archive consists of several black binders modelled after the latter's *I Went* and *I Read* series), but also in spirit. Like Kawara's forty-year investigation of time, Bonillas' carefully composed projects are variations on a single theme – the definition of photography.
Rubén Gallo

Lighting (Photographic Documentation of 20 Lightbulbs), 1999
slide projection

Dark Room, 2000
red bulbs, black painting
Installation 'Cuarto Oscuro', Colima 385, Mexico City, 2000

Ten Cameras Acoustically Documented, 1998
audio, 10 CDs installed in listening station, Tower Records, Mexico City

Library Project, 2001
documents

INAKI BONI

Osram 10 W, 2000
lightbox, 30 x 30 cm

Osram 60 W, 2000
lightbox, 30 x 30 cm

Osram 75 W, 2000
lightbox, 30 x 30 cm

Osram 150 W, 1999
lightbox, 30 x 30 cm

Born Hamilton, UK, 1967 Lives and works in Glasgow, UK

Selected Solo Exhibitions: 1999 Fruitmarket Gallery, Edinburgh 2000 'Fear View', Galerie Johnen + Schöttle, Cologne; Jerwood Gallery, London 2001 Els Hanappe Underground, Athens 2002 Contemporary Art Gallery, Vancouver; Museum für Moderne Kunst, Frankfurt; Tramway, Glasgow

Selected Group Exhibitions: 1997 'Material Culture', Hayward Gallery, London 1999 'Anarchitecture', De Appel, Amsterdam 2000 'Beck's Futures', Institute of Contemporary Arts, London; The British Art Show, Inverleith House, Edinburgh; 'What If', Moderna Museet, Stockholm 2001 '63 NYC', Casey Kaplan, New York; 'Martin Boyce and Toby Paterson', Foksal Gallery Foundation, Warsaw; 'My Head is on Fire But My Heart is Full of Love', Charlottenborg Exhibition Hall, Copenhagen; 'Trauma', Dundee Contemporary Arts, Dundee/Museum of Modern Art, Oxford

Selected Bibliography: 1998 Simon Morrissey, 'Yesterday Tomorrow', *Contemporary Visual Arts*, No. 20 1999 Dale McFarland, 'Martin Boyce', *frieze*, No. 46 2000 *David Crowley, Martin Boyce*, Jerwood Gallery, London; *Tom Gidley, Martin Boyce*, Fruitmarket Gallery, Edinburgh 2001 Will Bradley, *Zero Gravity*, Kunstverein Düsseldorf; Katrina Brown, *Trauma*, Hayward Gallery Publishing, London; Rob Tufnell, *Here and Now*, Dundee Contemporary Arts 2002 Rob Tufnell, *Greyscale/CMYK*, NIFCA, Helsinki

MARTIN BOYCE

'We enter the foyer of *For 1959 Capital Avenue* through two huge sliding doors. The icy air-conditioned interior chills me instantly, causing me to shudder physically. Inside we are directed to one of two groups of four chairs to wait.' (Martin Boyce)

1959 Capital Avenue is the fictitious address of a foyer set up by Martin Boyce in the Central Hall of the Museum für Moderne Kunst in Frankfurt. A wide expanse of drapery, prestigious armchairs, glass tables and gleaming ashtrays draws visitors into an atmosphere of cool elegance. But the sculptural and graphic character of Boyce's 'furnishings', along with a view of a distant sea of clouds, transform this place into a utopia. Inscribed in large letters on the gallery walls are the words: 'PUNCHING THROUGH THE CLOUDS'. Boyce's scenario reminds us of Modernism's visions of a 'better' future, presenting it as something that is yet to come.

Boyce examines and interprets the fragments of modernist design like an archaeologist or an anthropologist, often drawing on the formal repertoires of major architects and designers. He works on an increasingly large scale, focusing on the architecture and design of European and American modernism from both an aesthetic and a cultural point of view. He is most interested in work, and particularly furniture, by Jean Prouvé, Arne Jacobsen and Charles and Ray Eames dating from the 1940s and 1950s.

Boyce robs yesterday's modern design of its former function and aesthetic and transforms it into distressing objects and installations. When, for example, in *Mobile (for 276 Silent Falls)* (2002) he smashes Jacobsen's chairs and suspends them from the ceiling in an allusion to Alexander Calder's mobiles, he both fills the air with familiar quotations and radically alters their connotations.

Recently, modernist design has been rediscovered by the younger generation, and the response to these well-designed, reasonably priced and functional objects, whose form clearly points to mass production, has changed in the course of time. 'If you transfer an aesthetic from one historical period to another', suggests Boyce, 'it's possible to re-create the spirit of that period and its social and cultural conditions. But during this bit of time-travelling that aesthetic will cultivate its own ethos, which is not infrequently based on ideas of taste and exclusivity associated with money.' He has a keen eye for the collapse of the utopian vision of modern design, which took place in the middle years of last century as a result of the culture of connoisseurship and its value concepts, which are now imposing themselves again. Boyce uses that collapse to create new and unknown landscapes, mediating between then and now.

Udo Kittelmann

For 1959 Capital Avenue, 2002
furniture, doors, drapery
Installation 'For 1959 Capital Avenue', Museum für Moderne Kunst, Frankfurt, 2002

White Disaster, 2000
steel, wood, 150 x 120 x 40 cm
Installation 'Fear View', Galerie Johnen + Schöttle, Cologne, 2000

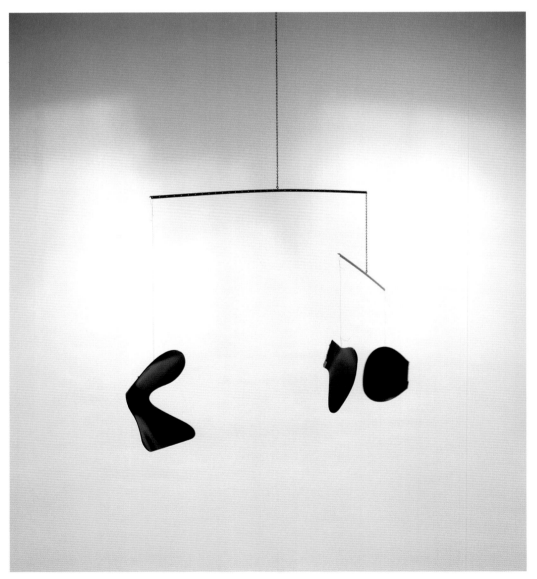

Mobile (for 276 Silent Falls), 2002
painted steel, chain, wire, altered Arne Jacobson 3107 chairs
Installation 'The Museum, the Collection, the Director, and his Loves', Museum für Moderne Kunst, Frankfurt, 2002

Phantom Limb (sister), 2002
C-type print, 130 x 90 x 4 cm

MARTIN

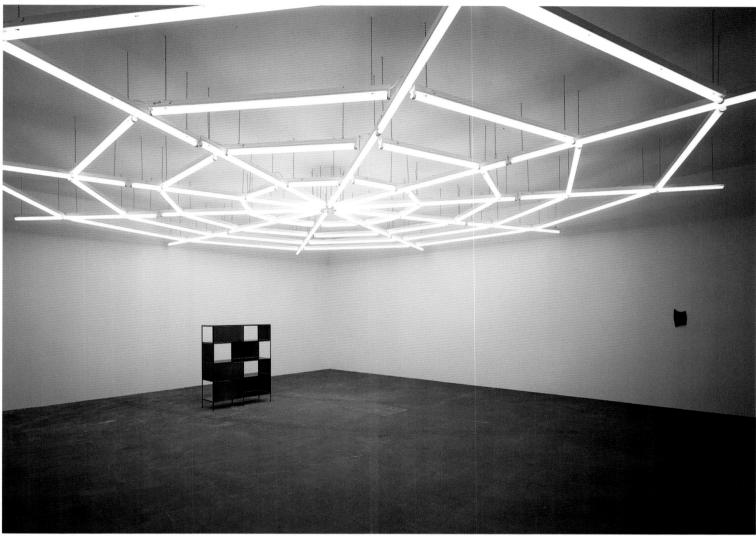

When Now is Night, 1999–2002
fluorescent lights, wood, steel, paint, dimensions variable
Installation Art Basel 33, Switzerland, 2002

Day Bed Frame (You Wake Up Lost), 2002
painted steel, fabric, 26 x 209 x 104 cm
Installation 'My Head is on Fire But My Heart is Full of Love', Charlotteborg Exhibition Hall, Copenhagen, 2002

Born Chisinau, Moldova, 1971 Lives and works in Chisinau, Maastricht and Brussels, Belgium

Selected Solo Exhibitions: 2001 'Gedankenaufnahme', Kunstbüro, Vienna 2003 "Performance White, or Pale Unfinished Thoughts', Kunstbüro, Vienna

Selected Film/Video/Performance Festivals: 1996 'CarbonART', Sadova, Moldova 1997 'AnnART: International Living Art Festival', St Anna Lake, Transylvania; 'DaKINO: International Film Festival', Bucharest; 'OSTranenie: International Electronic Media Forum', Bauhaus-Dessau 1998 'CarbonART', Straseni, Moldova; 'Gioconda's Smile', Chisinau; Split: International Festival of New Film, Bucharest 1999 'CarbonART99', Chisinau; 'OSTranenie: International Electronic Media Forum, Bauhaus-Dessau; 'Periferic: International Performance Festival', Iasi, Romania; VIPER: International Festival for Film, Video and New Media, Lucerne 2000 European Media Art Festival, Osnabrück; Kassel Documentary Film Festival 2001 Art Biennale WRO, Wroclaw, Poland; 'The One Minute Festival', Amsterdam; Paris/Berlin: Intenational Transmedia Festival; VIPER: International Festival for Film, Video and New Media, Basel

Selected Group Exhibitions: 1996 'Kilometrul 6', Gallery Brancusi, Chisinau 1997 'Masaje de la Tzara/Reflections in RE', National Museum of Art, Chisinau 1998 'Body and the East', Galerija moderna, Ljubljana; 'The Last Test Situation', Manej – Central Exhibition Hall, Moscow 1999 'After the Wall', Moderna Museet, Stockholm 2001 'The air palpably thickens as the Californian hairdresser comes in', Marres, Maastricht 2002 'Being All Things to All People: 7 Young Artists', Nouvelles Images, The Hague; Documenta 11, Kassel; 'New Habitats, New Attitudes', Museum of Contemporary Art, Novi Sad; Video Zone, Biennale, Herzliya Museum of Art, Tel-Aviv 2003 'Introducing Sites', Gallery for Contemporary Art, Leipzig

Selected Bibliography: 1997 Vladimir Bulat, 'AnnART'/Octavian Esanu, 'Performance Festival at St Ana', *ART-HOC*, September 2000 Vladimir Bulat, 'Moarte si idiote in epoca milleniumului moldovenesc', *ART-HOC*, October 2002 Parveen Adams, 'Reviewing Documenta 11', *frieze*, October–November; Dorina Bohantov, 'Shoes for Europe', *Observer*, 26 November; Fabrice Bousteau, 'Documenta 11', *Beaux Arts*, August; Laurentiu Bratan, 'Film – New Media and Technology', *ART-HOC*, September–December; Ghenadie Brega, 'Visiting D11 next to Pavel Braila', *SENS*, August; Vladimir Bulat, 'D11 & Manifesta 4 – Some Preferences', *ART-HOC*, September–December; Manray Hsu, 'In the Wake of the Empire', *tema celeste*, August; Axel Lapp, 'Documenta 11/2', *Art Monthly*, July–August; Angela Noroc, 'Between Reality and Fiction', *ART-HOC*, September–December; Dan Perjovschi, 'Traiasca capra vecinului', *ART-HOC*, September–December; Theo Tegelaers, 'Pavel Braila – Grenssverkeer', *Metropolis M*, August–September; Marin Turea, 'Mofex – Moldfilmexport', *ART-HOC*, July–August

PAVEL BRAILA

At Ungheni railway station, built in 1875 on the Moldavian–Romanian border, a burdensome and time-consuming procedure must be carried out every time a Western European train comes into the station. Its wheels must be changed to fit the Eastern European tracks, which are 85 mm wider than the Western ones. To do this, the heavy carriage is lifted a metre above ground level, while passengers go through passport control and customs. The process takes three hours. Prior to the collapse of the Soviet Union, Ungheni station was a busy junction; now, only a few lines remain, running between Chisinau, Bucharest, Moscow and Sofia.

For Moldavian video and performance artist Pavel Braila, this situation provides an apt metaphor for the inflexible boundaries separating East and West, the laborious processes of translation and conversion between the two, as well as the heavy machinery of globalization. Video footage of this nocturnal wheel-changing ritual comprised the film *Shoes for Europe*, shown at Documenta 11 in 2002. Shot in real time so that the onerous nature of the task could be fully appreciated, it emphasized the lengths to which different cultures must go if they wish to understand each other.

The metaphoric aspect of *Shoes for Europe* is representative of Braila's work in general. He has often used objects and situations found in everyday life to stand for modern social and global issues.

In an early work, *Communication* (1997), for example, he installed four telephones in the gallery space, which rang continuously, representing the pressures and tensions of the modern communication-dominated world. Viewers could pick up the receivers, but were greeted only with unclear phrases and confusing fragments, calling into question the true value of such ubiquitous but impersonal forms of communication.

This work articulated an edgy relationship with technology that can be identified in much Eastern European art. Braila's interest in the repetitive, habitual procedure depicted in *Shoes for Europe* betrays a more specifically Moldavian concern: a preoccupation with ritual. This is also evident in such works as the performance/video *Special Services* (1996–7), where he filed his toenails and shaved his feet in front of a live audience, and *Recalling Events* (2001), in which his body was transformed into a constantly rotating chalk eraser. Ritual has a long history in Moldavian art and culture, stemming from folkloric traditions and customs connected with the winter solstice and the cycles of human existence. These ceremonies often manifested themselves in performances centring on the body through mime and expressive gesture. Performance came to the forefront in Moldavian contemporary art during the 1990s, led by the group Phantom, which included artists Mark Verlan and Igor Scerbina. Hamza Walker

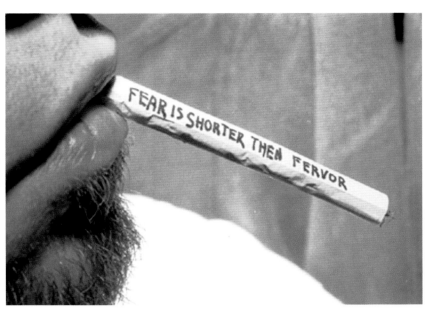
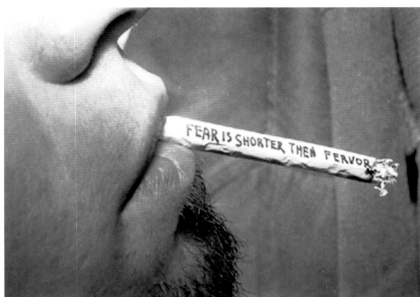

Fear is Shorter than Fervor, 2001
performance, 6 black and white photographs, each 15 x 18 cm

Shoes for Europe, 2002
video, 26 min., colour, sound
camera: Radu Zara, Vadim Hancu

Recalling Events, 2001
video/performance, 4 min., colour, sound

Born Basel, Switzerland, 1966 Lives and works in Basel

Selected Solo Exhibitions: 1998 'Home Affairs', TBA Exhibition Space, Chicago 1999 'Alles wird gut', Ausstellungsraum, Offenbach; 'Homeless Depot', Four Walls, San Francisco 2000 'Denn sie wissen nicht, was sie tun', Centre d'Art Contemporain, Geneva; 'Joy of Institution', Kunstmuseum St Gallen 2001 'Kunst Inc.', Maccarone Inc., New York 2002 'Capital Affair', Helmhaus Zürich; 'Shelter', Haus der Kunst, Munich

Selected Group Exhibitions: 1996 'Strategien in der Kunst der 90er Jahre', Kunsthaus Glarus 1999 'Empires without States', Swiss Cultural Institute, New York 2000 7th Biennale of Architecture, Swiss Pavilion, Venice; 'Aller Anfang ist Merz – von K. Schwitters bis heute', Sprengel Museum, Hanover; 'Concerted Compassionism', White Columns, New York 2001 1st Tirana Biennale; 'Strangers', P.S.1 Contemporary Art Center, New York 2002 'House of Fiction', Sammlung Hauser und Wirth/ Lokremise, St Gallen; Manifesta 4, Frankfurt; 'Public Affairs', Kunsthaus Zürich

Selected Bibliography: 1998 Fred Camper, 'Haunting House', *Chicago Reader*, 8 May; Madeleine Schuppli/Hamza Walker, *magsch no?*, Kunsthalle Basel 1999 Olivier Fiechter, 'Ween der Betrachter Teil des Werkes wird', *Tages-Anzeiger*, February 2000 Beate Engel, 'Joy of Institution', *Kunstbulletin*, Kunsthalle Basel, December 2001 Frantiska and Tim Gilman-Sevic, 'Christoph Büchel', *Flash Art*, November–December; Roberta Smith, 'Christoph Büchel', *The New York Times*, 21 December 2002 Joerg Bader, 'Ein echt Schweizer Afgahne', *Franfurter Allgemeine Zeitung*, 18 March; Carly Berwick, 'Fallen Angels', *ARTnews*, June; Katja Blomberg, 'Ausstellungsbeteiligung verhökert', *FAZ.NET*, 9 April; Meghan Dailey, 'Christoph Büchel', *Artforum*, March; Lauri Firstenberg, 'Christoph Büchel, Maccarone Inc., NY', *frieze*, No. 66; Michael Hauffen, 'Shelter', *Kunstforum International*, April–May; Birgit Sonna, 'Klaustrophobische Geheimkammern', *Neue Zürcher Zeitung*, 22 February

CHRISTOPH BÜCHEL

Christoph Büchel follows in a tradition of subversive artists from Marcel Duchamp to Maurizio Cattelan. Invited to participate in Manifesta 4, 2002, he undermined this curatorial decision by holding an auction on the website eBay, selling off his participation rights in the exhibition to the highest bidder. His place in Manifesta was eventually won by New York artist Sal Randolph, who paid Büchel $15,099 for it. He called this conceptual work *Invite Yourself*.

Büchel's mischievous approach to art was already evident in 1996, when he installed a car trailer in a gallery and placed an advertisement for its sale in the local newspaper. Potential buyers could come and view it in the exhibition space. Other works include *Homeless Depot* (1999), for which he turned Four Walls gallery in San Francisco into a 'one-stop shop' for the homeless, offering such merchandise as models for shelters, money-earning aids and objects for entertainment. 'The gallery is situated in an area where there are a lot of homeless people', he commented. 'The homeless problem was an important issue in San Francisco at the time of the exhibition because they had up-coming mayoral elections. It was interesting to hang out with the homeless and to see what techniques they've developed to survive, and the strategies and status symbols they use to differentiate themselves from one another.'

Büchel has been compared to Kurt Schwitters, Gordon Matta Clark, Gregor Schneider and Ilya Kabakov on the strength of works like *Home Affairs* (1998), in which he installs piles of junk in room-like spaces that recall the homes of obsessive collectors or lonely bachelors. For *Kunst Inc.* (2001) at Maccarone Inc., New York, he created a labyrinth of cramped, dysfunctional spaces for the visitor to crawl through. Rooms were cluttered with old mattresses, rubble and piles of newspapers; walls were punctured, floors scattered with debris and cigarette ends, while nightmarish ice-cream-van tunes and the sound of falling rain were broadcast throughout the spaces. All added up to an unnerving, dystopic experience as one squeezed into tiny spaces, or climbed up and down wobbly ladders in what the critic Lauri Firstenberg has called this 'architecture of failure'. 'In my installations', says Buchel, 'visitors have to find out where to go by themselves. I'm trying to connect different landscapes so that the outer and inner rooms become mixed up and you lose your spatial and intellectual orientation.'

Another recent installation, *Minus* (2002), began as a concert, held at the Kunsthaus Zürich. Following the gig, Büchel turned the enclosed cell in which it had taken place into a refrigerator. The bar, sound decks and instruments grew a frosty fur, recalling Pier Paolo Calzolari's poetic Arte Povera works using freezing structures to investigate process and alchemy. These motionless, silent ghosts contrasted strikingly with the heat, noise and activity of the live concert in a powerful evocation of the morning after the night before. Hamza Walker

Home Affairs, 1998
wood, sheet rock, doors, windows, paint, wallpaper, carpet, furniture, fireplace, lamps, televisions, newspapers, clothes, books, bric-a-brac, photos, games, food, storage boxes, cans, dead plants, trash etc., approx. 65 m²
Installation 'Home Affairs', 1998, TBA Exhibition Space, Chicago

Minus, 2002
event and installation, freezing cell, concert equipment, beer, ice, 5.6 x 4 x 2.7 m
Installation 'Public Affairs', Kunsthaus Zürich, 2002

Born Fort Frances, Canada, 1966 Lives and works in Berlin, Germany, Vienna, Austria and London, UK

Selected Solo Exhibitions: 1990 APAC Centre d'Art Contemporain, Nevers 1994 CCC, Tours/Fonds Régional d'Art Contemporain, Montpellier/Hamburger Kunstverein, Hamburg 1997 'Vehicles', Le Consortium Centre d'Art Contemporain, Dijon 2000 'Prototypes', Galerie Hauser & Wirth & Presenhuber, Zürich 2001 'Matrix', Magnani, London; 'Z-Point', Kunsthaus Glarus 2002 'Horizontal Technicolour', Institute of Visual Culture, Cambridge; 'Macro World: One Hour³ and Canned', Galerie Schipper & Krome, Berlin

Selected Group Exhibitions: 1988 'Freeze', PLA Building, Docklands, London 1991 'No Man's Time', Villa Arson, Nice 1993 XLV Venice Biennale 1997 'The Turner Prize 1997', Tate Gallery, London 1998 'Art From the UK', Sammlung Goetz', Munich 2000 'Media_City Seoul 2000', Seoul Metropolitan Museum; 'Sonic Boom – The Art of Sound', Hayward Gallery, London 2001 6th Lyon Biennale 2002 'Claude Monet … bis zum digitalen Impressionisms', Fondation Beyerler, Basel/Riehen; 'Frequezen (Hz)', Schirn Kunsthalle, Frankfurt; 'Remix', Tate Liverpool

Selected Bibliography: 1992 Francesco Bonami, 'Angela Bulloch – Lonesome Cowboy', *Flash Art*, March–April 1994 *Angela Bulloch*, CCC, Tours 1996 Hans Rudolf Reust, 'Szenen aus Betaville', *Kunstforum*, October–January 1997 Christoph Blase, 'The Yellow Light System', *Art at the Exhibition*, Centre Leipziger Messe/Oktagon, Cologne; David Bussel, 'Interview with Angela Bulloch', *Art from the UK*, Sammlung Goetz, Munich 1998 Angela Bulloch/Stefan Kalmár (eds.), *SATELLITE: Angela Bulloch*, Museum für Gegenwartskunst, Zürich/Le Consortium, Dijon 2000 Stefan Kalmár (ed.), *Rule Book: Angela Bulloch*, Book Works, London 2001 Beatrix Ruf (ed.), *Pixel Book: Angela Bulloch*, Kunsthaus Glarus 2002 Stefan Kalmár (ed.), *Material-01 Angela Bulloch*, Institute of Visual Culture, Cambridge; John Miller, 'United Colours of BBC', *Texte zur Kunst*, September 2003 *Parkett*, No. 66

ANGELA BULLOCH

Angela Bulloch has been working since the late 1980s, using a diverse number of methods and media, but during this time she has consistently pursued a single theme. She examines and manipulates our historical and contemporary social systems and ordering structures. Parallel bodies of work, which Bulloch intermittently revisits, include drawing machines that respond to movements or sounds made by the viewer, murals, series of photographs, video works, as well as sound and light projects that are sometimes interactive and sometimes merely suggest interactivity.

In the series of textual works 'Rules', begun in 1993, she takes as her subject the sets of rules and regulations imposed by different social spheres such as strip clubs, restaurants or the Houses of Parliament. Displayed in the gallery outside of their normal context these instructions become like a list of impossible regulations that must be followed by society in general, creating an image of social structuring and control.

Aesthetically, Bulloch's work adopts an anonymous appearance, shaped by the function of whatever technology is being used (video, film, sound or picture technology). We recognize the vocabulary she employs as part of our everyday lives, a recycling of the industrial designs Bulloch has encountered throughout her lifetime, from the 1960s to the present day and imaginatively into the future.

In her most recent group of works, the pixel light projects begun in 1999, digital images activate lightboxes. Working with computer technicians and designers, Bulloch has developed a modular light-mixing system that enables a possible 1.6 million colours to be produced by means of red, green and blue fluorescent tubes. In works such as *Blow Up TV* (2000) and *Matrix* (2001), illuminated coloured cubes are arranged in towers, banks or other structures. Recently Bulloch has composed these boxes in blocks as big as movie screens, referring to the aesthetics of cinema and television, and of analogue and digital imagery, as if pixels – the tiny dots that make up a picture – are being looked at through a gigantic magnifying glass.

For the pixel wall *Z Point* (2001), Bulloch processed the final scene from Michelangelo Antonioni's film of 1969, *Zabriskie Point*, where Daria Halprin fantasizes about blowing up a property-shark's villa in the desert. This is a scene that not only refers to looking and the eye, but also to the overlap between reality and fiction. In an installation version realized in 2002, and developed further in terms of both form and content, Bulloch also introduces new film material of her own – footage from the exhibition in which the work was originally shown.

Bulloch uses her materials – whether originated by herself or by others, whether quotations from the history of design, art, film or literature – like a DJ, sampling and reorganizing them so that we can experience them in new ways. She creates links between memory and perception, fact and fiction, exploring the interplay of object, perception and experience. Beatrix Ruf

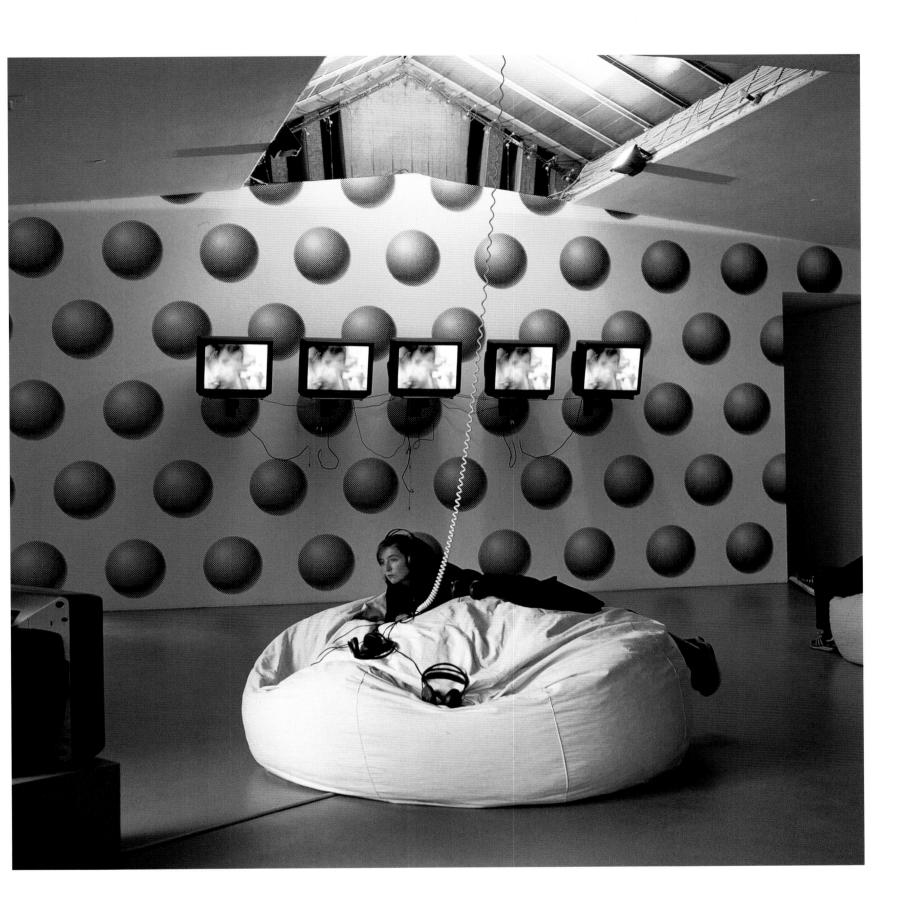

Popvideo, 1997
beanbag with headphones, unbleached fabric, Flo-Pak filling, 4 headphones, Ø 200 cm
Installation 'POPVIDEO', Kölnischer Kunstverein, Cologne, 1997

Macro World: One Hour³ and Canned, 2002
35 DMX modules (waxed birchwood), aluminium plate, white glass, diffusion foil, cables, RGB lighting system, DMX controller, mirror ceiling, sound system, Europalettes flooring, 253.5 x 355 x 51 cm
'BBC World' TV programme, 60 min., loop, sound ('BBC World' music: David Lowe)

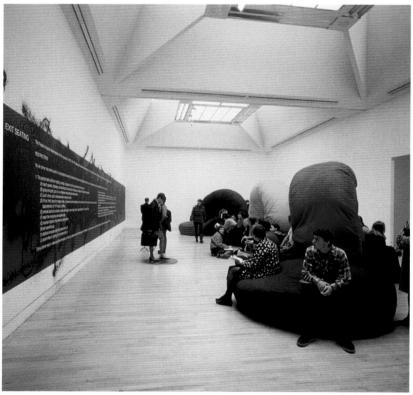

as installed left to right
Exit Seating, 1997, from 'Rules'
Superstructure with Satellites, 1997, seating, 3 soundtracks: 'Theramin',
'Space Invasion', 'L.I.F.E. with Bob'; metal discs, contact switches, light on wall,
bench, doorway with infra-red beams, dimensions variable
Installation 'The Turner Prize 1997', Tate Britain, London, 1997

Betaville, 1994
ink, metal rails, electronic motor, drawing, 3.5 m²
The machine draws vertical lines until someone sits on the bench,
when the lines are horizontal

ANGELA BULL

Geometric Audio Merge, 2002
9 DMX-modules: plastic, amplifier, 2 loudspeakers, 70 x 152 x 152 x 152 cm each

Chain B 1:1:52:4, Chain B 2:1:52:4, Chain B 3:1:52:4, Chain B 4:1:52:4, Chain B 5:1:52:4, Chain B 6:1:52:4, 2002
DMX Modules (waxed birchwood), chains of 2–7 units, each unit 50.7 cm
Installation Galerie Micheline Szwajcer, Antwerp, 2002

Let the Power Fall, An Album of Frippertronics, 2002
vinyl text on coloured wall; red wall: 7.5 x 3.5 m; blue wall: 4.75 x 3.5 m; yellow wall: 4.40 x 3.5 m
Installation Galerie Micheline Szwajcer, Antwerp, 2002

Born St Catherines, Canada, 1955 Lives and works in Toronto, Canada

Selected Solo Exhibitions: 1988 'Breaking Ground', Canadian Museum of Contemporary Photography, Ottawa, touring throughout Canada 1994 'The Carrara Marble Quarries', Mira Godard Gallery, Toronto 1999 'In the Wake of Progress', Robert Koch Gallery, San Francisco 2000 'Vues et points de vue: L'architecture de Borromini dans les photographies d'Edward Burtynsky', Canadian Centre for Architecture, Montreal 2001 'Shipbreaking', Mira Godard Gallery, Toronto 2002 Charles Cowles Gallery, New York; 'Rajasthan New Work', Flowers Central, London 2003 'Edward Burtynsky: Mid-Career Retrospective', The National Gallery of Canada, Ottawa/The Art Gallery of Ontario, Toronto/The Brooklyn Museum of Art, New York

Selected Group Exhibitions: 1982 'Transitions – The Landscape', The National Film Board Exhibition, The Photo Gallery, Ottawa/Winnipeg Art Gallery, Manitoba/The Canadian Centre of Photography, Toronto/The Photography Gallery, La Jolla 1992 'Beau: A Reflection on Beauty of Nature in Photography', Canadian Museum of Contemporary Photography, Ottawa 1997 'The Big Picture', Albright-Knox Gallery, Buffalo; 'Works, Workers, Works: Rearranging the Land', Dalhousie University, Halifax 1999 'Art & Architecture', Mira Godard Gallery, Toronto; 'The Sudbury Basin: Industrial Topographies', The Art Gallery of Sudbury, Ontario 2001 'Best of the Season: Selected Works from the 2000–2001 Manhattan Gallery Season', The Aldrich Museum of Contemporary Art, Ridgefield; 'Detourism', The Renaissance Society, Chicago; 'Site/Seeing', The Art Gallery of Ontario, Toronto 2002 'Altered States: Landscape Transformation in the Wake of Progress', University Art Gallery at the University of California, San Diego; 'New Acquisitions/New Work/New Directions 3: Contemporary Selections', Los Angeles County Museum of Art

Selected Bibliography: 1988 Christopher Hume, 'Environmental Art Breaks Artistic Ground', *The Toronto Star*, 8 July 2001 Kenneth Baker, 'Edward Burtynsky', *ARTnews*, May; Noah Richler, 'Residual Landscapes', *Saturday Night Magazine*, 19 May; Michael Torosian, *Residual Landscapes: Studies of Industrial Transfiguration*, Lumiere Press, Toronto 2002 Gordon Bowness, 'The Giants', *Report on Business Magazine*, April; Adrian Dannatt, 'New York: Contemporary Dealer Shows: Edward Burtynsky – Charles Cowles', *The Art Newspaper*, February; Edward Leffingwell, 'Reviews: Edward Burtynsky at Charles Cowles', *Art in America*, June; Gregory Williams, 'Reviews: Edward Burtynsky, Charles Cowles Gallery', *Artforum*, May

EDWARD BURTYNSKY

'Nature transformed through industry is a predominant theme in my work', says Edward Burtynsky. 'I search for subjects that are rich in detail and scale yet open in their meaning. Recycling yards, mine tailings, quarries and refineries are all places that are outside of our normal experience, yet we partake of their output on a daily basis.'

Burtynsky's large-scale, exquisitely detailed colour photographs concentrate on this conflict between nature and industry. While the piles of tyres, oil derricks, stacks of cans and compacted metal featured in these works seem to dominate the landscape, nature fights back, gradually reclaiming its territory in these run-down industrial wastelands. And although the conventional view might be that these structures represent the ugly intervention of man in the landscape, Burtynsky reveals their intense, melancholy beauty, their uncanny kinship with the environments they haunt.

This sense of the merging of organic and inorganic is never more apparent than in the series *Shipbreaking* (2000), luminous pictures of the rusting ghosts of vessels beached in Chittagong, Bangladesh. Protruding from the sand that will eventually claim them altogether, cannibalized by scrap-metal hunters, scourged by the elements, they are reduced to their bare structural bones like skeletons in an elephant's graveyard.

Burtynsky developed his interest in the industrial landscape during the late 1970s as a photography student in Toronto. Impressed by the scale and majesty of the city's skyscrapers, he aimed to capture their impact in the same way that landscape photography depicts the awesome structures of nature. In the 1980s he founded Toronto Image Works, a photographic laboratory, where he honed his technical skills. He later embarked on a number of commissions and architectural series, of North American banks and Borromini's buildings in Rome, for example.

Burtynsky can spend hours setting up a single shot, and takes equal care in printing his fine-grain images. Usually he employs a large-format viewfinder camera to achieve a richly textured breadth and depth of focus that favours no one detail over another. In the series *Oxford Tire Pile* (1999), for example, each tyre is immaculately delineated, singularly catching the light, whether in the immediate foreground or the distant background. These panoramic compositions are punctuated, however, with unexpected, eyecatching elements – a group of people dwarfed by the landscape, a ladder, a vehicle, a patch of vegetation, a logo on a can.

'I'm not using my art to browbeat corporations for the rack and ruin of our landscape', Burtynsky has claimed. 'One can look at these images as making political statements about the environment, but they also celebrate the achievements of engineering or the wonders of geology … The industrial landscape speaks to our times.'
Hamza Walker

Shipbreaking #4, Chittagong, Bangladesh, 2000
chromogenic colour photograph, 101 x 127 cm

Shipbreaking #13, Chittagong, Bangladesh, 2000
chromogenic colour photograph, 101 x 127 cm

Shipbreaking #49, Chittagong, Bangladesh, 2000
chromogenic colour photograph, 101 x 127 cm

Shipbreaking #31, Chittagong, Bangladesh, 2000
chromogenic colour photograph, 127 x 101 cm

Shipbreaking #11, Chittagong, Bangladesh, 2000
chromogenic colour photograph, 101 x 127 cm

Shipbreaking #8, Chittagong, Bangladesh, 2000
chromogenic colour photograph, 76 x 152 cm

Oxford Tire Pile #5, Westley, California, 1999
chromogenic colour photograph, 101 x 127 cm

Oxford Tire Pile #8, Westley, California, 1999
chromogenic colour photograph, 101 x 127 cm

Densified Oil Drums #4, Hamilton, Ontario, 1997
chromogenic colour photograph, 101 x 127 cm

Densified Cans #20, Hamilton, Ontario, 1997
chromogenic colour photograph, 101 x 127 cm

EDWARD BURTY

Nickel Tailings #30, Sudbury, Ontario, 1996
chromogenic colour photograph, 101 x 152 cm

Nickel Tailings #31, Sudbury, Ontario, 1996
chromogenic colour photograph, 101 x 152 cm

Oil Fields #2, Belridge, California, 2002
chromogenic colour photograph, 101 x 127 cm

Oil Fields #24, Oil Sands, Fort McMurray, Alberta, 2001
chromogenic colour photograph, 101 x 127 cm

Born Rio de Janeiro, Brazil, 1962 Lives and works in Rio de Janeiro

Selected Solo Exhibitions: 1988 'Ar', Museu de Arte Contemporânea de São Paulo; Galeria Macunaíma, Rio de Janeiro 1991 'Água', Instituto Brasil Estados Unidos, Rio de Janeiro 1995 'O Sonho de Whitney', Museu da República, Rio de Janeiro 1999 'Abrigo', Universidade do Estado do Rio de Janeiro/Galeria Cândido Portinari, Rio de Janeiro 2000 'Aeroelasticidade', Paço Imperial, Rio de Janeiro; 'Razão e Desejo', Galeria Baró Senna, São Paulo 2001 Greenway Art Gallery, Adelaide; 'Organismos Bioconcretos', Museu de Arte Moderna, Rio de Janeiro 2002 Museu de Arte da Pampulha, Belo Horizonte

Selected Group Exhibitions: 1995 'The Education of the 5 Senses', White Columns, New York; 'Romance Figurado', Museu Nacional de Belas Artes, Rio de Janeiro 1996 'Transformal', Secession, Vienna 1999 'Fundição em Concreto', Fundição Progresso, Rio de Janeiro 2000 '3rd Convocatoria Internacional de Jovenes Artista', Galeria Luis Adelantado, Valencia; 7th Havana Biennale; 'Coletiva', Galeria Baró Senna, São Paulo; 'Deslocamentos do Feminino', Centro Cultural da Caixa, Rio de Janeiro; 'Macunaíma Retrospectiva', Funarte, Rio de Janeiro; 2001 'Arco das Rosas', Casa das Rosas, São Paulo; 'Mira Schendel e Franklin Cassaro', Museu de Arte Moderna de São Paulo 2002 'Shift', Bard College: Center for Curatorial Studies, Annandale-on-Hudson, 'Ceará Redescobre o Brasil', Centro Dragão do Mar de Arte e Cultura, Fortaleza, Brazil

Selected Bibliography: 1999 Ernesto Neto, *Jornal e vento*, Universidade Estadual do Rio de Janeiro 2000 Ernesto Neto, 'Project Room: Franklin Cassaro', *Trans>arts.culture.media*, No. 8; Adriano Pedrosa, *A arte da topologia*, Galeria Baró Senna, São Paulo 2001 Fabio Cypriano, 'Franklin Cassaro experimenta o "bioconcretismo"', *Folha de São Paulo*, 4 December 2002 Adriano Pedrosa, 'Franklin Cassaro', *Salão nobre: Franklin Cassaro*, Museu de Arte da Pampulha, Belo Horizonte

FRANKLIN CASSARO

The work of Franklin Cassaro can be contextualized within a rich tradition of art produced in Rio de Janeiro that goes back to the 1950s Neoconcrete movement of leading, internationally acclaimed Brazilian figures such as Lygia Clark and Hélio Oiticica. Neoconcretism inaugurated a confrontation between geometric abstraction and constructivism, on the one hand, and quotidian and bodily themes on the other. This tradition leads on to important contemporaries such as Ernesto Neto and Fernanda Gomes.

Cassaro's references are not so much art-related as concerned with a number of sciences – biology, physics, geometry and medicine. He has given his research the emblematic, pseudo-scientific name 'Bioconcretism', and even created a fictitious physician to whom he attributed co-authorship of his works in an exhibition titled 'The Cabinet of Dr Andrade'.

However, fundamental to his work are the concerns of sculpture – its geometric, morphological and bodily configuration. A key motif is topology, understood as the transformation of the two-dimensional plane into three-dimensional objects. Here, Clark is a direct antecedent, with her sculptural interest in the Möbius strip, for example.

Cassaro works with several media (drawing, performance and what he calls 'sculptural acts'), scales (extra small or extra large), and materials (from medical materials and optical fibre to discarded household plastic or metal). His large inflatable sculptures are made from different kinds of plastic or paper (newspaper, porn magazines), kept in an improbable state of full inflation by air from a few small but stategically placed fans – the magic of physics, if you will.

The 19-metre long *Futuristic Shelter* (2002), exhibited at Museu de Arte da Pampulha, was made of a translucent silver plastic and inflated by two small fans. Inside this work, positioned next to the museum's glass panels overlooking a lake, the spectator experienced a different sculpture altogether, which articulated the notion of inside/outside, with indoor and outdoor views. Outside, on a sunny day, the giant silver sculpture could be seen shining inside the museum from the other side of the lake.

Cassaro's micro-sculptures (some of them pocket size) explore the possibilities of transformation into sculpture of a wide range of materials such as plastic, resin or foil. These comprise an inventory of works with strange mock-scientific titles: *Neotubideous*, *Seringuideas*, *Vulvas*, *Nodus Chorda Tubliform Carboni*. The drawings have similar names (*Biomandala*, *Filamentous Dry Cell*), and here the themes are reproduction, proliferation, liquefaction or solidification. Functioning as sculptures on paper, Cassaro's drawings present (rather than represent) the many processes to which the artist has submitted the paper: biting or staining it, covering it with wax, blowing or drying the liquid ink. Cassaro's cabinet of curious sculptures, both large and tiny, is above all seductive, playful and full of poetic and fabulous evocations.

Adriano Pedrosa

Cubic Levitation, 2002
bird's cage, 4 fans, red tracing paper, dimensions variable
Installation 'Salão Nobre: Franklin Cassaro', Museu de Arte da Pampulha, Belo Horizonte, 2002

Metallic Vulvae, 2000–1
7 metal pieces, dimensions variable

Yellow Neotubideous, 2000
40 yellow plastic pieces, dimensions variable

Mini-Umbilicas, 2001
19 aluminium and paper pieces, dimensions variable

Nodus Chorda Tubliform Carboni I, Nordus Chorda Tubliform II, 1998
2 bio-acrylic pieces, dimensions variable

Compounds Neotubideous, *c.*1999
12 coloured plastic pieces, dimensions variable

Overturned Tubideous and Seringuideas, 1994–2000
7 rubber and cast pieces, dimensions variable

Cranium, 2002
foil paper and Scotch tape, 15 x 13 x 24 cm

Filamentous dry cell, 2000
watercolour, pencil and felt-tip pen on paper
32 x 24 cm

Dry cell, *c.*1999
watercolour, pencil and felt-tip pen on paper
32 x 24 cm

FRANKLIN CAS

Futuristic Shelter (*interior view right*), 2002
silver-laminated plastic, fans, 3 x 19 x 5.4 m
Installation 'Salão Nobre: Franklin Cassaro', Museu de Arte da Pampulha, Belo Horizonte, 2002

Shelter (sculptural act), 1999
newspaper, air, 100 x 200 x 250 cm

Born Kortrijk, Belgium, 1969 Lives and works in Brussels, Belgium

Selected Solo Exhibitions: 1998 'Kindergarten Antonio Sant'Elia, 1932'/'Friends, 8 August 1998', Etablissement d'en Face, Brussels 1999 permanent sound installation, Hallen Kortrijk, Belgium; 'Untitled (Four Persons Standing)', De Vereniging, Stedelijk Museum voor Acutele Kunst, Gent 2000 Galerie Micheline Szwajcer, Antwerp; Internet project, DIA Center for the Arts, New York; 'Untitled', Nicole Klagsbrun Gallery, New York 2001 Galerie Johnen & Schöttle, Cologne; Rüdiger Schöttle, Munich 2002 'Cabinet Video: "Violetta"', Art + Public, Geneva; Kunstverein Hannover; 'Violetta – The Stack', Gallery Annet Gelink, Amsterdam

Selected Group Exhibitions: 1997 'Boom'/'Cat and Bird in Peace', Watertoren CHK, Vlissingen, The Netherlands; 'Ruurlo Bocurloscheweg, 1910', Pica en Flandes, Barcelona 1998 'I Never Promised You a Rose Garden', Beelden Buiten, Tielt, Belgium 1999 'FRI ART', Centre for Contemporary Art, Fribourg, Swizerland; 'Trouble Spot Painting', MUHKA, Antwerp 2000 'l'opera. Un chant d'étoiles', La Monnaie, Brussels 2001 2nd Berlin Biennale; 'Touch me ...', Cultural Centres Strombeek, Sint-Niklaas/Roeselare, Belgium; 2001 'Videoserie in der Black Box, 6 Künstler – 6 Positionen',

Sammlung Goetz, Munich 2002 'Besloten Wereld, Open Boeken', Groostseminair, Brugge; 'L'Herbier et le Nuage', MAC's Grand Hornu, Belgium; 'Lost Past 2002–1914 Memorial Signs for the Present', Ieper, Belgium; 'The Museum, the Collection, the Director and his Loves', Museum für Moderne Kunst, Frankfurt

Selected Bibliography: 1997 Paul Willemsen, 'Prix de la Jeune Peinture', *De Standaard*, 30 July 1999 Christoph Doswald, 'Frozen Time', *Nuevos Caminos*, Manuel Olveira, Vigo 2001 Anja Dorn, 'David Claerbout/Johnen & Shöttle Cologne', *frieze*, No. 61; Frank Maes, 'Belle comme la femme d'un autre', *Janus*, July 2002 Paul Amitai, 'David Claerbout/Inova, Milwaukee', *New Art Examiner*, May; Lynne Cooke/Stephan Berg/Rudi Laermans/Laurent Busine, *David Claerbout, Works 1996 – 2002*, A-Prior, Brussels/Kunstverein Hannover; Suzanne van de Ven, 'De herworteling van het verweesde beeld', *Metropolis M*, December

DAVID CLAERBOUT

Can we forget how to perceive? This is the question asked by David Claerbout's films, but only viewers who take the time to examine them thoroughly will be aware of it.

Recently the Museum für Moderne Kunst, Frankfurt, acquired Claerbout's video installation *Vietnam, 1967, near Duc Pho* (2001). It is projected onto the wall between two Jeff Wall works – his famous *The Storyteller* (1986) and his more recent *Diagonal Composition* – two lightbox works that are on the borderline between painting and photography. Claerbout's video shows an American military aircraft exploding over the lush green hills of Vietnam. In the museum one can tell from the fleeting glances of the viewers that they have mistaken this video for a still photograph, like Wall's lightbox work, not registering the gradual changes taking place in the image. What has misled them is the fact that the exploding aircraft is static. Only after watching the video for a while does one realize that the undulating Vietnamese landscape is constantly changing. Rays of sunshine illuminate it to a bright green then indiscernible clouds slowly darken it again. While these meteorological changes make themselves visible in the landscape, the exploding military aircraft hovers motionless in the air.

The 1998 work *Kindergarten Antonio Sant'Elia, 1932* involves something similar. This video installation, which like *Vietnam …* has no soundtrack, is based on a black and white photograph taken on the occasion of the official opening of the Kindergarten Antonio Sant'Elia in Como in 1932. It shows children playing in a garden in the intense Italian sun, their bodies casting sharp shadows. The children are frozen in time and space, and their rigidity is intensified by the slight, gentle movement of two tender young trees in the wind.

These works and others, like *Boom* (1996) or *Man under Arches* (2002), focus on perception, or the loss of it. Longer, closer more concentrated observation is required in order to notice these minute changes. Meanwhile, the acceleration of human perception demanded by the many and varied modern media is leading to a desensitization, if not a complete numbing, of perception. More than ever before in human history, it has become essential for people in society to be able to absorb a huge amount of visual data. At the same time, perception has become more and more superficial. David Claerbout's gentle but insistent work renders these facts visible.
Udo Kittelmann

Vietnam, 1967, near Duc Pho, 2001
video, 3 min., 30 sec., colour, silent

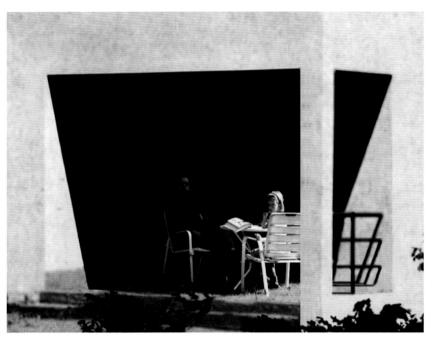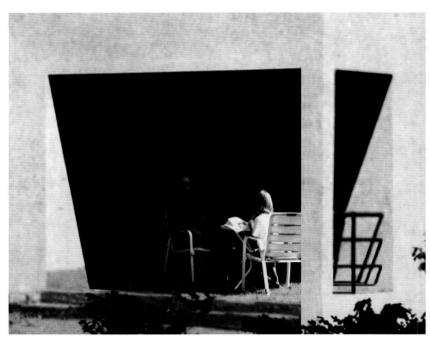

Untitled (Carl and Jule) I, 2000
sensor, interactive video, black and white, silent

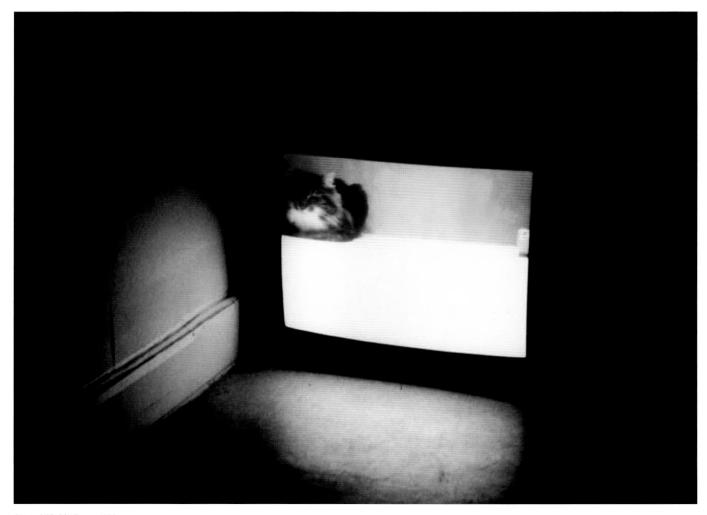

Cat and Bird in Peace, 1996
video, 60 min., colour, silent

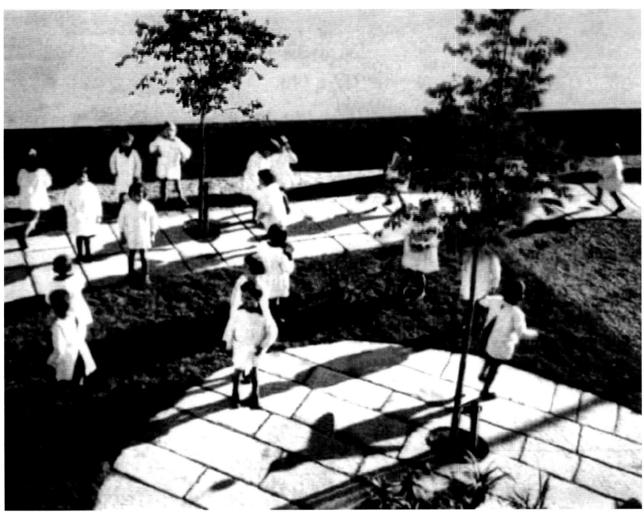

Kindergarten Antonio Sant'Elia, 1932, 1998
video, 10 min., black and white, silent

Four Persons Standing, 1999
video, 60 min., black and white, sound

Born Mexico City, Mexico, 1975 Lives and works in Mexico City

Selected Solo Exhibitions: 1998 'Selfdoor', Gallery I, Banff Centre for the Arts, Alberta 2000 'Mejor Vida Corp.', Museo Rufino Tamayo, Mexico City 2001 'MVC Biotec', Secession, Vienna 2002 'Dodgem', Galeria Kurimanzutto, Mexico City

Selected Group Exhibitions: 1998 'Mexcelente!', Yerba Buena Center for the Arts, San Francisco 1999 7th Havana Biennale; 'Democracy', Royal College of Art, London; 'Myself and My Surroundings', Musée des beaux-arts de Montréal; 'A Shot in the Head', Lisson Gallery, London 2001 24th Biennale of Graphic Arts, International Graphics Centre, Ljubljana; 'De adversidae vivemos', Musée d'Art Moderne de la Ville de Paris; 'Casino 2001', Stedelijk Museum voor Actuele Kunst, Gent 2002 'Arquitecturas para el Acontecimiento', EEAC, Castellon, Spain; 'Do It', Museo Carrillo Gil, Mexico City; 'Exchange and Transform', Kunstverein München, Munich; 'Exchange Rates of Bodies and Values', KW, Berlin/PS.1 Contemporary Art Center, New York; 'Life Ahead of You', FRAC, Montpellier; 'Urban Tension', Museum in Progress, Frankfurt/Rome/Vienna

Selected Bibliography: 2000 Eduardo Abaroa, 'Mobility', *I and My Circumstance – Mobility in Contemporary Mexican Art*, Musée des beaux-arts de Montréal/CONACULTA; Rose Guglielmetti, 'MVC – For a Human Interface', *Trans-Actions ou les noveaux commerces de l'art*, Collection Metiers de l'Exposicion-Presses Universitaires de Rennes; Emma Mahoney, 'Mejor Vida Corp.', *democracy! – Socially engaged art practice*, Royal College of Art, London; Cuauhtemoc Medina, 'Recent Political Forms, Radical Pursuits in Mexico', *TRANS>arts.media.culture*, No. 8; Francisco Reyes Palma, 'Guerra de corporaciones: la historia de Minerva y el puerquito BBV', *CURARE A.C.*, July–December 2001 *Da Adversidade Vivemos*, Musée d'Art Moderne de la Ville de Paris; Magali Arriola/Mario Garcia/Cuauhtemoc Medina, 'Mexico', *Parachute*, No. 104; Hans Ulrich Obrist, 'Conversation: Minerva Cuevas – Hans Ulrich Obrist', *tema celeste*, September–October 2002 Alberto Lopez Cuenca, 'Presents of Mind', *ARTnews*, March; Marti Peran, 'Minerva Cuevas', *Arquitecturas para el Acontecimiento*, EACC, Valencia

MINERVA CUEVAS

Minerva Cuevas' art is rooted in the socio-economic reality of Mexico, a country where the promises of capitalism have benefited only a few. Over forty million people live under the poverty line; the vast amounts of wealth accumulated there belong to a social elite hidden behind gated communities and policed by security guards.

In 1998 Cuevas inaugurated a fictional, not-for-profit company – Mejor Vida Corp. (Better Life Corporation) – premised on a politics of human interaction, good will and an anarchistic desire to evade the economic structures inherent to a capitalist system. Mimicking attributes of the multinational corporation, Cuevas set up an office in one of the tallest skyscrapers in Mexico City, a modernist, glass-encased building called the Torre Latinoamericana. She designed a logo showing two clasped hands and, with corporate identity established, launched a website that offers an array of services and goods, all available for free. The company's product is impossible to quantify; it is defined by singular gestures of generosity spurred on by basic human needs.

Through the Mejor Vida Corp. website (www.irational.org), one can order merchandise that is, in the end, semi-illegal: stickers replicating commercial bar codes for use in supermarkets to reduce prices up to forty percent on selected items; fake IDs that make one eligible for the International Student Identification card and all the discounts associated with it; canisters of tear gas for self-protection, presumably when demonstrating against the spread of global capitalism, and letters of recommendation for those seeking employment. Cuevas also arranged for the Lisson Gallery in London and Galerie Chantal Crousel in Paris to issue reference letters on request during the summer of 2000 as her contribution to exhibitions at both venues.

Cuevas' strategy is one of intervention. She stages quiet, unassuming actions that disrupt the flow of normal commerce, such as handing out free subway tokens during rush hour in the Mexico City subway or distributing pre-stamped envelopes to be used according to their owner's discretion. For a project in New York City of 1997–8, she provided subway riders with 'saftey pills' made from caffeine in response to an advertising campaign that reminded passengers – as potential victims of pickpockets – that 'Awake is Aware'. In a recent installation at an amusement park in Mexico City (*Dodgem*, 2002), the artist employed bumper cars painted with the logos of multinational energy corporations – Shell, Esso, etc. – to comment on the profit-driven motives of petrol companies that work aggressively to determine environmental policies and even governmental systems in order to secure their access to ever-dwindling natural resources.

Cuevas sees her practice as direct social activism rather than political art, which merely comments upon a specific social context. She imitates and inhabits the corporate structure in order to produce artwork that is, in her words, 'useful in social terms'. It is a subversive model that offers both humour and hope to its unsuspecting audience.

Nancy Spector

Dodgem, 2002
public intervention, Mexico City

Mejor Vida Corp., 2000
products and campaigns
Installation Museo Rufino Tamayo, Mexico City, 2000

How long does it take to get to NATO?, 2001
Installation '100 Billboard Project', 24th Biennale of Graphic Arts, Ljubljana, 2001

Nothing in excess – Everything with measure, 2000
poster campaign, public intervention, Havana

MINERVA C

Evian Campaign, 2001
intervened logo, banners, printed matter
Installed during street demonstrations in Rennes, and as a banner in Montpellier, 2001

Del Montte Campaign, 2002
intervened logo, printed matter

Born Guadalajara, Mexico, 1974 Lives and work in Guadalajara and Mexico City

Selected Solo Exhibitions: 1998 'Watch Your Step', NAP, Guadalajara 2001 '45 Minutes', Televicentro, Guadalajara; 'Monocromo', Project Room, Mexico City; 'Temporality is a Question of Survival', Camden Arts Centre, London 2002 'Erasing Memory', Galeria Enrique Guerrero, Mexico City

Selected Group Exhibitions: 1998 'Incidental', Condominio Guadalajara Piso 23, Guadalajara 1999 'Searching for an Unconquered Place', Museo Ex-Teresa, Mexico City 2000 'Demonstration Rooms/the Ideal House', Museo Alejandro Otero, Caracas/Apex Art, New York/NICC, Antwerp; 'Jet Propelled', Museo de las artes, Guadalajara; 'Open Studio', Braziers International Artists Workshop, Oxfordshire 2001 'Assemblée', Centre Culturel du Mexique, Paris; 'The Vanishing City', Programa Art Center, Mexico City; 'Ventanas', Centro de arte.com for ARCO 01, Madrid 2002 'Leisure Theory', Jumex Collection, Mexico City; 'Mexico City: an Exhibition about the Exchange Rate of Bodies and Values', P.S.1 Contemporary Art Center, New York/Kunstwerke, Berlin; 'Sauvage', La Panaderia, Mexico City

Selected Bibliography: 1999 Javier Dueñas/Jose Dávila, 'Prison', *Casper*, April; Yazmin Juandiego, 'Searching for an Unconquered Place', *Mural Newspaper*, 27 March 2000 Luz María Sepúlveda, 'Unnatural Science, the Intervened Space', *ArtNexus*, April–June 2001 Sacha Craddock, 'Temporality is a Question of Survival'/Rubén Gallo, 'Jose's Books', *Temporality is a Question of Survival*, Camden Arts Centre, London; Mark Currah, 'Jose Dávila, Sophie Ristelhueber', *Time Out*, 16–26 October; Dan Smith, 'Doris Salcedo, Sophie Ristelhueber, Jose Dávila', *Art Monthly*, November 2002 Omar Garcia, 'Re-creating Basic Needs', *Reforma*, 7 June

JOSE DÁVILA

Jose Dávila has incorporated many of the themes and strategies introduced by Conceptual artists in the 1960s and 1970s into provocative interventions that comment on the various ills plaguing the contemporary art world. *S,M,L,XL* (2000) one of his early works, can be read as a criticism of a recent trend in art-book publishing that has produced stunning and beautifully designed volumes, which are ultimately bulky, unreadable and destined to be little more than coffee-table books. In order to expose this kind of publication as an aesthetically pleasing but unreadable object, Dávila took a copy of *S,M,L,XL* by the architect Rem Koolhaas, and sliced it into three sections that were then shown as sculptural elements. It makes no difference, this piece seems to suggest, whether the book is intact or in parts, since it is not meant to be read but merely admired and handled like a precious object.

Pure will, without the confusions of the intellect (2000) suggests that not only modern books suffer from this problem. For this series, Dávila sliced up several books (including one dating from 1814) that he had bought from a Parisian antiquarian bookshop. This intervention implies that the value of antique books depends almost entirely on their material support, their content often becoming irrelevant (who, for example, would want to read a physics manual from the nineteenth century?). These antique books are treated like sculptures, transformed into objects with a purely decorative function.

A similar critique of the 'formalist fetish' that has shaped much recent art can be found in Dávila's 'topographic' landscapes. These large-scale, wall-mounted photographs touch on the current obsession with oversized Cibachrome prints that has become all the rage in galleries from Mexico City to London. But unlike the pristine photographs so loved by gallerists, Dávila's versions are crumpled, as if fished out of the garbage. Dávila also plays with the tension between the ostentatious scale of these photos and the triviality of their subject matter. One of his wrinkled photos presents a postcard image of the New York skyline (since the piece was created before 9/11, the World Trade Center dominates the image); another shows the lanes of an empty highway at night, while yet another depicts a nondescript tropical beach dotted with palm trees that could be anywhere from Cancún to Bali. These works not only stage a curious agreement between a damaged form (the crumpled photograph) and an equally devalued content (photographic clichés), but they also invite us to ask a pertinent question: has the art world fetishized Cibachrome prints and other glossy works to the point where their content has become irrelevant?

Rubén Gallo

S,M,L,XL (1), 2000
chromogenic print, 48 x 60 cm

Globalization – the world, 2000
C-print, 48 x 60 cm

top **Unproductive Machine**, 2002
Polystyrene foam, dimensions variable
Installation 'Flexible Packaging Group', San Juan Biennale PR02, Bayamon, 2002
Polystyrene spatial skeleton model of a polystyrene-making machine (*below*), occupying its space in the factory

JOSE

Topographic Landscape (Sunset), 2000
crushed offset print, 270 x 380 cm

Topographic Landscape (NY), 2001
crushed offset print, 140 x 290 cm

Born Osaka, Japan, 1977 Lives and works in Tokyo, Japan and Italy

Selected Solo Exhibitions: 2000 Mizuma Art Gallery, Tokyo 2001 Gallery Trax, Yamanashi, Japan

Selected Group Exhibitions: 2000 'Ground Zero Japan', Art Tower Mito, Contemporary Arts Centre, Ibaragi, Japan; Venice Architecture Biennale 2001 'Urgent Painting', Museé d'Art Moderne de la Ville de Paris

Selected Bibliography: 1999 Ichiko Minatoya, 'Deki, Yayoi', *Hana Tsubaki*, November; Noi Sawaragi, 'Report on the artists in the 22nd Century', *Esquire Magazine Japan*, December 2000 Akio Nakamuri, 'Sekai ga butsu-butsu ni naru hi made', *SPA!*, 1 March 2001 Akira Asada, 'Yayoi/Yayoi', *Bijutsu Techo*, February

YAYOI DEKI

Yayoi Deki makes colourful paintings with overwhelmingly dense fine detailing. She creates these accumulations of dots by applying colour to the pads of her fingers and dabbing them onto the medium. She then adds eyes and mouths. Each one just the size of a fingerprint, these simple faces range from human beings to a wealth of other creatures on a background of flowers, stars or polka-dots. All come together to form a single image – perhaps a rainbow-coloured galaxy, a fish or a gigantic face. Deki uses a variety of media, sometimes working in acrylics on canvas, sometimes creating murals that fill every inch of the walls in a room, and sometimes decorating shop-window mannequins.

This pathological proliferation of elements and obsessive detailing is related to the peculiar hallucinations Deki has experienced since she was a child. The fingerprint stamping comes from constantly pushing out the images that relentlessly pop into her mind, while elements of automatic drawing result from the compulsive tracing of the shapes she catches sight of. Deki claims that the images are all gleaned from a fantastic world that she calls Nanaka-mura, in which she's been 'living' since she was two years old. 'Nanaka-mura's where I live', she says. 'It's a place full of balloons and pandas and hippos and the sun and clouds and the moon and rainbows and soap bubbles and flowers and yellow and pink and lots of different colours. You can come to see me there if you like.'

Deki did not start out with a formal training in painting. When she was thirteen she fell for a musician on TV and decided that creating designs for CD jackets would be a good way to get close to him. Her art shares some elements with other artists who are self-taught, or have neurotic tendencies. The dots and colours, for example, call to mind similarities with the obsessive work of Yayoi Kusama.

Mimichin (1998) frontally portrays the head and shoulders of a bob-haired girl. The sharp outlines – as crisp as paper cutouts – are a feature of Deki's work; forms and colours are contrasted in a wonderfully lively manner. The blackness of her hair is juxtaposed with the red of parts of the face, the mix of red and black at the edge of the neck, and the different tones of pink and red on the right and left sides of the blouse. The blue of the background completes the bright contest of hues. Within the girl's left cheek is a multitude of vivid shapes – little animals or chrysanthemum petals – dropping like tears. They fall to her shoulder and seep into her blouse between the male and female faces that cover it. The girl's black head is a link to the emptiness of space; her eyes are closed in a meditation that continually gives birth to world after world, producing scary erotic fantasies. A related work, *Tentenpo* (1997–9), is a major production that portrays a girl with her eyes wide open. Eventually it will probably reach a size of about 30 metres, says Deki. The fine detailing appears at first to be simple repetition, but in fact displays amazing variety, presented with surprising orderliness.

Deki's paintings peel away layer after layer from the surface of reality, teeming with a savage strength, almost as if they were attempting to expose the true colours of life itself.

Yuko Hasegawa

Mimichin, 1998
acrylic on board, 145.5 x 103 cm

Tentenpo, 1997–9
acrylic on board, 300 x 927 x 753 cm
Installation 'Ground Zero Japan', Art Tower Mito, Contemporary Arts Centre, Ibaragi, 1999–2000

Tobu (*detail*), 1996
acrylic on board, 145.5 x 103 cm

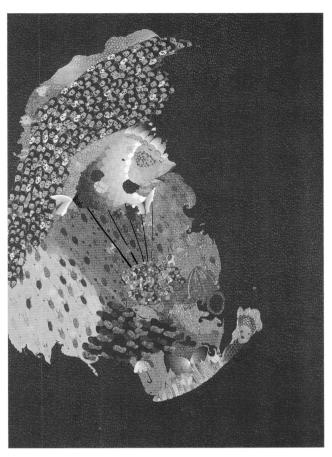

Hoshika, 1999
acrylic on board, 103 x 73 cm

Muttokochan, 1997
acrylic on board, 103 x 73 cm

Massan Christmas, 1999
acrylic, clay, 10 x 10 x 10 cm

Born San Francisco, USA, 1974 Lives and works in Los Angeles, USA

Selected Solo Exhibitions/Performances: 2000 'Echo', Artists Space, New York 2001 'Angel Heart', Air de Paris; 'A Little Bit of History Repeated', Kunstwerke, Berlin 2002 Air de Paris; Casey Kaplan, New York; Galerie Hauser & Wirth & Presenhuber, Zürich

Selected Group Exhibitions: 1999 'Minty', Richard Telles Gallery, Los Angeles 2001 'The Dedalic Convention', MAK Museum, Vienna; 'I Love Dijon', Le Consortium, Dijon; 'Mink Jazz', Mark Foxx, Los Angeles; 'The Wedding Show', Casey Kaplan, New York 2002 'Altoids Curiously Strong Collection', New Museum of Contemporary Art, New York; 'Gallery Luhman', Nils Staerk Contemporary Art, Copenhagen; 'How Extraordinary That the World Exists', CCAC Wattis Institute for Contemporary Arts, Oakland, California; 'Moving Pictures', Solomon R. Guggenheim Museum, New York; 'The Show That Will Show That a Show Is Not Only a Show', The Project, Los Angeles; 'Summer Cinema', Casey Kaplan, New York

Selected Bibliography: 2000 *Echo*, Artists Space, New York 2001 *A Little Bit of History Repeated*, Kunstwerke, Berlin 2002 Maurizio Cattelan/Bettina Funcke/Massimiliano Gioni/Ali Subotnick (eds.), *Charley*, No. 1; Jens Hoffmans, 'Trisha Donnelly', *Flash Art*, March–April; John Miller, 'Openings: Trisha Donnelly', *Artforum*, Summer

TRISHA DONNELLY

On the opening night of her first solo exhibition in New York, Trisha Donnelly staged a performance, or as she prefers to call it, a 'demonstration'. Dressed as a Napoleonic courier, she rode into the crowded gallery on a horse to deliver a message of surrender: 'If it need be termed surrender, then let it be so, for he has surrendered in word, not will … The Emperor has fallen and he rests his weight upon your mind and mine and with this I am electric. I am electric!' Having uttered this rebellious declaration of defeat, Donnelly turned and exited the gallery, leaving her guests to ponder the equally cryptic installation of video, photographs and drawings comprising her show. Donnelly's is an art of non sequiturs; the logic that connects her performances with her objects and installations is entirely her own. She communicates through privately coded belief systems powered by her expansive imagination.

In the video projection *Canadian Rain* (2002) Donnelly appears against a blank background wearing a trench coat. Her hair is blowing in the wind. She executes a series of stylized gestures from an entirely invented sign language to bring about a rainstorm somewhere in Canada, a country that she identifies with inclement weather. A grainy black and white photograph of a generic, mist-laden landscape on the adjacent wall offered 'proof' that her incantations worked. A second photograph, *The Black Wave* (2002), showing a close-up view of a large ocean swell, was explained in the press release as an image of 'the unbroken wave in deep water that occurs before and after a storm at sea', as further 'evidence' of Donnelly's paranormal powers. From time to time the sound of a lone wolf howling deep in the woods could be heard over loudspeakers in the gallery.

The abstract relationship between photography, video and performance in this installation is indicative of Donnelly's working methods. Her live demonstrations are never recorded on film. They may only be remembered and disseminated by written description or word-of-mouth. The photographs (traditionally used by performance artists to document their otherwise ephemeral acts) only further Donnelly's fictions. Her elusive narratives are woven from such webs of imaginary signs. In the video *Rio* (1999), Donnelly appears in silhouette against an ersatz, homespun sunset. To the accompaniment of a Latin ballad, she communicates in American Sign Language, but instead of translating the words of the song, she describes how to find the most beautiful spot on Earth.

In another video, *Untitled (jumping)* (1998–9), Donnelly re-enacts what she contends are the signature gestures of rock musicians at the moment they achieve their 'performance wall' – the point when they reach physical transcendence through their music. By jumping on an unseen trampoline, she floats in and out of the frame in slow motion, assuming a dreamlike state and recreating the musicians' adrenaline-induced moments of ecstasy. The identities of the different performers – from Ozzie Osbourne to Joey Ramone – are never revealed.

Nancy Spector

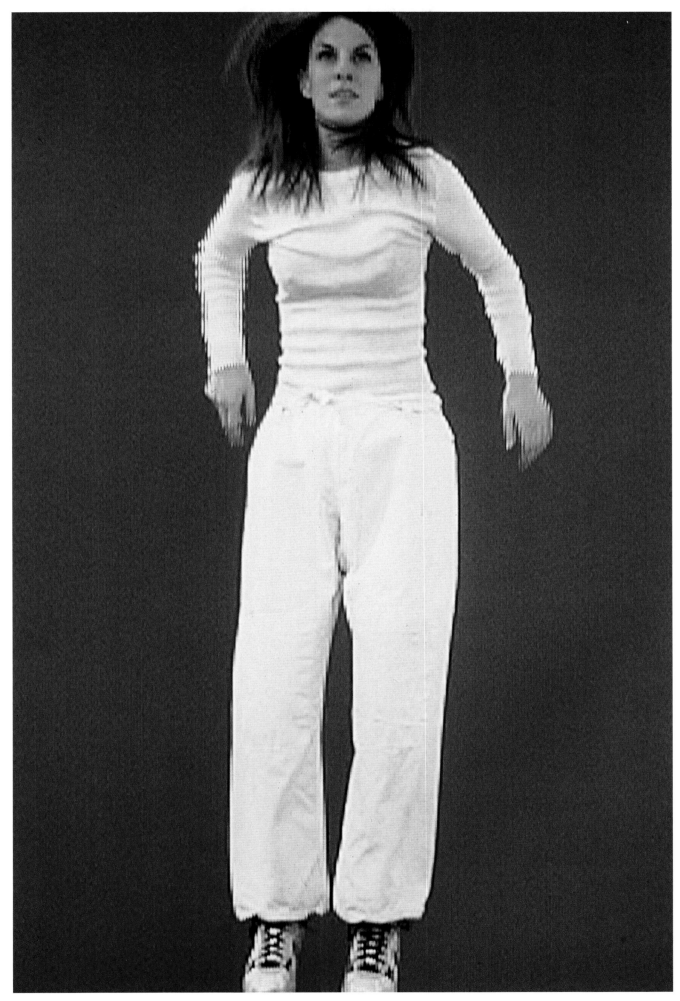

Untitled (jumping), 1998–9
video, 4 min., 30 sec., colour, silent

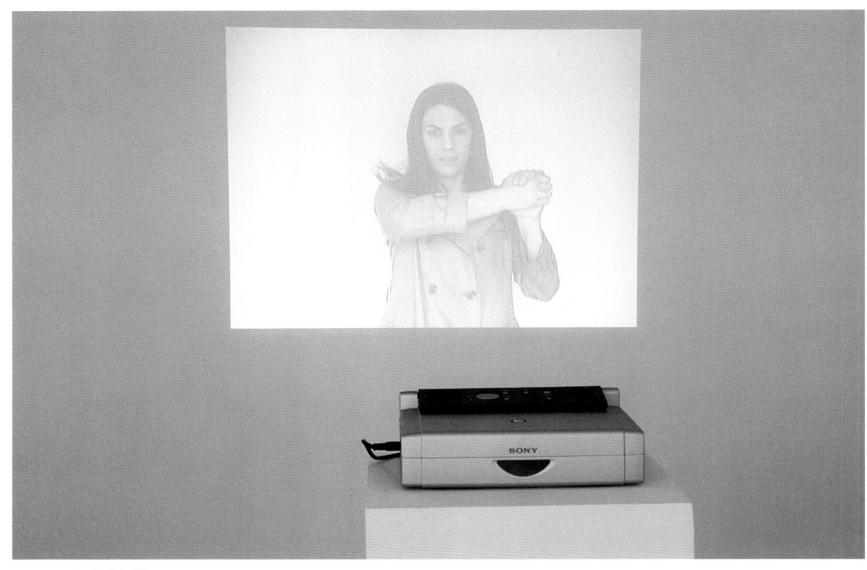

Canadian Rain, 2002
video projections, 5 min., loop, black and white, silent
Installation Casey Kaplan, New York, 2002

Canada, 2002
black and white fibre print, 40.5 x 51 cm

The Black Wave, 2002
silver gelatin print, 127 x 152.5 cm

TRISHA DON

[Title is a drum–beat sequence played by gallery upon request], 2002
12 drawings (*detail, left*), pencil on paper, CD, each 76 x 56 cm

[Title is a drum–beat sequence played by gallery upon request], 2002
triptych (**detail, left**), pencil on paper, each 88.5 x 57 cm

Sea Battles (*detail*), 2001
7 pencil-on-paper drawings related to a performance, each 24 x 30.5 cm
Musical compositions based on a performance in which Donnelly's hands on a keyboard represented opposing factions in a battle
Installation 'A Little Bit of History Repeated', Kunstwerke, Berlin, 2001

Born Seattle, USA, 1961, Lives and works in Los Angeles, USA

Selected Solo Exhibitions: 1992 'Pardon Our Appearance ...', Bliss, Pasadena 1999 'Altamont', Blum & Poe, Santa Monica; 'Into the Black', Kapinos, Berlin 2000 'Proposal for Monument in Friendship Park, Jacksonville, Florida', Blum & Poe, Santa Monica; Tomio Koyama Gallery, Tokyo 2001 'Southern Tree, Tree of Knowledge, Dead Tree', Galleria Emi Fontana, Milan 2002 The Museum of Contemporary Art, Los Angeles; 'Sam Durant: 7 Signs; removed, cropped, enlarged and illuminated (plus index)', Wadsworth Atheneum Museum of Art, Hartford; 'US Historian', Blum & Poe, Santa Monica 2003 Artist-in-Residence installation, Walker Art Center, Minneapolis; Kunstverein für die Rheinland und Westfalen, Düsseldorf

Selected Group Exhibitions: 1994 'Gone', Blum & Poe, Santa Monica; 'Thanks', Three Day Weekend, Los Angeles 1995 'Couldn't Get Ahead', Independent Art Space, London 1997 'Scene of the Crime', UCLA at the Arm and Hammer Museum of Art, Los Angeles 1998 'Entropy at Home', Ludwig Museum, Aachen; 'L.A. or Liliput?', Long Beach Museum of Art 1999 'A Living Theatre', Salzburger Kunstverein, Salzburg; 'Making History', Bard College, Center for Curatorial Studies, Annandale-on-Hudson; 'Proliferation', The Museum of Contemporary Art, Los Angeles 2000 'ForWart: a choice', Mont des Arts, Brussels 2001 'In Between: Art and Architecture', MAK Center for Art and Architecture, Los Angeles; 'New Settlements', Nicolaj Copenhagen Contemporary Art Centre, Copenhagen 2002 'From the Observatory', Paula Cooper Gallery, New York; 'Out of Place: Contemporary Art and the Architectural Uncanny', Museum of Contemporary Art, Chicago; 'Prophets of Boom: Werke aus der Sammlung Schurmann', Staatliche Kunsthalle, Baden-Baden

Selected Bibliography: 1995 Melanie Marino, 'Sam Durant at Roger Merians', *Art in America*, July 1996 Lisa Anne Auerbach, 'Sam Durant at Blum & Poe', *Artforum*, January; David A. Greene, 'Sam Durant at Blum & Poe', *Art Issues*, January–February 2000 Clayton Campbell, 'Sam Durant at Blum & Poe', *Flash Art*, January–February; Frank Hettig, 'Sam Durant', *Metropolis M*, June–July; James Meyer, 'Impure Thoughts: The Art of Sam Durant', *Artforum*, April; David Pagel, 'Durant's Pretend Theme Park Sends History Rockin', Rollin'', *Los Angeles Times*, 3 November 2001 Alex Coles, 'Revisiting Robert Smithson in Ohio: Tacita Dean, Sam Durant and Renée Green', *Parachute*, October–December; Stuart Comer, 'Interview with Sam Durant', *Untitled*, Spring; Kentaro Ichihara, 'Sam Durant', *Bijutsu Techo*, March 2002 Michael Darling, 'Sam Durant's Riddling Zones', *Sam Durant*, Hatje Kantz, Ostfildern; Rita Kersting, Sam Durant, Museum of Contemporary Art, Los Angeles/Kunstverein für Rheinland und Westfalen, Düsseldorf

SAM DURANT

Sam Durant's drawings, sculptures, photographs, lightboxes and installations involving sculptural elements and audio components emerge from his exhaustive research across a broad spectrum of cultural histories. Through the associative connections, reversals, distortions, condensations and repetitions of events from recent history, he creates a personal archaeology, welcoming the slips and mistakes that 'historical' accounts inevitably set into play. He sees the recollection of utopian visions and their interaction with the vernacular and with contemporary life as a way in which to reinvent a future.

In his early *Abandoned Houses* (1995), models of several postwar modernist homes built in the LA area are vandalized, shot up, graffitied and burnt out. Durant positions this 'destruction' of the architecture as an allegory for the failure of its utopian aspirations and of populist social engineering.

Many of Durant's works address, through the art, music and counterculture of the 1960s, the disappearance of the revolutionary America of that decade – a mythical time for Durant, who became a teenager in the 1970s. His art examines the interconnections between various aspects of culture that emerge out of the process of historicization. For example, a body of works on which he has been engaged since 1998 juxtaposes references to Robert Smithson's art with the rock culture of the period. Some of these works demonstrate Durant's humorous associations of ideas and materials: rock music may be played backwards, or emerge from speakers hidden within fibreglass rocks.

Reflected Upside down and Backwards (1999) is made from two scale replicas of Smithson's *Partially Buried Woodshed*. One of these models appears brand new, whilst the other is burnt to the point of near collapse. Surrounding the sculpture are speakers emitting songs by Neil Young and Nirvana. Smithson created his original work in 1970 for Kent State University campus just a few months before the shooting of anti-war demonstrators by police there, prefiguring the collapse of the peace movement that the massacre would later symbolize. By referring in his works to this tragedy; to the Rolling Stones Concert at Altamont in 1969 where fatal violence between Hell's Angels and fans erupted; to Smithson's death in a plane crash in 1973, and to the suicide of Nirvana's Kurt Cobain in 1994, Durant points to a late-century period of cultural entropy, nihilism and anger in American culture following the positive, idealistic outlook of hippy culture in the 1960s.

Another take on Smithson's work can be found in Durant's recent sculptures of upside-down fibreglass trees placed on mirrors. These merge references to Smithson's Land art with the history of slavery in America. Durant imagines a universe where entropy can be reversed, where history goes backwards to the roots of utopia, proposing a more communal future for society.

Another reference to the death of the radical in modern life can be found in a series of illuminated signs made in 2002, where protest slogans from the 1960s are retrieved from amnesia and relocated in contemporary discourse: 'Like, man, I'm tired of waiting', says one.
 Carolyn Christov-Bakargiev

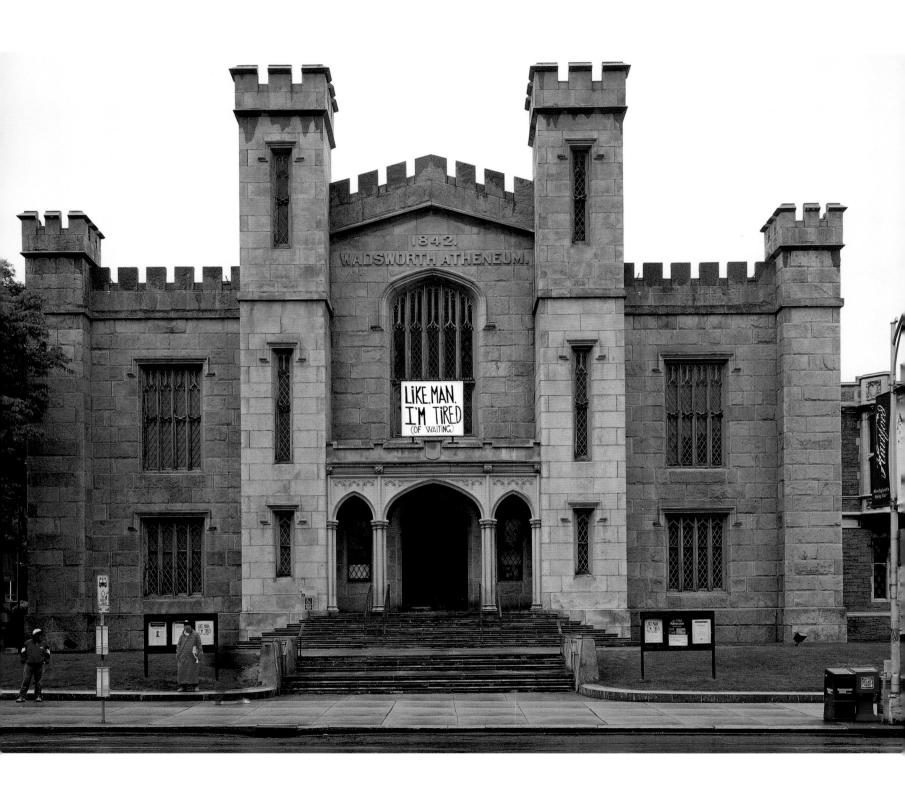

Like, man, I'm tired of waiting, 2002
from '7 Signs; removed, cropped, enlarged, and illuminated (plus index)', 2002
vinyl text on electric sign, 206 x 223.5 cm
Installation 'Sam Durant/Matrix 147', Wadsworth Atheneum Museum of Art, Hartford, 2002

125

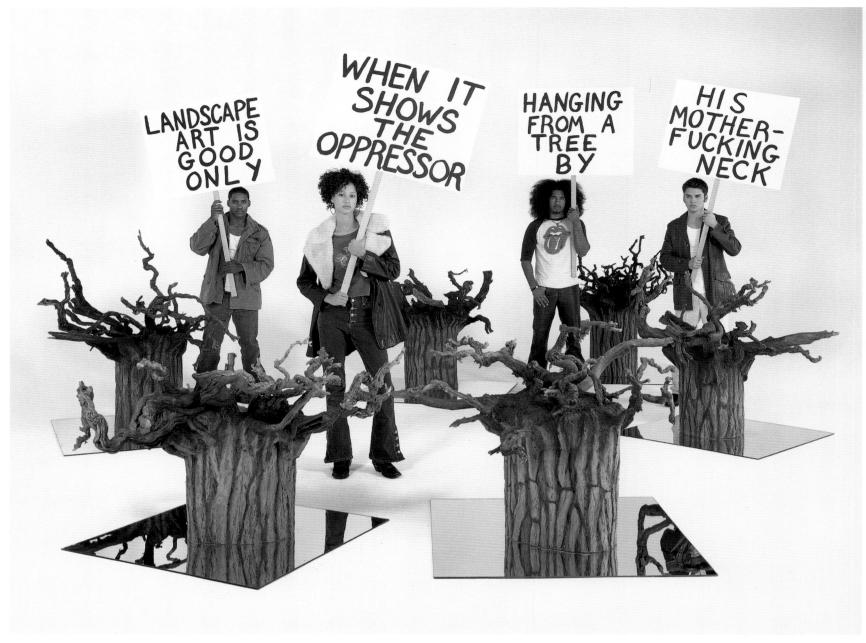

Landscape Art (Emory Douglas), 2002
C-print, 127 x 168 cm

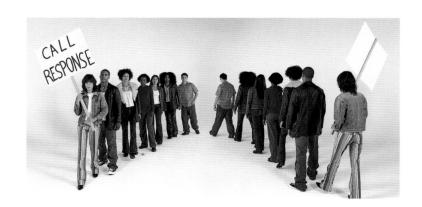

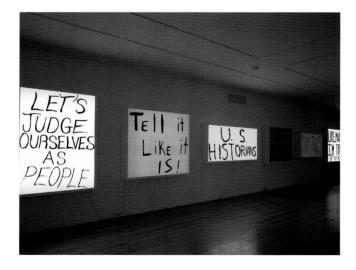

Call and Response, 2002
C-print, 114 x 228.5 cm

7 Signs; removed, cropped, enlarged and illuminated (plus index), 2002
vinyl text on electric sign, dimensions variable
Installation 'Sam Durant/Matrix 147', Wadsworth Atheneum Museum of Art, Hartford, 2002

SAM D

Abandoned House no. 1, 1995
foam core, cardboard, Plexiglas, tape, spray enamel, wood, metal, 76 x 76 x 13 cm

Abandoned House no. 2, 1995
foam core, cardboard, Plexiglas, tape, spray enamel, wood, and metal, 84 x 108 x 12 cm

Reflected Upside Down and Backwards, 1999
wood, acrylic, asphalt, CD players, 66 x 213 x 127 cm

Friendship Park–Primordial Mass; Friendship Park with Flags; Friendship Park Vocabulary, 2000
ink and collage on paper, each 46 x 60 cm

Michael Elmgreen born Copenhagen, Denmark, 1961 Ingar Dragset born Trondheim, Norway, 1969
Live and work in Berlin, Germany

Selected Solo Exhibitions: 1997 'Powerless Structures', Gallery Cambells Occasionally, Copenhagen 1998 'Powerless Structures, Fig. 45', Galleri Ingólfsstraeti/Reykjavik Art Museum, Reykjavik 2000 'Zwische anderen Ereignissen', Galerie für Zeitgenössische Kunst, Leipzig 2001 'Powerless Structures, Fig. 111', Portikus, Frankfurt; 'A Room Defined by its Accessibility', Statens Museum for Kunst, Copenhagen; 'Taking Place', Kunsthalle Zürich 2002 'Museum', Sala Montcada de la Fundacio la Caixa, Barcelona 2003 Vancouver Contemporary Art Gallery

Selected Group Exhibitions: 1996 'The Scream, Borealis 8', Arken Musuem of Modern Art, Ishoj, Denmark 1997 'The Louisiana Exhibition', Louisiana Museum of Modern Art, Humlebaek 2000 Manifesta 3, Ljubljana; 'Sporting Life', Museum of Contemporary Art, Sydney 2001 7th Istanbul Biennale 2002 XXV São Paulo Biennale; Palais de Tokyo, Paris; 'Pris der National Galerie für Junje Kunst', Hamburger Bahnhof, Berlin; 'Shopping', Schirn Kunsthalle, Frankfurt 2003 'Living Inside the Grid', New Museum of Contemporary Art, New York; 'Skulptur Biennale Munsterland', Münster

Selected Bibliography: 1996 Kim Levin (ed.), *The Scream, Borealis 8*, The Museum of Modern Art, New York 1998 Sanne Kofod Olsen, 'Transgressive Spaces', *Powerless Structures*, Galleri Ingólfsstraeti/Reykjavik Art Museum, Reykjavik 1999 Holland Cotter, 'Maria Elena Gonzáles; Michael Elmgreen and Ingar Dragset', *The New York Times*, 19 February 2000 Daniel Birnbaum, 'Borderline Syndrome', *Manifesta 3*, Ljubljana; Jan Winklemann (ed.), *Michael Elmgreen and Ingar Dragset: Between Other Events*, Galerie für Zeitgenössische Kunst, Leipzig 2001 Jennifer Allen, 'Michael Elmgreen and Ingar Dragset', *Artforum*, October; Sven Bjerkhof/Marianne Torp (eds.), *A Room Defined by its Accessibility*, Statens Museum for Kunst, Copenhagen; Massimiliano Gioni, 'New York Cut Up ... Art Fragments from the Big Apple', *Flash Art*, November–December 2002 Daniel Birnbaum, 'The Art of Michael Elmgreen and Ingar Dragset; White on White', *Artforum*, April; Daniel Birnbaum, 'From White Cube to Super Houston', *Parkett*, 63; Beatrix Ruf (ed.), *Michael Elmgreen and Ingar Dragset: Taking Place*, Kunsthalle Zürich/Hatje Cantz, Ostfildern

MICHAEL ELMGREEN & INGAR DRAGSET

Architectural space is not in and of itself powerful or coercive. Rather, its effect is conditioned by the context in which it is utilized, the ideologies that determine its programme, and the behaviours it promotes or disallows. This is the premise (learned from Michel Foucault's *History of Sexuality*, 1976) behind the ongoing series of sculptural installations by Michael Elmgreen and Ingar Dragset titled 'Powerless Structures'. Working together as a collaborative team since 1995, the artists have created crisp, clean spatial interventions that provocatively skew the original intended use of the structures they reference. A public pavilion in a park near Aarhus, Denmark, for example, is cast as a venue for gay cruising, complete with glory holes; a beautifully lit gallery space is sunk into the ground in Reykjavik; the floor and ceiling of Portikus' exhibition space surge upwards and downwards respectively, like rolling waves; and a perfectly square wishing-well dug into a Berlin pavement is forever sealed with a sheet of Plexiglas.

Elmgreen and Dragset's minimalist aesthetic, inspired in part by the classic Scandinavian design with which they grew up in their native Denmark and Norway, is deliberately deceptive. Its supposed neutrality – as once invoked in the sculptural investigations of Robert Morris or Donald Judd – provides the perfect empty canvas on which to layer a host of intended meanings. Firstly, they query the defining powers of modernism's 'white cube', the now almost universal typology used for gallery space. In a number of performative projects, they or their collaborators have applied successive coats of white paint to generic-looking structures, making visible what typically remains behind the scenes in our cultural institutions. Additionally, Elmgreen and Dragset, who are a gay couple, interrogate how so much public – and even private – space is heterosexually coded. In *Powerless Structures, Fig. 117* (2001), for instance, they allude to a history of sexual and racial segregation demarcated by spatial boundaries. A white park bench bears a bold black text stating 'Homosexuals Only', accompanied by a small fragment of a similar bench inscribed with the lone word 'Only'.

Elmgreen and Dragset's investigations are largely site-specific, taking into account the political or social conditions in which they are located. These subversive projects can also be humorous. For an international triennial exhibition in an agricultural region of Japan, they constructed a scale model of the Hollywood sign in a hill above a small town, but in this instance, the sign read 'Harlem'. The triennial was inaugurated to help revitalize this rural area by encouraging cultural tourism, a situation similar to what was happening in New York City in the largely black-populated Harlem, as chain stores like Starbucks opened north of 125th Street. The commercialization and gentrification of our urban landscapes in the age of global capitalism was the subject of another piece in New York. For their first exhibition at the Tanya Bonakdar Gallery, they closed the space with a large sign that read 'Opening Soon: Prada'.

Nancy Spector

Powerless Structures, Fig. 185, 2001
wood, paint, stencilled lettering, 1 x 1 x 1 m

Elevated Gallery/Powerless Structures, Fig. 146, 2001
MDF, wood, paint, cables, vinyl balloons, office furniture, 5.3 x 5.7 x 3.4 m
Installation 'A Room Defined by its Accessibility', Statens Museum for Kunst, Copenhagen, 2001

Prison Breaking/Powerless Structures, Fig. 333, 2002
cellular concrete, cement, steel, 3.7 x 5.5 x 7.5 m
Installation XXV São Paulo Biennal, 2002

Traces of a Never Existing History/Powerless Structures, Fig. 222, 2001
wood, stainless steel, aluminium, Perspex, fluorescent lighting, paint, 3.1 x 4.3 x 7.8 m
Installation 7th Istanbul Biennale, 2001

Cruising Pavilion/Powerless Structures, Fig. 55 (*exterior and interior*), 1998
wood, paint, Perspex, rubber matting, 2.3 x 4 x 4 m
Commissioned for Marselisbourg Forest by the City of Aarhus, Denmark

Powerless Structures, Fig. 117, 2001
iron, MDF, silk-screened letters, paint, 50 x 80 x 40 cm
Installation 'Hartus Conclusus', Witte de With Centre for Contemporary Art, Rotterdam, 2001

Born Buenos Aires, Argentina, 1973 Lives and works in Buenos Aires, New York, USA and Paris, France

Selected Solo Exhibitions: 1991 Centro Cultural Recoleta, Buenos Aires 1997 'Inner City', Consulate of Argentina, New York 1999 'El Living', Kent Gallery, New York; 'Rain', Moody Gallery, Houston 2000 Galeria de Arte Ruth Benzacar, Buenos Aires 2001 'Neighbours', Museo del Barrio, New York 2002 Galerie Gabrielle Maubrie, Paris

Selected Group Exhibitions: 1995 'Taller de Barracas', Galería de Arte Ruth Benzacar, Buenos Aires 1998 'Core 1998', Glassell School Museum of Fine Arts, Houston 1999 'Paralelos/Paralelas', ARCO: Fondo Nacional de las Artes, Madrid 2000 7th Havana Biennale; 'Natural Deceits', The Museum of Modern Art, Fort Worth; Whitney Biennial, Whitney Museum of American Art, New York 2001 7th Istanbul Biennale; 49th Venice Biennale 2002 1st Busan Biennale, South Korea; 'Faster Than the Eye', Yerba Buena Center for the Arts, San Francisco; 'Politicas de la Diferencia', Museo de Arte Latino Americano, Buenos Aires

Selected Bibliography: 1997 Ines Katzenstein, *The Eye Whitness*, Consulate of Argentina, New York 1999 Ken Johnson, 'El Living', *The New York Times*, 8 October; Santiago Garcia Navarro, 'Pensar El Espacio', *La Nacion*, 16 April; Patricia Rizzo, *ARCO '99*, Fondo Nacional de las Artes, Buenos Aires 2000 Michael Kimmelman, 'A New Team at the Whitney Makes its Biennale Pitch', *The New York Times*, 24 March; Fabian Lebenglik, 'Verdad Mentira y Ficcion', *Pagina 12*, 3 October; Victoria Noorthoorn, *Leandro Erlich*, Galeria de Arte Ruth Benzacar 2001 Holland Cotter, 'Leandro Erlich at El Museo Del Barrio', *The New York Times*, 17 April; Julia Hertzberg, *Neighbours*, Museo del Barrio, New York; Kim Levin, 'Leandro Erlich's Disappearing Act Parallel Universe', *Village Voice*, 27 February; Roberta Smith, 'Turismo', *The New York Times*, 6 July 2002 Rodrigo Alonso, *The World as Reality and Representation*, Galerie Gabrielle Maubrie, Paris

LEANDRO ERLICH

Leandro Erlich initially studied architecture, but restricted by the many limitations placed upon it, he began searching for a freer avenue of expression within the world of art. His works are sculptures in which architectural components are utilized to create a fictional space of perception.

In *Neighbors* (1997) a door is placed on either side of a minimal white architectural structure. One door is locked; through its peephole an illusory empty corridor can be seen. The peephole in the other door, which is unlocked, looks onto a real corridor. Walking in we encounter a steel elevator door, which opens automatically to reveal a black hole – a bottomless elevator shaft that is in fact an illusion created by the interplay of mirrors on the ceiling and floor. This ordinary space is thus suddenly transformed into a fictional maze. The resulting illusion suggests two superimposed parallel worlds – one in which people exist, and one in which they disappear.

The installation as a device for creating illusion is put to even stronger use in *The Living Room* (1998). Walking into a space containing a sofa, we see two large mirrors, framed like a window, on one of the walls. One reflects back the image of the viewer, while the other turns out to be a glass window through which an elaborate reconstruction of the room is visible. The clock on the wall, the poster of a Warhol exhibition, the purple bottle on the window sill – each object is duplicated and placed at the same distance from the wall with craftsman-like accuracy. Through the use of the frame, this work makes reference to hyperrealism in art, to Minimalist sculpture and to Felix Gonzalez-Torres' work *Untitled (perfect lovers)* (1987–90), in which two clocks are placed side by side.

These installations attempt to explore the depths of psychological illusion as shaped by our perceptions, even suggesting scepticism about existence itself. Many of Erlich's works, while containing real architectural elements, can be seen as independent sculptures in their own right – like spatial versions of Duchamp's readymades.

Looking at the rectangular surface of *The Swimming Pool* (1999) we see people below it, looking up at us. We realize that the pool can be accessed from below. The light reflected on the ripples in the several centimetres of water, supported by a sheet of glass, creates an enticing boundary for encounters. A space for meetings is also created in *Rain* (1999), an otherworldly communication area for the residents of two adjacent buildings. Through the snow and rain that falls in the small space between the two windows, viewers can watch each other, and are able to open the window and shake hands. From the voyeurism of lonely urban dwellers to the gaze of strangers as they glimpse each other for the first time, Erlich's work explores the possibilities and dreams that lie behind the chance encounters hidden in the city. Combining a Borgesian magical realism with a minimalist aesthetic, he beckons us towards a new psychological and physical experience.
 Yuko Hasegawa

El Ballet Studio, 2002
3 Tai-Chi performers, 3 symmetrical spaces, mirror
Performance at Shanghai Art Museum, Shanghai Biennale, 2002

The Living Room, 1998
twin living-room set, mirror, mirror-image posters, clocks, dimensions variable
Installation Kent Gallery, New York, 1999

Neighbors, 1997
metal structure, doors, Formica, peep holes, corridor maquette, 130 x 210 x 410 cm
Installation 1st Mercosur Biennale, Porto Alegre, 1997

The Swimming Pool, 1999
metal structure, wood, rubber paint, Plexiglas, water, fans, 250 x 600 x 300 cm
Installation 49th Venice Biennale, Fondaco dei Tedischi via Rialto, Argentinian Pavilion, 2001

Born Mococa, Brazil, 1963 Lives and works in São Paulo, Brazil

Selected Solo Exhibitions: 2000 The Fabric Workshop and Museum, Philadelphia 2001 The Contemporary Arts Center, Cincinnati; 'Nada Mais Natural', Galeria Fortes Vilaça, São Paulo; 'Photoshop Sunset', Museu de Art Moderna, Higienópolis, São Paulo; 'Rivane Neuenschwander and Iran do Espírito Santo', The Americas Society, New York 2002 Centro Cultural Dragão do Mar, Fortaleza; Museu de Arte Moderna Aloísio Magalhães, Recifel; 'Parallel Reality', Sean Kelly, New York

Selected Group Exhibitions: 1987 XIX São Paulo Biennale; 'Lingua latina est Regina', Stux Gallery, New York 1995 'Fogosites', Gallery 400, Chicago 1996 'Beige', Galeria Luisa Strina, São Paulo 1997 'In Site 97', San Diego/Tijuana; 'Panorama de Brasileira', Museu de Arte Moderna de São Paulo; 'Present Tense: Nine Artists in the Nineties', Museum of Modern Art, San Franciso 1999 48th Venice Biennale 2000 6th Istanbul Biennale 2001 'No es solo lo que vês: Pervertiendo el minimalismo', Museu Nacional Centro de Arte Reina Sofia, Madrid; 'Trajetória da Luz na arte brasileira', Itaú, São Paulo

Selected Bibliography: 1997 Gary Garrels, *Present Tense: Nine Artists in the Nineties*, Museum of Modern Art, San Francisco 1998 Wayne Baerwaldt, 'Iran do Espírito Santo: to resist is elegance', *Plug In Cahier*; Felipe Chaimovich, 'Iran do Espírito Santo', *art/text*, August–October; Felipe Chaimovich, 'Iran do Espírito Santo', *Trans>art.culture.media*, No. 5 1999 Ivo Mesquita, 'Nelson Leirner and Iran do Espírito Santo, Venice 1999'/Adriano Pedrosa, 'Truth Lies', *48 Biennale di Venezia – Padiglinoe Brasile*, São Paulo; Katy Siegel, 'Rad Weather', *Artforum*, September 2001 Roberta Smith, 'Rivane Neuenschwander and Iran do Espírito Santo', *The New York Times*, 20 July 2002 Roberta Smith, 'Iran do Espírito Santo', *The New York Times*, 4 October

IRAN DO ESPÍRITO SANTO

Iran do Espírito Santo's work is concerned with art's oldest subject matter: representation. However, he is not so much interested in representing things as in the very process of representation, perception and interpretation and above all the gaps that may exist between the three. He engages with the material and conceptual systems, strategies and codes through which ordinary objects become art objects and are contextualized and presented as such. It is thus not by chance that his work often flirts with what are perhaps the closest fields to art: architecture and design.

Working with sculpture, painting, drawing, photography, printmaking and installation, Espírito Santo uses different processes according to the specific needs of his project – from carved marble or granite to wall painting or digital imaging. The work invariably has a slick finish, as if material and formal precision were essential in order to tackle the imprecise nature of our daily experience of the things that surround us. In this context, a key motif is abstraction, which appears somewhat ambivalently within heavily loaded figurative settings. The works from the 'Restless' series, for example, are glass pieces, geometric sections of which have been sandblasted, mirrored or left transparent, resulting in a layered or superimposed effect. Resting on the floor against a white wall, they short-circuit the distinctions between reflection, translucency and transparency.

The play between nature and culture is another frequent motif. In the 'Corrections' series (2001–2), for example, a group of stones is sculpted into polyhedrons, putting natural (the raw stone) and cultural forms (the abstract geometric sculpture) into friction. *Nostalgia* (1999) is a simple rectangular rug woven in a luscious green, the work's title suggesting pastoral memories that are in turn counterpoised by its minimalist, monochromatic rendition. *The Night* (1998) is the image of the Brazilian flag where all the elements but its twenty-seven stars have been blacked out, evoking melancholic and romantic overtones connected with nature, as well as the darkness of Brazilian politics.

On another note, *Untitled (Keyhole)* (2002) is a small, metal wall sculpture in the form of a keyhole, yet cast as an absurd three-dimensional object. The circular section of the keyhole is a metallic half sphere, about half an inch in diameter, and has been highly polished so as to reflect the room in which it is installed, again articulating notions of perception, reflection and representation.

Espírito Santo's works often establish a dialogue with that somewhat lowbrow artistic genre, the *trompe l'oeil*. The artist's intention, however, is never to fool us, but rather to make us aware of the inevitability of the condition of being fooled. The eye, his art seems to tell us, is far from a reliable instrument.

Adriano Pedrosa

Untitled (Keyhole), 2002
granite, h. 44.5 x Ø 20 cm

Untitled (Keyhole), 1999
stainless steel, h. 8 x Ø 4 cm

Recurrency II, 2000
stainless steel, copper, brass, dimensions variable

Extension, 1997
latex on wall, dimensions variable
Installation 'Present Tense: Nine Artists in the Nineties', Museum of Modern Art, San Francisco, 1997

The Night, 1998
screenprint on paper, 45 x 64.5 cm

UFO, 2000
stainless steel, h. 7 x Ø 31 cm

IRAN DO ESPÍRITO S

Correction B, 2001
granite, dimensions variable
Installation 'Nada Mais Natural', Galeria Fortes Vilaça,
São Paulo, 2001

Parallel Forest, 2001
latex on wall, dimensions variable
Installation 'Nada Mais Natural', Galeria Fortes Vilaça, São Paulo, 2001

Déjà Vu, 2000
latex on wall, dimensions variable
Installation The Americas Society, New York, 2001

Divider, 1997
automotive paint on plywood, 275 x 400 x 53.5 cm

Born Jerusalem, Israel, 1972 Lives and works in Berlin, Germany

Selected Solo Exhibitions: 2002 &: gb Agency, Paris 2003 Frankfurter Kunstverein, Frankfurt; Fribourg Centre of Contemporary Art, Switzerland; Postmasters Gallery, New York

Selected Group Exhibitions: 2000 'Omer Fast and Akiko Ichikawa', Momenta Art, New York; 'Some New Minds', P.S.1 Contemporary Art Center, New York 2001 'Affinités Narratives', &: gb Agency, Paris; 'Out of Bounds', &: gb Agency, Paris; 'Travelling Scholars', Museum of Fine Arts, Boston; 'Video Jam', Palm Beach Institute of Contemporary Art, Florida; 'Weak Architecture', Midway Projects, St Paul, Minnesota 2002 'Here and Now', Büro Friedrich, Berlin; 'Submerge', Kunstbunker Nürnberg, Nuremburg; 'Video: Monitor 2', Gagosian Gallery, New York; Whitney Biennial, Whitney Museum of American Art, New York

Selected Bibliography: 2002 Tracy Adler/Judicael Lavrador, 'Original Bootleg', *Omer Fast: I Wanna Tell You Something*, &: gb Agency, Paris; Jennifer Allen, 'A Tank Translated', *Insideout: Fifth Festival of New Art*, Berlin; Holland Cotter, 'Never Mind the Art Police, These Six Matter', *The New York Times*, 5 May; Charlotte Laupard, 'Think Fast', *Technikart*, July–August; Emmanuelle Lequeux, 'Omer Fast, Citoyen d'un Monde qui Cloche', *Aden, Le Monde*, 20 June; Lawrence Rinder, *2002 Whitney Biennial*, Whitney Museum of American Art, New York; Jerry Saltz, 'American Blandstand', *Village Voice*, 14 March; Lynn Sullivan, 'Personal Productions of the Big Picture', *Second Sight: Selections of Recent Work by Alumni from the Second Decade of the MFA Program at Hunter College 1991–2001*, Hunter College of the City University of New York

OMER FAST

Omer Fast disrupts and interacts with media constructions such as video and television – mechanisms that might seem impervious to outside interference. In doing so he suggests the empowering possibility of individual human agency.

One of his first projects, made in 2001 in New York City just after graduating from Hunter College, was *T3-AEON*. For this ninety-minute work he rented cassettes of James Cameron's movie *The Terminator* (1984) and added short voiceover recordings into their soundtracks. In each segment a different individual from his family recalls an experience of having been subjected to violence, delivering their story in a flat, monotone, dreamy voice. Fast then put the tapes back into circulation via video-rental distribution. To experience the work, viewers had to rent one of the altered tapes from a store, and could watch it in the privacy of their own home. The interventions were so subtle and brief that one wasn't sure whether or not one had actually heard them or had simply imagined them in some psychological projection or daydream while watching the movie.

Similarly oneiric is Fast's recent eighteen-minute video *CNN Concatenated* (2002), where the artist sampled and collaged together hundreds of individual words – snippets from CNN news reports taped from television. The result is a completely fictitious text spoken by a variety of news anchors, but whose content is dictated by Fast himself. His text is subjective, revolving around fundamental personal experience of life and death, yet, absurdly, it is recited by a multitude of voices and is restricted to the 10,000-word lexicon he was able to gather, a mere tenth of the normal adult vocabulary. The work draws attention to our preference for mediated news over the chaos and dangers of real life.

Glendive Foley (2000) is a two-channel video installation, shown at P.S.1 Contemporary Art Center, New York, in Winter 2000–1 and at the Whitney Biennial the following year. For this work Fast exhibited views of houses in Glendive, Montana – which constitutes the smallest television market in the United States – opposite multiple portraits of himself producing a soundtrack for this suburban footage with his own mouth and hands, like an old-fashioned foley artist. Again, Fast inserts personal narratives, experiments, memory and desire within the folds of public structures – an almost paradoxically modernist gesture in our postmodern cultural landscape.

Carolyn Christov-Bakargiev

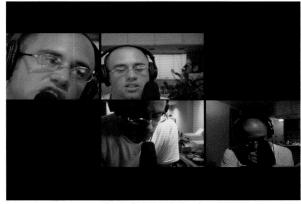

Wind

Wind – Bird – Insect – Insect

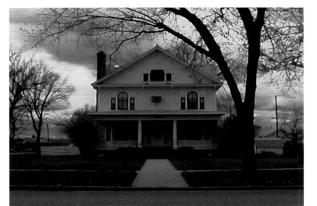

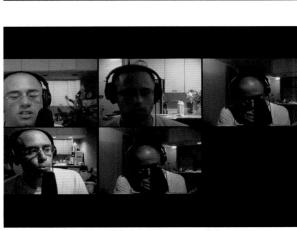

Wind – Bird – Insect – Lawnmower - Bird

Wind – Car – Insect – Dog – Lawnmower – Dog

Glendive Foley, 2000
2-channel video, 20 min., colour, sound

< suburban neighborhood sounds >
< children playing, a car approaches >

< car stops >

< door opens, heavy step >

I came home one day.

Somebody threw a very large stone and...

I didn't crack my head but I had a fairy large wound
on the scalp which was bleeding very heavily.

Somebody threw a stone in children's games and –
as you know – skull lacerations wound very profusely because there is
abundant blood supply.

< dog barks >

I ran away.

I ran immediately home.

And I rang the doorbell.

And he opened the door...

T3-AEON, 2001
video, 90 min., colour, sound

OMER

< Sarah Connor? >

< Yes? >

And when he saw me with this thing - he was so upset that the first thing he slapped me in the face.

He couldn't handle the stress.

You have to understand that this is the second family for him after the holocaust.

He lost his son in the holocaust.

Anything that would happen to me would...

< gun shot > would drive him crazy.

< more gun shots >

< >

< I'm on my break Chuck, Carl's got my patients >

< Sarah!! Come here! It's about you! >
< Well, sort of... >

Born Düsseldorf, Germany, 1941 Lives and works in Düsseldorf

Hans-Peter Feldmann does not wish his biographical/bibliographical information to appear in publications

HANS-PETER FELDMANN

Hans-Peter Feldmann remains one of the great unknowns of recent German art history. Though he started to work as an artist in the 1960s, his work has so far failed to trigger a broad international response. This may be the reason why, unlike many other artists, he has maintained his commitment to ideological principles – for example, to Mao Tse Tung's dictum that art belongs to the people. An early catalogue contains a quotation attributed to Gerhard Richter: 'I find some amateur photographs better than the best Cézanne. It is certainly not all about painting good pictures, because painting is a moral action.' Feldmann's creative work moves between these two formulations.

Feldmann is a member of the generation of artists who attempted to detach themselves from painting, and he has responded to the changing reality of modern media from the outset. He helps himself from the reservoir of conceivable and inconceivable images and media worlds, using them in the spirit of Roland Barthes to produce 'an image rubbed from reality'. In doing so, he reduces to absurdity Walter Benjamin's concept of the original artwork and its special aura, pushing plagiarism into the category of art.

Feldmann constantly works against the myth of the artist-genius, refusing even to provide biographical notes in publications, and importing everyday things and perceptions into his art. His artistic work will have no truck with originals; his objects, books and notebooks, photographs and posters are always available as published objects, never signed. Feldmann's work is based on the principle of the series, repetition, and above all on accumulating visual analogies. He does not arrange his pictorial material – either found or produced by himself – from an aesthetic point of view, but through formal and thematic criteria. The art he produces always goes back to banal pictorial clichés that define our environment and our world of ideas, and thus subjects existing perception patterns, in both art and society, to critical examination.

Feldmann's eye is like that of a child, whether he is recording a woman's entire wardrobe in photographs, robbing a house of cards of its fragility, making model railways travel through space, or choreographing formations of pencils, spectacles and cups. When faced with his work one is reminded of Franz Kafka's comment that philosophers have always learnt a good deal in the presence of children.

Udo Kittelmann

145

above and overleaf
Untitled, 2002
Installation 'Das Kinderzimmer', Museum für Moderne Kunst, Frankfurt, 2002

Born Zürich, Switzerland, 1973 Lives and works in Zürich and Los Angeles, USA

Selected Solo Exhibitions: 1997 'Hammer', Galerie Walcheturm, Zürich 1999 'Espressoqueen – Sweet Feelings, Worries and Other Stuff You Have to Think About Before You Get Ready for the Big Easy', Galerie Hauser & Wirth & Presenhuber, Zürich 2000 'The Membrane – Why I Don't Mind Bad Mooded People', Stedelijk Museum Bureau, Amsterdam; 'Soups of the Days'/'6 1/2 Domestic Pairs Project', Kunsthaus Glarus; 'Without a Fist – Like a Bird', Institute of Contemporary Arts, London 2001 'Mastering the Complaint', Galerie Hauser & Wirth & Presenhuber, Zürich 2002 'Bing Crosby', Contemporary Fine Arts Galerie GmbH, Berlin; 'Mystique Mistake', The Modern Institute, Glasgow; 'What Should an Owl do with a Fork?', Santa Monica Museum of Art 2003 Gavin Brown's Enterprise, New York; Sadie Coles HQ, London

Selected Group Exhibitions: 1995 'Bundesstipendianten', Kunsthaus Glarus 1998 'Ironic/Ironisch', Migros Musuem für Gegenwartskunst, Zürich 1999 'Holding Court', Entwistle, London 2000 Manifesta 3, Ljubljana 2002 'The Object Sculpture', The Henry Moore Institute, Leeds

Selected Bibliography: 2000 Beatrix Ruf (ed.), *Time Waste Urs Fischer – Radio-Cookie und kaum Zeit, kaum Rat*, Kunsthaus Glarus/Edition Unikate, Glarus 2002 Kirsty Bell, 'Urs Fischer', *frieze*, No. 67; Brigitte Werneburg, 'Brigitte Werneburg schaut sick in den Galerien von Berlin um', *Die Tageszeitung*, 15 January

⌐ URS FISCHER ¬

Urs Fischer's work resists easy categorization since it runs the entire gamut of artistic resources and media. It includes sculpture, drawing, painting, installation and objects, as well as texts, photography and film. His choice of genres ranges from traditional forms – still lifes, portraits, nudes, landscapes, interiors – to more up-to-date manifestations such as atmospheric installations like *Madame Fischer* (1999–2000), in which the artist transported his entire London studio into a gallery, breaking down the relationship between art and life.

We live in a present dominated by an all-pervasive information culture, in which virtual worlds seem as real as reality itself, and reality has become like a collage of things, places, thoughts, fictions, processes, relationships, urbanity, nature, subculture, genetic engineering, design, politics, philosophy, all arranged on a flat surface entirely without hierarchies. Fischer has opened up a study that is in permanent dialogue with these structures of material and social reality. His work is not so much shaped by an individual artistic signature as by a constant flow of questions addressed to art's structures, relationships and modes of action. He constantly finds new approaches to form, materials and content, exposing them to a relentless process of interrogation and transformation: what is a chair, a wall, a head, a shadow … ?

In Fischer's hands these familiar objects often metamorphose into uncanny, uncomfortable and surreal things. *Rotten Foundations* (1998), for example, is a large brick wall that sinks and distorts as it teeters on a foundation of decaying fruit and vegetables. In *Boffer Bix Kabinett* (1998) dark-coloured furnishings are completely covered with hand-written quotations from philosophical set-pieces. Their shadows, cast on the wall, are over-painted with rose-hip jam, which seems to double the number of objects present. Concepts, texts, questions, poems and images are often inscribed onto the surface of objects or superimposed to form three-dimensional structures. In a number of other works, such as *The Art of Falling Apart* (1998), glasses, shelves, tables, chairs, mattresses, sheets and other everyday things are painted with a black and white triangulated network, a sort of grid structure that constructs and dissolves surfaces at the same time, making them seem almost cartoonish.

The principle of *Dr. Katzelberg (Ruin of Civilization)* (1999) is the reorganization of the way we see: cats made up of mirrored surfaces are themselves reflected kaleidoscopically in mirrored spaces in a process of endless refraction, reflection and deflection. Another favourite transformative material is wax, which remoulds nudes, heads and objects. Countless drawings make use of everything from internal views of bodies to advertising images. In *Jet Set Lady* (2000), these hang like abundant fruit from a tree knocked up out of crude timber.

Beatrix Ruf

The Art of Falling Apart, 1998
painted furnishings, shelf: 120 x 200 x 80 cm; suitcase: 150 x 140 x 60 cm; chair: 200 x 180 x 151 cm

Rotten Foundations, 1998
bricks, mortar, fruit, vegetables, dimensions variable

Madame Fischer, 1999–2000
artist's London studio

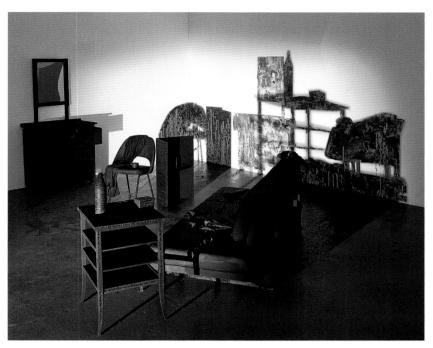

Boffer Bix Kabinett, 1998
jam, paper, fabric, cardboard, foam material, spotlight, mirror, dimensions variable
Installation 'Ironisch/Ironic', Museum für Gegenwartskunst, Zürich, 1998

Jet Set Lady, 2000
colour copies, wooden frames, wood, water-repellent colour, 450 x 450 x 420 cm

Tea Set, 2002
foam, silver, acrylic, 45 x 39 x 23 cm

151

Born Lugano, Switzerland, 1976 Lives and works in Malmö, Sweden

Selected Solo Exhibitions: 2000 'Fragments of the Everyday', Italian Cultural Institute, Edinburgh 2001 'Silver Tags', Yellow House, Reykjavik 2002 'Critical Studies Classroom', Malmö Art Academy; 'Eleven Titles', Cargobar, Basel; 'A Laboratory for Proposals/Proposals for a Laboratory', Galleri Peep, Malmö; 'New Office Space + Lounge', Galleri Index, Stockholm; 'Space Jockeys', Rooseum Center for Contemporary Art, Malmö; 'Suggestions for Empty Spaces', Rooseum Lobby, SAS Radisson, Malmö

Selected Group Exhibitions: 2000 'Alternative Strategies', Municipal Museum, Cork; 'protoacademy apartment', George IV Bridge, Edinburgh 2001 'Greetings from Liverpool', Bluecoat Gallery, Liverpool; The Wight Biennale 2001, The New Wight Gallery, Los Angeles 2002 4th Gwangju Biennale

Selected Bibliography: 2001 Sara Jordenö, 'Institutionalised freedom – notes on art, education and social change', The Wight Biennale 2001, University of California, Los Angeles 2002 Luca Frei/ Mats Stjernstedt, 'Proposal for a new office space', PA SYSTEM, protoacademy, Edinburgh; Alexander Gutke, Making a Lasting Impression, Gwangju Biennale Press, Gwangju; Åsa Nacking, 'Twisting, turning models for language, mediation and architecture', Rooseum Provisorium, Malmö

LUCA FREI

Born in Switzerland and now based in Malmö, Luca Frei is young enough to have experienced only postmodernism in his lifetime. As such, his revisitations of some of the ideas and speculations about modernist form and ambition display a refreshing level of optimism. Starting from a purely formalist training in fine art in Switzerland, Frei has developed what might be termed an 'engaged formalism' in which his geometric designs appear in both two and three dimensions as collages, drawings, furniture and 'total environments', to quote Arne Jacobsen. The turn to the functional in his work is not, however, simply a search for a purpose for his art but rather a way of developing questions and facilitating open-ended audience responses.

Thus, when he redesigned the office spaces at Galleri Index in Stockholm, he took into account its functional needs and the possible unpredictable uses that may be demanded by the visitor. The shelving and seating systems are therefore developed to excess in order to provide literal space for imaginative use. In a more recent project, *Space Jockeys* (2002), he transformed a public studio into an Aladdin's cave of colourful card, paper and light, with which each visitor could play and configure their own environment.

In Frei's two-dimensional works, the speculative element again emerges in titles such as *A Laboratory for Proposals, Proposals for a Laboratory* (2002) or *Suggestions for Empty Spaces* (2002). The latter, shown in a Malmö hotel, was a series of inventive geometric collages, returning to his earlier formal interests, but this time sited within the non-space of a hotel foyer, in which they shone out as propositions for turning the ugly into the comfortable, or the kitsch into the original. Another ongoing project has been to reconfigure in tape found graffiti tags, again taking on formalist design not as a exclusive product but as an unacknowledged everyday phenomenon.

Frei's work as a whole can be seen to take a number of interesting positions relating to modernism. It is clear from his urge to consider both functional and symbolic potential that he understands the promise of that time, but he seems finally less concerned with an arid discourse about modernism than with the ludic possibilities that can be produced through its mechanisms today. 'Basically, this is more about playing, because I made the rules myself', he says. 'If we think about game and play, children's practice … it has this kind of playful input. I don't have to respond to any other rules here – so this is a bit more like a thinking process, rather than looking for an answer – it's more like questioning.'

Charles Esche

New Office Space + Lounge, 2002
plywood, adhesive vinyl tape
Installation 'New Office Space + Lounge', Galleri Index, Stockholm, 2002

Untitled, 2000
MDF, acrylic paint. approx. 50 x 30 x 70 cm

Book Shelf, 2002
plywood, adhesive vinyl tape, h. 80 x ∅ 110 cm
Installation 'Critical Studies Classroom', Malmö Art Academy, 2002

Editing Table, 2002
plywood, adhesive vinyl tape, table: 75 x 240 x 72 cm; 2 benches: 44 x 120 x 36 cm
Installation 'Critical Studies Classroom', Malmö Art Academy, 2002

LUCA

Black Tag, 2002
black adhesive vinyl tape, dimensions variable
Installation 'Pause', Gwangju Biennale Hall, 4th Gwangju Biennale, 2002

Space Jockeys, 2002
overhead projector, mixed media, dimensions variable
Installation 'Space Jockeys', Arbetsrum, Rooseum Center for Contemporary Art, Malmö, 2002

Lounge for a Laboratory for Proposals, 2002
plywood, adhesive vinyl tape, carpet, dimensions variable
Installation 'A Laboratory for Proposals/Proposals for a Laboratory', Gallery Peep, Malmö, 2002

Suggestions for Empty Spaces, 2002
collage, 21 x 30 cm
Installation 'Suggestions for Empty Spaces', Rooseum Lobby, Radisson SAS Hotel, Malmö, 2002

155

Born Iowa City, USA, 1973 Lives and works in New York, USA

Selected Solo Exhibitions: 1996 Off/Ice Gallery, University of Manitoba 1997 'Recent Work', Plug In, Winnipeg 2000 303 Gallery, New York 2001 303 Gallery, New York; Donna Beam Fine Art Gallery, University of Nevada, Las Vegas; Galeria Il Capricorno, Venice

Selected Group Exhibitions: 1999 'No Place Rather than Here', 303 Gallery, New York 2000 'Drawings 2000', Barbara Gladstone Gallery, New York; 'Greater New York', P.S.1 Contemporary Art Center, New York 2001 'Best of the Season', The Aldrich Museum of Contemporary Art, Ridgefield; 'Brooklyn!', Palm Beach Institute of Contemporary Art; 'The Way I See It', Galerie Jennifer Flay, Paris;

'Works on Paper From Acconci to Zittel', Victoria Miro Gallery, London

Selected Bibliography: 1999 Jennifer Higgie, 'Natural Selection', *frieze*, November–December 2000 Vincent Katz, 'Tim Gardner', *Art in America*, September; Frances Richard, 'Tim Gardner', *Artforum*, March; Jerry Saltz, 'Look Homeward', *Village Voice*, 1 February; Peter Schjeldahl, 'Pragmatic Hedonism', *The New Yorker*, April 2001 Sarah Douglas, '303 Gallery', *Flash Art*, July–September; Tim Griffin, 'Boyz II Men', *Time Out New York*, 3–10 May; Kim Levin, 'Voice choices: Tim Gardner', *Village Voice*, 8 May

TIM GARDNER

Based on snapshots of college-age guys drinking beer, passing out, pissing from balconies, going on Spring Break escapades to beach resorts like Cancún and Hawaii, or simply hanging out in front of the television, Tim Gardner's small-format paintings of his brother's friends might promise a voyeuristic glimpse into a hedonistic world of priapic hunks, gripped by the forces of Eros at their most youthfully intense. The atmosphere captured by these works, however, couldn't be further from our expectations: though these men are in the prime of their lives, they inhabit a stagnant, lifeless world where time seems to stand still. They exist in a forgotten, literally soul-destroying suburban corner of the world. Sto, Mitch and the other protagonists are in their twenties, but their bodies already carry the marks of middle age – pasty skin, puffy eyes, flabby bellies – and if we look closely we sense the looming spectre of death. One imagines them fifty years from now, aged and alcoholic, killing time in a barren nursing home in Mississauga, Ontario.

Tim Gardner grew up in Kitchner, a small, nondescript city in Canada, and when he was a teenager his family moved to Winnipeg, another small, nondescript Canadian city. His brother, who had stayed behind, began sending him snapshots of all the fun – parties, get-togethers, beach outings – that he was missing. Gardner had enrolled in art school in Manitoba, and began making watercolours based on these suburban scenes. The work was an instant hit, landing him a cover article in *frieze* magazine and later a solo show at 303 Gallery in New York.

Although critics have compared Gardner's work to the photographs of Richard Billingham, the British artist who documents the impoverished, alcoholic existence of his working-class family, the works of these two artists couldn't be more different: one uses photography while the other uses watercolours. Curiously, photography – the most logical choice for documentary projects – allows both Billingham and the viewer a certain distance from the subject matter; one feels safely removed from the toothless women and obese men in the photos. Gardner's watercolours, however, achieve the opposite effect: they abolish all distance and instantly envelop the viewer in the dense atmosphere of boredom, banality and lifelessness that permeates these pastel scenes.

In a perverse way, Gardner has made a brilliant discovery: he has found the perfect technique for representing suburban adolescence. As a medium, watercolour – with its associations of Sunday painters and bored housewives churning out pastel landscapes of sunflower fields – is as banal and lifeless as the keg parties and piles of beer bottles it serves to depict. These works give a new meaning to the term 'still life': they are stills of stagnant existence, arrested moments of banal lives in a suburban limbo.

Rubén Gallo

Untitled (Lars & Brad with Sigfried & Roy), 2002
watercolour on paper, 23 x 15 cm

Untitled (Nick with Marilyn Monroe), 2002
watercolour on paper, 13 x 16.5 cm

Untitled (Hawaii Camaro), 2000
watercolour on canvas, 20 x 15 cm

Mt. Rushmore, 2002
watercolour on paper, 35 x 38 cm

TIM GAR

Untitled (Nick & S with Bottles, Tampico, Mexico), 2000
watercolour on paper, 13 x 18 cm

Untitled (S in Vegas), 2001
watercolour on paper on board, 22 x 30 cm

Born Göttingen, Germany, 1968 Lives and works in Berlin, Germany

Selected Solo Exhibitions: 1996 'Mein Leben als Taube', Klosterfelde, Berlin 1997 'Let's Get Physical Digital', Art Node, Stockholm 1998 'Mein erstes Buch', Portikus, Frankfurt 1999 'Telemistica', Kölnischer Kunstverein, Cologne 2000 De Appel, Amsterdam; 'The Matrix Effect', Wadsworth Atheneum Museum of Art, Hartford 2001 Swiss Institute-Contemporary Art, New York 2002 'The Holy Artwork', Aspen Museum of Art, Colorado 2003 Carnegie Museum of Art, Pittsburgh

Selected Group Exhibitions: 1997 4th Lyon Biennale 1999 48th Venice Biennale; 'Crash', Institute of Contemporary Arts, London 2000 'Preis de Nationalgalerie für junge Kunst', Hamburger Bahnhof, Berlin 2001 2nd Berlin Biennale; 'Let's Entertain', Walker Art Center, Minneapolis/Kunstmuseum, Wolfsburg; 'New Works: 01.2', ArtPace, San Antonio 2002 'Art and Economy', Deichtorhallen, Hamburg; 'Public Affairs', Kunsthaus Zürich; Whitney Biennial, Whitney Museum of American Art, New York

Selected Bibliography: 2000 *German Open 1999 – Gegenwartskunst in Deutschland*, Kunstmuseum Wolfsburg; Noemi Smolik, 'Christian Jankowski: Kölnischer Kunstverein/Schnitt Ausstellungsraum', *Artforum*, February; Raimar Stange, 'Der Zeitspieler', *Kunst-Bulletin*, No. 3 2001 Jörg Heiser, *Play*, De Appel, Amsterdam 2002 Julia Friedrich/Ulrike Knöfel, 'Himmlische Fügung', *Der Spiegel*, November; *Lehrauftrag*, Neuer Aachener/Kunstverein Klosterfelde, Berlin; Jordan Kantor, 'Christian Jankowski: Swiss Institute', *Artforum*, February; Helena Kontova/Massimiliano Gioni, 'Christian Jankowski: You Will Never Walk Alone', *Flash Art*, March–April; James Trainer, 'Poisoned Arrow', *frieze*, April

CHRISTIAN JANKOWSKI

Christian Jankowski stages collisions between art and the real world that shed light on the sincerity and artifice of both. His video-based work, in which he records collaborations with often unsuspecting protagonists, has a candid-camera-like feel. Over the past ten years Jankowski has enlisted fortune tellers, border guards, magicians and psychotherapists to perform the routine tasks of their respective professions. In some of his taped exchanges with these individuals, Jankowski interjects questions about his own practice and the efficacy of the visual arts in general. In others, he simply allows his subjects' actions to accentuate idiosyncrasies inherent to contemporary art and the industry that supports it.

Jankowski's position evolves from a deep-seated sense of self-doubt, but like the classic figure of the clown whose true pathos is obscured by humour, he has a flair for comedy. His antics are not in any way sarcastic, however. There is an earnestness about the work that forecloses irony and allows for the possibility that art may be redeeming and even transformative. In fact, in 1996 he hired a magician to turn him into a dove for the duration of an exhibition. When faced with the task of inventing new work for the Venice Biennale in 1999, Jankowski telephoned an Italian call-in show featuring televised tarot-card readings to inquire if the piece he was planning would be successful. He taped the predictions of five psychics on the VCR in his Venetian hotel room, turning their prophecies of achievement into a video titled *Telemistica*, the very artwork about which they were speculating. Jankowski's self-deprecating search for guidance also found expression in an earlier

piece called *Desperately Seeking Artwork*, which was made for a show in Graz in 1997. Frustrated by his inability to formulate an appropriate response to the exhibition site, Jankowski employed the services of a psychiatrist to help him overcome his creative block. His videotape and photographs of the final therapy session comprise the finished work – a piece hewn from uncertainty and a healthy sense of mischief.

Having already appropriated the tools of psychoanalysis and soothsaying, Jankowski next turned to organized religion in his quest for meaning. He collaborated with the San Antonio-based televangelist Pastor Peter Spencer to record a sermon on the spiritual dimensions of art. Videotaped in the style of a rousing evangelical service intended for television, *The Holy Artwork* (2001) communicates a surprisingly moving and open-minded account of the need to nurture creativity. The piece begins as Jankowski is called to address the Texan church, but instead of speaking, he falls to the pastor's feet in a pose of supplication not unlike that of the artist depicted in Juan Bautista Maino's Renaissance painting of divine intervention in the painter's studio. The rest is pure improvisation as Spencer pontificates on the role that contemporary art can play in modern Christianity. Even though Jankowski intended this piece to function exclusively as a work of art, he was satisfied to learn that the pastor aired the sermon on his local Christian TV channel, proving that the collaboration was mutually beneficial.

Nancy Spector

The Holy Artwork, 2001
video, 16 min., 22 sec., colour, sound

My Life as a Dove, 1996
video, 6 min., colour, sound

Desperately Seeking Artwork, 1997
video, 18 min., colour, sound

CHRISTIAN JANK

Telemistica, 1999
video, 22 min., colour, sound

Born Barre, USA, 1974 Lives and works in Portland, USA

Selected Solo Exhibitions: 1999 'Love Diamond', New York Video Festival 2001 'The Swan Tool', Institute of Contemporary Arts, London/Rotterdam International Film Festival 2002 'The Swan Tool', The Kitchen, New York

Selected Group Exhibitions: 1999 'The Amateurist', Whitney Museum of American Art, New York 2001 'Drama Queens: Women Behind the Camera', Solomon R. Guggenheim Museum, New York; 'Nest Of Tens', The Museum of Modern Art, New York 2002 'Time-Share', Sara Meltzer Gallery, New York; Whitney Biennial, Whitney Museum of American Art, New York

Selected Bibliography: 1999 Stephen Holden, 'Mixing Technologies', *The New York Times*, 16 July; Alison Maclean, '99 Channels and Nothing On', *Filmmaker Magazine*, April; Amy Taubin, '24 Hour Women', *Village Voice*, 6 July 2000 Stella Rollig (ed.), 'Video as Female Terrain', *<hers>*, Springer-Verlag, Vienna 2001 Chris Chang, 'Renaissance Riot Grrrl Rising', *Film Comment*, July–August; David Cote, 'The Swan Tool', *Time Out New York*, 13 December; James Hannahan, 'The Multimedia is the Message', *Village Voice*, 12 December 2002 Chrissie Iles/Lawrence Rinder/Debra Singer, *Whitney Biennial 2002*, Abrams/Whitney, New York

MIRANDA JULY

Multimedia artist Miranda July makes films, performances and sound recordings. She has directed a pop video, acted in a feature film, and founded a movie distribution network for women, which operates in similar way to a chain letter. Sometimes she combines a number of these art forms in one work. The multimedia *Swan Tool* (2001), a blend of video, solo performance, music and new media, has been described as a 'live movie'. In this bizarre, often humorous work, she plays an insurance company employee who buries herself in the back garden. July's aim is to transcend the barriers of performance and digital media, and to blur the boundaries between disciplines. By placing herself between two screens that meet at the height of her waist, she literally merges with the imagery projected on them, creating the impression that she is walking between offices or touching objects.

'Most of my work originates in writing', says July, 'and tells the story of how spirit got inside matter – inside e-mails and hair and beds – and how humans live with it'. She digs deep into the murky layer beneath the surface of everyday life, insightfully observing the strange tics of human behaviour through cryptic narratives and a range of endearingly dysfunctional characters. *Nest of Tens* (2000), for example, is an ambitious video featuring a group of children and an adult that weaves together four disconnected stories on the theme of fear and control. These include an adolescent boy's strange experimentation on a baby girl, a developmentally disabled man lecturing an audience on phobias, a sexually dysfunctional family, and a girl flirting with a businessman at an airport. The result is both unsettling and darkly funny.

The video *Getting Stronger Every Day* (2001) also takes childhood and the family as its theme, focusing on the fear of exclusion from the familial unit. It is based on two movies that July saw as a child, both about boys who were taken from their families and then returned to them years later; neither was able to reintegrate successfully.

'I re-eanact things you've seen a million times before', says July. 'Straight things, TV things and medical things: these are the transactions that we all participate in and memorize accidentally. Then I wiggle my hand and wink and you know that everything I just said was in code, and the real truth is the sick or incredible way you feel.'

Hamza Walker

The Swan Tool, 2001
performance with video, 2 projection screens, helium, plastic bag, catwalk, live music by Zac Love
Performance at Virginia Museum of Fine Arts, 2001

Nest of Tens, 2000
video, 27 min., colour, sound

Miami Beach High School 2, 2002
digital photograph, document of performance, 54 x 72 cm
from a collaborative residency with students at Miami Beach Senior High, Miami, Florida

Getting Stronger Every Day, 2001
video, 6 min., colour, sound

Gymnast, 2002
found photograph with dot stickers, 53 x 33 cm

Draft, 2002
found photograph with dot stickers, 33 x 46 cm

Born Salsk, Russia, 1962 Lives and works in Moscow, Russia and Berlin, Germany

Selected Solo Exhibitions: 1991 'Night in Venice', Guelman Gallery, Moscow 1992 'Big Order', Galerie La Base, Paris 1994 'Promising Architecture', Architectural Gallery, Moscow 1995 'Fonte Latino', Walter Bischoff Gallery, Stuttgart 1996 Galerie Michael Schultz, Berlin 1997 'Permanent Residence', Russian Cultural Centre, Geneva; San Jose University, California 1998 'Hermitage for Housing office No. 5', Moscow; 'Temple of Art', Guelman Gallery, Moscow 2000 'Cabinett', Picture Gallery, Tver, Russia; 'From South through North to East', Museum of Fine Arts, Ivanovo, Russia 2001 'Choice of Scale', Shusev Museum for Architecture, Moscow

Selected Group Exhibitions: 1989 'Rose and Blue Drawing Room', public convenience, Rostov-on-Don, Russia 1994 'Exchange/Datcha', Almere Flevopolder, Amsterdam 1995 'New Russian Art: Paintings from the Christian Keesee Collection', City Art Center, Oklahoma City 1996 'Zeitgenössische Kunst aus Russland', Daimler-Benz Aerospace, Munich 1997 3rd Cetinje Biennale, Montenegro 1999 'Under Roof', Town Exhibition Hall, Moscow 2000 'Bonnes Baisers de Russie', Festival Garonne, Toulouse; 'Freezing Pole, Russian Art of the 90s', Ecole des Beaux-arts, Paris 2001 'Moscow Contemporary Art', Castle Grafenegg, Vienna; 'Moscow Paradise 2001', Galerie Krinzinger, Salzburg 2002 4th Cetinje Biennale, Montenegro; XXV São Paulo Biennale; 'Davaj! From the Free Laboratory of Russian Art', Postfuhramt, Berlin; Museum of Applied Arts, Vienna; '[un]painted', Sammlung Essl, Vienna

Selected Bibliography: 1992 Leonid Bazhanov/Achille Bonito Oliva, *A Mosca…a Mosca*, Olograf Edizioni, Verona 1995 Andrei Kovalev, *Between the Utopias: New Russian Art during and after Perestroika (1985–1993)*, Craftsmen House, London 1996 Jekaterina Degot, *Zhazhdushchie monumenty*, Galerie Guelman, Moscow 1997 Andrej Erofeev, *Koshlyakov. Une vision russe comme thème d'une installation*, Galerie Russe de Centre, Geneva 1999 *S Juga. K Severu. Na Vostok. V. Koshlyakov*, Museum Ivanovo; Valery Koshlyakov, *Sketch Book*, Maya Polsky Gallery, Chicago 2000 *Iskusstvo Protiv Geografii*, Russian Museum, St. Petersburg 2002 Peter Noever (ed.), *Davaj! Russian Art Now*, Hatje Cantz, Ostfildern; Elena Selina, *Contemporary Russian Painting 1992–2002*, New Manege, Moscow; Stefan Skowron, *IX. Rohkunstbau*, Druckerei Heenemann, Berlin; XXV São Paulo Biennale; *[un] gemalt*, Edition Sammlung Essl, Klosterneuburg

VALERY KOSHLYAKOV

Valery Koshlyakov has limited his imagery to the traditions of art and culture. His subjects are almost exclusively important works from the history of art, and he employs traditional academic skills. One might therefore be tempted to connect his work with those tendencies in Russian art, such as Sots Art or the New Academy movement, that similarly refer (often ironically) to the academic tradition. But Koshlyakov is not interested in the ways in which ideologies enlist cultural traditions and artistic skills, nor is he aiming at the re-establishment of high art on the basis of academic ideals, whether ironically or otherwise.

Irony and even humour are present in Koshlyakov's work, but other issues seem to be more important; for example the tension between a strong material presence and a highly suggestive illusionist depth. His techniques – broad brushstrokes, dripped paint and so on – accentuate the surface of his works. The materials he employs, such as large pieces of cardboard or layers of adhesive tape, sharply contrast with the depicted imagery. His large cardboard structures remind one of the makeshift shelters built by the poor and homeless, but they nevertheless offer visions of fascinating cityscapes. Koshlyakov's strategy seems to be to emphasize the discrepancy between the material and the illusional in order to maximize their effects. The opposition of imagery and materials has become even more obvious as he has expanded his activities into urban surroundings, turning the firewalls of suburban houses into visions of museum halls or sublime landscapes.

The critic Barbara Wittwer has compared Koshlyakov's approach to Leonardo da Vinci's idea that the painter should systematically observe spots on walls, smoke, clouds, in order to discover in them persuasive landscapes and scenes. One could say that the power that transforms such shapes into illusory depth is the observer's desire.

Koshlyakov is primarily interested in space. Architecture, landscapes and monumental sculpture prevail among his subjects. The spatial structure of his works, however, is not homogeneous. He uses linear perspective and other traditional means of spatial illusion, but also different approaches, including the methods of the avant-garde (collage and Constructivist and Suprematist ideas) and spatial systems employed in traditional icon painting. For Koshlyakov, icons are not a folkloric curiosity but an important example of spatial organization. It is no coincidence that the Formalist and Structuralist theoreticians (as well as the Russian avant-garde artists) were highly interested in icons as specific semiotic systems. In the context of Koshlyakov's painting, these references turn our attention to the fact that space is always conceptually constructed.

Koshlyakov's imagery, however, also indicates that it is power that decisively structures space. The monumental forms he depicts do not represent any particular ideology, but power in general. The fascination of his pictorial space is ultimately the fascination of power. Igor Zabel

Ikons of Constructivism, 2002
cardboard, Scotch tape, h. approx. 4.5 m
Installation 'Cicades', XXV São Paulo Biennale, 2002

Coliseum, 1995
tempera, cardboard, 320 x 250 cm

Hermitage for Housing Office No. 5, 1998
paintings on brick walls in Moscow courtyard, dimensions variable

170
Gioconda, 2000
Scotch tape on plastic foil, 300 x 200 cm
Installation 'S Yuga. K Severu. Na Vostok. From South through North to East',
Art Museum Ivanovo, Russia, 2000

as installed left to right **Horse Head**, 2000, tempera on cardboard, 200 x 300 cm
Gattamelata, Scotch tape on wall, 300 x 350 cm
Installation 'S Yuga. K Severu. Na Vostok. From South through North to East',
Art Museum Ivanovo, Russia, 2000

from **Ideal Landscapes**, 1996
collage, painting on print, 50 x 70 cm

from **Ideal Landscapes**, 1996
collage, 33 x 50 cm

Born Warsaw, Poland, 1963 Lives and works in Warsaw

Selected Solo Exhibitions: 1996 'Olympia', Centre for Contemporary Art, Ujazdowski Castle, Warsaw 1997 'Bathhouse', Zacheta Gallery, Warsaw 1999 48th Venice Biennale 2001 Musej suvremene umjetnosti, Zagreb 2002 'Lords of the Dance', Espacio Uno at Museo Nacional Centro de Arte Reina Sofia, Madrid; Postmasters Gallery, New York; 'The Rite of Spring', The Renaissance Society, Chicago/Zacheta Gallery, Warsaw

Selected Group Exhibitions: 1997 'Art From Poland', Mucsarnok, Budapest 1999 'After the Wall', Moderna Museet, Stockholm; 'Fireworks', De Appel, Amsterdam; 'Zweitwenden', Kunstmuseum Bonn 2000 'Arteast 2000+', Moderna galerija, Ljubljana; 'L'autre moitie de l'Europe', Jeu de Paume, Paris 2001 1st Valencia Biennale; 'Sammlung', Museum Moderner Kunst Stiftung Ludwig Wien, Vienna 2002 XXV São Paulo Biennale; 'Media_City Seoul 2002', Seoul Museum of Art; 'Private Affairs', Kunsthaus Dresden

Selected Bibliography: 1999 'Katarzyna Kozyra im Gespräch mit Artur Zmijewski', *Zeitwenden, Ausblick*, Kunstmuseum Bonn 2000 Margaret Hawkins, 'Bathed in beauty, video and ordinary fascinates', *Chicago Sun-Times*, 21 April; Jan Kalia, 'Katarzyna Kozyra interviewed by Jan Kalia', *Katarzyna Kozyra*, Taldehall, Helsinki 2001 Mauela Ammer, *Katarzyna Kozyra: The Rite of Spring I*, The Collection Museum Moderner Kunst Stiftung Ludwig Wien, Vienna; 'Bathhouse Babe', *The Economist*, 9 February; John Brunetti, 'Subtleties of Dissidence and the Politics of Formalism: 50 Years of Art from Poland', *New Art Examiner*, July–August; Rainer Fuchs, 'With Roles Switched: Notes on Rites of Spring', *Katarzyna Kozyra*, Art Pavilion, Zagreb 2002 Frantiska and Tim Gilman-Sevcik, 'Katarzyna Kozyra', *Flash Art*, July–August; Laura Hoptman/Tomas Pospiszyl (eds.), 'A Case Study: the Life and Death of a Horse', *Primary Documents: A Sourcebook for Eastern and Central European Art since the 1950s*, The Museum of Modern Art/MIT Press, New York; Michael Rush, 'A Renegade's Art of the Altogether', *The New York Times*, 21 April

KATARZYNA KOZYRA

With her first major piece, *Pyramid of Animals* (1993), Katarzyna Kozyra had already begun her pursuit of the socially forbidden and repressed. This sculpture raises many issues that point indirectly to the source of the discomfort provoked by her art in general. In this work, she accepted responsibility for the death of the animals that were subsequently stuffed and piled on top of each other, raising the issue of socially acceptable ways of killing and exploiting animals. It is normal, for instance, that a horse should be slaughtered by a butcher and its skin used for leather, but it is generally considered unacceptable that it should be killed by an artist (even if it was actually carried out by an expert and was destined for the slaughterhouse anyway) and used in a sculpture.

The scandalous aspect of this work, however, is not only that Kozyra has trespassed into a prohibited area of society. It is also that she has jeopardized the repressive social mechanisms that serve as a defence against reality. The horror disclosed by *Pyramid of Animals* is the way in which animals are killed, stored and processed, as well as the recognition that our society inevitably depends on death and destruction, that our lives are finite and, at the same time, part of an endless food chain.

In her video installations *Bathhouse* (1997) and *Men's Bathhouse* (1999), Kozyra also transgresses established social borders, intruding into the private areas in which one's control over the body relaxes. For *Men's Bathhouse* she was even prepared to seemingly reverse her gender identity in order to experience directly an area reserved for male bodies. The body determines our identity, our very being. At the same time it belongs to the organic world; it is an integral part of a permanent circle of transformation, growth, destruction and, eventually, decomposition. It must therefore be constantly subject to control and discipline, covered and adapted to social norms. Interest in the body is an essential characteristic of Kozyra's art. Often she exposes the uneasy aspects of it, showing ageing, crippled or ill bodies (including her own).

Culture adopts mechanisms for transforming and repressing the unbearable. The particular power of certain works of art is based on their ambiguous nature; they both draw attention to the presence of trauma, and transform it into a phantasmal image. A striking and disquieting aspect of Kozyra's works is the unusual tension between their traumatic content and their formal and conceptual perfection. In the video installation *Rite of Spring* (1999–2002), for example, she replaced the dancers in Stravinsky's ballet with old people, their genitalia reversed from male to female and vice versa, drawing attention to the traumatic core of this work normally hidden under established conventions. While venturing into socially taboo fields in order to allow the viewer a glimpse of unbearable reality, she also transcends this horror with an unusual sense of freedom and a (sometimes absurd) re-affirmation of beauty.

Igor Zabel

Pyramid of Animals, 1993,
taxidermied animals, 260 x 190 x 120 cm; video, 5 min., 35 sec., colour, sound

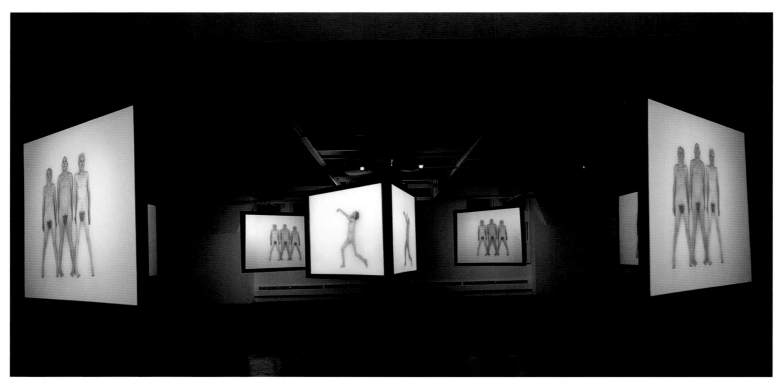

Rite of Spring (*details below*), 1999–2002
video installation, 4 films on 9 screens (in two circles), each 4 min. 33 sec., colour, sound
Installation The Renaissance Society, Chicago, 1999

Men's Bathhouse, 1999
5 videos presented simultaneously
4 on screens arranged in the shape of an octagon, each 8 min. 30 sec., colour, sound
1 on TV monitor, 3 min., 44 sec., colour, sound

Bathhouse, 1997
6 videos presented simultaneously
5 on TV monitors, 1 on big screen
14 min. 15 sec.; 8 min. 14 sec.; 10 min. 10 sec.; 13 min. 4 sec.; 11 min. 59 sec.; 4 min. 15 sec., colour, silent

Lords of the Dance, 2002
7 videos, each 2 min. 30 sec. to 4 min., colour, sound

Born Como, Italy, 1969 Lives and works in Berlin, Germany and Milan, Italy

Selected Solo Exhibitions: 1999 Contemporary Art Center, Vilnius; INOVA, Institute of Visual Arts, Milwaukee 2000 Kettle's Yard, Museum of Contemporary Art, Cambridge; Studio Guenzani, Milan 2001 Gallery Koyanagi, Tokyo; Palazzo Re Rebaudengo, Guarene d'Alba, Italy 2002 Marc Foxx Gallery, Los Angeles 2003 The Menil Collection, Houston

Selected Group Exhibitions: 1997 'L'Evidence', Centre d'Art Contemporain, Geneva 1998 '1968–1998: Fotografia e Arte in Italia', Galleria Civica, Modena, Italy; 'Spectacular Optical', Museum of Contemporary Art, Miami; 'Yesterday Begins Tomorrow', Bard College, Center for Curatorial Studies Museum, New York 1999 48th Venice Biennale 2000 'Contemporary Photography II: Anti Memory', Yokohama Museum of Modern Art 2001 'Chain of Visions', Hara Museum of Contemporary Art, Tokyo; 'Playing Amongst the Ruins', Royal College of Art, London 2002 'Sleeping, Dreaming, Awakening', Kawamura Memorial Museum of Art 2003 'Living Inside the Grid', New Museum of Contemporary Art, New York

Selected Bibliography: 1999 Francesco Bonami, *Luisa Lambri*, INOVA, Institute of Visual Arts, Milwaukee; Massimiliano Gioni, *A Place for Everything and Everything in its Place*, Contemporary Art Center, Vilnius 2000 Ian Blom, 'Luisa Lambri', *frieze*, No. 53; Emanuela de Cecco/Gianni Romano, 'Luisa Lambri', *Contemporanee: Percorsi, lavori e poetiche delle artiste dagli anni Ottanta*, Costa & Nolan, Genoa; Luca Cerizza, *Espresso: Art Now In Italy*, Electa, Milan; Roy Exley, 'Into the Interior', *Portfolio: The Catalogue of Contemporary Photography in Britain*, No. 31 2001 Francesco Bonami, *Luisa Lambri*, Palazzo Re Rabaudengo/Edizioni Scheiwiller, Milan; Roy Exley, 'The Luminous and the Numinous', *Camera Austria*, No. 75; Francesca Pasini, 'Luisa Lambri', *Artforum*, April; Liutauras Psilibskis, 'Luisa Lambri: No Sense of Place', *Flash Art*, No. 221 2002 Shino Kuraishi, 'Luisa Lambri', *BLINK*, Phaidon Press, London

LUISA LAMBRI

Luisa Lambri works obsessively with just one group of motifs. These are concerned with modern architecture, usually with interiors (and even landscape, vaguely seen through veiled windows, is part of the interior). In an interview, she made a list of every building she has photographed. She named more than forty, starting with Giuseppe Terragni's designs for her hometown Como, and including works by Le Corbusier, Mies van der Rohe, Ludwig Wittgenstein, Alvar Aalto and Kazuyo Sejima.

These pictures do not constitute straightforward architectural photography, however. Rather, they indicate an examination of the spirit of modernity, in both its rational and utopian dimensions. With their pure forms and principles of rational construction, these buildings embody the modernist ideals of systematic objectivity. Yet, in the act of being photographed they necessarily enter into a mutual relationship with the observer/photographer, creating a tension between objective construction and personal experience involving memories and emotions. As Lambri says: 'Between my gaze and their design, I hope a seed of variation insinuates itself, from which new possibilities and emotions can be born. It is like imagining an architecture of pure potential.'

This tension can be clearly felt in these minimal pictures. Sometimes they are presented in a series of almost identical images, yet emotionally and experientially they are extremely intense. Lambri's reductive approach, and the fact that she never re-arranges the spaces she enters, emphasizes details (a door or window left ajar) that can provide an immense new value.

In *La chambre claire* (1980), Roland Barthes writes about the particular impact of the photographic medium. The point, or *punctum*, with which a photograph stings the observer is in its detail, an addition to the formal or documentary value of the image (*studium*). The *punctum* cannot be objectively determined, since it is an emotional element, a particular experience of time, of presence and loss. It is exactly this idea of loss that fascinates Lambri: 'No matter which direction you pick, you are bound to lose something, either the frigid beauty of geometry or the personal memory that each place preserves.' What better medium to materialize this idea than photography, which makes absent present and present absent?

In *L'empire des signes* (1970), Barthes published a picture of a corridor in a seventeenth-century Japanese castle, a simple, subtly designed structure. Of this image, he wrote: 'Reverse the image: nothing more, nothing different, nothing.' This 'nothing' describes an emptied presence that condenses and transcends all rich meanings and emotional charges, and which can also be seen in Lambri's pictures. Perhaps the power of her works can best be understood in relation to the writings of the seventeenth-century samurai Miyamoto Musashi, who concluded his *Book of Five Rings* with 'The Scroll of Emptiness'. For him, emptiness is only possible when one has completely mastered the (martial) arts. 'Without any confusion in mind, without slacking off at any time, polishing the mind and attention, sharpening the eye that observes and the eye that sees, one should know real emptiness as the state where there is no obscurity and the clouds of confusion have cleared away'. Igor Zabel

Untitled (M House, h), 2000
Cibachrome print, 110 x 80.5 cm

Untitled (O Museum, e, d and f), 2000
Cibachrome print, 110 x 155 cm

Untitled, 2002
Cibachrome print, 120 x 144 cm

Untitled, 2002
Cibachrome print, 108 x 128 cm

Born Yongwol, South Korea, 1964 Lives and works in Seoul, South Korea

Selected Solo Exhibitions: 1997 'Projects', The Museum of Modern Art, New York 1998 IL Gallery, Seoul 1999 Kunsthalle Bern 2000 Fukuoka Asian Art Museum 2001 'The Divine Shell', BAWAG Foundation, Vienna; 'Live Forever', Fabric Workshop and Museum, Philadelphia/The Power Plant Contemporary Art Gallery, Toronto/New Museum of Contemporary Art, New York; San Francisco Art Institute 2002 Le Consortium, Dijon; Musée d'Art Contemporain, Marseille

Selected Group Exhibitions: 1997 4th Lyon Biennale; 'Cities on the Move', Secession, Vienna 1998 'Hugo Boss Prize 1998', Guggenheim Museum SoHo, New York 1999 48th Venice Biennale; 'Zeitwenden', Kunstmuseum Bonn 2000 'Der anagrammatische Körper', ZKM, Karlsruhe; 'Let's Entertain', Walker Art Center, Minneapolis 2001 '01.01.01: Art in Technological Times'; 7th Istanbul Biennale; San Francisco Museum of Modern Art; 'ARS 01: Third Space', Kiasma Museum of Contemporary Art, Helsinki 2002 'Fusion Cuisine', Deste Foundation, Athens; 'The Uncanny', Vancouver Art Gallery

Selected Bibliography: 1994 James B. Lee, 'Desire Under Siege', *World Art*, Vol. 3 1997 Hans-Ulrich Obrist, 'Stinkende vis,' *Metropolis M*, October 1999 Alex Farquharson, 'Lee Bul at Artsonje Center', *frieze*, March–April 2000 Robert Fouser, 'Lee Bul', *Art AsiaPacific*, No. 28; Yvonne Volkart, 'This Monstrosity, This Proliferation … ' *Make*, September–November 2001 Franck Gautherot, 'Supernova in Karaoke Land', *Flash Art*, March–April; Glen Helfand, 'Sing a Song', *Artbyte*, July–August; Karlheinz Schmid, 'Shooting Star: Lee Bul', *Kunstzeitung*, March 2002 Frank Hoffman, 'Lee Bul: Cyborgs and Karaoke', *Art in America*, May; Kim Seungduk, 'Lee Bul: les deux corps de l'artiste', *Art Press*, May; Franklin Sirmans, 'Lee Bul: 'Live Forever'', *Time Out New York*, 6–13 June

LEE BUL

Through her work, the Korean artist Lee Bul searches for an identity within a traditional, male-dominated society in which independent women are seen as rebellious, even monstrous. Responding to this perception, in her earliest performances she transformed herself into a threatening figure, dressing up in a bizarre body suit as a mollusc. Later, she began projecting images of herself as a strange hybrid of Eastern and Western cultures onto a large balloon.

'There have always been monsters and cyborgs throughout history', Lee has said. She sees the cyborg as an evolved version of the Greek hero, who was himself a hybrid of man and god. In her 'Cyborg' series, begun in 1997, Lee decided to eliminate her own body from the work, representing it instead in the form of a shell resembling a suit of space-age armour or sci-fi robot. These doll-like cyborgs portray the body as a mere container for the bundle of neurons and cables within. This is made manifest in *Plexus Blue* (2000), with its explosion of brightly coloured neurons. Hybrids of machine and organic life forms, these creatures hover between reality and fiction. Each is missing a section of its head or a limb, evoking the anonymity and abstract nature of identity as well as a tangible sense of loss and sadness.

Lee went on to create darkly grotesque sculptures of monsters, or failed hybrids, which were followed by the 'cymonster',

a hybrid of the cyborgs and the monsters. To her, the cymonster represents another evolutionary step into the future. With its wild, curving tentacles, *Amaryllis* (1999) is almost baroque; its energy, combined with its neutral white colour, achieves a subtle balance between gravity and velocity. *Apparition*, first exhibited in Lee's installation at the 7th Istanbul Biennale in 2001, is a dramatic work influenced by Gustave Moreau's painting of the same title, and depicts the moment when a cyborg, robed in classical dress, morphs into a monster.

In her quest for an identity, Lee draws both on primordial imagery and on subcultural images of women such as the beautiful nymph with supernatural powers in Hong Kong B movies, or the heroines of science-fiction Japanimation. She is also interested in the archetypes of popular culture that lie in the depths of our collective unconscious. In her installation *Gravity Greater than Velocity + Amateurs* for the Korean pavilion at the 1999 Venice Biennale, she explored this notion by creating a sculptural karaoke booth that could be entered by visitors who could then select music to sing along to. This developed into *Live Forever I, II and III* (2001), in which the box became three pods, resembling streamlined cars.

Yuko Hasegawa

Amaryllis, 1999
hand-cut polyurethane panels on aluminium armature, enamel coating, 210 x 120 x 180 cm

Live Forever, 2001
fibreglass pods with acoustic foam, leather upholstery, electronic equipment, video projections
each pod 254 x 152.5 x 96.5 cm
Installation Fabric Workshop and Museum, Philadelphia, 2001

Cyborg W4, 1998
cast silicone with paint pigment, polyurethane filling, 188 x 60 x 50 cm
Installation 'dAPERTTutto', 48th Venice Biennale, 1999

Plexus Blue, 2000
leather, velvet, sequins, beads in a glass and steel vitrine, 170 x 80 x 60 cm
Collection Walker Art Center, Minneapolis

Cyborg Blue, 1997–8
cast silicone mixed with paint pigment, steel pipe support and wooden base, 160 x 70 x 110 cm

Hydra II (Monument), 1999
photoprint on vinyl, air pumps, 12 x 7 x 6 m
Installation 'Hot Air', Granship Centre, Shizuoka, 1999

183

Ada Tolla born Potenza, Italy, 1963, Giuseppe Lignano born Naples, Italy, 1964
Live and work in New York, USA

Selected Solo Exhibitions: 1998 'TV-TANK: Television Lounging Tube', Deitch Projects/Henry Urbach Architecture, New York 2000 'Mixer', Henry Urbach Architecture, New York

Selected Group Exhibitions: 1993 'Transient Décor', Horodner-Romely Gallery, New York 1994 'Hello Again! Recycling for the Real World', Museum at F.I.T., New York 1996 'The Perfect Chair for Barbie in the 90s', I.C.F.F., New York/Vitra Design Museum, Germany 1997 'New York, New York: Materials for '96 Projects', Material Connexion, New York 1998 'TV-LITE: Modular Television Lighting System', Henry Urbach Architecture, New York 1999 'I'm the Boss of Myself', Sara Meltzer Gallery, New York 2000 Design Triennale, National Design Museum, New York; 'Experiments in Architecture', The Museum of Modern Art, San Francisco 2001 'BitStreams', Whitney Museum of American Art, New York; 'LITE-SCAPES', Henry Urbach Architecture, New York; 'Workspheres', The Museum of Modern Art, New York 2002 'Architecture in Motion', Vitra Museum, Weil-am-Rhein and Berlin; 'New Worldtrade Center', Venice Biennale of Architecture; 'Synthetic', Galerie Zurcher, Paris

Selected Bibliography: 1998 Anthony Iannaci, 'Think Tank', *Interior Design*, December; Roberta Smith, 'TV-TANK', *The New York Times*, 20 November 1999 Tim Culvahouse, 'LOT-EK, TV-TANK', *Art Papers*, July–August; Pierantonio Giacoppo, 'LOT-EK – Una nuova dimensione abitativa', *Domus*, May 2000 Joseph Giovannini, 'The New Primitive Hut', *Architecture*, January; Christopher Hawthorne, 'The Lod/own on LOT-EK', *Metropolis M*, August–September; LOT-EK and Mark Robbins, *Mixer*, Edizioni Press, New York; Lucie Young, 'Think Tank', *The New York Times Magazine*, 8 October 2001 Doug Harvey, 'About Time', *LA Weekly*, 16 February; 'LOT-EK: Morton Loff', *A+U*, August; John Seabrook, 'A Pod of One's Own', *The New Yorker*, 12 February 2002 Linda Hales, 'A Policy of Containment', *International Herald Tribune*, 27 August; *LOT-EK Urban Scan*, Princeton Architectural Press, New York; Barbara MacAdam, 'Digging the Dirt', *ARTnews*, January; *MOBILE: The Art of Portable Architecture*, Princeton Architectural Press, New York

The recent interdisciplinary trend in contemporary art has seen artists researching and seeking crossovers not only with visual art's neighbouring fields – film, design, fashion, literature, architecture and theatre – but also with other, wider disciplines such as anthropology and science. It is as if, frustrated by fine art's detachment from the real world, artists have begun to open up their practices, allowing their art to be contaminated with everyday life, as well as with more mundane disciplines. Practitioners from other fields have taken the opposite route, reaching out from their own disciplines and infiltrating their work into the art circuit, or appropriating the modes and strategies of its economic structure. This is the case with the architectural firm LOT-EK, formed by the New York-based Italians Ada Tolla and Giuseppe Lignano. They have worked with what is perhaps the closest physical relative to art objects – exhibition design and art-space architecture – as well as creating actual art objects and gallery-based projects. The New York gallery that represents them as 'artists' has itself a dubious, marginal denomination: Henry Urbach Architecture.

LOT-EK's principal strategy is to excavate, appropriate, recycle and transform industrial materials (from hollow oil-truck tanks, cement mixers and shipping containers to bare TV tubes) into art objects, furniture or composite architectural elements. In stark contrast to contemporary digital architecture, LOT-EK is interested in 'the most banal objects, the stuff around us that you see everyday', as Ligano puts it. Thus their work demonstrates both striking post-industrial features, as well as low-tech (as their very name suggests) and relatively inexpensive ones.

The critic Tod Allen has likened LOT-EK's strategies to the concept of bricolage, and to 'the amateur tinkerer, the jack of all trades, the inspired oddjobsman'. In this context, it is interesting to note that LOT-EK has been commissioned to design exhibitions and art spaces devoted to highly sophisticated ideas involving new media (video, sound and computer art). These include New Media gallery at The New Museum, New York (2000), 'Making Time: Considering Time as a Material in Contemporary Video & Film' at the Institute of Contemporary Art Palm Beach (2000), the sound-art section of 'Bitstreams' at the Whitney Museum of American Art, New York (2001) and the video lounge of Art Basel Miami Beach (2002). The contrast between high-tech media and low-tech means offers a strong architectural statement that goes far beyond the modernist white cube. LOT-EK's most ambitious project opened in New York in the fall of 2002: the exhibition space of the Bohen Foundation. It is formed from sixteen shipping containers with moveable parts that slide along tracks, allowing for maximum flexibility. With this ingenious system, artists can completely customize their own gallery spaces.

Adriano Pedrosa

Plans for the Bohen Foundation exhibition space, 2002–3

MIXER 01–32, 2000
transparencies with cast rubber, each 18 x 18 cm
Installation 'MIXER', Henry Urbach Architecture, New York, 2000

Litescapes 0–6, 2001
poured rubber with neon tubing, each approx. 63.5 x 33 x 5 cm
Installation 'Third Anniversary Show', Henry Urbach Architecture, New York, 2001

MIXER (*detail, right*), 2000
steel concrete mixer drum with 12 video monitors, 3 satellite TV receivers, 1 Sony Playstation 2, 2 surveillance cameras, 2.2 x 2.2 x 3.2 m
Installation 'MIXER', Henry Urbach Architecture, New York, 2000

TV-TANK, 1998
petroleum trailer tank with televisions, rubber tubing, foam, 2.4 x 13 x 2 m
Installation 'TV-TANK', Deitch Projects/Henry Urbach Architecture, New York, 1998

Born Mexico City, Mexico, 1967 Lives and works in Madrid, Spain and Montreal, Canada

Selected Solo Exhibitions: 1999 'Vectorial Elevation', Zócalo Square, Mexico City 2001 'Airport Cluster', Galerie Kaethe Kollwitz, Berlin; 'Grounding', V2_Organisatie, Rotterdam 2002 'Vectorial Elevation', Basque Museum of Contemporary Art, Vitoria

Selected Group Exhibitions: 1995 ARCO International Art Fair, Fundación Telefónica, Madrid; 'European Media Art Festival', Kunsthalle Dominikanerkirche, Osanbrück 1997 Architecture and Media Biennale, Landeszeughaus, Graz; 'Arte Virtual Realidad Plural', Museo de Monterrey, Mexico; 'Fleshfactor', Ars Electronica Festival, Linz 1999 'Yo y mi Circunstancia', Musée des Beaux Arts, Montreal 2000 7th Havana Biennale 2001 7th Istanbul Biennale 2002 'Emoçao Art.ficial', Itau Cultural, São Paulo; 'Fragilities', Festival Printemps de Septembre, Toulouse; Liverpool Biennale; 'Unplugged', Ars Electronica Festival, Linz

Selected Bibliography: 1997 Pier Luigi Capucci, 'Presenze remote e relazioni insiuate', *Domus*, May; 1999 Mathew Mirapaul, 'Online Art Lights up a Square in Mexico City', *The New York Times*, 30 December 2000 Arturo Cruz Bárcenas, 'El Zócalo se convirtió en una escultura de luz interactiva', *La Jornada*, 7 January; Roberta Bosco, 'Lozano-Hemmer indaga con las palbras en la Bienal de la Habana', *El Pais*, 7 December; Rafael Lozano-Hemmer (ed.), *Vectorial Elevation*, Conaculta Press, Mexico City; José Jiménez, 'Un sitio si lugar', *El Mundo*, 28 October; Geert Lovink, 'Interview with Rafael Lozano-Hemmer', *Archis*, No. 9; Yukiko Shikata, 'Relational Architecture', *Bijutsu Techo*, November 2001 Merel Bern, 'Daar duiken schaduwen op vanuit het niets', *De Volkskrant*, 1 September 2002 Alex Adriaansens/Joke Brouwer, 'Alien Relationships from Public Space', *Transurbanism*, V2/NAI Publishers, Rotterdam; Randy Gladman, 'Rafael Lozano-Hemmer: An Interview', *Canadian Art*, Winter; Carlos Jiménez, 'Historias virtuales, intercambios y revelaciones', *Revista Lápiz*, No. 182; Gregory Volk, 'Back from the Bosphorous', *Art in America*, March

RAFAEL LOZANO-HEMMER

Rafael Lozano-Hemmer uses various media as catalysts to transform viewers into active participants. His projects play out both through inter-relating networks formed in cyberspace and through interactive communication environments created in real spaces. In the 'Relational Architecture' (RA) series, he projects text and images onto historical buildings and other structures, drawing observers into an interaction with the latent memories of the location.

In installations like *Two Origins, Relational Architecture 7* (2002) Lozano-Hemmer projects texts that are specifically related to the actual history of the site. However, this is not always the case. *Body Movies*, *Relational Architecture 6* (2002) projected onto buildings portraits of thousands of people photographed on various city streets. The people walking in front of the building become the creators of the work when their shadows block the floodlights illuminating them and allow the projections to be seen. Depending on the distance of the participants from the light sources, the sizes of the shadows and the images they reveal can be anything between 2 and 25 metres, and can appear in a myriad of different shapes.

Vectorial Elevation, Relational Architecture 4 (1999–2000) makes a connection between the information environment of the Internet and real urban spaces in a provocative work that opens up the potential for the actions of individuals to become public art. *RA4* was a millennium celebration project for Zócalo Square in Mexico City, a space surrounded by monumental buildings, and a symbol of Mexico's discontinuous historical memories. Lozano-Hemmer installed searchlights on the tops of the buildings so that their criss-crossing beams would form an ephemeral structure made from the mid-air intersection of light. People around the world could access the project's website and move the beams to change the design of the structure. Conceived in the tradition of *son et lumière* spectacles, the project linked the people gathering in the square and those on the Internet into one global and virtual information space, and became a pointer to the potential for new creation by a collective intellect working through cyberspace.

33 Questions per Minute, Relational Architecture 5 (2001) asked philosophical questions about authorship and the relationship between machines and people. Lozano-Hemmer used software programmed to create a generator capable of using grammatical rules to combine words from the dictionary, creating fifty-five billion different questions. These were presented on tiny LED screens at a rate of thirty-three per minute, mingled with other questions entered by participants so that observers were unable to distinguish between them. The screens were sited in the Hagia Eirene Church in Istanbul, a structure dating back to the time of Emperor Justinian. The solidity of historical time and the context of the Orient bathed the project in a special philosophical significance, giving it the atmosphere of an interactive Zen dialogue. Not knowing whether the questions were machine- or manmade brought in the issue of individuality. In querying the collective memory buried in the history of place, as well as the potential of collective intelligence, Lozano-Hemmer's work represents a new type of media catalyst.

Yuko Hasegawa

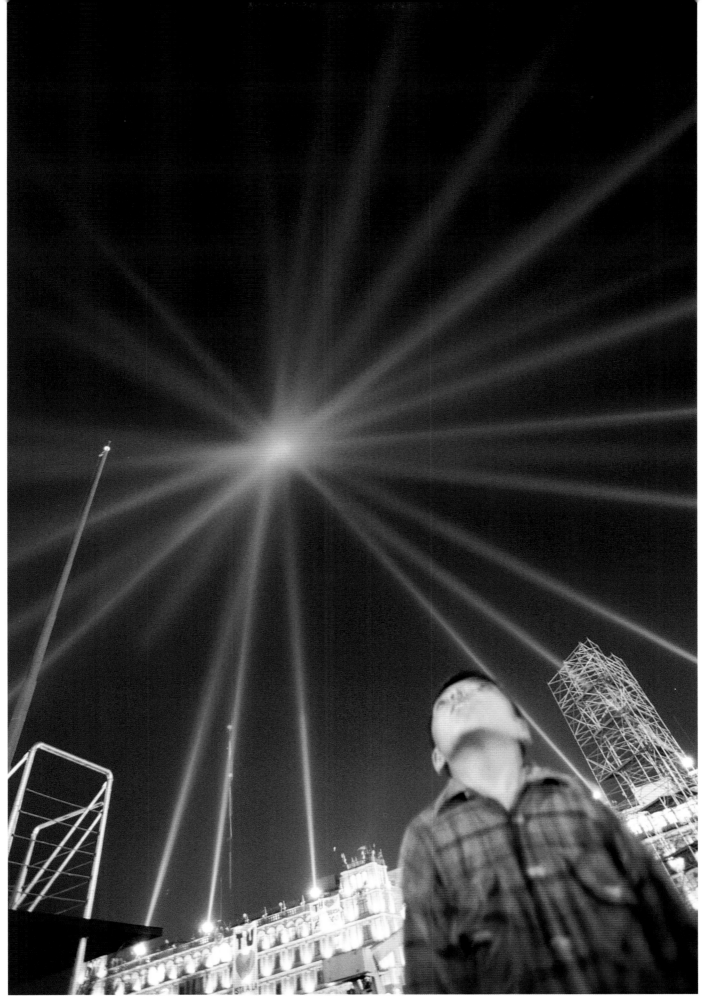

Vectorial Elevation, Relational Architecture 4, 1999–2000
18 robotic 7kW searchlights, 3 webcams, DMX-TCP/IP converter, Java interface, GPS tracker, web server, light sculptures up to 15 km high
Installation millennium celebrations, Zócalo Square, Mexico City, 2000

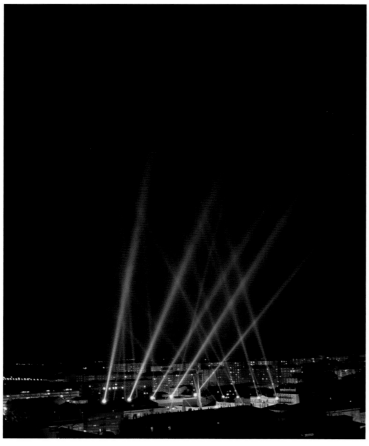

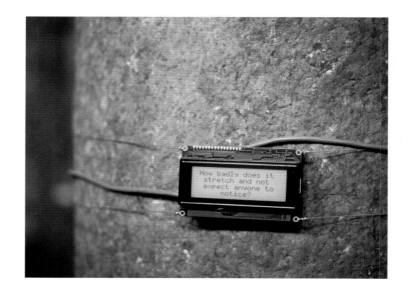

Vectorial Elevation, Relational Architecture 4, 2002
18 robotic 7kW searchlights, 4 webcams, DMX-TCP/IP converter, Java interface, GPS tracker, web server, light sculptures up to 15 km high
Installation 'Artium Opening', Basque Museum of Contemporary Art, Vitoria, 2002

Re:Positioning Fear, Relational Architecture 3 (with Will Bauer), 1997
2 robotic 7kW xenon film projectors, 2 Barco projectors, webcam, custom IRC Java client, 3-D ultrasonic tracking system, PA system, control computers, 900 m² of projections from an online symposium on the concept of fear
Installation Architecture and Media Biennale, Graz, 1997

33 Questions per Minute, Relational Architecture 5, 2001
21 liquid-crystal displays, laptop computer, piezo electric tweeters, video projector, each LCD screen 6 x 10 x 3 cm
Installation 7th Istanbul Biennale, Hagia Eirene, Turkey, 2001

RAFAEL LOZANO-HEM

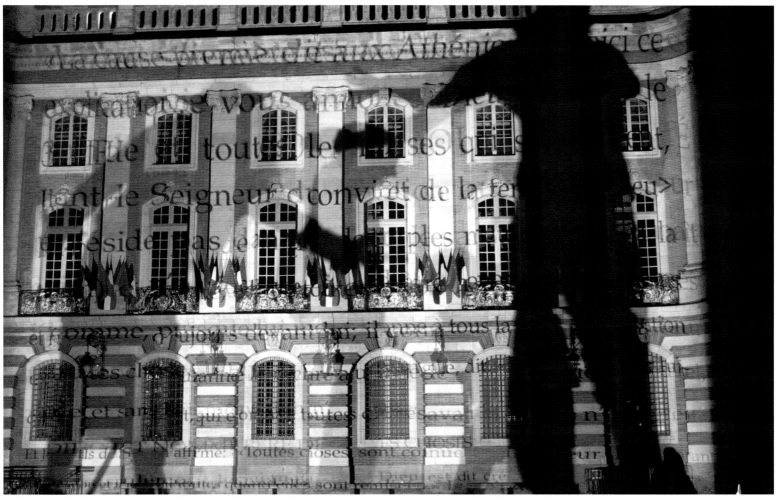

Two origins, Relational Architecture 7, 2002
4 robotic 7 kW xenon film projectors, computer controller, mirrors, 1,000 m² interactive projection of
the *Book of Two Origins*, a heretic thirteenth-century manuscript; with the assistance of Jennifer Laughlin
Installation 'Fragilities', Festival Printemps de Septembre, Place du Capitole, Toulouse, 2002

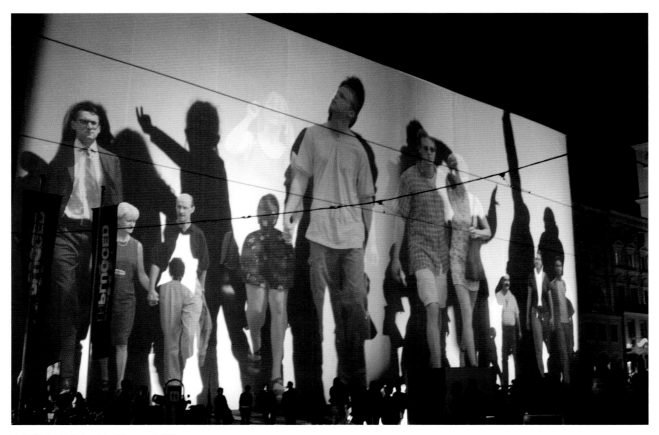

Body Movies, Relational Architecture 6, 2002
4 robotic 7kW xenon film projectors, custom-made shadow tracking system, 1,200 portraits
on duratrans film, PA system, control computers, mirrors, 1,000 m² interactive projection
Installation 'Unplugged', Ars Electronica Festival, Linz, 2002

Born Manchester, UK, 1961 Lives and works in Edinburgh, UK

Selected Solo Exhibitions: 1998 Collective Gallery, Edinburgh; 'Plans and Elevations', Laurent Delaye Gallery, London 1999 'Food, Shelter, Clothing, Fuel', Attitudes, Geneva 2000 'People take turns to do difficult jobs', Laurent Delaye Gallery, London 2002 'Snake', Laurent Delaye Gallery, London

Selected Group Exhibitions: 1998 'Surfacing: Contemporary Drawing', Institute of Contemporary Arts, London 1999 'Sampling', Ronald Feldman Fine Arts, New York; 1st Melbourne Biennale 2000 British Art Show 5, touring throughout Britain; 'Protest and Survive', Whitechapel Art Gallery, London 2001 'Here + Now: Scottish Art 1990–2001', Dundee Contemporary Arts/Generator Projects/ McManus Galleries, Edinburgh/Aberdeen Art Gallery/Peacock Visual Arts, Aberdeen; 'The Other Brittania', Tecla Sala, Barcelona 2002 'The Galleries Show', Royal Academy of Arts, London; 'Landscape', ACC Galerie, Weimar; 'Utopia Now! (and Then)', Oliver Art Center, Oakland Campus/CCAC Institute, San Francisco/The Sonoma County Museum, Santa Rosa

Selected Bibliography: 1997 Kate Bernard, 'Choice Afternoon in the Park', *Evening Standard*, 5 June 1998 John Slyce, 'Chad McCail', *Flash Art*, Summer 1999 David Burrows, 'Locale', *Art Monthly*, June 2000 Barry Schwabsky, 'Drawing on the New Town: Chad McCail and Paul Noble', *Art on Paper*, July–August; Ben Seymour, 'Chad McCail', *frieze*, No. 94 2001 'Art and other colours: six young British artists at the Tecla Sala', *Barcelona Metropoli*, May; *Here + Now: Scottish Art 1990–2001*, Dundee Contemporary Arts 2002 Jeremy Ackerman/Chad McCail, *Active Genital*, Bookworks, London; Morgan Falconer, 'Viper Trail', *What's On in London*, 29 May–5 June; Phillip Hensher, 'Don't reject the dealers' best offer …', *The Mail on Sunday*, 15 September; Pernilla Holmes, 'The Royal Treatment', *Art and Auction: Talk of the Trade*, October

CHAD McCAIL

'Courage is stronger than fear', 'No-one really dies', 'Love is rooted in sharing and trust' … British artist Chad McCail's illustrative, graphic drawings propose what seems an impossibly idealistic model for living together and understanding each other. In the same way that children often ask the most important questions, McCail's drawings display a youthful naivety whilst raising significant issues and proposing interesting solutions. By building up series of drawings following a similar format and style, and repeating symbols, characters and icons from one to another, McCail evolves a personal doctrine. In his kind, generous world, philosophy, religion and politics unite to form a new path of potentiality informed by good sense and poetic vision. The aesthetic choices of the drawings, using the colour, clarity, repetitive structure and spare text of children's books and cartoons, is a way of tapping into a vernacular, straightforward method of storytelling. McCail wants to be clear about his intentions, however complex or sophisticated the script he seeks to construct.

In the series of twelve drawings 'Food, Shelter, Clothing, Fuel' (1999), McCail proposes an alternative future. Subtitling each of the images with slogans including: 'Money is destroyed', 'Land is shared', 'Mercy is shown', 'People have relaxing orgasms', he depicts a new proto-socialist Utopia in which everyone's needs are fulfilled, calm is restored and excess and waste are unknown. Sheer optimism, however forlorn, jumps out of these works and acts as an effective antidote to the resigned cynicism that so often commanded attention in the British art world of the 1990s.

McCail's most recent project is the book *Active Genital* (2002) a semi-autobiographical work that segues into a creation/ destruction myth. Beginning with simple line drawings of significant events in the artist's life between the ages of four and twelve, it includes a list of writings that have influenced his thinking. The second part of the book charts the understanding McCail found when he became aware of, and submitted to, his unconscious. Peopled by McCail's familiar cast of generic characters, the book follows the path of a child learning about responsibility, the pleasures of life and the inevitability of death, through experience and experimentation.

Earlier works such as *Ariel* (1996) and *Spring* (1997) were detailed pencil drawings of dystopian city suburbs viewed from the air. Packed with minute detail, on close inspection the cities are shown to be broken and racked by discord, violence and physical breakdown. The development in McCail's work from these renderings of apocalyptic dystopias to his more narrative explorations of complex social manifestos shows him to be something of an idealistic zealot. He seems genuinely to believe in the possibility that the world could behave in the ways he proposes, and he leaves you asking 'Why not?' His questioning of some basic assumptions is done with an intelligence and directness that subverts its own naivety, providing us with an oddly convincing map for a life less ordinary.

Charles Esche

The healthy child has a vital, active genital – the source of life to come. It has two parents. Beneath the portrait of the patriarch, the children explore one another and experience the adult's disapproval. The children receive a profound shock. The source of pleasure is denied and a fundamental and debilitating conflict is established.

Alien Genital I/VI, 1999
gouache on paper, 23 x 25 cm

Spring (*detail*), 1998
pencil on paper, 242 x 242 cm

Spring, 1998
pencil on paper, 242 x 242 cm

Spring (*detail*), 1998
pencil on paper, 242 x 242 cm

'Armour dissolves', from **Food, Shelter, Clothing, Fuel**, 1999
gouache on paper, 30.5 x 61 cm

'Wounds are healed', from **Food, Shelter, Clothing, Fuel**, 1999
gouache on paper, 30.5 x 61 cm

'School is not compulsory', from **Food, Shelter, Clothing, Fuel**, 1999
gouache on paper, 30.5 x 61 cm

'Money is destroyed', from **Food, Shelter, Clothing, Fuel'**, 1999
gouache on paper, 30.5 x 61 cm

'Zombies want their children to become robots', from **Snake**, 2001–2
digital print on Fuji Archival Paper, 188 x 127 cm

'No-one really dies', from **Snake**, 2001-2
digital print on Fuji Archival Paper, 188 x 127 cm

'Loneliness drives people mad', from **Snake**, 2001–2
digital print on Fuji Archival Paper, 188 x 127 cm

'Robots run Zombies for wealthy parasites', from **Snake**, 2001–2 digital
print on Fuji Archival Paper, 188 x 127 cm

'Friends lose touch', from **Snake**, 2001-2
digital print on Fuji Archival Paper, 188 x 127 cm

'Everything is alive', from **Snake**, 2001–2
digital print on Fuji Archival Paper, 188 x 127 cm

Born LaCrosse, USA, 1969 Lives and works New York, USA

Selected Solo Exhibitions: 2002 Stephen Friedman Gallery, London 2003 Maccarone, Inc., New York

Selected Group Exhibitions: 1998 '444', Apex Art, New York; 'Lovecraft', South London Gallery; 'The Unconditional State of Search', Transmission Gallery, Glasgow 1999 'Arrangements for Another Oshi-ita', Patrick Callery, New York 2000 'Above and Beyond: Extra Super Meta', Yerba Buena Center for the Arts, San Francisco 2001 'Detourism', The Renaissance Society, Chicago; 'Presentness is Grace', Arnolfini, Bristol; 'Selections 2001', The Drawing Center, New York 2002 'Periphera', Murray Guy Gallery, New York; 'Urgency', Objectif, Antwerp 2003 'Brandon Lattu, Scott Lyall, Corey McCorkle,' Mary Goldman Gallery, Los Angeles

Selected Bibliography: 1996 Laurie Palmer, 'MWMWM', *frieze*, Summer 1997 Richard Pandicio, 'Ones to Watch', *Interview*, February 1998 Mungo Thompson, *Elevator*, Stephany Martz Gallery, New York 2000 Anna Gaskell, 'Top 10', *Artforum*, Summer 2001 John Ewing, 'New New York', *New Art Examiner*, February; Martin Herbert, 'The Big Slowdown', *Presentness is Grace*, Arnolfini, Bristol; Catsou Roberts, 'The Absolute Presence of Things', *Presentness is Grace*, Arnolfini, Bristol; Hamza Walker, 'Detourism: Expect the World', The Renaissance Society, Chicago 2002 Izi Glover, 'Presentness is Grace', *frieze*, No. 67; Sally O'Reilly, 'Review: Stephen Friedman', *Time Out*, 19–26 June; Emma Safe, 'Presentness is Grace', *Art Monthly*, February

COREY McCORKLE

Interested in notions of transcendence and healing, Corey McCorkle invites long-neglected ideas of the spiritual back into art. This exploration of inner space is paralleled by an examination of how we operate within public space, how mind body and spirit interact, and how modernist design has facilitated this interaction. He has stated: 'In particular, terminal or transitory spaces remain interesting situations … Works exploring problems of structure and stability are linked by the preoccupation with design under pressure … architectural accessories (departure lounges, lighting sytems), specific environmental categories (conference rooms) or entire communities (Utopia on colonial modernism's receding edge).'

The related works *New Life Expo* (1997) and *For Greater Velocity Towards Grace* (1997–2002) combine these preoccupations with the transcendant and the functional, the soul and the body. Sets of chairs made from bent wood and acrylic respectively, they allow the user to assume the lotus position and therefore attain both orthopaedic benefit and spiritual solace. These organic works, verging on abstract sculpture, also demonstrate McCorkle's application of the language of Minimalism to the principles of modernist Scandinavian design. They are based on Alvar Aalto's Paimo Chair and the biomorphic splint developed by Charles and Ray Eames for soldiers injured in World War II.

This Minimalist aesthetic pervades *Eleven Eleven (Graft)* (2001), a material allegory of globalization. It features over two dozen varieties of wood from around the world, which the artist had sliced to veneer thinnness and adhered to 48-inch fluorescent light tubes. Albeit through the introduction of wood, the most sacred of sculptural materials, *Eleven Eleven Graft* continues the art-historical trajectory of the readymade (from Duchamp to Dan Flavin). When the tubes were installed in the vaulted ceiling of the Renaissance Society in Chicago, light was able to pass through the veneer with different degrees of intensity depending on the density and darkness of the wood. The alternating pattern revealed a breadth of grains, and a rich palette of luminous golden browns and chrome yellows reminiscent of a bar shelf lined with a variety of single-malt scotches. Indeed, *Eleven Eleven Graft* functions on the principle of extraction, if not distillation, that is fundamental to culture when it is defined as the adaptation of natural resources towards human ends. Here, culture is literally and figuratively a thin veneer that when applied to a utilitarian object results in the production of meaning and beauty. But despite McCorkle's economy of means and the work's sublime, formalist restraint, the work evokes a conspicuous luxury. Deforestation and the bartering of natural resources as a way for non-industrialized nations to pay off debt is a familiar story. The fluorescent lights further this narrative of economic alienation by subjecting the wood to a clinical analysis reminiscent of the bureaucratic and scientific procedures needed to extract wood's chemical and aesthetic wealth. Hamza Walker

New Life Expo, 1997
birch laminate, upholstered in carpet, 5 units, each 33 x 71 x 122 cm; carpet swatch, dimensions variable
Installation Chicago Navy Pier, 1997

For Greater Velocity Towards Grace, 1997–2002
cast acrylic, 33 x 72 x 122 cm
Installation Stephen Friedman Gallery, London, 2002

Findhorn Pastoral (1 of 40), 2000–1
1 of 40 slides, dimensions variable

Findhorn Pastoral (2 of 40), 2000–1
1 of 40 slides, dimensions variable

Middle of Nowhere (1 of 40), 2002
1 of 40 slides, dimensions variable

Middle of Nowhere (2 of 40), 2002
1 of 40 slides, dimensions variable

New Ruin (Sonic Nimbus), 2002, foamboard, aluminium ring, h. 60 x Ø 390 cm, ceiling 220 cm
with **Control**, 2002, plant, vinyl on window, Ø 120 cm
Installation Stephen Friedman Gallery, London, 2002

COREY McCO

Eleven Eleven (Graft), 2001
wood, veneer, adhesive, 4 fluorescent 48-inch bulbs (24 fixtures), dimensions variable
Installation 'Detourism', The Renaissance Society, Chicago, 2002

Born Glasgow, UK, 1977 Lives and works in Glasgow

Selected Solo Exhibitions: 2000 'Decemberism', Cabinet, London 2001 'Heavy Duty' (with Paulina Olowska), Inverleith House, Edinburgh; 'Global Joy', Galerie Daniel Buchholz, Cologne 2002 'If It Moves, Kiss It', Galerie Christain Nagel, Berlin 2003 NAK, Aachen

Selected Group Exhibitions: 2000 'Charisma Presents: It May be a Year of Thirteen Moons, But It's Still the Year of Culture', Transmission Gallery, Glasgow; 'Dream of a Provincial Girl', private apartment, Gdansk; 'Panache', Els Hanappe Underground, Athens 2001 'Charisma & Deutsch Britische Freundschaft Present', Glasgow Art Fair; 'Here + Now: Scottish Art 1990–2001', Dundee Contemporary Arts/Aberdeen Art Gallery; 'Painting at the Edge of the World', Walker Art Center, Minneapolis 2002 'Hotel Sub Rosa', Marc Foxx Gallery, Los Angeles; 'The Best Book About Pessimism I Ever Read', Kunstverein Braunschweig; 'Painting on the Move', Kunsthalle Basel

Selected Bibliography: 2000 Lucy McKenzie, 'International Youth Congress', *Dream of a Provincial Girl*, Gdansk; Lucy McKenzie, 'Preface', *Richard Kern: Model Release*, Taschen, Cologne; Neil Mulholland, 'Nasal and Facial Hair: Reactions to Various Heritage Disasters', *Untitled*, Autumn 2001 Michael Archer, 'Lucy McKenzie', *Artforum*, September; Alex Farquharson 'Decemberism', *Art Monthly*, February; Isabelle Graw, 'A Star is Born', *Texte zur Kunst*, December; Neil Mulholland, 'Lucy McKenzie', *Flash Art*, July; John Slyce, 'Decemberism: Review', *art/text*, May–July 2002 Lucy McKenzie, *The Best Book About Pessimism I Ever Read*, Kunstverein Braunschweig/Walter König, Cologne; Lucy McKenzie, 'Desky Maiden', *Paulina Olowska: Romansujac Z Awangarda*, Panstwowa Galeria Sztuki, Gdansk; Lucy McKenzie, *Global Joy*, Galerie Daniel Buchholz, Cologne

LUCY McKENZIE

Lucy McKenzie is often featured in exhibitions as a representative of the return of realism in painting. But painting is only one of numerous elements in her work, which examines popular imagery and its relationship to social phenomena. Although she does produce images on paper and canvas using traditional techniques, other activities include murals, room installations, photography, music and texts.

A central feature of McKenzie's work is the concept of participation, discussion and collaboration. To this end, she has established a complex network of relationships with other artists operating in a variety of fields. In 1999, for example, she and Keith Farqhuar founded the Charisma Gallery in Chicago as 'a collaboration forum for the interplay of artistic and curatorial practice'. In 2002, invited to make a solo show by a German museum, McKenzie staged instead a large-scale group exhibition entitled 'The Best Book About Pessimism I Ever Read', which discussed themes of meaning, medium and representation in art through drawings, paintings, illustrations, literature, film, video, sculptures and room installations. She also launched a series of events entitled 'Flourish Nights Two Thousand and Two', which linked music, literature and art with general social activities.

McKenzie works with historical and pictorial material gleaned from a variety of sources, from Charles Rennie Mackintosh's Arts and Crafts design, omnipresent in her native Glasgow, to mass symbols like banknotes, typography and commercial designs, ephemera from the Olympic Games, popular collective phenomena and rituals such as sport, 'public' monuments, social realism, graffiti, pornography, along with visual languages from the political subculture and the world of music. All of these manifestations of seduction and manipulation act in her work as representatives of the ways in which individuals and groups construct identity. She presents a complex, ambivalent attitude to nostalgia and lost utopias.

An example of McKenzie's complex network of diverse materials and sources can be found in her publication *Global Joy* (2001). Here, in a photograph that appears to have been taken in Gerhard Richter's studio, a young woman who looks exactly like McKenzie aims a pistol. It is not clear whether this is montage, a reference to artists taking pot shots at art history, or general political agitation. We find the same figure in a lino-cut resembling a preliminary study for a socialist mural, along with an early sketch by Richter for a wall painting. Also included is an interview with Stalin's grandson; covers for Russian bootleg albums – including one for Sonic Youth, for which Richter's famous picture of a candle was used – works by Walter Womacka, who was responsible for numerous murals in the former GDR, photographs of murals in Scotland and Poland, and a record of McKenzie's monumental public mural, made the same year with Paulina Olowska in Gdansk. In this work visual codes from various times and cultures combine to form a comprehensive collage, which is less an act of appropriation than a demonstration of the special way in which the individual builds up a personal history and identity. This theme is echoed in the paintings *Keith* and *Kerry* (both 2001), in which the shadows of the individuals depicted become like monumental giants, laid over maps of the UK and the world. Beatrix Ruf

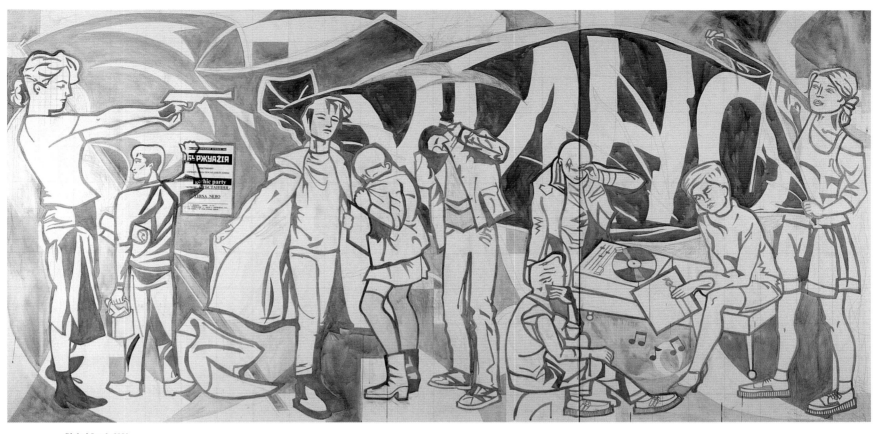

Global Joy 1, 2001
collage, 182 x 366 cm

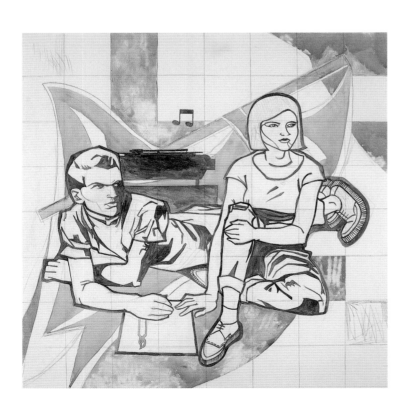

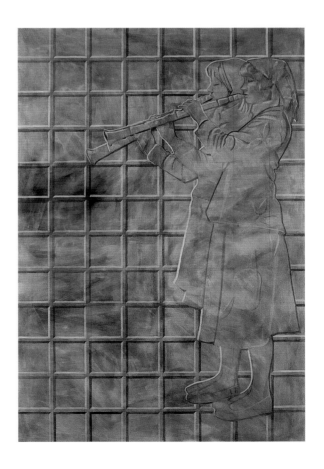

Global Joy II, 2001
acrylic and lead pencil on canvas, 122 x 122 cm

Global Joy III, 2001
acrylic on canvas, 182 x 122 cm

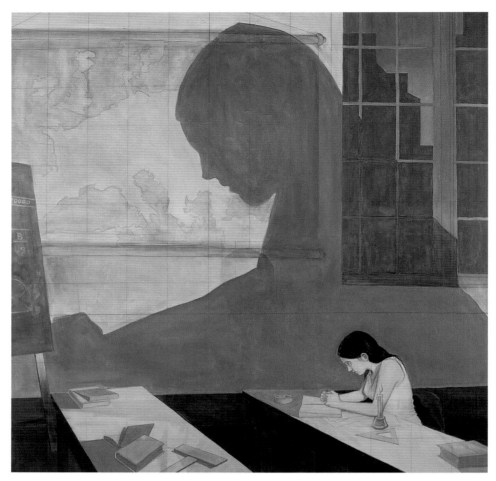

Kerry, 2001
oil on canvas, 182 x 182 cm

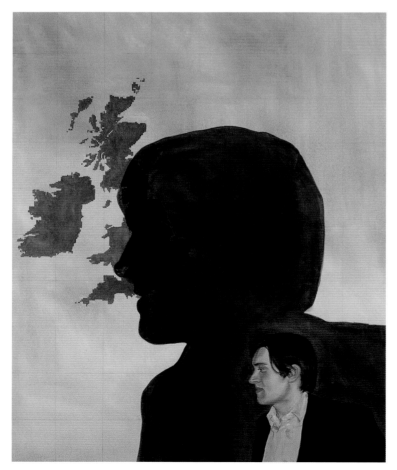

Keith, 2001
oil on canvas, 152 x 122 cm

Panache (*detail*), 2001
enamel paint, metal, 214 x 274 cm

LUCY McKE

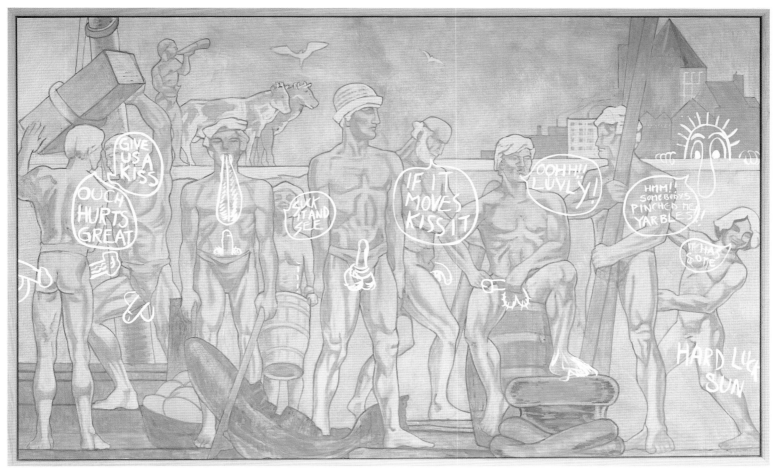

If It Moves, Kiss It–I, 2002
acrylic paint on canvas, 200 x 323 cm

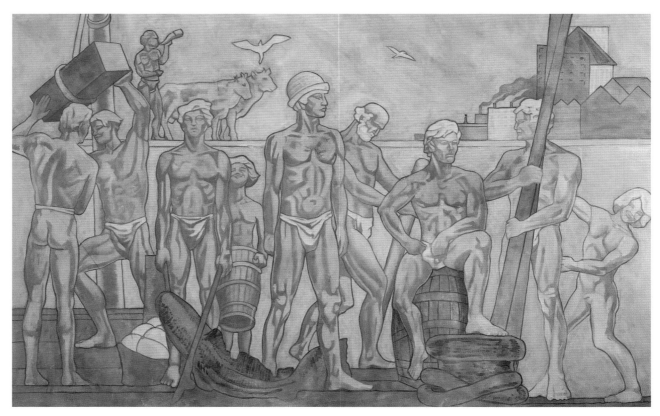

If It Moves, Kiss It–IV, 2002
acrylic paint on canvas, 200 x 307 cm

Born Huntington, USA, 1955 Lives and works in New York, USA

Selected Solo Exhibitions: 1991 'Patrick McMullan: Photographs', World Gallery, Miami 1998 Tony Shafrazi Gallery, New York 1999 'Interview Show', Armani, New York 2000 'Patrick McMullan: Photographs', Homer, New York 2001 'Men's Show/Secret of the Riviera', Tony Shafrazi Gallery, New York 2002 'New York Character', Steuben @ the Corning Gallery, New York; 'Patrick McMullan: Color Photographs', Alpan Gallery, Huntington

Selected Bibliography: Michael Kaplan, 'Patrick McMullan's Night Out', *American Photo*, July–August 1998 Katherine Rosman, 'The Un-Paparazzi', *Brill's Content*, October 2000 Nancy Haas, 'All Parties: All the Time: New York's Bloodshot Eye', *The New York Times*, 26 November; Jay McInerney, 'Snap, Crackle, Pop', *Hampton's Magazine*, 1–7 September 2001 Patrick McMullan, *Men's Show*, Editions Stemmle, Zürich; Patrick McMullan, *Secrets of the Riviera*, Welcome Rain Publishers, New York; Horacio Silva, 'Saint Patrick', *Jalouse*, July 2002 'Patrick McMullan: Zero Degrees of Separation', *Nikon Owner*, No. 5

PATRICK McMULLAN

Patrick McMullan began his career as a photographer at Andy Warhol's Factory in New York. Warhol liked his work and told him to carry a camera wherever he went. For the past twenty years, McMullan has followed this advice as he hops from celebrity parties to bar openings, from exclusive dinners to downtown clubs. Over the years he has become one of the most successful chroniclers of the New York social scene, and his photographs and columns regularly appear on the pages of *The New York Times Magazine*, *Vogue* and *Vanity Fair*, but also in more humble publications like the gay weekly *HX*, which publishes his pictures of drag queens and club boys.

But McMullan is not just a celebrity photographer: one of his main lines of work is shooting fashion shows, and in recent years he has been a permanent fixture at New York's fashion week. By far the most intriguing aspect of his work has been his documentation of the backstage world of fashion shows – dozens of photographs that give us a glimpse of how models operate behind the scenes. This body of work landed him a solo show at New York's Shafrazi Gallery in 1998.

In 2000, McMullan published *Men's Show*, a book of his backstage photographs that provides a fascinating insight into the world of male models. Men in the modelling industry have received much less attention than their female counterparts, perhaps because our assumptions about masculinity are ill-suited to a line of work associated with the traditionally feminine vice of vanity. As we discover from the photographs in *Men's Show*, they are much more open than women about the sexual nature of modelling: these young men stare right into the camera with a self-assurance (and even defiance) that betrays no feelings of vulnerability, no anxieties about being caught half undressed, no qualms about being sexually objectified.

McMullan's photos capture the constant tension between work and play, between the rigid choreography of the runway and the unstructured time backstage. A typical image shows a guy preparing for the runway, surrounded by a small army of stylists, tailors, prompters and make-up artists; the model's smirk confirms our suspicions that for him this is an elaborate form of ego-pampering. But there is also hard work: a photo depicts a dozen models doing push-ups on the floor, no doubt under strict orders from a fashionable drill sergeant to pump-up for their next walk down the runway; in other images we see walls lined with Polaroids outlining the strict choreography of the day's show: who wears what, when and after whom.

Perhaps the most revealing photos are the ones that give us a taste of the model's private life, which is often at odds with the haughty pose and impeccable outfit that he must sport on the runway. One image shows a blond boy sitting in his underwear, waiting for his cue; he has just put down a paperback (*Stick* by Elmore Leonard). Next to him, carefully tucked behind a pair of white sneakers, is a cheap T-shirt and white socks: the everyday dress of someone who gets paid to wear tens of thousands of dollars worth of clothes. Perhaps even models prefer not to bring their work home with them.

Rubén Gallo

Untitled, 2000
Cibachrome print, 25 x 20 cm

Untitled, 2000
Cibachrome print, 20 x 25 cm

Untitled, 1996
Cibachrome print, 20 x 25 cm

Untitled, 1999
Cibachrome print, 20 x 25 cm

Untitled, 1998
Cibachrome print, 25 x 20 cm

Untitled, 1996
Cibachrome print, 25 x 20 cm

Untitled, 1996
Cibachrome print, 25 x 20 cm

Born Buenos Aires, Argentina, 1963 Lives and works in Buenos Aires

Selected Solo Exhibitions: 1989 'Pinturas y retablos de fines del siglo XX', Alberto Elia Gallery, Buenos Aires 1991 Fundación Banco Patricios, Buenos Aires 1994 '32 morceaux d'eau', Jorge Alyskewyz Gallery, Paris 1998 'Incidental Music', University of Essex Gallery, Colchester; 'Música incidental', Galería de Arte Ruth Benzacar, Buenos Aires; 'The Wandering Golfer', Museum van Hedendaagse Kunst, Antwerp 2001 'Le 10 neuf', Centre Régional d'Art Contemporain, Montbéliard, France 2002 'Fuegos de artificio', Galería de Arte Ruth Benzacar

Selected Group Exhibitions: 1991 'L'Atelier de Buenos Aires', CREDAC, Ivry sur Seine 1995 'Searching South', John Hansard Gallery, University of Southampton 1997 'Grupo de la X', Museo Sívori, Buenos Aires 1998 'Evindencias Circunstanciales', Museo de Arte Moderno, Buenos Aires; 'Retorno y Presencia', Galería de Arte Ruth Benzacar, Buenos Aires 1999 'Borges.es', Casa de América, Madrid 2000 7th Havana Biennale 2001 '12 Views', The Drawing Center, New York; 'El fin del eclipse', Fundación Telefónica, Madrid; 'Mouvements Immobiles', Museo de Arte Moderno, Buenos Aires

Selected Bibliography: 1991 Philippe Cyroulnik, *L'Atelier de Buenos Aires*, CREDAC, Ivry sur Seine 1994 Mario Flecha, 'Searching South: Two South-American Artists', *Art and Design*, October 1996 Jorge Glusberg, 'Jorge Macchi', *D'ars*, Winter 1997 Jorge López Ananya, 'Jorge Macchi', *Historia del Arte Argentino*, Emecé, Buenos Aires 1998 Belén Gache, *Música Incidental*, Galería de Arte Ruth Benzacar, Buenos Aires; Gabriel Pérez Barreiro, *Artist in Transit*, University of Essex 2000 Gustavo Buntinx, 'Bajo continuo, Cuatro primeras notas sobre *Música Incidental* de Jorge Macchi', *Arconoticias*, September 2001 Belén Gache, 'Jorge Macchi', *Le 10 Neuf*, Centre Regional d'Art Contemporain, Montbéliard; Santiago García Navarro, 'Ser Urbano', *La Nación*, 2 February; Violetta Weinschelbaum, 'El movimiento mínimo', *Teatro Colón*, July–August 2002 Fabián Lebenglik, 'Juegos de artificio', *Página 12*, 12 May; Adriano Pedrosa, 'Buenos Aires: Jorge Macchi at Galería de Arte Ruth Benzacar', *Artforum*, October

JORGE MACCHI

It is difficult to place Jorge Macchi within the Argentinian artistic context – there seems to be little connection between his work and that of his compatriots, either in this century or the previous one. Perhaps this is because of his peripatetic existence, punctuated by trips and residencies to Belgium, France, Germany, Italy, the Netherlands and the United Kingdom. Or possibly it is due to his background in theatre and music, coupled with his close interest in literature. Curiously, however, Macchi's work retains a distinct Buenos Aires aroma.

'My intention is to make extremely simple works with the minimum movement', Macchi stated in a 2001 interview. Indeed, the works – ranging from photographs, text pieces, drawings, sculptures and paper cut-outs to installations and videos – are usually discrete or small, often black, white or grey in colour. They display a strong concern with language and representation – the gaps and pitfalls in different systems of communication, the relationships between the visual and the musical, between what is said/written and what is unsaid/unwritten. One could thus attempt to establish connections between his work and Minimalist or Conceptual art. However, his art is also highly figurative, drawing on common everyday materials and themes. These include newspapers and the stories found in them, often glued in strips and sculptural configurations to the wall or pinned onto wood. 'My point of departure is a purely experiential relationship with my surroundings', he said in the same interview. Thus his native Buenos

Aires, to which he has always returned, constantly reappears in his work. *Buenos Aires Tour* (2003), for example, is an artist's book and installation that presents an erratic guide of the city, comprised of objects, photographs, recorded sounds and texts.

The works' minimal and conceptual traces are offset by poetic, romantic, melancholic and at times tragic overtones, signalled by titles like *A Pool of Blood* (1998), *Dos Adios* (Two Farewells) (2000), *Souvenir of a Night Trying to Forget You* (1996), *Intimacy* (2001), *Accident in Rotterdam* (1996–8). Music is also present as a different form of language brought into the realm of the visual: *Incidental Music* (1998), *The Song of the End* (2001), *Nocturne – Variation on Nocturne No.1 by Erik Satie* (2002).

Yet perhaps the most important references in Macchi's work are literary: the fictions and truths of Argentine masters Jorge Luis Borges and Julio Cortázar, and the rich Buenos Aires tradition of fabulous and poetic play with language. It is not by chance that some of Borges' well-known motifs appear in Macchi's works – symmetry, the double, the mirror, the fragment. His deceptively simple pieces are imbued with a highly complex charge. They explore fate, chance, accident, coincidence. An object or a fragment of text appears to be the key to a mystery or crime, all of a sudden assuming extraordinary and inexplicable symbolic importance, as if it will reveal a well-kept secret or a long locked-up treasure. Ultimately, it is up to the viewer to look for these clues and follow the path through art and meaning.

Adriano Pedrosa

A Pool of Blood (*detail below*), 1998
paper cut-outs glued on wall (texts from the Buenos Aires newspaper *Cronica*, containing the phrase
un charco de sangre ('a pool of blood'), 170 x 600 cm
Installation 'Evidencias Circunstanciales', Museo de Arte Moderno, Buenos Aires, 1998

The Speaker's Corner (*detail*), 2002
paper cut-outs from newspapers, pins, on wood, 170 x 130 cm

Dos Adios (Two Farewells), 2000
paper cuts, pins, 20 x 15 cm

JORGE MA

Untitled, 2000
gouache on paper, 29 x 20 cm

Accident in Rotterdam (*detail*), 1996–8
6 photo prints, each 40 x 40 cm

Ornament, 2002
acrylic paint on wall, 3 x 10 m
Installation 'Fuegos de artificio', Galería de Arte Ruth Benzacar, Buenos Aires, 2002

Born Culiacán, Sinaloa, Mexico, 1963 Lives and works in Mexico City

Selected Bibliography: 1994 Carlo Blas Galindo, 'Grupo SEMEFO', *Art Nexus*, No. 60 1998 Estrella De Diego, 'De la muerte, los demás y otras parábolas modernas'/Oswaldo Sanchez, 'SEMEFO La vida del cadaver', *Revista de Occidente*, No. 201 2001 Coco Fusco, 'La insoportable pesadez de los seres: el arte en México después de NAFTA', *Atlántica*, No. 29; Coco Fusco, 'The Unbearable Weightiness of Beings', *The Bodies That Were Not Ours*, inIVA, London; Maria Fernanda Terán Gómez, 'La muerte viviente en el paraiso perdido de SEMEFO', *Zugo*, No. 7; Cuauhtémoc Medina, 'México – Zones de tolérance: Teresa Margolles, SEMEFO et l'au delá', *Parachute*, No. 104 2002 Carlos Aranda Márquez, 'Mexico en chute perpétuelle dans l'abime', *Inter Art Actuel*, No. 82; Eduardo Pérez Soler, 'SEMEFO/Teresa Margolles: La mort ens impregna', *Tranversal*, No. 17; Victor Zamudio Taylor, 'Mexico City: Art, Aggression, and Violence', *NY Arts*, February

TERESA MARGOLLES

Teresa Margolles is one of the founding members of SEMEFO, an artists' collective with a morbid bent that erupted onto the Mexico City art scene in the early 1990s. For their first major exhibition, they filled the Carillo Gil museum with dead horses sliced into sculptural elements. Unlike Damien Hirst, however, the group was not intent on shocking the audience but on investigating the aesthetic potential of death. SEMEFO is the acronym for Servicio Médico Forense, the city morgue – a creepy, dilapidated building that in recent years has become, for all practical purposes, Margolles' studio.

The morgue provides Margolles with the raw materials for her work. Her incursions into the Mexican netherworld began with visits made in order to draw the unclaimed dead bodies that filled the warehouse-like space (perhaps the relatives of those too poor to prove that arrangements had been made for proper burial). She then began removing tongues, tattoed skin and other body parts from the corpses (sometimes buying them from the victim's impoverished relatives), which she would then show as 'found objects'. For *Burial* (1999) she interred a foetus (given to her by a friend who after suffering a miscarriage asked Margolles to conceive of a resting place for the dead child) in an elegant cement block whose smooth surface evokes the language of Minimalism.

Not all of Margolles' work, however, is made up of human remains. It is an exploration of death and all its manifestations, and she often works metonymically, showing inert objects and materials that serve as accessories to the act of dying. *Vaporization* (2001–2) invites the viewer to step into a room filled with dense steam, made from the water used to wash corpses at the morgue. For other installations she has used bloody sheets, formaldehyde vats and even body fat, all taken from the morgue.

Some critics have interpreted Margolles' fascination with death as a comment on the violence that has recently exploded in Mexico: the country has lived through a wave of political assassinations, kidnappings and even shoot-outs unseen since the years of the Revolution. But although Margolles has devoted a few pieces to violent themes (her *Cards for Cutting Cocaine* of 1997 bear photos of those murdered by drug traffickers), the focus of her work is on dying and the many different forms that this experience can take.

Ocatvio Paz once wrote that some rituals and mythic beliefs are so engrained in certain cultures that they remain constant throughout history, surviving colonization, revolution and even modernization. As an example, he points to the 1968 student massacre at Tlatelolco, an event that he interprets as a twentieth-century recurrence of the bloody sacrifices favoured by Aztec rulers. Perhaps Margolles' work, too, should be seen as a modern manifestation of the peculiar fascination with death that has defined Mexican culture and that remains firmly entrenched in Mexico, even in the age of neoliberalism, free trade and the relentless aspiration to join the first world. Rubén Gallo

Vaporization, 2001–2
vaporized water used to wash corpses in the morgue
Installation, 'Zebra Crossing', Kulturhaus Mitte Berlin, 2002

Vaporization, 2001–2
vaporized water used to wash corpses in the morgue
Installation 'Obra reciente', ACE Gallery, Mexico, 2001

Cards for Cutting Cocaine, 1997
performance and colour photographs, 10 x 7 cm

Untitled, 1997
8 metal vats used to clean skeletons for anatomical studies, installed dimensions variable

Dermis, 1995
blood on hospital sheets, 140 x 200 cm
(in collaboration with SEMEFO)

End, 2002
cement mix made with 100 litres of water used to wash corpses
Installation marking the closure of La Panadería, Mexico City, 14 August 2002

Born Vienna, Austria, 1967 Lives and works in Vienna

Selected Solo Exhibitions: 1993 'Mein Schlafzimmer in Prag', Forum Stadtpark, Prague 1994 'Das Haus ohne Küche', Neue Galerie, Graz 1997 'containerize', Kunstwerke, Berlin 1999 'Short Hills', Grazer Kunstverein, Graz 2000 'Bringing It All Back Home', Galerie Krobath Wimmer, Vienna 2001 'Everyday Life', Galerie im Taxispalais, Innsbruck 2002 'Event Horizon', Galerie Krobath Wimmer, Vienna; 'Some Establishing Shots', museum in progress, Vienna

Selected Group Exhibitions: 1991 'Material, Texte, Interviews', Jaenner Galerie, Vienna 1993 'Backstage', Hamburger Kunstverein, Hamburg 1994 'Oh Boy It's A Girl', Kunstverein München, Munich 1998 'The Making Of', Generali Foundation, Vienna; 'schnittstelle/produktion', Shedhalle Zürich 2000 'hers – Video as Female Terrain', steirischer herbst/Joanneum, Graz; 'Man muss ganz schoen viel lernen um hier zu funktionieren', Frankfurter Kunstverein, Frankfurt 2001 '20/35 Vision', MAK Center for Art and Architecture, Los Angeles; 'You Are the World', Wiener Festwochen/ Künstlerhaus Wien, Vienna; 'tele(visions)', Kunsthalle Wien, Vienna 2002 'Archi-tourism', The Buell Center, New York

Selected Bibliography: 1991 Helmut Draxler, 'Material, Texte, Interviews', *Texte zur Kunst*, September 1996 Silvia Eiblmayr, 'Schauplatz Skulptur', *White Cube/Black Box*, Generali Foundation, Vienna 1999 Yvonne Volkart, 'Gebaute Traeume', *springerin*, December–January 2000 Christian Kravagna, 'Dorit Margreiter', *Artforum*, Summer 2001 Susanne Leeb, 'Installation als Verfahren', *Texte zur Kunst*, June; Alexandra Seibel, 'Visiting Global Hollywood', *Objekte*, Austrian Gallery Belvedere, Vienna; 'The World According to Art', *Parnass*, May–August 2002 'Dorit Margreiter – Galerie im Taxispalais', *Artforum*, April; Matthias Dusini, 'Dorit Margreiter', *frieze*, No. 65; Georg Schoellhammer, 'Alltag im Modell', *springerin*, April–May

DORIT MARGREITER

The mass media, especially television, have often been criticized for producing a false, fictitious world, an illusory retreat from everyday reality. In spite of their artificially constructed plots and stereotypical characters, however, soap operas and similar programmes can be highly effective in their presentation of various aspects of reality, often dealing with topical and contentious societal issues. For her video installations, Dorit Margreiter uses soaps and other popular forms as a means of research, adopting the interplay of truth and fiction through which TV and the mass media simultaneously conceal and disclose reality. An obvious example of this was her idea to produce a soap opera, *Into Art* (1998), that would present, through video and storyboards, the roles and relationships in an art institution similar to the Generali Foundation in Vienna.

Margreiter does not deny that reality, as it is represented in the media, is basically a construction. In the exhibition 'Everyday Life' (2001), she explored the discrepancies between architectural and social projects, media images and actual life. *Case Study No. 22* (2001), for example, looks at an important example of inexpensive well-designed, modern architecture in Los Angeles, bringing together its architect Pierre König, its owner and builder Carlotta Stahl, and its photographer Julius Shulman. But she also recognizes that the media have a special, reciprocal relationship with everyday life: they not only represent but also shape reality. Several of her projects suggest that today image and reality have become inseparable.

Among these is *Around the World Around the World* (2001), eight stories on video that deal with the issues of place and identity, based on the complex history of Shanghai and its personal meaning to the artist and her family.

Margreiter's works also indicate another, more far-reaching idea: that there *is* no reality as such, since it is always mediated through social patterns. The mass media, in their intriguing dialectics of the false and the genuine, both represent these patterns and project them into the world, making them seem 'natural'. Her analysis in *Short Hills* (1999) of the issue of identity as it demonstrates (and constructs) itself in relation to the home, the landscape, TV programmes, personal items etc. is an example of this. The title refers to the town in New Jersey in which Margreiter's aunt and cousin live. The work examines their sense of identity as reflected in their relationship to TV programmes, particulary their favourite soaps.

Margreiter is not, however, a social scientist observing from a safe, distant position. She herself enters into the game of representation, reality and identity that she presents. Just as the protagonists of *Short Hills* disclose information about their desires and opinions through describing their preferred TV programmes, Margreiter also makes things visible indirectly. And finally, viewers, too, cannot escape being caught up in these relationships, discovering on Margreiter's TV screens reflections of themselves. Igor Zabel

Case Study No. 22, 2001
digital print, 30 x 40 cm

Short Hills (*detail, and stills above*), 1999
landscape model, wooden construction, projection, monitor, DVD player, blueprints, photograph, video, 15 min., 57 sec., colour, sound
Installation 'Short Hills', Grazer Kunstverein, Graz, 1999

Around the World Around the World (*stills above*), 2001
wooden construction, projection, monitor, 8 videos, each 6 min., colour, sound
Installation 'You Are the World', Künstlerhaus Wien, Vienna, 2001

Born Addis Ababa, Ethiopia, 1970 Lives and works in New York, USA

Selected Solo Exhibitions: 1995 'Ancestral Reflections', Hampshire College Gallery, Amherst 1998 Barbara Davis Gallery, Houston 1999 'Module', Project Row Houses, Houston 2001 ArtPace, San Antonio; The Project, New York 2002 'Renegade Delirium', White Cube, London 2003 Walker Art Center, Minneapolis

Selected Group Exhibitions: 1999 'Texas Draws', Contemporary Arts Museum, Houston 2000 'Greater New York', P.S.1 Contemporary Art Center, New York 2001 'The Americans: New Art', Barbican Art, London; 'Casino 2001', Stedelijk Museum Voor Actuele Kunst, Gent; 'Freestyle', Studio Museum in Harlem, New York; 'Painting at the Edge of the World', Walker Art Center, Minneapolis; 'Urgent Painting', Musée d'Art Moderne de la Ville de Paris 2002 1st Busan Biennale; 8th Baltic Triennial of International Art; 'Drawing Now: Eight Propositions', The Museum of Modern Art, New York; 'Out of Site', New Museum of Contemporary Art, New York; 'Stalder-Mehretu-Solakov', Kunstmuseum Thun

2003 'The Moderns', Castello di Rivoli, Museo d'Arte Contemporanea, Turin; Smithsonian Institute, Washington D.C.

Selected Bibliography: 1998 Shaila Dewan, 'Bugs to Beauty', *Houston Press*, 30 July–5 August 1999 Alexander Dumbadze, 'Core 1999', *Art Papers*, July–August 2000 Laura Hoptman, 'Crosstown Traffic', *frieze*, September 2001 Lawrence Chua, *Julie Mehretu*, Kunstmuseum Thun; Meaghan Daily, 'Freestlye', *Artforum*, May; David Hunt, 'Julie Mehretu', *Freestyle*, Studio Museum in Harlem, New York; Tim Griffin, 'Race Matters', *Time Out New York*, 24–31 May; Tim Griffin, 'Exploded View', *Time Out New York*, 6–13 December; Franklin Sirmans, 'Mapping a New, and Urgent, History of the World', *The New York Times*, 9 December 2002 Carley Berwick, '10 Artists to Watch', *ARTnews*, March; Susan Harris, 'Review of Exhibitions: Julie Mehretu at The Project', *Art in America*, March

JULIE MEHRETU

Julie Mehretu depicts multi-dimensional, multi-layered universes that refer to past, present and future architectures and places. At the crossroads of abstraction and cyber-fiction, her paintings, drawings and wall-works are exuberant mappings and visualizations of the complex, 'web-like' nature of the mind in the digital age, a mind charged by hypertextual experience, with its overlapping links and interconnections. However, these works are also artistic explorations of the ways in which visual imagery can be expanded through a re-engagement with early modernist experiments – in particular those of the Futurists, Constructivists and Suprematists. She both celebrates those experiments and depicts their explosion into myriad shards.

Mehretu joins various linguistic registers and styles – urban maps, idiosyncratic scribbles and notations in black ink, comic-book figures, highly coloured, foreshortened, flat, geometric shapes in red, yellow and blue acrylic – in order to achieve a sense of physical space and depth that is contingent on delirious perspectival fugues within each painting. There is no horizon line in her worlds; rather, the horizon seems to have imploded upon itself and become a shaft leading to many different vanishing points and recesses from which energy is released and fans outwards. The works suggest explosion, speed and reverberation, yet they are made very slowly, building layer on top of layer, and zooming in on different portions that are treated separately and with greater intimacy. After taking in the finished whole in one breath, the viewer is drawn towards a minute observation of the small marks and cartoon-like micro-figures that populate her imaginary cityscapes.

But Mehretu's work is not just an experiment in painting and cartography: born in Addis Ababa of Polish, French, Virginian, South American and Ethiopian extraction, raised in Michigan, studying both in Senegal and Rhode Island, and currently living in New York, Mehretu points in her art to the speed of the globalized world, and also to its needs. The lack of any unitary perspective in her work suggests the importance of the non-hierarchical, of decentralization and of the hybridization of thoughts and ideas. Her art celebrates and charts the possibilities of an international language that does not imply homogenized uniformity – an optimistic view similar, again, to the revolutionary utopian outlook of so many early modernists. Carolyn Christov-Bakargiev

Renegade Delirium (*detail above*), 2002
acrylic on canvas, 228.5 x 366 cm

Retopistics: A Renegade Excavation, 2001
acrylic and ink on canvas, 259 x 549 cm

Bombing Babylon (*detail*), 2001
acrylic and ink on canvas, 152 x 213 cm

Rise of the New Suprematists, 2001
ink and acrylic on canvas, 20 x 25 cm

JULIE MEH

Back to Gondwanaland, 2000
acrylic and ink on canvas, 244 x 305 cm

Ringsite (*detail*), 2000
ink and polymer on canvas, 213 x 183 cm

Untitled (thesis), 1997
ink and polymer on canvas, 107 x 152 cm

Born Rio de Janeiro, Brazil, 1960 Lives and works in Rio de Janeiro

Selected Solo Exhibitions: 1993 Galeria Camargo Vilaça, São Paulo 1994 Galeria Ramis Barquet, Monterrey 1995 Dorothy Goldeen Gallery, Los Angeles 1996 Edward Thorp Gallery, New York 1997 Barbara Farber Gallery, Amsterdam; 'Beatriz Milhazes, 1989/1993', Museu Alfredo Andersen, Curitiba 1998 Galerie Nathalie Obadia, Paris 2000 Galeria Camargo Vilaça, São Paulo; Edward Thorp Gallery, New York 2001 Galería Elba Benítez, Madrid; Galería Pedro Cera, Lisbon; Ikon Gallery, Birmingham 2002 'Mares do Sul', Centro Cultural Banco do Brasil, Rio de Janeiro; The Museum of Modern Art, New York; Stephen Friedman Gallery, London

Selected Group Exhibitions: 1995 Carnegie International, Carnegie Museum of Art, Pittsburgh 1998 11th Sydney Biennale; XXIV São Paulo Biennale; 'Abstract Painting Once Removed', Contemporary Arts Museum, Houston/Kemper Museum of Art, Kansas City; 'Decorative Strategies', Bard College, Center for Curatorial Studies, Annandale-on-Hudson; 'Painting Language', L.A. Louver, Venice 1999 'Painting', Galerie Nathalie Obadia, Paris; 'Transvanguarda Latino Americana', Culturgest, Lisbon 2000 'Drawings', Stephen Friedman Gallery, London; 'F[r]icciones', Museo Nacional Centro de Arte Reina Sofía, Madrid; 'Opulent', Cheim & Read Gallery, New York; 'Projects 70', The Museum of Modern Art, New York 2001 'Espelho Cego', Museu de Arte Moderna de São Paulo; 'Hybrid', Tate Liverpool; 'Operativo', Museo Rufino Tamayo, Mexico City; 'Posters of the Years to Come', Portfolio Kunst, Vienna; 'Viva a Arte Brasileira', Museu de Arte Moderna do Rio de Janeiro 2002 'Urgent Painting', Musée d'Art Moderne de la Ville de Paris

Selected Bibliography: 1996 Barry Schwabsky, 'Opening/Beatriz Milhazes', *Artforum*, May; Roberta Smith, 'Beatriz Milhazes', *The New York Times*, 22 March 1999 Martin Coomer, 'Beatriz Milhazes', *Time Out*, 17–24 November; David Moos, 'Painting at the End of the Century', *Art Papers*, May–June 2000 Abreu Gilberto, 'Exagero ou Lucidez', *Journal do Brasil*, 23 January; Ken Johnson, 'Opulent', *The New York Times*, 21 July 2001 Philip Auslander, 'Beatriz Milhazes', *Artforum*, November; Tony Godfrey, 'Liverpool, Birmingham, London, Hybrids, Milhazes, Heilmann', *Burlington Magazine*, June; Carl Little, 'Beatriz Milhazes at Edward Thorp', *Art in America*, May; Adrian Searle, 'Excess all Areas', *The Guardian*, 10 April 2002 Adriano Pedrosa, 'Beatriz Milhazes', *Bomb*, Winter; Adriano Pedrosa (ed.), *Mares do Sul*, Centro Cultural Banco do Brasil, Rio de Janeiro; Deanna Sirlin, 'Birmingham', *Art Papers*, January–February

BEATRIZ MILHAZES

Colour and life: these are the central concerns of Rio de Janeiro-based painter Beatriz Milhazes. More specifically, she is interested in the relationships between the two. The delight she takes in colour is unmistakable: a multitude of bright, vivid, joyful hues (black and white are scarce here) are juxtaposed to overwhelming and at times even psychedelic effect. Moving a step beyond colour, the spectator is invited to consider the figurative and abstract elements that populate the canvas. These are appropriated and manipulated from various cultural sources, both high and low, foreign and native: tropical fauna and flora, folk art and craft, pop culture, street fashion and couture, jewellery, embroidery and lace, Brazilian Baroque imagery, colonial art, mid-twentieth-century organic design and art deco motifs. One also senses the presence of key women painters' art in these works, such as Bridget Riley, Sonia Delaunay and Tarsila do Amaral. This diverse subject matter provides the evidence of Milhazes' life, as she surfs through different territories and periods, picking up bits and pieces of visual information on her journeys, and trying to make sense of them by piecing them back together in her studio using a kind of hybrid collage strategy.

Milhazes' painting technique is unique, itself related to collage: she paints different elements in acrylics on sheets of transparent plastic, and then glues them to the canvas, experimenting with various possible positions, juxtapositions and superimpositions. Scrutinizing the painting's surface, one can detect the handmade, gestural quality of the paintings, traces of the painter's 'hand' – evidence that is both duplicitous and ironic. It would be a mistake, however, to see Milhazes as one of the many contemporary artists who approach painting with suspicion, irony or derision. These are serious, honest, full-blown canvases, concerned with the age-old medium's history, tradition and formal elements. In these intricate works, formal compositional norms of balance and symmetry are confronted with other, less traditional strategies: a hyper-figurative, labyrinthine abundance. The path taken by the spectators' eyes is full of tricks and treats. But while these paintings are invariably luscious, copious, seductive, they never paint a pretty picture; they are tough to look at, and not easy to live with. The imagery always seems on the verge of disintegrating, collapsing or melting down, evoking the chaotic, excessive life of Rio de Janeiro. Adriano Pedrosa

The Fairy of Home, 2001
acrylic on canvas, 229 x 159 cm

My Boss, 2001
acrylic on canvas, 250 x 170 cm
Collection Museo Nacional Centro de Arte Reina Sofía, Madrid

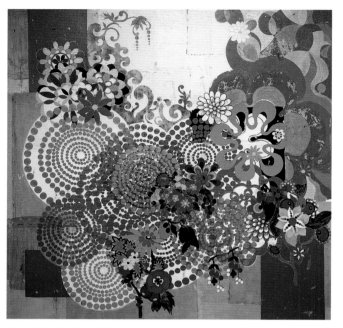

Nazareth das Farinhas, 2002
acrylic on canvas, 239 x 240.5 cm

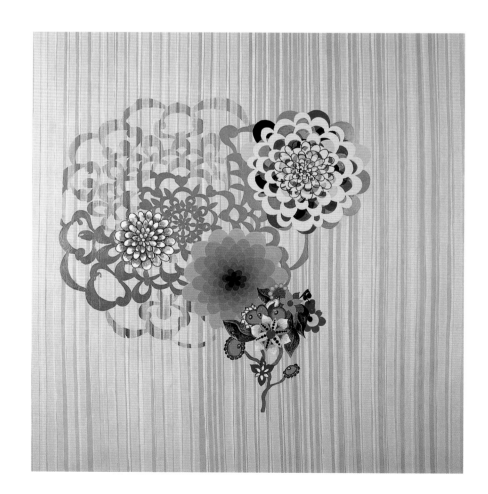

The Blue House, 2001
acrylic on canvas, 280 x 270 cm

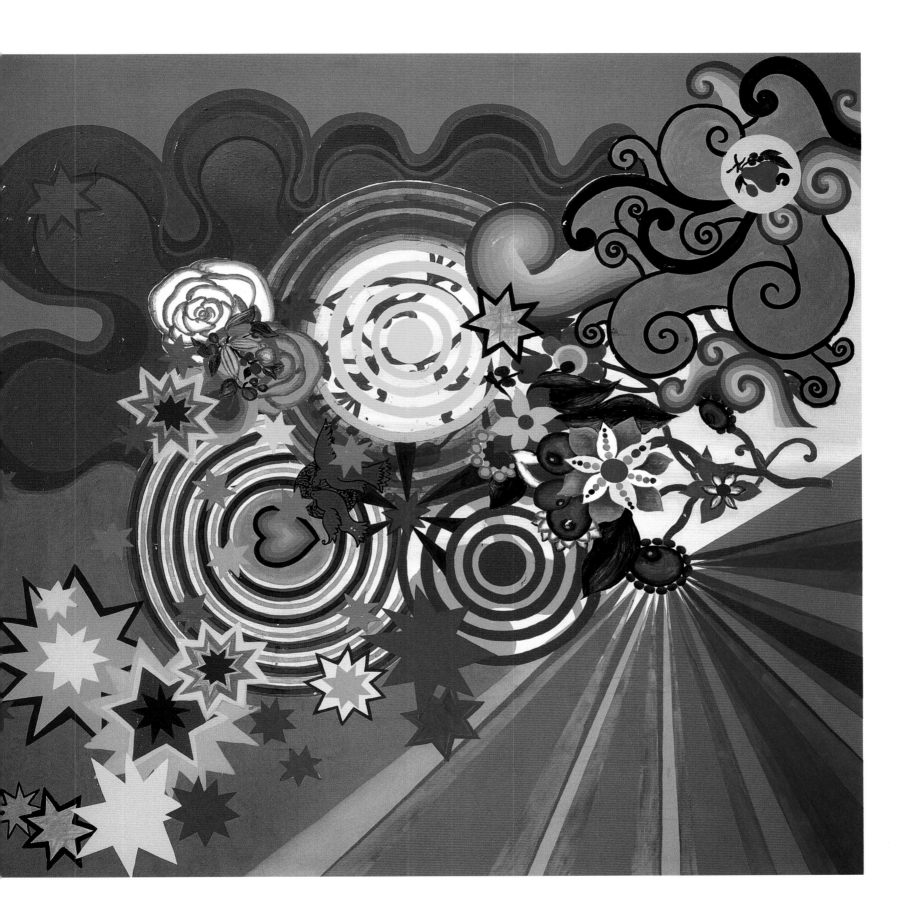

Summer Time, 1999
acrylic on canvas, 190 x 200 cm

Born Rochester, USA, 1970 Lives and works in Chicago, USA

Selected Solo Exhibitions: 1997 Chicago Project Room 2000 'beforsten', Meyer Riegger Galerie, Karlsruhe; Gasser & Grunert, New York 2001 'Sky-wreck', The Renaissance Society, Chicago 2002 'Declining Interval Lands', Whitney Museum of American Art, New York; 'Vanzetti, Sacco', Galleria Francesca Kaufmann, Milan 2003 Meyer Riegger Galerie, Karlsruhe; Stephen Friedman Gallery, London

Selected Group Exhibitions: 1996 'Persona', The Renaissance Society, Chicago/Kunsthalle Basel 1997 'Some Kind of Heaven', Kunsthalle Nürnberg, Nuremberg; 'Up Close', Philadelphia Museum of Art 1998 'Trance', Philadelphia Museum of Art 1999 'The Stroke', Exit Art, New York 2000 'Age of Influence', Museum of Contemporary Art, Chicago 2001 'Making the Making', Apex Art, New York 2002 'Here and Now', Chicago Cultural Center; 'Sudden Glory', CCAC Institute, San Francisco; 'Zusammenhänge herstellen', Kunstverein Hamburg 2003 'Land, Land', Kunsthalle Basel

Selected Bibliography: 1995 Joe Scanlan, 'San Quentin Tarantino', *Youth Culture Killed My Dog*, Contemporary Arts Council, Chicago 1998 Greg Purcell, 'Helen Mirra: Third', *Cakewalk*, Fall 1999 Jan Estep, 'Helen Mirra', *New Art Examiner*, April; Laurie Palmer, 'Helen Mirra', *frieze*, May 2000 Karl Erikson, 'On Books: Helen Mirra', *New Art Examiner*, December 2001 Bill Meyer, 'Transmissions', *Chicago Tribune*, 14 August; Nancy Princenthal, 'Artist's Book Beat', *Art on Paper*, September; Susan Snodgrass, 'Helen Mirra', *Art in America*, December; James Yood, 'Helen Mirra', *Artforum*, September 2002 Ralph Rugoff, 'Falling with Style', *Sudden Glory*, CCAC Institute, San Francisco; Hamza Walker, 'Thread-skies', *Sky-wreck*, The Renaissance Society, Chicago

HELEN MIRRA

Given the disparate nature of her practice and her interest in language, the label 'Conceptual artist' suits Chicago-based Helen Mirra well. The components of her installations are often very simple, combining a textual element with a minimalist textile form. In addition, she has produced a sizeable output of film and video, audio recordings and artist's books, all of which bring to mind Fluxus works.

Like other prominent young artists of the past decade, however, Mirra has adopted and reconfigured Conceptual strategies so that they become the means to more narrative, personal and poetic ends. The rigorous form of her work is overshadowed by an unabashedly romantic if not downright cozy sensibility, befitting her favourite subjects: the sea, the landscape and childhood. These themes extend throughout her work, from the video *The Ballad of Myra Furrow* (1994) in which Mirra dresses as a sailor, performing nautical dirges sans accompaniment on a stormy lake Michigan, to her audio recording *Field Geometry* (2000), a homage to Friedrich Froebel, the inventor of the kindergarten.

These tropes unavoidably suffuse Mirra's minimalist installations with a sense of longing, a sentimental streak that can also be identified in the work of earlier Conceptualists from Bas Jan Ader to Felix Gonzalez-Torres. Mirra's work, however, is distinguished by an all-pervasive nostalgia for antediluvian forms of memory and imagination, be they those associated with childhood, or with a time when the seas held mystery, or a yesteryear when people used looms, typewriters, windmills and record players.

Beneath Mirra's preoccupation with the aural and linguistic is a keen disposition for the tactile. Her books and records (most notably the 1996 vinyl release *Stowaway*) are always warm to the touch, packaged and bound in nondescript, earthy materials (felt and/or a toothy, matte cardboard). Despite being industrially produced, these materials retain a sense of their natural as opposed to laboratory origins. In addition, she uses crafts – knitting and stitching – that translate the repetitious manual labour associated with rail and sail.

Based on the geometry of Buckminster Fuller and a short poem by Paul Celan, the indigo-cotton floorpiece *Sky-wreck* (2000) is the latest addition to a recent body of work – including *Portable Deck* (1999), *Map of Parallels* (1998) and *Sleepers* (2000) – about voyages, mapping and topologies. In many respects, *Sky-wreck*'s closest conceptual sibling is *Under Potemkin* (2000), a textual transcription of filmic imagery from Sergei Eisenstein's *Battleship Potemkin* (1925) typed onto a 16 mm strip of blue cloth neatly hung around the room at eye level so as to create a thin blue horizon line doubling as the expanse of sea and sky. This installation was not a spare poetry of the sublime, but a sublime poetry achieving more through less. Like *Sky-wreck*, *Under Potemkin* employs word and object as a referential tag-team, signifying an absence that our post-aesthetic imagination is meant to fill. By referring to filmic imagery, the text, printed directly on the object, activates the imagination's capacity for visualization, substituting something where once there was nothing.

Hamza Walker

Elm dropcover (*detail*), 2002
wool, 8 x 450 x 400 cm
Installation 'Declining Interval Lands', Whitney Museum of American Art, New York, 2002

Under Potemkin, 2000
ink on cotton, 1.5 cm x 70 m
Installation, 'Age of Influence', Museum of Contemporary Art, Chicago, 2000

Map of Parallel 52 degrees N at a scale of one inch to one degree (*detail*), 1998
cotton banding, 1.6 x 910 cm

Sky-wreck, Southwest 1%, 2000
carbon on paper, 44 x 54 cm

Sky-wreck (*detail*), 2000
indigo-dyed cotton, dimensions variable
Installation 'Sky-wreck', The Renaissance Society, Chicago, 2000

HELEN M

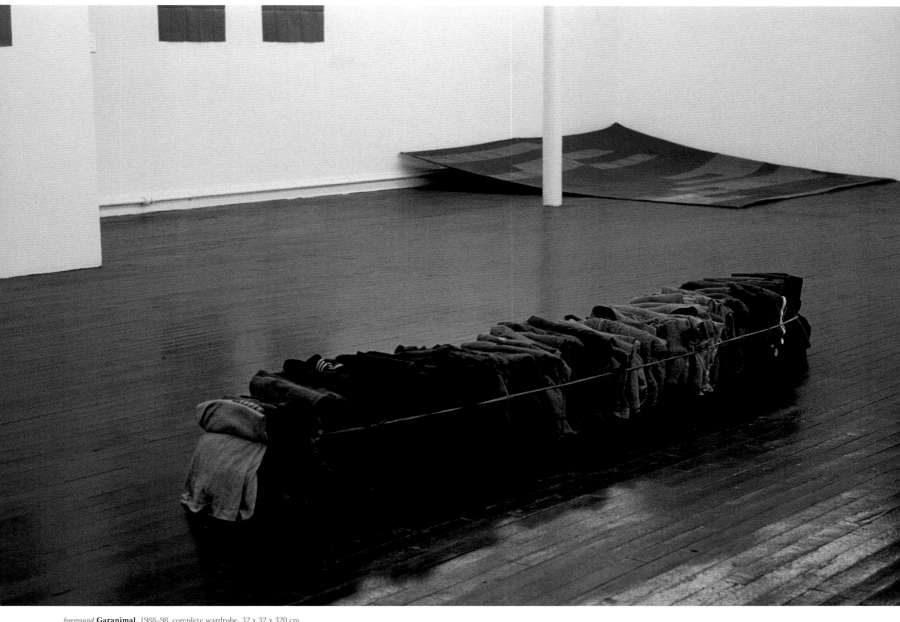

foreground **Garanimal**, 1988–98, complete wardrobe, 32 x 32 x 320 cm
background **Portable Deck**, 1999, corduroy, wool, 320 x 320 cm
Installation Chicago Project Room, 1999

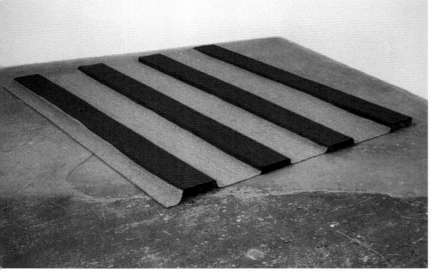

Sleepers (4), 2000
undyed wool, wood, 6 x 210 x 230 cm

Portable Deck (*detail*), 1999
corduroy, wool, 320 x 320 cm

231

Born Leicester, UK, 1969 Lives and works in Berlin, Germany

Selected Solo Exhibitions: 1992 'On the Cheap', Centre for Contemporary Arts, Glasgow 1995 'Lust for Life', Galleri Nicolai Wallner, Copenhagen 1997 'Anything by the Smiths', Centre d'Art Contemporain, Neuchatel 1998 Lisson Gallery, London 1999 'Meine Onkel', Meyer Riegger Galerie, Karlsruhe 2000 'Jonathan Monk: Tea Party at 36 + Other Works', Galerie Yvon Lambert, Paris 2002 Atelier Augarten, Österreichische Relvedere, Vienna; 'Jonathan Monk: How the World Works', Lieu d'Art Contemporain, Hameau du Lac

Selected Group Exhibitions: 'Contact', Transmission Gallery, Glasgow 1994 Galleri Nicolai Wallner, Copenhagen 1995 'Ideal Standard Summertime', Lisson Gallery, London 1997 'Des Histoires en Formes', Magasin, Grenoble 1999 Galerie Yvon Lambert, Paris 2000 5th Taipei Biennale; 'Film/Video Works', Lisson Gallery at 9 Keane Street, London; Casey Kaplan, New York 2001 'Ingenting', Rooseum Centre for Contemporary Art, Malmö 2002 'Jim, Jonathan, Kenny, Francis, and Sol', Stedelijk Museum Bureau, Amsterdam; 'Tableaux Vivant: Living Pictures + Attitudes in Photography, Film, and Video', Kunsthalle Wien, Vienna

Selected Bibliography: 1995 Rebecca Gordon-Nesbitt, 'Urban Myths', *Contemporary Visual Arts*, No. 17; Philip Sanderson, 'Ideal Standard Summertime', *Art Monthly*, No. 189 1997 Lars Modin, 'Jonathan Monk', *Magasin Schäfer*, No. 8 1998 Evelyne Jouanno, 'Jonathan Monk: Cote-Rüe', *Flash Art*, October; David Perreau, 'Jonathan Monk l'Initateur Chugalug the Beer, but Don't Swallow the Rules', *Art Press*, June 1999 Dave Beech, 'Jonathan Monk', *Art Monthly*, January 2000 Raimar Strange, 'Jonathan, Der Libero', *Kunst-Bulletin*, September; Stephanie Moisdon Trembley, 'Jonathan Monk', *Art Press*, July–August 2001 Axel Lapp, 'Berlin Biennale 2', *Art Monthly*, June; Raimundas Malasauskas, 'Their Trip Out West', *Newspaper Galerie Jan Mot*, March–April 2002 Michael Wilson, 'Jonathan Monk', *Artforum*, February

JONATHAN MONK

Jonathan Monk's work is all about the mixing of high and low sources. Art-historical references are blended with popular, personal or domestic ones. Thus the strategies of canonical modern and contemporary artists – Jackson Pollock, Marcel Duchamp, Andy Warhol, Lawrence Weiner, Gilbert & George, On Kawara and Agnes Martin – are either faithfully appropriated, freely interpreted or wholly inverted. These are juxtaposed with common household snapshots and stories relating to Monk's family and to the artist himself.

Robert Smithson's *Continuous Project Altered Daily* (1969) is directly referenced in Monk's *To Be Altered Daily* (2002), a slide projection of a domestic snapshot showing a boy alone on a dirt road, the image altered daily during the show in different ways – turned upside down, reversed, rendered smaller, larger, out of focus, subjected to all possible 'correct' and 'incorrect' representations. The 16 mm film *High School Boogie Woogie* (2002) consists of a looped animation of a Rubik's Cube being solved. The reference here is to Mondrian's celebrated paintings, *Broadway Boogie Woogie* (1942–3) and *Victory Boogie Woogie* (1942–4), densely packed compositions of squarish shapes in yellow, red, blue, black and white. Another high-art reference could be Sol LeWitt's grid-like sculptures of the 1960s. Yet what is truly represented here is a Rubik's Cube, an 'intelligent toy' that appeared in the mid-1970s, with which Monk may have played and perhaps, like most of us, never solved. Now he cheats the puzzle through art, achieving a balanced composition that repeatedly and magically constructs and deconstructs itself.

The use of family references is not merely autobiographical. Domestic stories and memories take on a wider role. There is a clever play on antecedents and predecessors in art history and personal history (after all, Monk has been called a 'grandson' of the Conceptualists, whom he mocks yet cannot but admire); an infusion of the personal into the Conceptual (something that links him to his 'uncle', the late Felix Gonzalez-Torres), and an attempt to bring humorous everyday and mundane references into the most intellectual of all art genres. Interestingly, transferring pleasure into hard-core Conceptualism has not necessarily created a divide between himself and his predecessors: LeWitt is known to have bought one of Monk's animations made after the master Minimalist's own drawings.

Monk draws from much more beyond his beloved artistic allusions, however. Three hundred of his 'references' are featured in his website (www.swissinstitute.net/Exhibitions/jmonk.htm), which include magazines like *frieze* and *The Face*; planes, trains, boats and bikes; Leicester City Football Club and The National Gallery; speed, LSD and mushrooms; Morrissey and Frank Sinatra; James Bond and Marilyn Monroe; the Empire State Building and the Eiffel Tower; Venice and Venice Beach … The list goes on, encompassing all things high and low, close to home and to art, at once improbably wide, and incredibly precise. In the end, Monk's work seems to focus on that place where all these references come together: life, his own and ours.

Adriano Pedrosa

To Be Altered Daily, 2002
slide projection, 48 alternatives

Day 1 - correct
Day 4 - side (right)
Day 17 - correct/smaller

Day 2 - upside down
Day 5 - reversed
Day 18 - upside down/smaller

Day 3 - side (left)
Day 16 - reversed side (right)/out of focus
Day 26 - upside down/out of focus/smaller

High School Boogie Woogie, 2002
projected cube, 15.87 cm³; 16 mm film, loop, 20 sec., colour, silent

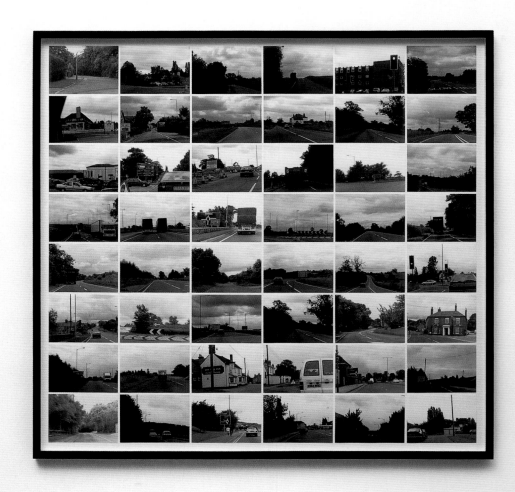

The gap between my mother and my sister, 1998
48 black and white photographic prints, 213.5 x 152.5 cm, text on paper, 29 x 29 cm

Shelf – Mantelpiece Piece, 1998
painted wood, postcards, 7.5 x 214 x 31 cm

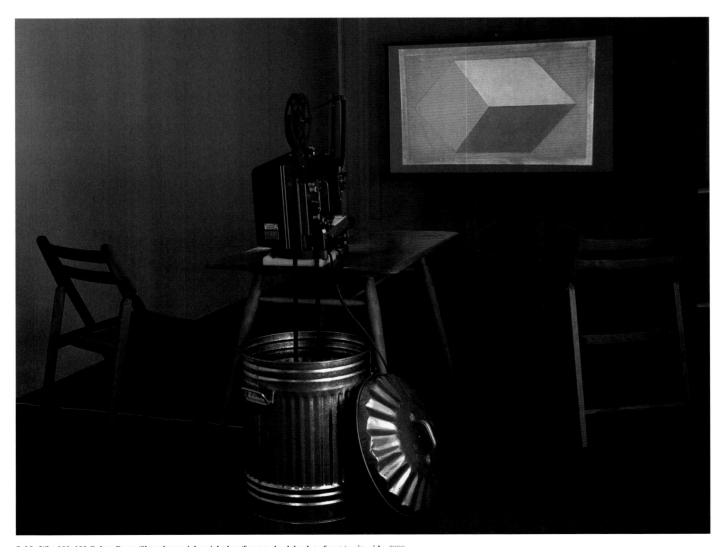

Sol LeWitt 100. 100 Cubes Cantz/Slow slow quick quick slow/front to back back to front/on its side, 2000
16 mm film loop, colour, silent
Installation 'Film/Video Works', Lisson Gallery at 9 Keane Street, London, 2000

Born Ottawa, Canada, 1965 Lives and works in Birmingham, USA

Selected Solo Exhibitions: 2000 'Friends and Enemies', Fredericks Freiser Gallery, New York 2001 'Domestic', Fredericks Freiser Gallery, New York 2002 'Friends and Enemies', The Contemporary Museum, Honolulu; 'The Hat Ladies', Birmingham Museum of Art, Alabama; 'Monsanto', The Renaissance Society, Chicago

Selected Group Exhibitions: 2000 'Collector's Choice', Exit Art Gallery, New York 2001 'Chelsea Rising', Contemporary Art Centre, New Orleans 2002 'Curators Forum: Collecting Contemporary Art', Ackland Art Museum, The University of North Carolina, Chapel Hill; 'Staging: Janieta Eyre, Julie Moos, Zwelethu Mthethwa', Contemporary Art Museum, St Louis; 'Visions from America: Photographs from the Whitney Museum of American Art 1940–2001', Whitney Museum of American Art, New York; Whitney Biennial, Whitney Museum of American Art, New York

Selected Bibliography: 2001 Donald Odili Odita, 'Julie Moos at Fredericks Freiser', *Flash Art*, January–February 2002 Brooks Barnes, 'Art & Money', *Wall Street Journal*, 15 July; Amie Barrondale, 'Odd Couples: Artist Julie Moos makes her own cliques', *Surface Magazine*, Fall; Shannon Fitzgerald, *Staging: Janieta Eyre, Julie Moos, Zwelethu Mthethwa*, Contemporary Art Museum, St Louis; Clare Henry, 'The art of listening carefully', *Financial Times*, 27 March; Robert Hobbs, '"I Got Freedom over My Head": Julie Moos' Hat Ladies of New Pilgrim Baptist Church', *Julie Moos: The Hat Ladies*, Birmingham Museum of Art, Alabama; Jordan Mejias, 'Raume, Stamme, Seinszustande', *Frankfurter Allgemeine Zeitung*, 27 March; Mark Stevens, 'Irony Lives, 2002 Biennial', *New York Magazine*, 18 March; Glen Waldron, 'Julie Moos', *i-D*, May; Hamza Walker, *Corporate America*, The Renaissance Society, Chicago

JULIE MOOS

Sporting a scarlet hat adorned with a magnificent display of crimson plumage, a matching satin-trimmed suit and elaborate costume jewellery, Mrs Taylor stares stonily at the camera, conveying a no-nonsense demeanour that contrasts with her gaudy attire. Her companion, Mrs Poole, wears a similar red outfit, but she seems somewhat meeker, less confident than her friend, overshadowed both by the brim of her diamanté-sprinkled boater and by Mrs Taylor's more splendid headgear. Almost always arranged in pairs, posed full-frontally before a neutral background, Julie Moos' subjects tend to invite the viewer to make such psychological and physical comparisons between them. We know nothing about the impeccably dressed women depicted in this series (*Hat Ladies*, 2000–1), except that they are all members of the New Pilgrim Baptist Church in Moos' home town of Birmingham, Alabama, where she photographed them over the course of eight consecutive Sundays. We must therefore rely on details of expression, dress and posture to satisfy our curiosity about who they are and their relationships with each other. Taking in Mrs Merritt's veiled and beribboned Nefertiti-style headdress, Mrs Rose's rakish sequinned beret and Mrs Pleasant's extravagant pink and green bonnet, it becomes clear that there is sartorial competition between these ladies, and that their manner of dress attests to the seriousness with which they take their worshipping. It is thus possible to start to form an idea of this community, its mores, beliefs and behaviours.

In other series, Moos has similarly focused on different social groups, using the same dead-pan but strangely revealing format to elucidate a specific cultural milieu through its individual members. *Friends and Enemies* (1999–2000), for example, honed in on a group of adolescent high-school students, their sullen expressions barely concealing their vulnerability. Moos made these pictures at the invitation of the school principal, spending several months researching and interviewing her subjects, then dividing them into pairs of friends, enemies or strangers. Taken not long after the shootings at Columbine High School in Colorado, they remind one of the intense rivalries, friendships and other interpersonal relationships that dominate high-school life, even though, as always, her subjects never interact with each other. *Domestic* (2001) took as its theme the relationship between wealthy Birmingham residents and their housekeepers. While exploring, in Moos' words, 'the personal bond between employer and employee', they also bring into play the tension surrounding hierarchy, race and class.

For all these works, which are almost life-size in scale, Moos set up on-site studios, using a 4 x 5 camera and simple lighting. This straightforward style recalls the portraiture of earlier generations of photographers. *Hat Ladies*, for example, is reminiscent of the studio portraits of people dressed up in their finest clothes taken by Seydou Keïta in Mali during the 1940s and 1950s. Moos' most recent group of works, however, titled *Monsanto* (2001), go out of the studio into the outdoors. Here, pairs of farmers who work for the Monsanto Company on genetically modified crops are photographed standing in fields, again recalling an older photographic tradition – the iconic farmer in the American landscape.

Hamza Walker

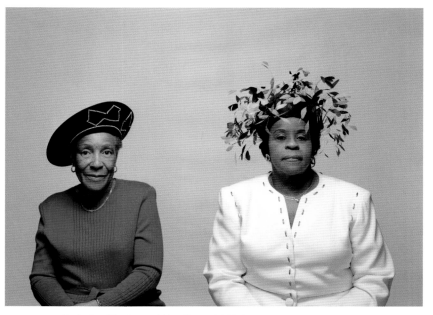

Hat Ladies (Mrs. Rose and Mrs. Pleasant), 2000–1
C-type photograph, 101.5 x 132 cm

Hat Ladies (Mrs. Merritt and Mrs. Crum), 2000–1
C-type photograph, 101.5 x 132 cm

Hat Ladies (Mrs. Taylor and Mrs. Poole), 2000–1
C-type photograph, 101.5 x 132 cm

Domestic (Martin and Raymond), 2001
C-type photograph, 101.5 x 132 cm

Domestic (Bell and Beebe), 2001
C-type photograph, 101.5 x 132 cm

Domestic (Lillie and Scott), 2001
C-type photograph, 101.5 x 132 cm

Monsanto (Resa and Phil), 2001
C-print mounted on Plexiglas, 178 x 232 cm

Monsanto (Ralph and Doug), 2001
C-print mounted on Plexiglas, 178 x 232 cm

Monsanto (CJ and Craig), 2001
C-print mounted on Plexiglas, 178 x 232 cm

Born Hirosaki, Japan, 1959 Lives and works in Tokyo, Japan

Selected Solo Exhibitions: 1995 'Cup Kids', The Museum of Contemporary Art, Nagoya; 'In The Deepest Puddle', SCAI The Bathhouse, Tokyo 1998 Institute of Visual Arts, University of Wisconsin 1999 'Somebody Whispers in Nurnberg', Institute für Moderne Kunst Nürnberg, Nuremberg 2000 'Lullaby Supermarket', Santa Monica Museum of Art; 'Walk On', Museum of Contemporary Art, Chicago 2001 'I Don't Mind, If You Forget Me', Yokohama Museum of Art; 'In The White Room', Blum & Poe, Santa Monica

Selected Group Exhibitions: 1996 'Ironic Fantasy: Another World by Five Contemporary Artists', The Miyagi Museum of Art; 'Tokyo Pop', The Hiratsuka Museum of Art 1999 'Almost Warm and Fuzzy: Childhood and Contemporary Art', Des Moines Art Center; 'New Modernism for a New Millennium', Museum of Modern Art, San Francisco 2000 'Dark Mirrors of Japan', De Appel, Amsterdam 2001

'Public Offerings', Museum of Contemporary Art, Los Angeles; 'Superflat', Museum of Contemporary Art, Los Angeles 2002 'Drawing Now: Eight Propositions', The Museum of Modern Art, New York

Selected Bibliography: 1995 David Pagel, 'Review', *Los Angeles Times*, 27 July 1997 Michael Darling, 'Yoshitomo Nara', *frieze*, November–December 1998 Maru Sanders/Fumiya Sawa, 'Toy Stories', *Dazed & Confused*, April 1999 Roberta Smith, 'Yoshitomo Nara', *The New York Times*, 5 November 2001 Michael Darling, 'Plumbing the Depths of Superflatness', *Art Journal*, Fall; Midori Matsui, 'Yoshitomo Nara with Midori Matsui', *Index*, February–March; 'Special Feature: Yoshitomo Nara', *Bijutsu Techo*, December; Stephan Trescher, 'My Life as a Dog', *Yoshitomo Nara: Lullaby Supermarket*, Institute für Moderne Kunst Nürnberg/Kadokawa Shoten, Nuremberg

YOSHITOMO NARA

Since the early 1990s, Yoshitomo Nara has created drawings, sculptures, paintings and books that explore the vocabulary of Japanese pop. His cartoon-like works depict round-faced boys and girls, bunnies, kittens, dogs on stilts, and range from drawings inspired by Manga comic books to life-size pastel sculptures of characters resembling relatives of Hello Kitty and My Melody. But despite their candy colours and storybook origins, Nara's works are far from innocent: many of his animals wear angry, bitter expressions, and one girl even clutches a knife.

Nara's creations foreground a crucial difference between Western and Japanese conceptions of childhood: unlike Japan, the West has insisted on portraying children as angelic, virginal beings who inhabit a world of pure good and are untouched by the evils of adulthood. But as thinkers from Sigmund Freud to Melanie Klein to Michel Foucault have pointed out, the vision of childhood as an innocent age is little more than an adult fantasy: children, too, are sexual beings, and often – since they have not yet internalized societal rules and taboos – their capacity for aggression and destruction far surpasses that of adults. Japanese culture gladly acknowledges the dark side of childhood: representations of boys and girls tend to highlight their sexuality (think of the fetishization of schoolgirl uniforms), as well as the intensity of their aggressive drive, as seen in the martial-arts video games and comic books that scandalize American censors.

But not all of Nara's works are about children: he has also devoted numerous pieces to exploring the meaning of traditional Japanese iconography at a time when life in Tokyo has more in common with downtown New York than with the long-gone world of geishas and samurais. Nara is especially interested in appropriating and reworking the iconography of *ukiyo-e* prints – the famous Edo-period woodcuts depicting geishas, kabuki actors and demons. *Ukiyo-e* means 'pictures of the floating world', and as the name implies, they depict the flighty world of pleasure that flourished in the entertainment districts of Japanese cities in the 1700s and 1800s. Though artists like Utamaro and Sharaku conceived most of these images of courtesans and actors as clearly erotic works, the modern viewer – especially if non-Japanese – tends to miss the sexual connotations and usually interprets them as lofty examples of high art. In his re-elaborations of *ukiyo-e* prints, Nara inserts modern objects that expose the salacious undertones already present in the original works: in his pastiche of Utamaro's *The Fancy-Free Type* (1792–3), a geisha appears with a breast exposed, carrying a sign that reads 'No Fun'; and in his rendition of Sharaku's *The Actor Ichikawa as Takemura Sadanoshin* (1794–5) the Kabuki actor sports a punk hairdo, spikes and earrings. Though a Western viewer might judge these interventions irreverent, Nara has merely emphasized the themes that were already present in the originals. As he shows, the Old Masters were also interested in transgressive subcultures.

Rubén Gallo

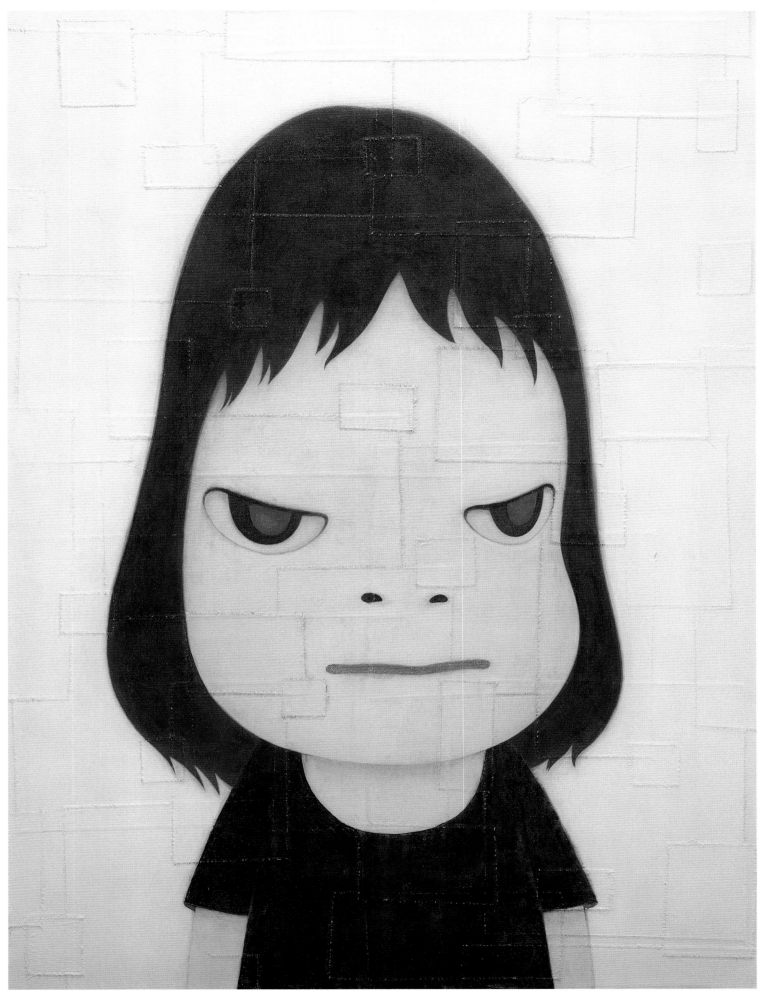

Little Ramona, 2001
acrylic on cotton, 130 x 97 cm

The Little Pilgrims (Night Walking), 1999
fibreglass, cotton cloth, acrylic paint, each 71 x 48 x 48 cm

Dogs From Your Childhood, 1999
fibreglass, wood, fabric, acrylic paint, each 183 x 152 x 102 cm

I Don't Mind If You Forget Me, 2001
Plexiglas, stuffed animals, figurines, plywood, various toys
upper part 57 x 745 x 33.5 cm; lower part 54 x 745 x 33.5 cm

Pee – Dead of Night, 2001
acrylic on cotton, 80.5 x 91 cm

Too Young to Die, 2001
acrylic on cotton mounted on fibre-reinforced plastic h. 26 x Ø 180 cm

Born Tokyo, Japan, 1968 Lives and works in Ho Chi Minh City, Vietnam

Selected Solo Exhibitions: 1995 'New Works 95:02, Jun Nguyen-Hatsushiba', ArtPace, San Antonio 1997 'Dream', 29 Hang Bai Exhibition House, Hanoi 1998 'Individuals-Collections', Mizuma Art Gallery, Tokyo 2000 'Xich Lo 2001 – The Making of Alternative History', Mizuma Art Gallery, Tokyo 2002 'Jun Nguyen-Hatsushiba: Towards the Complex', Galeria Animal, Santiago; 'Memorial Project Minamata: Neither Either nor Neither – A Love Story', Mizuma Art Gallery, Tokyo; 'Towards the Complex', De Appel, Amsterdam 2003 'Matrix 2003: Jun Nguyen-Hatsushiba, Memorial Project Nha Trang, Vietnam: Towards the Compex', UC Berkeley Art Museum, California; 'Jun Nguyen-Hatsushiba: Memorial Project Nha Trang, Vietnam: Towards the Complex', New Museum of Contemporary Art, New York/MIT List Visual Arts Center, Cambridge, Massachusetts

Selected Group Exhibitions: 1999 'Gap Vietnam', The House of World Cultures, Berlin 2000 3rd Gwangju Biennale 'Invisible Boundary: Metamorphosed Asian Art', Utsunomiya Museum of Art, Japan 2001 1st International Triennale of Contemporary Art, Yokohama 2002 1st Busan Biennale; 13th Sydney Biennale; XXV São Paulo Biennale; 'Attitude 2002', Contemporary Art Museum of Kumamoto, Japan; 'Video Cube: Jun Nguyen-Hatsushiba', FIAC 2002, Paris 2003 8th Istanbul Biennale; 'The Moderns', Castello di Rivoli Museo d'Arte Contemporanea, Turin

Selected Bibliography: 2001 Daniel Birnbaum, 'Best of 2001', *Artforum*, December; Massimiliano Gioni, 'Speaking in Tongues', *Flash Art*, November–December; *Yokohama 2001, International Triennale of Contemporary Art*, Tokyo 2002 Nico Israel, 'XXV Biennale de São Paulo', *Artforum*, Summer; Ewen McDonald (ed.), *2002 Biennale of Sydney: (The World May Be) Fantastic*, Sydney; Christopher Phillips, 'Crosscurrents in Yokohama', *Art in America*, January; *XXV Biennale de São Paulo: Iconografias*, Metropolitanas, Paises

JUN NGUYEN-HATSUSHIBA

Jun Nguyen-Hatsushiba has been making work since the mid-1990s, but has been exhibiting internationally only recently. His early performances, sculptures and photographic works dealt with 'social debris' and the celebration of apparently unimportant events. *Rice Around Motorcycle Track* (1994), for example, was a photograph showing tyre marks picked out with grains of rice.

The *Memorial Project* video trilogy, made between 2001 and 2003, commemorates a specific historical trauma: the already near-forgotten tragedy of the Vietnamese 'boat people', homeless refugees wandering the Pacific at the close of the Vietnam War. This unjustifiable catastrophe of human suffering occurred while Nguyen was growing up between Vietnam, Japan and the United States. He explores his subject through a series of metaphorical performances shot underwater. These beautiful, dreamlike works recalling Impressionist paintings suggest the paradoxes and problems of being 'in-between' – in-between cultures, feelings and historical periods – life as a passage forever unresolved.

For the first work in the trilogy, *Memorial Project Nha Trang, Vietnam: Towards the Complex – For the Courageous, the Curious, and the Cowards* (2001), he collaborated with a group of fishermen, who drove into the sea on 'cyclos' – three-wheeled man-powered vehicles. Deep below the surface, they anchored mosquito nets to the seabed, thus creating an underwater memorial. The laborious process of peddling through the murky depths suggests the muted, slowly turning mechanisms of memory, as recollections surface or fall away. Without diving equipment, the fishermen struggle to hold their breath – reminding the viewer of the many boat people who drowned. Nguyen-Hatsushiba's vision demonstrates the absurd struggle of life, softened and diffused as if seen through the thin woven mesh of a mosquito net.

In autumn 2002, the artist premiered the third part of the trilogy, the performance/video *Memorial Project Minamata: Neither Either nor Neither – A Love Story*, in memory of the victims of Minamata disease, caused by mercury poisoning due to industrial pollution. In spring 2003 he completed the second part: *Happy New Year – Memorial Project Vietnam II* (2003), a pictorial narrative featuring underwater 'fireworks', performers and sculptural props created by the artist. These include a 'fate machine', or large circular object that works like a lottery, randomly releasing spherical capsules of air and coloured powder that explode while rising to the surface. Also involved was a large, colourful paper and fabric dragon that danced underwater, slowly disintegrating while activated by the fishermen. These props make reference both to human destiny in general and to the surprise Tet offensive during the Vietnam War, which took place in 1968 during the Chinese New Year, and which had an enormous impact on the conflict, ultimately leading to the Vietcong victory of 1975. In these works Nguyen-Hatsushiba recalls, memorializes and ponders the mysteries of human interaction and history. Carolyn Christov-Bakargiev

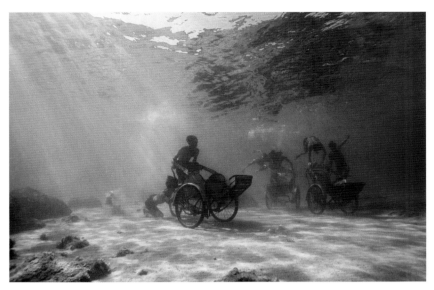

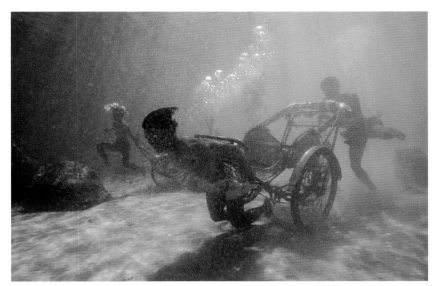

Memorial Project Nha Trang, Vietnam: Towards the Complex – For the Courageous, The Curious, and the Cowards, 2001 (location still)
video, 13 min., colour, sound

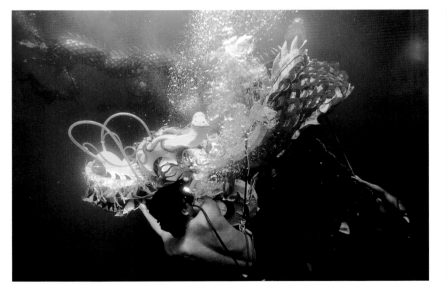

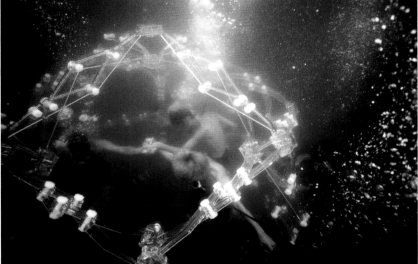

Happy New Year: Memorial Project Vietnam II, 2003 (location still)
video, colour, sound

Memorial Project Minamata: Neither Either nor Neither – A Love Story, 2002 (location still)
video, 16 min., colour, sound

Face Series from the project Lich Lo 2001: The Making of Alternative History, 2000
digital print on FujiColor Crystal Archive paper, 25 x 38 cm

Thinker, Dreamer and Whatever, 1997
3 live chickens, mosquito net, wire
Installation 'Dream', 29 Hang Bai Exhibition House, Hanoi, 1997

Rice Door, 1994
cooked rice on door, dimensions variable

Rice Tree, 1995
cooked rice on seed pods
Installation, 'New Works 95:02, Jun Nguyen–Hatsushiba', ArtPace, San Antonio, 1995

Shore – Arriving, Departing, 1996
charcoal briquettes, rice, dimensions variable
Installation Brookhaven College Studio Gallery, Dallas, 1996

Born Karl-Marx-Stadt, Germany, 1965 Lives and works in Berlin and Chemnitz, Germany

Selected Solo Exhibitions: 1986 Galerie EIGEN + ART, Leipzig 1997 Galerie EIGEN + ART, Berlin and Leipzig; Städtisches Kunstmuseum Spendhaus Reutlingen, Germany 1998 'polyfoto', Galerie für Zeitgenössische Kunst, Leipzig 1999 1% Space, Copenhagen; 'Produktionen 1999/2000', Kunsthalle Vierseithof, Luckenwalde 2000 Galerie EIGEN + ART, Berlin; 'Polar' (with Marko Peljan), Canon Artlab 10, Tokyo 2001 Art Gallery of New South Wales, Sydney; Galerie EIGEN + ART, Berlin; Milch, London; Paolo Curti & Co., Milan 2002 2nd Buenos Aires Biennale; Watari-Un Museum of Contemporary Art, Tokyo

Selected Group Exhibitions: 1997 Documenta X, Kassel 1999 'Examining Pictures', Whitechapel Art Gallery, London; 'Empty Garden', Watari-Un Museum of Contemporary Art, Tokyo 2000 'Audible Light', Museum of Modern Art, Oxford; 'Volume', PS.1 Contemporary Art Center, New York 2001 'Art/Music: Rock, Pop, Punk, Techno', Museum of Contemporary Art, Sydney; 'Perspectives', MICAMOCA, Milan; 'Wild Zone', Witte de With Centre for Contemporary Art, Rotterdam 2002 'Frequenzen (hz)', Schirn Kunsthalle, Frankfurt

Selected Bibliography: 1998 Peter Guth, 'Modelle für ein Leben im Zwischenraum', *Frankfurter Allgemeine Zeitung*, 30 July; Martin Pesch, 'Galerie für Zeitgenössische Kunst', *frieze*, No. 42 1999 Stephan Koehler, 'Watari-un cultivates creative spaces', *The Japan Times*, 16 May; Ben Ratcliff, 'Fluffs, Tremors and Skeletal Noises', *The New York Times*, 29 January 2000 David Briers, 'Audible Light', *Art Monthly*, March; 'Welcome to the ear-splitting, eye-popping disco', *The Times*, 26 April 2001 Luca Cerizza, '10,30,65 hertz: Carsten Nicolai', *tema celeste*, Summer; Luca Cerizza, *An Introduction to the World of Carsten Nicolai*, Witte de With Centre for Contemporary Art, Rotterdam; Claudia Wahjudi, 'Carsten Nicolai: System aus Klang und Bild', *Kunstforum International*, June–July 2002 Miki Nakayama, 'Parallel lines cross at infinity', *Sound & Recording Magazine*, July

CARSTEN NICOLAI

Carsten Nicolai is not only a visual artist whose work ranges from painting to installations, but also a sound artist who owns a record label. Through his work he searches for a sense of organic continuity in both form and sound, transcending existing genres. Due to his unique aesthetic he succeeds in uniting science and digital technology with the arts. As a result, the viewer discovers a totally different aspect of everyday space. Things are stripped to their basic materials and structure both in his visually minimalist paintings and installations, with their focus on light and transparency, and in his acoustic work, in which everything is reduced to pure sound waves.

Nicolai's technique can be described as 'audible plastic'. First he captures sound as a material and then converts it into something that can be touched and looked at, as if using it to carve out space as one would with sculpture. *Milch* (Milk) (2000), for example, is a photographic work that depicts the geometric patterns formed on the surface of milk as a result of the vibrations created by applying sound at varying frequencies. The work enables the observer to experience visually the scientific fact that sound is actually air vibrating. In *Kerne* (1998), water in containers placed on sheets of glass and rubber vibrates as a result of sound pulses projected from speakers. The liquid's surface undergoes diverse changes depending on the position and movement of the observer, hinting at the existence of massive, undulating waves that are normally invisible to us. *Telefunken* (2000) is another example of

Nicolai's transformation of sonic information into visual information. A CD player is connected to a television monitor, its sound data converted into moving images that alter in accordance with the changes in frequency transmitted by digital sound signals. Infinite variations on this calm 'minimalist painting' in monochromatic parallel lines develop in front of the viewer.

Nicolai is conscious of the structure of 'things' and their relationship with our perception. *Realistic* (1998) consists of recordings of every sound in an environment onto a tape recorder using a high-sensitivity microphone, a diagram by the scientist Takashi Ikegami explaining loop construction and self-organization, tapes hung on the wall, and Polaroid shots of the tape. Each stores memories of the surrounding environment, including sounds beyond the audible range, randomly superimposed. This work acts as a metaphor for our recollections, and for the process by which the errors generated during the course of recording them induce an intelligent creativity.

Nicolai's interest in collaborations with scientists is represented by *Snow Noise* (2001). The catalyst for this work was the research on snow conducted by Ukichiro Nakaya. Nicolai focused on the fact that crystals cannot be created without a medium (impurities in the air) and that although there is a specific pattern in crystallization, it is impossible to predict which one will be created. In this work, gallery visitors could participate in an experimental and creative process by making their own snow crystals to the accompaniment of white noise.

Yuko Hasegawa

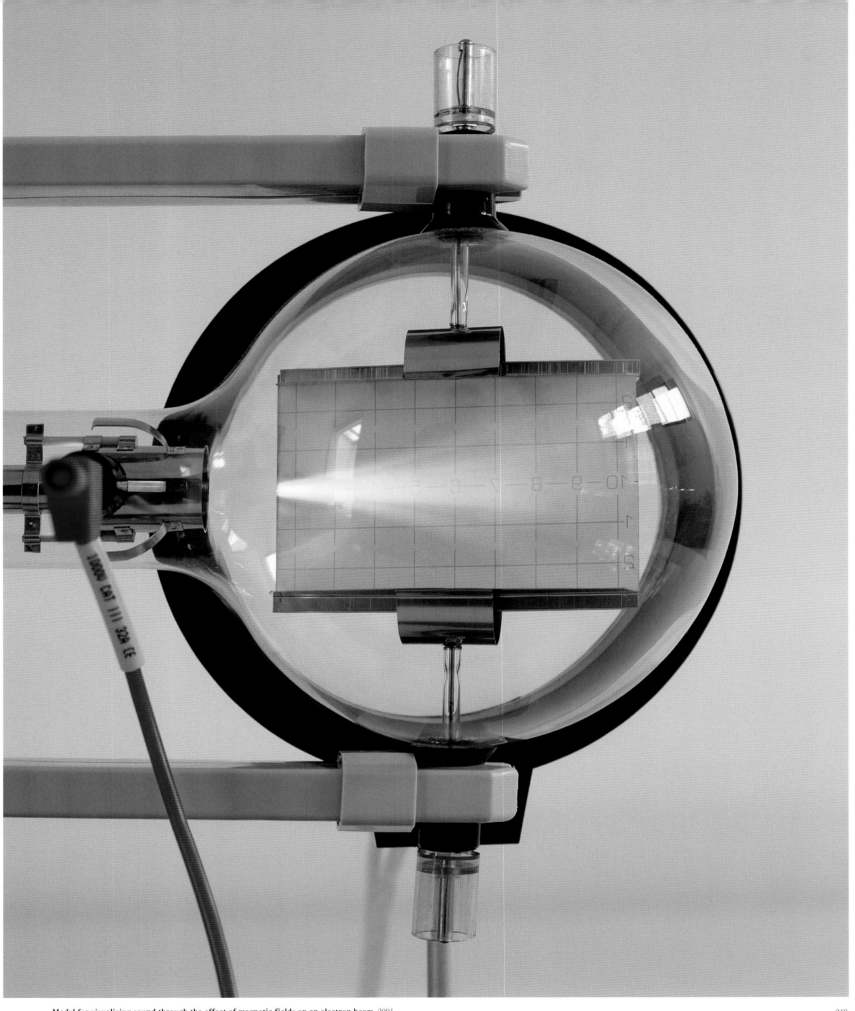

Model for visualizing sound through the effect of magnetic fields on an electron beam, 2001
electron-beam tube, magnetic field, loudspeakers, amplifier, CD, CD player, light table, various cables, dimensions variable
Collection 21st Century Museum of Contemporary Art, Kanazawa

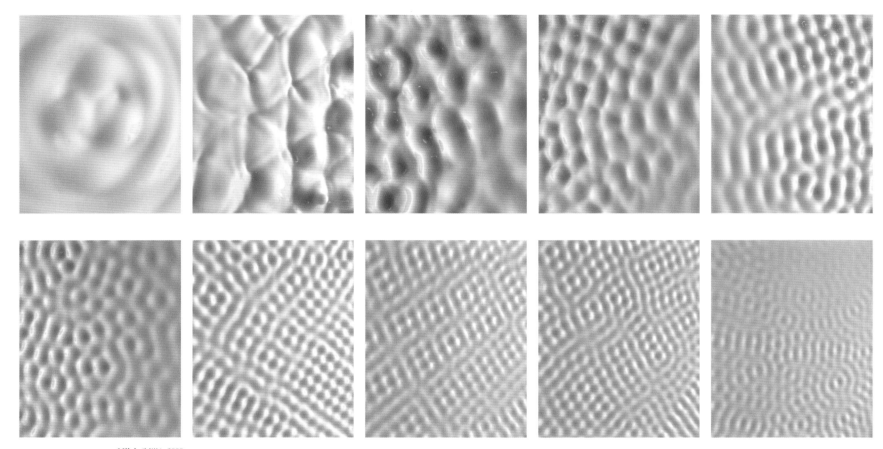

Milch (Milk), 2000
Cibachrome mounted on aluminium, 68 x 55 cm
10 hz, 20 hz, 25 hz, 40 hz, 50 hz, 55 hz, 80 hz, 95 hz, 100 hz, 110 hz

Wellenwanne, 2001
wave baths, speakers, amplifiers, CD, CD player, light table, various cables
Installation Witte de With Centre for Contemporary Art, Rotterdam, 2001

CARSTEN NIC

Frozen Water, 2000
modular tables, glass flasks, distilled water, Bose sub-woofer acoustic wave canon, Bose amplifier, Bose controller, modular system, audio mixer, dimensions variable
Installation 49th Venice Biennale, 2001

Snow Noise (*detail*), 2001
acrylic tubes, polystyrene boxes with copper tubes, dry ice, magnifying lamps, acrylic and
steel tables, gloves, wall drawing, random noise generators, instructions, dimensions variable

Born Halle an der Saale, Germany, 1962 Lives and works in Berlin, Germany

Selected Solo Exhibitions: 1999 'Labyrinth', Galerie für Zeitgenössische Kunst, Leipzig; 'Parfum für Bäume', Bundesgartenschau, Magdeburg 2000 '… fading in, fading out, fading away …', Westfälischer Kunstverein, Münster; 'Pantone wall, instrumented and odds and ends', Kunstverein Bonn; 'A Portrait of the Artist as a Weeping Narcissus', Galerie EIGEN + ART, Berlin 2001 'Enjoy Survive Enjoy', Migros Museum for Contemporary Art, Zürich; 'Favorites', Galerie für Zeitgenössische Kunst, Leipzig; 'Territories (1, 2, 3)', Galerie EIGEN + ART, Leipzig

Selected Group Exhibitions: 2001 49th Venice Biennale; 'Casino 2001', Stedelijk Museum voor Aktuele Kunst, Gent; 'Sous les Ponts, le long de la Riviere …', Casino Luxembourg, Forum d'Art Contemporain, Luxembourg; 'Squatters', Museu Serralves, Porto/Witte de With, Rotterdam 2002 4th Gwangju Biennale; 13th Sydney Biennale; 'Empty Gardens', Watari-Un Museum of Contemporary Art, Tokyo; 'Kunst in der Stadt III', Kunsthaus, Bregenz; 'Landscape out of frame', MIT List Visual Art Centre, Cambridge, Massachusetts; 'Skulpturenbiennale 1999', Munster; 'What if – Art on the verge of architecture and design', Moderna Museet, Stockholm

Selected Bibliography: 1994 Olaf Nicolai, 'Sammlers Blick', *Verlag der Kunst*, Amsterdam/Dresden 1997 Olaf Nicolai, 'Landschaft/Interieur', *Politics – Poetics. Das Buch zur Documenta X*, Cantz Verlag, Ostfildern; Pierre Restany, 'The Art System in the Face of Global Culture', *Domus*, June 1998 Igor Zabel 'Production of Nature', *Annual Catalogue of the Skuc Gallery*, Ljubljana 1999 'Olaf Nicolai', *Kunstforum International*, Vol. 146 2001 Harald Fricke, 'Olaf Nicolai', *Artforum*, Summer; Holger Liebs, 'House Style', *frieze*, January–February; Olaf Nicolai, *Enjoy/Survive*, Verlag die Gestalten, Berlin; Jan Wenzel, 'SUBJEKT/PRODUKT: Interview with Olaf Nicolai', *Spector*, March

OLAF NICOLAI

One of the key elements in Nicolai's work is the concept of design, with its ability to define the essence of an object destined for mass (re)production. In *Möbel/Skulptur, nach Donald Judd* (2000), he addressed this idea by publishing designs that make it possible for anyone to make a 'Donald Judd' sculpture. Nicolai produced several such sculptures himself, which doubled as furniture for exhibition visitors to sit on. The particular irony of this act lay in the fact that it reversed and exposed the principles of mass production behind these exclusive objects. In *Untitled (Blutstropfen)* (2001), shown at the 49th Venice Biennale, he explored similar notions of reduction and reproduction by isolating a detail (a drop of blood) from a medieval painting and using it as a repetitive pattern in wallpaper.

This approach can also be applied to nature. In several of his works Nicolai has demonstrated how natural forms can be produced and designed. An obvious example is his use of repetitive decorative patterns based on plant forms in works like *Kabinet/ Landschaft* (1997). He seems to refer in these pieces to the tradition of idealistic thought that has historically searched for the essence behind the 'accidental' appearance of natural forms. What he also shows, however, is how this approach can be adopted in highly practical modern arenas such as mass industry, which searches for 'essential' relationships in nature in order to establish models that can be extracted and utilized for reproduction.

An essential aspect of design is its formal perfection and visual appeal. Nicolai's works often have a strong visual presence, demonstrating through their combination of basic elements how such eye-catching qualities are produced. The allure of the designed object is connected to the fact that it arouses our desire. Like nature, desire can be produced, directed and included in systems of production and reproduction, which essentially means the systems of power. This point is made in Nicolai's book *STILL LIFE: A Sampler* (1999), which allows readers to produce their ideal identities through the combination of clothes, architecture, furniture, books and other lifestyle accessories.

Nicolai is not only interested in the ways in which we use and participate in design, but also how we can change and rearrange it. His approach has been compared to 'sampling' or 'mixing', allowing for endless reproductions of sounds and images. Yet he is critical of such comparisons. He sees cultural imagery as a way of organizing our emotions and decisions, and therefore his arrangement of these signs, objects and activities is not just play; it is intended to open new perspectives for acting and thinking. His *RACETRACK, after M.D. Or: a metre is a metre isn't a metre* (1999) reveals an almost utopian belief in the possibility of dissent, openness and freedom. Each track is a different shape but the same length, indicating that the patterns pre-determining our behaviour can be modified. Igor Zabel

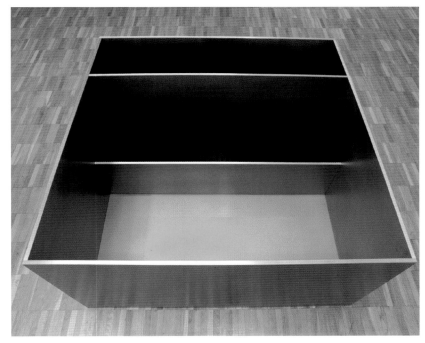

Möbel/Skulptur, nach Donald Judd I, **II**, **III**, **IV**, 2000
4 objects: aluminium and coloured acrylic glass, each 100 x 100 x 500 cm
Installation Galerie für Zeitgenössische Kunst, Leipzig, 2001

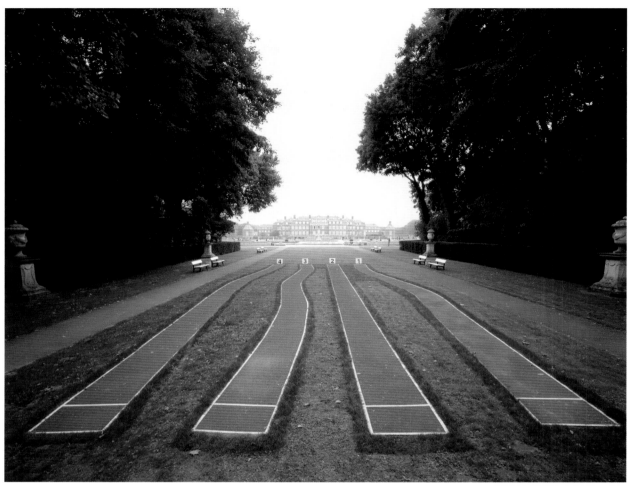

RACETRACK, after M.D., or: a metre is a metre isn't a metre, 1999
4 concrete start blocks, 4 tracks with white markings, each 100 x 27 cm
Permanent installation, Schloss Nordkirchen, Münster, 1999

Enjoy/Survive I and **II** *(right)*, 2001
slide lightboxes, each h. 35 x Ø 210 cm

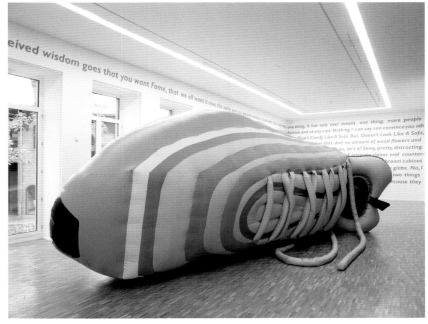

Big Sneaker (The Nineties) 2001–2
tarpaulin, foam interior, with text by Sadie Smith, 4 x 9 x 3 m
Installation Galerie für Zeitgenössische Kunst, Leipzig, 2001–2

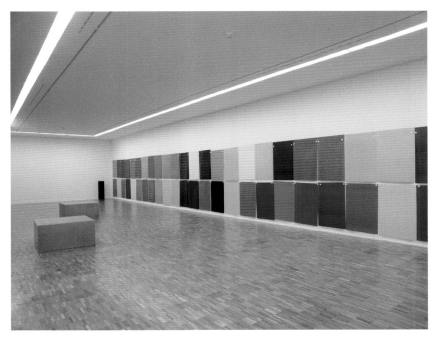

30 Farben/Poster 30 +30, 2001
magnets, magnetic tape, 6-track CD composed by To rococo rot, 30 posters, each 100 x 70 cm
Installation Galerie für Zeitgenössische Kunst, Leipzig, 2001

Bubblegram, a Street Surfing Painting, 1999
street-marking paint on bitumen, 25 x 40 m

Born Kyoto, Japan, 1972 Lives and works in Tokyo, Japan

Selected Solo Exhibitions: 1997 'Phantom Limb', P-House, Tokyo 1998 'Transfiguration', Röntgen Kunstraum, Tokyo 2001 'En Melody', Fine Art Rafael Vostell, Berlin/Marella Art Contemporanea, Milan

Selected Group Exhibitions: 1997 'Potential of Sculpture', Tokyo National University of Art and Music 1998 'Reality Tama Vivant '98', Tama Art University, Tokyo 1999 'Fancy Dance', Songe Art Centre, Kyongju; 'Ground Zero Japan', Contemporary Art Gallery, Art Tower Mito, Ibaragi; 'Guarene Art 99', Fondazione Sandretto Re Rebaudengo per l'Arte, Turin; 'Net_Condition', NTT InterCommunication Centre (ICC) 2000 5th Lyon Biennale 2001 4th Gwangju Biennale; 7th Istanbul Biennale; 'Cast Cycle', SCAI The Bathhouse, Tokyo; 'Translated Acts', Haus der Kulturen der Welt, Berlin

Selected Bibliography: 1997 Monty DiPietro, 'Soap Bubbles Bursting with Blood', *Asahi Evening News Weekend*, 6 November; Chikako Ikeda, 'Konoyo ha nani wo hikari toshite irunoka', *Lady's Slipper* No. 8 1998 Natumi Araki, 'Odani Motohiko/Phantom Limb/P-House, *Bijutsu Techo*, February; Noi Sawaragi, 'Geijutsu ha gyagu manga ka inaka', *Esquire*, February 2000 Yuko Hasegawa, 'Odani Motohiko', *Bijutsu Techo*, January; Noi Sawaragi, 'Motohiko Odani', *Ground Zero Japan*, Contemporary Art Gallery, Art Tower Mito, Ibaragi

MOTOHIKO ODANI

Motohiko Odani grew up in Kyoto, receiving formal training in wood-carving at art school. Born in 1972, he belongs to a generation of visual artists that shares a sense of material loss, an absence of substance in an increasingly digitized age. Aware of this, Odani attempts through the act of 'carving' – using a range of media and approaches – to explore new options for what he calls the 'restrictive' aspects of sculpture, placing a strong emphasis on surfaces.

The photographic work *Phantom-Limb* (1997) reflects this sense of missing physical tactility. A young girl in a hypnotic state appears to float against a pure white background, her arms outstretched. Her palms are stained red with raspberries clenched in her fists, but there is also the sense that her hands could have been amputated ('phantom limb' phenomenon is a state whereby an amputee continues to feel sensation in a limb that no longer exists).

Drape (1998) is a sculpture in which the pleats of a circular skirt are carved with elaborate workmanship into hard willow, and appear to be floating in mid-air or on water. Odani has said that his art is influenced by Rebecca Horn's performative 'wearable sculpture', and it can certainly be seen within this context. However, this work, where the wearer's hair appears to be connected to the pleats of her skirt, seems more to convey a process of bodily mutation. Similarly, *Fingerspanner* (1998) is a hybrid sculpture in which a corrective device used by pianists to strengthen their fingers has been fused with a violin-shaped form. In this sense, Odani's interest is similar to that of Matthew Barney: the process of formation and transformation rather than the static finished form.

Odani's criticism of the concept of sculpture as a fixed entity is evident not only in his use of suspension and anti-gravity but also in his subject matter. His proposition is to sculpt air – to carve the immaterial. In the video work *Engulf*, waves are split symmetrically down the centre of the screen, while the horizontal line of the beach is vertical. The crashing rollers, accompanied by sound effects that create a deafening roar, have a violence and ferocity that resembles a chainsaw carving up the air. This work represents a challenge to the limitations of digital imagery – a hazardous interaction between the moving image and sculpture. Meanwhile, the 3.4 metre-high wooden sculpture *Air 'Fall'* (1999) has been carved to depict grotesque baroque 'folds' of water. This is not a stylized representation of falling water, but a representation that has been frozen in time, as if depicted when the video camera's freeze button was pressed. The acts of sculpting, filming and seeing have thus become fused.

9th Room (2001) is a video installation comprising a series of monitors and surround speakers set into four screens and the floor. The title is inspired by Dante's *Inferno*. Through the use of mirrors on the ceiling and floor, images of crashing waterfalls and spraying blood are repeated endlessly both above and below us, creating a dizzying experience in which the vibrating air, sound and images are etched into the viewer's physical senses. Eventually one becomes aware of a different version of one's body, realizing that this is a device for sculpting the observer. Yuko Hasegawa

Drape, 1998
carved willow, h. 15 x Ø 270 cm
Collection 21st Century Museum of Contemporary Art, Kanazawa

Fingerspanner, 1998
wood, string, 41.5 x 28 x 22 cm; photo: C-print, acrylic frame, 58 x 28 cm

Air 'Fall', 1999
camphor wood, 340 x 64 x 60 cm
Collection 21st Century Museum of Contemporary Art, Kanazawa

Human Lesson (Dress 01), 1996
wolf pelts, 16.5 x 8 x 3 cm

Phantom–Limb, 1997
C-type print, 148 x 111 x 2.7 cm
Installation P-House, Tokyo, 1997

9th Room, 2001
mirror, screen, woofer, 4-video projector, sound system, video loop, colour, sound by Kei Takashima, 3.2 x 3.2 x 3 m
Installation Tokyo Opera City Art Gallery, 2001

Born Cologne, Germany, 1953 Lives and works in Cologne

Selected Solo Exhibitions: 1998 'Marcel Odenbach: Recent video installations', New Museum of Contemporary Art, New York 1999 'Ach, wie gut, dass niemand weiß', Kölnischer Kunstverein, Cologne 2000 'Marcel Odenbach', Anton Kern Gallery, New York 2002 'Die Befreiung von meinen Gedanken', Kunsthalle Bremen; 'Das große Fenster-Einblick eines Ausblicks', Galerie Ascan Crone, Berlin; 'Die Kirche im Dorf lassen', Kunstverein Heilbronn; 'Viver longe para sentir-se em casa', Goethe-Institute, Salvador de Bahia

Selected Group Exhibitions: 2000 'Ich ist etwas anderes', Kunstsammlung NRW, Düsseldorf; 'Times are changing: Auf dem Wege! Aus dem 20 Jahrhundert!', Kunsthalle Bremen 2001 'Open Ends/Counter-Monuments and Memory', The Museum of Modern Art, New York; 'The Overexcited Body', Palazzo Reale Flavio Caroli, Milan/SESC Pompéia, São Paulo; 'Sex, vom Wissen und Wünschen', Deutsches Hygiene-Museum, Dresden; 'Unreal Time Video', Fine Art Centre, The Korean Culture and Arts Foundation, Seoul 2002 XXV São Paulo Biennale; 'The First Decade: Video EAI', The Museum of Modern Art, New York; 'Klopfzeichen – Wahnzimmer', Museum der bildenden Künste, Leipzig; 'The Museum, the Collection, the Director and his Loves', Museum für Moderne Kunst, Frankfurt; 'Video Zone', Centre for Contemporary Art, Tel Aviv

Selected Bibliography: 1989 Dan Cameron/Kobena Mercer/Maria Tucker/Theodora Vischer, *Marcel Odenbach*, New Museum of Contemporary Art, New York 1997 Yilmaz Dziewor and Friedemann Malsch, *Marcel Odenbach: Zeichnungen 1975–77*, Liechtensteinische Staatliche Kunst-sammlung/Galerie für Zeitgenössische Kunst, Leipzig/Verlag der Bucchandlung/Walter König, Cologne 1999 Jörg Heiser, 'Stars and Stripes', *frieze*, Issue 47; Udo Kittelmann, *Marcel Odenbach: Ach wie gut, dass niemand weiß*, Kölnischer Kunstverein, Verlag der Buchhandlung Walter König, Cologne 2001 Yilmaz Dziewior, 'Marcel Odenbach: Presentiments from the viewpoints of memories', *Camera Austria*, No. 75 2002 Joan Müller/Nikolaus Schafhausen, *Marcel Odenbach: Blenden*, Franfurter Kunstverein/Kunstraum Innsbruck, Lucas & Sternberg, New York/Berlin

MARCEL ODENBACH

Marcel Odenbach's credo seems to be that nothing is more frightening than reality. His video works often present documentary set-pieces from contemporary history in the form of found footage, archive material and photographs, along with his own pictorial inventions, informed by his highly personal way of seeing things. All these are fitted together to form an aesthetic panorama of the age.

Odenbach's interest in art is always more than simply aesthetic; he seeks out a public quality extending beyond the incestuous art world. As a polyfunctional structure, art starts to make a public impact when it can develop its complexities in ideological, political, moral, educational and entertaining terms. Creating conditions in which this can happen is a political task, but it is an artistic one as well. Odenbach's art responds to social processes by looking both objectively and subjectively at reality: through journalistic documentation and artistic creativity. He mingles these strategies in a highly sophisticated way.

Looking at Odenbach's work, we become aware of how surprisingly few artists articulated any conspicuously social interests in the 1980s and 1990s. The conviction that artists and their work play a part in and on behalf of society seems to have shifted in favour of the role they play inside the art world. But not in Odenbach's case. As an artist whose work is still influenced by the ideological sensibility of the 1960s, he creates art that makes its point precisely because the political, social and critical commitment is always visible behind the formal criteria, whilst not obliterating it. Due to this approach, Odenbach's work is also rooted in certain contexts in terms of contemporary and cultural history, but it is from this that it draws its timelessness.

'From what point is something history and no longer the present?' asks Odenbach, identifying the theme around which his work revolves. His videos and installations combine historical memory and sensual experience, which allows him in a sense to hurry ahead of his time, both reflecting it and reflecting on it, appealing for enlightenment and against the erosion of historical awareness.

Udo Kittelmann

Ach, wie gut, dass niemand weiß (Ha! How Glad I Am that No One Knows), 1997–9
4 videos, each 8 min., 11 sec., black and white, sound
Installation 'Marcel Odenbach: Ach, wie gut, dass niemand weiß', Kölnischer Kunstverein, Cologne, 1999

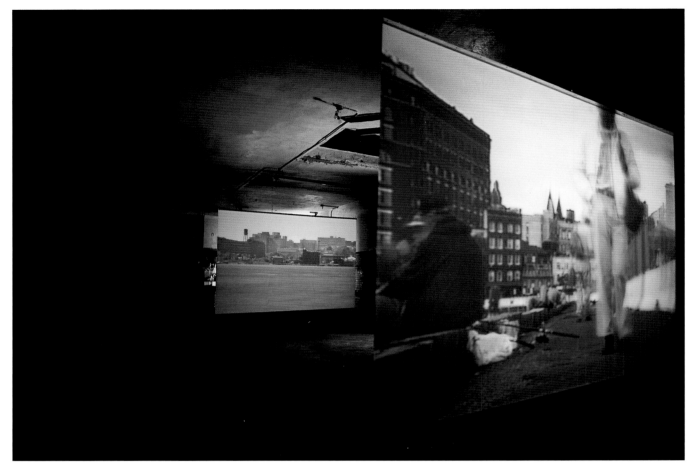

Two Sides of the Coin, 1995–6
2 videos, each 13 min., colour, sound
Installation Firehouse, New York, 1996

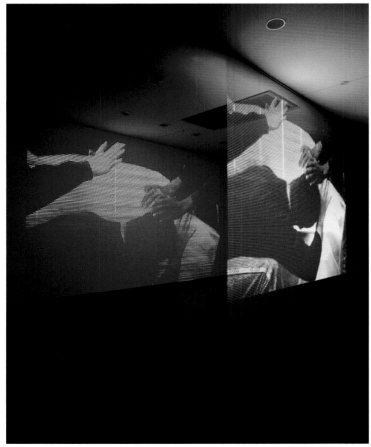

It Turned My Head, 1996
2 videos, each 5 min., 8 sec., colour, sound
Installation New Museum of Contemporary Art, New York, 1999

Internal Security, 2001–2
window shade, video, 8 min., 30 sec., colour, sound
Installation Frankfurter Kunstverein, 2002

MARCEL ODEN

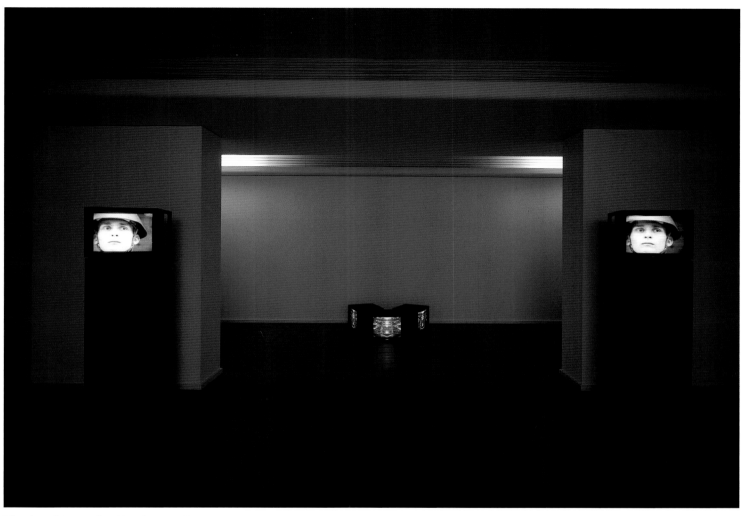

When the Wall Moves to the Table (*stills below*), 1990–1
5 monitors, text, 2 videos, each 6 min., 30 sec., colour, sound
Installation 'Metropolis', Martin Gropius Bau, Berlin, 1991

Born Zilina, Czechoslovakia, 1966 Lives and works in Bratislava, Slovakia

Selected Solo Exhibitions: 1996 'Drawings', Gallery Ruce, Prague 1998 'Exposure', Contemporary Arts Centre, Ujazdowski Castle, Warsaw; 'I've definitely been here before', City Gallery, Prague 1999 'Through the Eye Lens', Ludwig Museum, Budapest 2000 Knoll Gallery, Vienna; 'Room Extension', Kunsthof, Zürich; 'Storyboard', MK Expositieruimte, Rotterdam 2002 'Guided Tour', Moderna galerija, Zagreb

Selected Group Exhibitions: 1992 'Germinations 7', Le Magasin, Grenoble 1995 'Artists of Central and Eastern Europe', Mattress Factory, Pittsburgh 1996 Manifesta 1, Rotterdam 1997 'Designed in SK', Knoll Gallery, Budapest 1999 'After the Wall', Moderna Museet, Stockholm; 'Aspects Positions', Museum Moderner Kunst, Vienna 2000 'Chinese Whispers', Apex Art, New York; Manifesta 3, Ljubljana 2001 'Ausgeträumt', Secession, Vienna; 'Common Ground', Begane Grond, Utrecht 2002 'I promise it's political', Ludwig Museum, Cologne

Selected Bibliography: 1995 Pavel Liska, 'Die Kunst Bleibt Frei', *Neue Bildende Kunst*, April–May 1998 Judith Stein, 'Out of East', *Art in America*, April 2000 Patrizia Gronzka, 'Feines Bunt als geistreicher Diskurz', *Profil*, 26 June; Mária Hlavajová, 'Five or Six Examples', *Guarene Arte 2000*, Fondazione Sandretto Re Rebaudengo, Turin; Kim Levin, 'Neo-Exoticism in the New Europe Border Crossings', *Village Voice*, 26 July–1 August; Christopher Schenker, 'Roman Ondák im Kunsthof', *Kunst–Bulletin*, May 2001 Kathrin Rhomberg, 'Roman Ondák', *Ausgeträumt*, Secession, Vienna 2002 Dietar Buchhart, 'Ausgeträumt…', *Kunstforum*, January–March; Dorothea von Hantelmann/Marjorie Jongbloed, 'I promise it's political', *I promise it's political*, Ludwig Museum, Cologne; Georg Schöllhammer, 'Generation Skoda. Eine Reversion', *springerin*, April–May; Kathrin Rhomberg, 'Keine Kunst ohne Politik', *Kunstforum*, No. 160, June–July

ROMAN ONDÁK

For his project *SK Parking* (2001) Roman Ondák parked several old Skodas with Slovak licence plates outside the Secession gallery in Vienna for two months. This work was perhaps intended less for visitors to the gallery than for regular passers-by. At first, they may not even have noticed it, but eventually they would begin to ask, 'What are so many cars doing in the back yard of a gallery? Why have they been there for so long? Why only old Slovak Skodas?'

Even if one were not aware that the cars were a work of art, one could then begin to discover the complexity of meanings and the strong emotional charge embodied in this installation. The essence of the car is travel, yet these cars were left sitting motionless – as if frozen in time – for weeks. They had in a sense, however, travelled through both time and space, since they belonged to a different era and place. Sixty kilometres away in Bratislava they would have been considered completely normal; when transferred to Vienna they were strangely incongruous.

The particular context of the exhibition also charged the situation with more direct meanings. It could be read as a metaphor for social and political issues, such as East–West relations, the transformation of both societies, or – in direct connection to the exhibition's title 'Ausgeträumt' ('End of Dream') – the disappearance of the initial optimism after the fall of the Berlin Wall. Ondák's works always remain open to many different or opposing interpretations. Nevertheless, such interpretations cannot exhaust their meaning and impact; they add to the works' complexity, while never fully explaining them.

Ondák often presents seemingly simple situations that expand into complex networks of relationships and meanings. He frequently works with paradoxes and contradictions, using them to build precise formal and conceptual structures. *Antinomads* (2000), for example, depicts people, in the form of postcards, who dislike travelling, so that their images undertake a journey in lieu of the people themselves. In *Tickets, Please* (2002), visitors to a museum in Prague encountered a young boy on the ground floor, to whom they paid half their admission fee, and then gave the remainder to his grandfather on the first floor. In *Common Trip* (2000), Ondák asked people who have never gone anywhere to make images of faraway places they had never visited based on his descriptions.

The restrained but intense emotional impact of Ondák's works is connected to the experience of time, transformation and absence, themes present in most of his works. Their subtle visual appearance corresponds to an undertone of nostalgia, never obvious at first glance. The images of children impersonating politicians in the series of posters *Tomorrows* (2002), for example, are not only cute, but also deeply uncanny: everything will change, and yet nothing will change.

Igor Zabel

SK Parking, 2001
Slovak Skoda cars
Installation 'Ausgeträumt', Secession, Vienna, 2001

Tickets, Please, 2002
Performance at Spala gallery, Prague, 2002

Antinomads, 2000
2 of 12 postcards, each 10.5 x 15 cm

Tomorrows, 2002
2 of 6 posters, each 41 x 58.5 cm

Common Trip (*detail, above*), 2000
drawings, dimensions variable
Installation Manifesta 3, Moderna galerija, Ljubljana, 2000

Born Osnabrück, Germany, 1970 Lives and works in London, UK

Selected Solo Exhibitions: 2000 Galerie Karin Günther, Hamburg 2002 Galerie Karin Günther, Hamburg; 'Imagining LA: Silke Otto-Knapp and Ed Ruscha', Kunstverein Wolfsburg 2003 Galerie Daniel Buchholz, Cologne; Kunstverein für die Rheinland und Westfalen, Düsseldorf

Selected Group Exhibitions: 1999 'Limit-less', Galerie Krinzinger, Vienna 2000 'Die Gefahr im Jazz', Deutsch Britische Freundschaft, Berlin; 'Songs sung by men from the point of view of a woman', Platform, London 2001 'The Magic Hour – The Convergence of Art and Las Vegas', Neue Galerie, Graz 2002 'Get Out! An Exhibition on the Subject of Going Away', Galeria Arsenal, Bialystok, Poland; 'The Unique Phenomenon of a Distance', Magnani, London 2003 'Creeping Revolution', Rooseum Centre for Contemporary Arts, Malmö; 'deutschemalereizweitau enddrei', Frankfurter Kunstverein, Frankfurt

Selected Bibliography: 2000 Nina Moentmann, 'Fata Morgana', *Texte zur Kunst*, October; Sadie Murdoch, 'Songs sung by men from the point of view of a woman', *Make*, December 2001 Alex Farquarson (ed.), *The Magic Hour: The Convergence of Art and Las Vegas*, Hatje Cantz, Graz 2002 Soren Grammel (ed.), *Get Out! An Exhibition on the Subject of Going Away*, Germinations, Bialystok; Jörg Heiser, 'Silke Otto-Knapp, Ed Ruscha, Kunstverein Wolfsburg', *frieze*, No. 68; David Lillington, 'The Magic Hour: The Convergence of Art and Las Vegas' *Art Monthly*, January; Maren Lübbke, 'Silke Otto-Knapp und Ed Ruscha im Kunstverein', *Kunstbulletin*, No. 4; Silke Otto-Knapp, 'Eaglerock-Sunset-Chautauqua', *Texte zur Kunst*, March; Melanie Ohnemus, 'Get Out! An Exhibition on the Subject of Going Away', *Springerin*, No. 1; Jan Verwoert, 'The Magic Hour', *frieze*, No. 64

SILKE OTTO-KNAPP

If there is such a phenomenon as a return to painting in the early twenty-first century, then it's a return imbued with a sense of painting's new possibilities in the light of its lost hegemony. But painting has always been a technique for image-making laden with personal, gestural creativity – a quality that Silke Otto-Knapp exploits to the full.

What jolts you when seeing her works is the realization that these are watercolours. It's difficult to get much lower in the hierarchy of painterly media, yet in Otto-Knapp's hands it seems that only this technique could express the melting, folding and indistinct charm of urban West Coast America. The brightness of the colours is all the more artificial due to the medium used. The structure of the scene is never clearly delineated; buildings slip over the edge (*Flamingo (The Magic Hour)*, 2001), neon signs blast out indecipherable messages (*Riviera*, 2000). Light is particularly well rendered, the buzz of electric street lighting beyond Griffith Park, for example, pushing up out of the image like an imitation sunrise.

The grid of the city sometimes becomes the only clue to its human inhabitation, and even directly identified city points such as *Wilshire (Sunset)* (2001) lose their urbanity, which becomes displaced by a momentary glance upwards at the palm trees and the beauty of a smog-filled sky. While it is uplifting to look at Otto-Knapp's work, with its uneasy celebration of the contemporary city's artifice, this is undoubtedly an ambivalent optimism that cannot escape a European concern for balance and historical identity.

Recent works such as *Elyria Drive (Mount Washington)* (2002), with its flora breaking in on all sides, have started to emphasize the natural elements in this urban jungle. In these paintings, comparisons with stories by J.G. Ballard, like *Crystal World* and *High-Rise*, seem unavoidable: there is the same sense of a dissolving, disappearing order, though Ballard's dystopian moralism is absent. Instead, Otto-Knapp provides a more measured gaze that finds not only superficial beauty in California but also a sense of another structure of organization, created as much by the natural environment as by human intervention.

In works where Otto-Knapp leaves the American continent, the images are imbued with a slightly more careful, suspicious approach. A painting like *Haus am Berg* (2002) is more centrally composed, more solid and unchanging, its subject at a greater distance from the painter, even though the horizon is much closer. In the light of this painting, we might begin to understand Otto-Knapp's Californian works as enthusiastic and doubtful at the same moment. The technique, the composition and the choice of subject all lead to an understanding that the scenes depicted will not remain the same forever. The present moment is acutely there in Otto-Knapp's work, yet behind this lies an equal sympathy for longer-term cycles and the vanity of human machinations.

Charles Esche

Flamingo (The Magic Hour), 2001
watercolour on canvas, 30 x 38 cm

Griffith Park (Grey), 2001
watercolour on canvas, 60 x 60 cm

Wilshire (Sunset), 2001
watercolour on canvas, 51 x 76 cm

Elyria Drive (Mount Washington), 2002
watercolour on canvas, 60 x 76 cm

Griffith Park (Big View), 2001
watercolour on canvas, 80 x 100 cm

SILKE OTTO-K

Haus am Berg, 2002
watercolour on canvas, 45 x 30 cm

Born Oran, Algeria, 1964 Lives and works in Paris, France

Selected Solo Exhibitions: 1990 'Les Ateliers du Paradise' (with P. Perrin and P. Joseph), Air de Paris 2000 'No Ghost Just A Shell: Anywhere Out of the World', Galerie Schipper & Krome, Berlin/Air de Paris; 'One Thousand Pictures Falling from One Thousand Walls', MAMCO, Geneva; 'No Ghost Just A Shell: Anywhere Out of the World', Air de Paris 2001 'Alien Seasons', Musée d'Art Moderne de la Ville de Paris; 'El Sueno de una cosa', Moderna Museet, Stockholm; 'One Thousand Pictures Falling from One Thousand Walls', Friedrich Petzel Gallery, New York 2002 'El Sueno de una cosa', Portikus, Frankfurt

Selected Group Exhibitions: 1991 'No Man's Time', Villa Arson, Nice 1993 'Backstage', Hamburger Kunstverein, Hamburg/Luzern Kunstmuseum, Lucerne 1996 'Traffic', CAPC, Bordeaux 1999 48th Venice Biennale (with D. Gonzalez-Foerster & P. Huyghe) 2000 'Let's Entertain', Walker Art Center, Minneapolis/Centre Georges Pompidou, Paris; 'What if: art on the verge of architecture and design', Moderna Museet, Stockholm 2001 7th Instanbul Biennale; 'Double Life', Generali Foundation, Vienna; 'Vivre sa vie' (with P. Huyghe), Tramway, Glasgow 2002 14th Sydney Biennale

Selected Bibliography: 1992 Nicolas Bourriaud, 'Philippe Parreno', *Galeries Magazine*, February–March 1995 Nicolas Bourriaud, 'Philippe Parreno, Virtualité Réelle', *Art Press*, December 2000 Eric Troncy, 'No Ghost, Just a Shell', *Art Press*, September 2001 Emmanuelle Lequeux, 'Philippe Parreno: Petits contes modernes', *Aden – Le Monde*, 19 December; Mai-Thu Perret, 'Philippe Parreno', *frieze*, March; Andrea K. Scott, 'interview', *Artforum*, May; Philippe Vergne, 'Speech Bubbles', *Art Press*, January; Elisabeth Wetterwald, 'Philippe Parreno, l'exposition comme pratique de liberté', *Parachute*, April 2002 *Alien Affection – Philippe Parreno*, ARC/Musée d'Art Moderne de la Ville de Paris/Les Presses du Réel, Paris; Els Fiers, 'Alien Seasons', *Metropolis M*, August–September; Nina Möntmann, *Art Now*, Taschen, Cologne

PHILIPPE PARRENO

Philippe Parreno's work is not distinguished by a recognizable artistic signature or choice of medium; it is a broad-based practice combining a series of conceptual approaches and communicative strategies. He is constantly on the lookout for methods by which he can rethink current models of production, exhibition and authorship, interrogating the classical exhibition format and other structures controlling the production and reception of art. He often juxtaposes social realities with the pictures and commentaries that represent them, in order to address the interplay of the real, the symbolic and the imaginary. TV, leisure, work, childhood memories, comic characters and everyday objects are all players in his critique of reality.

Parreno has stated that a key feature of his work is an 'aesthetic of alliances', referring to his numerous collaborations with his artist friends, including Pierre Huyghe, Dominique Gonzalez-Foerster, Liam Gillick, Rirkrit Tiravanija and Carsten Höller, or with architects and designers like François Roche and M/M in Paris. He also examines individual 'alliances' within collective social situations in everyday life. Less interested in the final work or exhibition than in its ongoing effect, Parreno often presents a set of narrative instruments that can create chains of events, images, collective production and communication. *Speech Bubbles* (1997), for example, consists of helium-filled balloons in the form of cartoon speech bubbles, hanging from the ceiling like empty signs. They create an imaginary communication area that can be filled with individual content by each visitor.

This idea of individual agency within a shared experience can also be found in *No Ghost Just a Shell*, a large-scale collaborative project with Pierre Huyghe, begun in 1999. For this series of works, they bought the rights to the cartoon character Annlee from a Japanese design agency that develops ideas for the booming Manga industry. In the marketplace, this unremarkable, disposable character would have quickly disappeared from view. However, the artists rescued her from this fate, bringing her into new contexts. She featured, for example, in their videos *Two Minutes Out of Time* and *Anywhere Out of the World* (both 2000). In a later work they made the figure available to other artists, as a 'shell' to fill with their own ideas and stories. The work raises questions about the market, copyright, authorship and artistic identity. At the end of the project, a contract transfers the copyright to Annlee herself. Perhaps she will even start to dream up new ideas for herself, like *El Sueno de una Cosa* (*The Dream of a Thing*) (2001), the one-minute oneiric landscape that Parreno has both implanted into TV commercials and projected onto a white work by Robert Rauschenberg dating from 1951.

Beatrix Ruf

Le Mont Analogue, 2001
video projection, coloured monochrome sequences edited on the basis of the Morse Code, transmitting the story of a film
based on a novel by René Daumal, 60 min., loop, colour, silent
Installation 'Alien Seasons', Musée d'Art Moderne de la Ville de Paris, 2002

Alien Seasons, 2002
musical computer programme/video screening, 16 mm film and digital footage transferred onto
hard drive, show-controller, 2 min., 30 sec., loop, colour, silent
Installation 'Alien Seasons', Musée d'Art Moderne de la Ville de Paris, 2002

Anywhere Out of the World, 2000
stills from animated 3-D movie, 4 min., colour, sound, collaboration with Pierre Huyghe

Snow Dancing, Footsteps 1997–1995, 1997
glass, dimensions variable

Happy Ending, Stockholm, 1997–1995, 1997
glass, approx. 65 x 30 cm

PHILIPPE PAR

El Sueno de una Cosa (The Dream of a Thing) (*stills above*), 2001
motorized curtain, show-controller, 35 mm film projected onto 'White Series' painting by Robert Rauschenberg
1 min., loop, colour, sound
Installation 'Alien Seasons', Musée d'Art Moderne de la Ville de Paris, 2002

Born Hildesheim, Germany, 1963 Lives and works in Berlin, Germany

Selected Solo Exhibitions: 1995 'Zeichnungen und Modelle', Galerie Neu, Berlin 1998 'Bad, Bath', Anton Kern Gallery, New York; 'Platz', Galerie Neu, Berlin 1999 Galerie nächst St Stephan, Vienna; 'Infrastructure', Institute of Visual Arts, University of Wisconsin, Milwaukee 2000 '1a–Dosenfeld '00', Portikus, Frankfurt; Kunsthalle Zürich 2001 'Sieg & Infrastructure', Anton Kern Gallery, New York; Sprengel Museum 2002 'Casino', Mai 36, Zürich; 'Restapfanne', Galerie Neu, Berlin

Selected Group Exhibitions: 1996 'Sardinien', European Artforum, Berlin; 'Something Changed', Klosterfelde Galerie, Hamburg 1997 4th Lyon Biennale; 'Weinberg', Produzentengalerie, Hamburg 1998 'Ars Viva 98/99', Kunstammlungen, Cottbus/Kunstverein, Braunschweig; 'Titles for Drawings', AC Project Room, New York 2000 'escape_space', Ursula Blickle Stiftung, Kraichtal 2001 'Public Offering', Museum of Contemporary Art, Los Angeles 2002 Documenta 11, Kassel; Institute of Contemporary Art, Boston

Selected Bibliography: 1997 Uwe Clewing, 'Manfred Pernice', *Art*, No. 10 1998 Isabelle Graw, 'Manfred Pernice', *Texte zur Kunst*, September; *Mai 98, Positionen zeitgenossischer Kunst seit den 60er Jahren*, Kunsthalle Cologne; Gregory Williams, 'Manfred Pernice', *frieze*, No. 42 1999 Yilmaz Dziewior, 'Manfred Pernice', *German Open*, Kunstmuseum Wolfsburg; Matthew Ritchie, 'The New City', *art/text*, March 2000 *Manfred Pernice*, Kunsthalle Zürich; Christiane Scheider, 'Systematisch voorbehoud, Manfred Pernice', *Metropolis M*, April–May 2001 Peter Herbstreuth, 'Manfred Pernice – Hamburger Bahnhof', *Flash Art*, January–February 2002 Jan Verwoert, 'Pre-fabs Sprout', *frieze*, September

MANFRED PERNICE

Manfred Pernice's work first came to public attention in 1996 at the Art Forum in Berlin, when he debuted *Sardinien*, a large, obdurate sculpture that nearly filled the exhibition space allotted to his gallery. Constructed from the most humble of materials – partially painted plywood and chipboard – this form is vaguely architectural: it has an interior space into which one can peer but not enter. It also resembles a camping trailer, the kind pulled behind four-door automobiles for a family vacation. A lone photograph showing some picturesque Mediterranean vista graces its side, furthering the reference to leisure. On a formal level, the placement of this picture interestingly confuses the work's volumetric presence with its use as a surface. The sense of uncertainty engendered by this oscillation between form and function is the conceptual crux of Pernice's practice. His structures, models and installations refuse to cohere as discrete, completed entities. They appear untamed and unfinished, like propositions. While their sizes are obvious, their scales are not: when small, are they maquettes for some kind of visionary low-tech architecture, or diminutive modular sculptures? When large, are they fragments from a delirious construction site?

Pernice's investigations stem in part from a long-standing interest in containers – whether shipping vessels or buildings – as a symbol for the unprecedented mobility of goods and people in the new global economy. After spending time in the German seaport of Bremerhaven, he began a series of plywood sculptures, as manifest in the installation *Bell II, 1–14* (1998), that reiterated the shape of cargo holds used to transport commodities around the world. As empty, neutral-appearing vessels, these forms suggest a state of potentiality, which represents the more utopic side of Pernice's art. On a more critical level, he thinks of containers or 'cans' as symbols for our obsession with packaging, systematizing, categorizing and regulating – as evidenced architecturally today in banal shopping malls, sprawling suburban developments, multiple cineplexes, multinational financial centres, and so on. Pernice refers to this phenomenon as 'canning the world'. This socio-economic reality is the source of his sculptural cylinders constructed from vertical plywood laths and 'decorated' with eccentric touches of paint, photographs and even illuminated light bulbs. He combines these forms in liberating, nonsensical arrangements, as in the installation *1a–Dosenfeld '00* (2000) at Portikus, which playfully suggests a city of the absurd.

Pernice's architectural references are more general than site-specific, though his work perfectly addresses the massive reconstruction efforts in the newly unified Berlin, where he bases his practice. For the 1st Berlin Biennale, he presented *Haupt/Centraldose* (1998–2000), a 6-metre-tall cylinder constructed from horizontal layers of stacked chipboard. Deliberately evoking Vladimir Tatlin's revolving *Monument to the Third International* (1919), with its hubristic intent to surpass the Eiffel Tower in height, Pernice's tower stood in Albert Speer's former studio, now a crumbling ruin co-opted as an exhibition site. This anti-monument, a paean to false pride, was located just miles from the renowned Potsdamer Platz, then a construction site for a new corporate theme park. Nancy Spector

Haupt/Centraldose, 1998–2000
laminated wood, 6 x 2 m
Installation Kunsthalle Zürich, 2000

Ars Viva 98/99, 1998–9
various wood materials, paint, photos, Xeroxes, light fixture, dimensions variable
Installation Kunstsammlungen, Cologne, 1998–9

Kü.mo, 1998–2000
various wood materials, photos, Xeroxes, video projection, dimensions variable
Installation 'Werkraum2', Hamburger Bahnhof, Hamburg, 2000

Sardinien, 1996
plywood, laminated wood, 2 x 6.5 x 4.5 m
Installation Art Forum Berlin, 1996

Untitled, 2001
mixed media on paper (two-sided), 29 x 21 cm

Untitled, 2001
mixed media on paper, 21 x 29 cm

Born Minneapolis, USA, 1960 Lives and works in Chicago, USA

Selected Solo Exhibitions: 1993 FRAC, Poitou-Charentes, Angoulème, France 1994 'Options 48: Dan Peterman "Sulfur Cycle"', The Museum of Contemporary Art, Chicago 1996 'Accessories to an Event', Klosterfelde Cycle, Berlin/Hamburg 1998 'Currents 73: Dan Peterman', The St Louis Arts Museum; 'Dan Peterman and Tobias Rehberger', Kunsthalle Basel 2001 '7 Deadly Sins', Kunstverein Hannover 2002 Museum Abteiberg, Mönchengladbach

Selected Group Exhibitions: 1988 'Chicago Compost Shelter', The Resource Center, Chicago 1994 'Backstage', Kunstmuseum, Lucerne 1997 'Home Sweet Home', Deichtorhallen, Hamburg 1998 'Minimal Maximal', Neues Museum Weserberg, Bremen 1999 'dream city', Museum Villa Stuck, Munich 2000 'Amateur/Eskdale', Kunstmuseum, Göteborg, Sweden; 'Ecologies: Marc Dion, Peter Fend, Dan Peterman', The David and Alfred Smart Museum of Art, University of Chicago 2001 2nd Berlin Biennale; 'Arbeit Essen Angst', Kokerei Zollverein, Essen; 'Plug-in: Einheit und Mobilität', Westfälisches Landesmuseum, Münster

Selected Bibliography: 1994 Joe Scanlan, 'Back to Basics and Back Again', *frieze*, No. 18 1997 Zdenek Felix (ed.), *Home Sweet Home*, Deichtorhallen, Hamburg 1998 *Dan Peterman*, Kunsthalle Basel; Rochelle Steiner, *Currents 73: Dan Peterman*, The St Louis Arts Museum 1999 *Dream City*, Museum Villa Stuck, Munich 2000 Kathryn Hixon, 'Dan Peterman: Recycle, Reuse, Resurrect', *New Art Examiner*, October 2001 *7 Deadly Sins and Other Stories*, Kunstverein Hannover; Daniel Birnbaum/Nicolas Bourriand/Charles Esche/Annie Fletcher/Eberhard Mayntz, *2nd Berlin Biennale*, Oktagon Verlagsgesellschaft mbH, Berlin; *Plug-In: Einheit und Mobilität*, Westfälisches Landesmuseum, Münster

DAN PETERMAN

'I want to introduce a language of ideas and issues, as opposed to drawing conclusions', the American artist Dan Peterman has said. 'One of my pathways is to look at ecological systems, but not knock you over the head. The claim of being an ecological artist leads people to assume you have a "save the world" philosophy; I would simply say that the environment is quietly motivating me.'

Peterman is peculiarly resistant to the seductions of the international art world. Though he participates in biennales and is represented by galleries, it is clear that the real motivation for his engagement with art is elsewhere. It is easy to pinpoint his core focus in the extraordinarily dense and involved project he oversees in Chicago. In 1996 Peterman bought a building located on the border of the rich University of Chicago campus and South Chicago, a poor, mainly black neighbourhood. It housed not only Peterman's own studio but an array of cultural and non-profit organizations including a bicycle repair shop, the premises of a furniture designer, the editorial offices of *The Baffler* magazine and a community garden. Peterman devoted much of his time to developing various community initiatives there, negotiating the practicalities of survival in the city as well as conceptualizing new initiatives in collaboration with tenants. In 2001, the building burnt down, whether by accident or design; now the effort focuses on securing it as a cultural resource and rebuilding it. Whatever its future, the project as a whole underlines the earnestness of Peterman's approach and his ongoing belief in art as a mechanism for real, small-scale social change.

Although much of the energy Peterman puts into this project produces no actual art, he sees it as a fundamental inspiration for his independent art activities. The latter often make use of recycled or reused materials, which he then casts into various functional forms. *Running Table* (1997) was a platform for discussion, made from modest recycled plastic materials, and placed in a city-centre Chicago park for workers, the homeless, picnickers and tourists. The sculpture became a constantly changing mise-en-scène of Chicago society, revealing all kinds of unarticulated social codes.

Other recycled works such as *Villa Deponie* (2002) have involved rescuing dumped materials from landfill sites for artistic use in the form of empty functional structures. *The Universal Lab* (2000) presented the extraordinary hoard of discarded material that a group of university technicians and amateur scientists had gathered from the University of Chicago. The initial idea was to provide an alternative resource for non-sanctioned research, but the task of collecting overwhelmed any scientific discovery. Presented as a classical sculpture, the material takes on the appearance of a future archaeological find, with the memory of Chicago's role as a site for nuclear weapons development, amongst other government research, hovering in the background.

Dragging Café (2002) brings a lighter touch with a mobile café towed round the gallery by an environmentally friendly electric car. The piece slowly destroys both the café furniture installed in the space and the gallery itself, in a bid, perhaps, to speed up the recycling process.

Charles Esche

Dragging Café, 2002
electric car, used café furnishings, approx. 1.5 x 3 x 1.3 m
Installation Klosterfelde, Berlin, 2002

The Universal Lab (*detail*), 2000
recycled refuse, dimensions variable
Installation 'Ecologies: Mark Dion, Peter Fend, Dan Peterman', The David and Alfred Smart Museum of Art, The University of Chicago, 2000

Winter Garden, 1998
greenhouse, volcanic rock, bench, open window with view of valley (*right*)
Installation Le Creux de l'enfer, Thiers, 2002

Villa Deponie, 2002
recycled closed-cell foam, 4 x 6 x 4.5 m
Installation Brixen Festival, 2002

Mobile Bike Shop, prototype, 1999
bicycle stands, assorted bicycle repair tools, chain, table, umbrella, cart, green paint, dimensions variable
Installation Hamburg, 1999

Accelerated Forest, 2002
compost from local organic waste materials, China grass, industrial shipping sacks, dimensions variable
Installation Basel, 2002

Born Honolulu, Hawaii, 1966 Lives and works in New York, USA

Selected Solo Exhibitions: 1998 'The Pure Products Go Crazy', The Project, New York 2000 Kunstwerke, Berlin; The Project, New York 2001 Kunsthaus Glarus; 'Sex Machine', The Project, Los Angeles; UCLA Hammer Museum, Los Angeles 2003 MIT List Visual Arts Centre, Cambridge, Massachusetts; Museum of Contemporary Art, Chicago

Selected Group Exhibitions: 1998 'Warming', The Project, New York 2000 'Greater New York', P.S.1 Contemporary Art Center, New York; Whitney Biennial, Whitney Museum of American Art, New York 2001 49th Venice Biennale; 'The Americans: New Art', Barbican Art, London; 'Bitstreams', Whitney Museum of American Art, New York; 'Subject Plural', Contemporary Arts Museum, Houston 2002 'Loop', Kunsthalle der Hypo Kulturstiftung, Munich; 'Out of Place', Museum of Contemporary Art, Chicago; 'Tempo', The Museum of Modern Art, New York 2003 'The Moderns', Castello di Rivoli, Museo d'Arte Contemporanea, Turin

Selected Bibliography: 1998 *At Home and Abroad: 20 Contemporary Filipino Artists*, San Francisco Asian Art Museum, San Francisco 1999 Shonagh Adelman, 'Paul Pfeiffer: The Project, NY', *frieze*, No. 45 2000 Katy Siegel, 'Art Openings', *Artforum*, Summer 2001 Hilton Als, *Paul Pfeiffer*, UCLA Hammer Museum, Los Angeles; Stefano Basilico, 'An Interview with Paul Pfeiffer', *Documents*, Fall–Winter; Joan Kee, 'Processes of Erasure', *Art AsiaPacific*, October–December; *Orpheus Descending*, Public Art Fund, New York; Debra Singer, *The Contemporary Series*, Whitney Museum of American Art, New York; Linda Yablonsky, 'Making Microart That Can Suggest Macrotruths', *The New York Times*, 9 December 2002 Holland Cotter, 'Art in Review', *The New York Times*, 18 January; Uta Grosenick, 'Paul Pfeiffer', *Art Now*, Taschen, Cologne

PAUL PFEIFFER

In the information age, the era of the human genome, Paul Pfeiffer delves into the manic modes of contemporary human consciousness by experimenting with our relationship to technology. He is particularly concerned with our addiction to spectacle, our cannibalistic consumption of the body image, our body-turned-machine.

Pfeiffer's strategy is to painstakingly edit and manipulate snippets of TV and movie footage as if it were a sculptor's material. The results are displayed on tiny monitors or LCD screens that grip the walls as if they were mechanical limbs or prostheses. Their small scale dramatizes the imagery by offering a sense of condensation and of accumulated, coiled energy, seemingly on the verge of exploding.

In *Fragment of a Crucifixion (After Francis Bacon)* (1999), a thirty-second clip of Afro-American basketball star Larry Johnson's cry of joy during a game is endlessly repeated. Thus his body is trapped in a fantasy moment of fame and power, while the viewer becomes a consumer with eternal access to his energy and emotion. The game itself, and the other players, are edited out so that only the moment of ecstasy is visible, recalling a religious experience. In *John 3:16* (2000), on the other hand, Pfeiffer digitally edited NBA basketball footage so that only the ball was on view, always centred on the screen. It is as if our gaze is following the ball so obsessively that we become one with it through meditation. The ball hovers mysteriously in the middle of the screen, suggesting suspended movement and the mystery of transubstantiation. In *The Long Count (I Shook Up the World)* (2000), Pfeiffer edited out Muhammad Ali and his opponent from footage of a boxing fight, grafting onto the shapes of their erased bodies views of the entranced crowd. One can sense where the bodies of the boxers ought to be, as their eerie ghosts seem to flow through the audience, which moves convulsively, following yet inhabiting these spectres.

In the more recent work, *Corner* (2003), Pfeiffer explores depth and perspective as opposed to surface by editing out a boxer from footage shot during time out. The fighter becomes an absent figure surrounded by coaches ministering to him and giving him counsel. But Pfeiffer doesn't just give us one view through time here; he layers different images of edited out boxers on top of each other, creating a giddy hyper-perspectival tunnel that seems to pierce through the monitor to another dimension within and beyond it.

By carefully taking out figures to leave only their surroundings, or by repeating small gestures obsessively in loops, Pfeiffer addresses a throbbing 'heart of darkness'; a carved-out self invaded by technology.

Carolyn Christov-Bakargiev

Self Portrait as a Fountain, 2000
mixed media, 300 x 48 x 182 cm

Dutch Interior, 2001
wall-recessed diorama, live video feed, projector, peephole, dimensions variable

Sex Machine, 2001
projector, mounting arm, DVD player, video, loop, colour, sound, 51 x 20 x 43 cm

The Long Count (I Shook Up the World), 2000
video, loop, black and white, silent, LCD monitor, mounting arm, DVD player, 14 x 17 x 152 cm

Three Studies for Figures at the Base of a Crucifixion, 2001
video, loop, colour, silent, projectors, mounting arms, DVD players, 51 x 112 x 43 cm

Born Glasgow, UK, 1965 Lives and works in Berlin, Germany and Belfast, Northern Ireland

Selected Solo Exhibitions: 1997 'Susan, Barbara, Joan and Sarah: A Song Apart', Context Gallery, Derry 1999 'Red Standard', The New Works Gallery, Chicago 2000 'Some Place Else', Consortium Gallery, Amsterdam 2001 'Tomorrow Belongs to Me', Stadtlabor, Lüneburg 2002 Ellen De Bruijne Projects, Amsterdam; 'Cast Together in C', Triskel Arts Centre, Cork; 'Wild as the Wind', San Sebastian; Women's Library Commission, London 2003 38 Langham Street, London; ArtPace, San Antonio; 'Rosa', Kunstwerke, Berlin

Selected Group Exhibitions: 1997 'European Couples and Others', Transmission, Glasgow; 'Limits of Silence', Pierce Institute, Glasgow 1998 'Eu + A98', St Michael's Church, Limerick; 'Perspectives '98', Ormeau Baths Gallery, Belfast; 'Resonate', Laganside Bus Station, Belfast; 'Reverend Todds Full House', College Green House, Belfast 1999 1st Melbourne Biennale; 'Milieux', Le Lieu, Quebec City; 'My Eye Hurts', Thread Waxing Space, New York 2000 'Girl', New Gallery Walsall; Manifesta 3, public underpass, Ljubljana; 'Petty Crimes', The Gallery of Modern Art, Glasgow 2001 1st Tirana Biennale; 'Loop', PS.1 Contemporary Art Center, New York; Plug In ICA, Winnipeg; public walkway, Tirana; 'Total Object Complete with Missing Parts', Tramway, Glasgow 2002 'Art and Memory', Synagogue of Ostia Antica, Rome; 'Islands and Aeroplanes', Sparwasser HQ, Berlin; 'New York, New Sounds, New Spaces', Museum of Contemporary Art, Lyon 2003 'Days Like These', 2nd Tate Triennial of Contemporary British Art, London; 'The Moderns', Castello di Rivoli Museu de Arte, Turin

Selected Bibliography: 1997 Jane Tynan, 'Susan, Barbara, Joan, and Sarah', *A Song Apart*, *CIRCA*, November 1999 Julianna Engsberg, *Signs of Life*, 1st Melbourne Biennale; Annie Fletcher, 'Sound Teasing', *CIRCA*, June; Peter Suchim, 'Some Markers Spoil Memory', *Resonate*, Grassy Knoll Productions, Belfast 2000 Annie Fletcher, 'Sound Effects, 'Strategies for Evocation', *MAKE*, No. 89; 2001 Paulo Herkenhoff, 'Strangers/Etrangers', *PS1 Residents*, PS.1 Contemporary Art Center, New York; Mike Wilson, 'Breathless', *Untitled*, December; Niamh Ann Kelly, 'Solo Voice', *Art Monthly*, October

SUSAN PHILIPSZ

Susan Philipsz has used sound, video and performance to create works that are often ephemeral and site-specific. She makes recourse to a broad range of references, from John Huston's film of James Joyce's *The Dead* to Rosa Luxembourg's revolutionary life. Intruding on everyday life and suspending productivist and functionalist logics with unexpected moments of poetry and intimacy, her works can appear like small epiphanies.

She achieves this through the use of communication technology, which she redirects to insinuate her sound pieces – often featuring her own singing voice – into various different locations. In exhibitions and in public space, she makes use of the existing public-address systems incorporated into the infrastructure of the building; when working outdoors, she installs trumpet speakers through which to broadcast her works. Her chosen sounds and songs are laden with references to utopian revolutionary events and the spirit of the nineteenth and early twentieth century, as well as to cinematic memories and popular or folk culture.

For *Victory* (2001), made for an exhibition entitled 'International Language' in Belfast, Philipsz hired a tuba player to recreate the sound of the viking horn in the 1958 movie *The Vikings*, starring Kirk Douglas. This was broadcast from a loudspeaker placed on a passenger boat that went up and down the river Logan during the project. The result was absurd, yet also eerily natural in this new location. Fact and fiction overlapped, just as different narratives and moments of history also meshed in a work that left the question of whose victory was being celebrated wide open.

There is something poetic, nostalgic and even sad in Philipsz's solitary singing of the old Communist anthem, 'The Internationale', which she played back in short bursts at ten-minute intervals in a railway underpass in Ljubljana during the exhibition Manifesta 3 in 2000. We associate this song with bygone historical moments, when the artistic avant garde felt it was possible, and necessary, to oppose existing economic and political systems. We also associate it with choral and collective singing, and rarely hear it performed by an unaccompanied solo voice. Philipsz's lonely incantation comes across not only as a dreamlike recollection from the past, but also as a poignant expression of survival. While music usually transports listeners mentally to another place, Philipsz's disembodied, vulnerable and fallible voice produces a heightened awareness of one's self.　　　　Carolyn Christov-Bakargiev

Pledge, 2002
sound and light installation
Installation 'Pledge', Temple Bar Gallery, Dublin, 2002

Two Part Harmony, 1995
sound installation
Installation 'Barrage', Catalyst Arts, The Design Centre, Belfast, 1995

It Means Nothing to Me, 2000
sound installation and photograph, 158 x 170 cm
Installation 'Glen Dimplex Awards', Irish Museum of Modern Art, Dublin, 2002

The Internationale, 1999
sound installation 1 min., 54 sec.
Installation 'Toot (Totally out of Tune)', Hull Time-Based Arts, 1999

Strip Tease, 1999
sound and light installation
Installation 'Strip Tease', Annual Programme, Manchester, 1999

Wild as the Wind, 2002
sound installation
Installation 'Front Line Compilation', DAE, San Sebastian, 2002

The Internationale, 1999
sound installation, 1 min., 54 sec.
Installation Manifesta 3, underpass, Ljubljana, 2000

Born New York, USA, 1968 Lives and works in New York

Selected Solo Exhibitions: 2000 'Above the Grid', P.S.1 Contemporary Art Center, New York 2001 'John Pilson: New Work', Nicole Klagsbrun Gallery, New York; Raucci/Santamaria Gallery, Naples 2002 Annet Gelink Gallery, Amsterdam; 'Clean Lines – Art Statements', Art Basel 33

Anfang', Hypokunsthalle, Munich; 2002 'Moving Pictures', Solomon R. Guggenheim Museum, New York; 'Sudden Glory: Sight Gags and Slapstick in Contemporary Art', California College of Arts and Crafts, Oakland

Selected Group Exhibitions: 2000 'Greater New York', P.S.1 Contemporary Art Center, New York; 'The City', Nicole Klagsbrun Gallery, New York; 'Some New Minds', P.S.1 Contemporary Art Center, New York; 'MOMA 2000: Open Ends', The Museum of Modern Art, New York 2001 'The Americans: New Art', Barbican Art, London; 'Bureaucracy', Foksal Gallery Foundation, Warsaw; 'Ghosty', 1000 Eventi, Milan; 'Video Jam', Palm Beach Institute of Contemporary Art, Lake Worth; 'Loop – Alles auf

Selected Bibliography: 2000 Carolyn Christov-Bakargiev, *P.S.1 Greater NY*, P.S.1 Contemporary Art Center, New York 2001 Jeffery Anderson, 'John Pilson', *49 Esposizione Internazionale D'arte: Platea Dell'Umanita*, Venice; Anthony Huberman, 'Ouverture: John Pilson', *Flash Art*, March–April; Adam Lerner, 'Moving Pictures', *Artforum*, November; Anders Stephanson, 'Openings: John Pilson', *Artforum*, April; Gregory Williams, 'John Pilson', *tema celeste*, Summer

JOHN PILSON

After gaining a degree in photography, John Pilson found employment in the graphic-design department of a major Wall Street financial firm. He worked the 'grave-yard shift', late into the night when the hustle and bustle of regular business hours give way to the uncanny quiet of nearly vacant buildings. This is the milieu that has most informed Pilson's video-based practice, which contemplates the hidden side of corporate uniformity – the inner lives of those who appear to conform to its strictures. Pilson's debut work, *Interregna* (1999–2000), presents a series of propositions about what might occur in that nocturnal no-man's zone of endless office space that occupies so much of our urban real estate. A bare-chested man vaults over cubicle partitions with the grace of a track star; another reads aloud from Wittgenstein; a young woman sings an aria; and a man in a business suit sits alone in a bathroom stall methodically wrapping toilet paper round his arm. The work's title is the plural of 'interregnum', which refers to the interval of time between the conclusion of a sovereign's reign and the appointment of a successor. It implies a gap in continuity, a momentary suspension of authority. In the cold half-light of a sleeping office building, Pilson imagines what happens when no one is looking. Employees, some aspiring singers, actors or artists, who only work there to support their more creative endeavours, are caught in the midst of their private reveries.

In *Above the Grid* (2000), two suited executives break into doo-wap harmony while they career around an otherwise empty office building. Pilson records their actions in marginal, interstitial spaces – a bathroom, corridors, outside an elevator – as if to underscore the tangential and private nature of their game. Their light-hearted pursuit eventually turns darker, as the two men begin to obstruct a hallway with duct tape. The camera switches between their clandestine performance and a scene of multicoloured balls bouncing inexplicably down a stairwell into a waiting elevator car. By animating the corporate building in this way, Pilson seems to be suggesting that sheer lunacy may reign above the rational grid of the city.

In *A la Claire Fontaine* (2001), a multi-channel video installation, Pilson continues his meditation on the unconscious of the anonymous corporate environment. A little girl is seen standing in an office high above the street, her face pressed against the window, which looks out at other glass-enclosed skyscrapers. She makes drawings in the condensation formed by her breath on the windowpane. A recording of her singing the French love song of the title provides the soundtrack to this image as well as to views of unoccupied office space elsewhere in the building, and an ominous cloaked figure pummelled by rubber balls. This bogey-man character may be a figment of the child's imagination, or perhaps more appropriately in the architectural uncanny of Pilson's universe, both girl and monster are conjured by the building itself.

Nancy Spector

Interregna, 1999–2000
single-channel video, 10 min., 35 sec., colour, sound

Above the Grid, 2000
2-channel video, 9 min., 30 sec., colour, sound

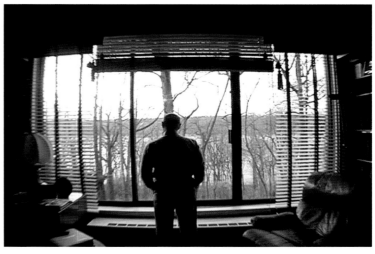

Clean Lines, 2002
3-channel video, 6 min., colour, sound

A la Claire Fontaine, 2001
8-channel video, 2 min., 35 sec., loop, colour, sound

Born Ljubljana, Slovenia, 1960 Lives and works in Ljubljana

Selected Solo Exhibitions: 1989 'Four Continents', Stil und Bruch, Berlin 1995 'My Beautiful Home', Moderna galerija, Ljubljana; 'Short Cuts', CULT, Vienna; 'Two Masters', IFA Galerie, Berlin 2001 'Agent of Change', International Graphics Centre, Ljubljana; 49th Venice Biennale 2002 'Reconstructions', Contemporary Centre for Performing Arts, Celje, Yugoslavia 2003 'CODE: RED Global Sex Work', Whitebox, New York

Selected Group Exhibitions: 1996 Manifesta 1, Rotterdam; 'The Collection of P.A.R.A.S.I.T.E. Museum – Slovene Art of the 90s', Museum Bochum 1997 'Cartographers', Ernst Museum, Budapest 1999 'After the Wall', Moderna Museet, Stockholm 2000 'Friends and Neighbours', City Gallery, Limerick; 'Snapshot', Contemporary Museum, Baltimore 2001 'Vulgata', Neuer Berliner Kunstverein 2002 'The Art of the Balkan Countries', S.M.A.C.K., Thessaloniki; 'ARTEAST Collection 2000+', ZKM, Karlsruhe; 'Do It!', Museo de Arte Carrillo Gil, Mexico City; 'OSTENSIV', Central House of Artist, Moscow

Selected Bibliography: 1997 Alenka Pirman, 'The P.A.R.A.S.I.T.E. Museum', *Sculpture*, Vol. 16, No. 9 2001 Mateja Medvedic, 'P.A.R.A.S.I.T.E. Museum & CODE: RED', *Oris*, Vol. 3, No. 12; Ralf Hoppe, 'Der Buergerlichen Huren', *Der Spiegel*, 27 August; Pa.Po. 'Biennale, arrivano le "sex worker" – A Venezia prostitute de titto il mondo', *Corriere dela Serra*, 4 June; 'Sex Workers and New Parasitism – What the World is Coming to', *Herald Tribune*, 5 June; Misko Suvakovic, 'The Trangressive Policy of Parasitism'/Igor Zabel, 'The Para-Mirror of the New Parasitism', *Absolute One*, 49th Venice Biennale/International Graphics Centre, Ljubljana, June 2002 Tomislav Vignjevic, 'Original Paraphrases of Marginality', *Delo*, 5 January; Patricija Kis, 'Tadej Pogacar presents a Monument to an Unknown Prostitute', *Jutarnji List*, 30 January; Irena Brejc, 'Ljubljana is Metropolis', *Dnevik*, 4 February; Jaka Zeleznikar, 'Tadej Pogacar in New York', *Mladina*, No. 20

TADEJ POGACAR

Tadej Pogacar established the P.A.R.A.S.I.T.E. Museum of Contemporary Art in 1990. PMCA has no other staff, nor a collection, or even a space. It is simply a format used by Pogacar to enter different social contexts, both institutional and non-institutional, to appropriate their resources and to operate within them.

PMCA's general strategy is to use the form of the museum to make underlying structures visible. As a guest in other museums, PMCA has often thrown light on their hidden conceptual foundations – the ideas on which their practices are based that are usually taken for granted. In the project *Welcome to History* (1998), for example, the collections and equipment of the Museum of Modern History in Ljubljana were appropriated to question the issues of collecting and of re-presenting history. Another tactic is to use the host museum's collections to construct new, parallel narratives. In *Art of History: Through the Body*, installed in the same museum in 1994, Pogacar explored the role and representation of the body in the objects and documents in the collection.

But, like every good museum of contemporary art, PMCA is also active outside the institutional context. Pogacar is interested in the hidden, overlooked and suppressed aspects of society, ranging from accidental 'sculptures' discovered on the streets, to social groups such as the homeless. In *Kings of the Street* (1995) he paid homeless people to sit on platforms – a combination of a royal throne and a theatre stage – in Ljubljana's busiest streets. He developed this idea with *The Queen Meets Marcel* (1999), in which a homeless woman sat on a platform in a gallery alongside Duchamp's readymades and other works in the Moderna Museet, Stockholm.

Pogacar tests the limits of the art project as a socially effective tool. In *CODE: RED* (2001–2), one of his recent, ongoing projects, PMCA probes a hidden social and economic system – the world of sex workers. According to Pogacar, the project 'gives the sex workers – who are among the most marginalized and deprived population groups in the urban environment – a chance to speak out and be seen in a new context'. A range of different people and organizations within the sex industry react to his proposals, actively contributing ideas and actions. They use a wide variety of strategies, from lectures and performances to Fluxus-style provocations. At the Venice Biennale, for example, Pogacar organized a programme of events involving sex workers from all over the world. It concluded with a march through the city, during which each participant carried a red umbrella. In another intervention, he transformed a public statue in Ljubljana into a *Monument to the Unknown Prostitute* (2002) using newspaper clippings and other documents.

It is interesting to observe how Pogacar's collaborators adapt to this new context, finding fresh possibilities, and confronting the sophisticated art public with a different reality. In turn, their contributions – simultaneously protest, analysis, play and political action – often stir a taste for the spectacular in the audience, which raises intriguing moral questions centring around issues of voyeurism and guilt.

Igor Zabel

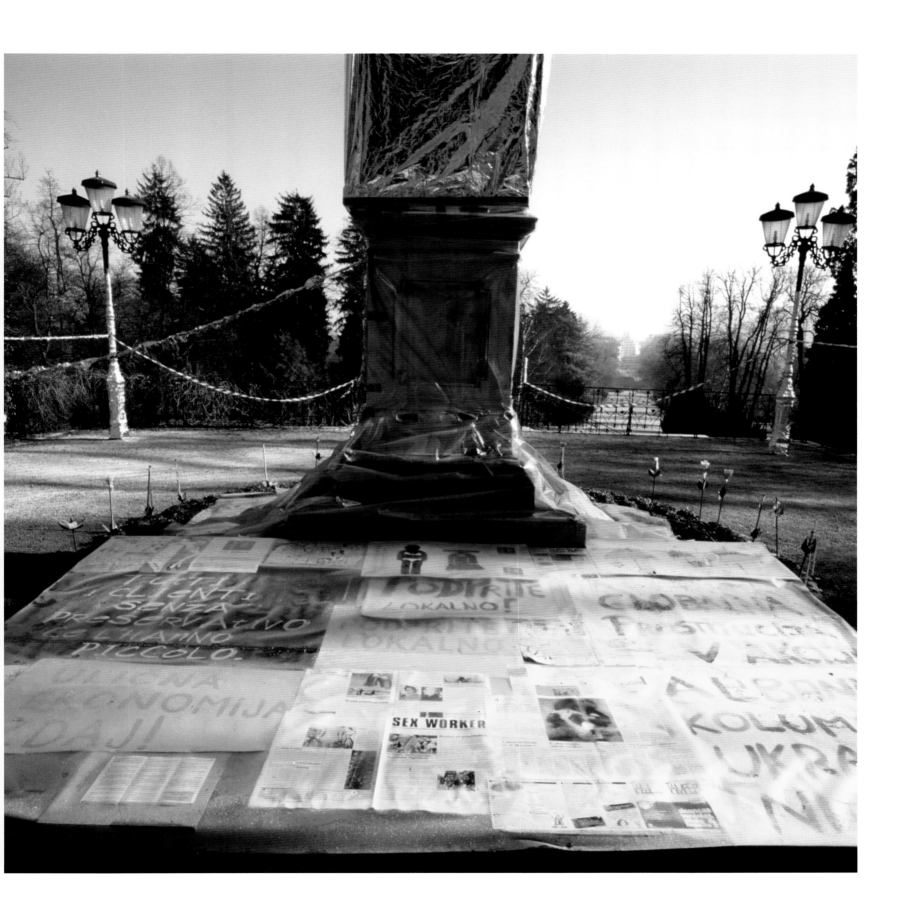

CODE: RED, Sex Worker, Monument to the Unknown Prostitute, 2002
public sculpture, PVC, newspapers, wood, central structure approx. 5 x 3 x 3 m
Installation International Graphics Centre, Ljubljana, 2002

The Queen Meets Marcel, 1999
Performance/installation 'After the Wall', Moderna Museet, Stockholm, 1999

CODE: RED, Sex Worker: Red Umbrellas March, 2001
Urban intervention, 49th Venice Biennale, 2001

Kings of the Street, 1995
Action at 'Urbanaria', Soros Centre for Contemporary Arts, Ljubljana, 1995

Stripping with Marx, 2002
Performance at Humboldt University, Berlin, 2002

Classroom with Maps, 1997
school maps, approx. 7 x 3 m
Installation 'Views of Exhibition', Museum of Modern History, Ljubljana, 1997

Born Vienna, Austria, 1971 Lives and works in Vienna

Selected Solo Exhibitions: 1993 'Bürgerforum', Forum Stadtpark, Graz 1996 'On or Off Earth', Grazer Kunstverein, Graz 1998 'Covering the Room', Salzburger Kunstverein, Salzburg 2000 'Humanist and Ecological Republic', Secession, Vienna 2001 Galerie Krobath Wimmer, Vienna 2003 Kölnischer Kunstverein, Cologne

Selected Group Exhibitions: 1991 'Material, Texte, Interviews', Jänner Galerie, Vienna 1993 'Backstage', Kunstverein Hamburg 1998 'Sharawadgi', Felsenvilla, Baden 2000 'Parallel Realities', HayArt, Yerevan, Armenia 2001 1st International Triennale of Contemporary Art, Yokohama; 'Du bist die Welt', Künstlerhaus, Vienna 2002 'Designs für die wirkliche Welt', Generali Foundation, Vienna; 'ForwArt 2002, a choice', Mont des Arts, Brussels; Manifesta 4, Frankfurter Kunstverein, Frankfurt; 'Nachgemacht', Kunstraum, Innsbruck; 'Northern Radicalism', Charlottenborg, Copenhagen

Selected Bibliography: 1991 Helmut Draxler, 'Material, Texte, Interviews', *Texte zur Kunst*, March 1998 Christian Kravagna, 'Die Moderne sehen', *Sharawadgi*, Verlag Walter König, Cologne 1998 Georg Schöllhammer, 'Covering the Room', *springerin*, April 2000 Renée Green, 'Marode Moderne', *Texte zur Kunst*, March; Christian Kravagna, 'Historische Praxis', *springerin*, March 2001 Matthias Dusini, 'Florian Pumhösl', *springerin*, April 2002 Daniela Gregori, 'Untergehen in einem See auf Madagaskar', *Frankfurter Allgemeine Zeitung*, 4 August; Jan Verwoert, 'Under Construction', *frieze*, No. 65; Vitus H. Weh, 'Florian Pumhösl', *Kunstforum*, January–March

FLORIAN PUMHÖSL

Florian Pumhösl bases his work on theoretical research into social systems, architecture, design and art displays. He is interested in alternative lifestyles, political utopias and the formal vocabulary of modernism as an aesthetic imperative that continues to insist on prestigious forms in everyday art and design, and as the element that shapes municipal systems within industrial society. He converts his research into installations that reconstruct the manifestations and meanings of the vocabulary he treats, thus operating as self-critical analytical representations.

Pumhösl has been making a name for himself both as an artist and as an initiator of books, catalogues and magazines since the early 1990s. Between 1991 and 1993 he embarked on a number of collaborations with other artists, including the projects *Material, Texts, Interviews and Impact* with Dorit Margreiter and Mathias Poledna. These examine the conditions under which exhibitions are mounted. His journalistic project, *montage*, begun in 1997, offers a platform for collaboration between artists and authors.

Since the mid-1990s, Pumhösl has been conducting a series of projects that examine the influence of utopian, modernist approaches to design and architecture, and their transferral to so-called developing countries that have very little or no industrialization. In the process he reveals concealed power structures and relationships, as well as the different forms that failure can take.

The installation *Humanist and Ecological Republic* (2000), for example, is based on research into the Lac Mantasoa dam area in Madagascar, where an enormous industrial complex was built in the mid-nineteenth century. This facility was partially destroyed as a result of anti-European policies, then flooded in 1936–7 when the dam was built. The ruins were used for a variety of different purposes, or pulled down. Pumhösl's installation, in which modular concrete moulds are treated as architectural components, incorporates the video *Lac Mantasoa* (2000), which shows the present state of the buildings around the reservoir, and the under-water landscape. A sculpture by Henry Moore acts as a typical example of the modernist aesthetic.

Two further projects stem from this research in the form of 'videographic archives' and installations. *Proposal for a Space with More Than One Video Projection* (2001) looks at the conflict between imported and local ideas of modernism by examining the master-plan of German town planner Ernst May for the Ugandan capital Kampala. He wished to graft modernist garden-city ideas onto the 'brutal borders drawn in colonial capitals'. The third work in this series, *Village, Museum* (2002), examines the *ujamaa* village structuring project commissioned by the Tanzanian President Julius Nyerere in 1967. This was intended to revolutionize the country's economy, but foundered on lack of resources, periods of drought, a war against Idi Amin, and the collapse of idealism among inhabitants subjected to enforced resettlement. Pumhösl's video installation presents several 'fragments' of this failed utopia alongside images of cinemas and museums.

Beatrix Ruf

Lac Mantasoa, 2000
video installation (*stills above*), 12 min., 54 sec., colour, silent
Installation 'Lac Mantasoa', Secession, Vienna, 2000

301

Proposal for a Space with More Than One Video Projection, 2001
video, 3 tracks, each 15 min., colour, silent

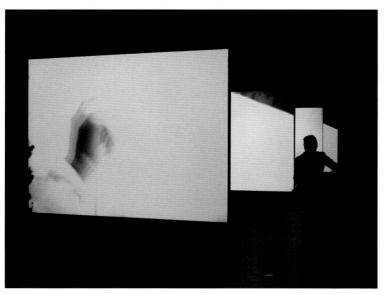

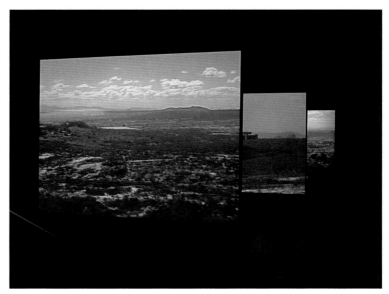

Village, Museum, 2002
video installation, 4 screens, each 180 x 240 cm; 4 videos, each 13 min., 48 sec., loop, colour, silent
Installation 'ForwArt 2002, a choice', Mont des Arts, Brussels, 2002

Humanist and Ecological Republic, 2000
wood, metal, glass, paint, concrete, cement, Henry Moore sculpture, dimensions variable
Installation Secession, Vienna, 2000

You have several times been paralleling or anticipating some (as yet not fully appreciated) recent developments in exact science – of which you may not be fully aware (few are), 2001
video, 4 min., 48 sec., black and white, silent

Born Chbanieh, Lebanon, 1967 Lives and works in Beirut, Lebanon and New York, USA

Selected Solo Exhibitions: 2001 'The Dead Weight of a Quarrel Hangs: Documents from The Atlas Group Archive', Bspecebe, Brussels 2002 'The Atlas Group Project', Museum of Modern Art, Beirut; 'The Loudest Muttering Is Over: Documents from the Atlas Group Archive', Mousonturm, Frankfurt/ Eurokaz Festival, Zagreb; 'Mapping Sitting' (with Akram Zaatari), Palais des Beaux Arts, Brussels/Die Photographische Sammlung SK Stiftung Kultur, Cologne

Selected Group Exhibitions: 2002 'Anxious Omniscience', Princeton University Art Museum; 'Contemporary Arab Representations: Lebanon', Witte de With Centre for Contemporary Art, Rotterdam/Fundacio Antoni Tapies, Barcelona; 'CTRL [Space]: Rhetoric of Surveillance from Bentham to Big Brother', ZKM, Karlsruhe; 'The Dead Weight of a Quarrel Hangs: Documents from The Atlas Group Archive', Documenta 11, Kassel; 'Paradise in Search of a Future', The Atlanta Contemporary Art Center/CEPA Gallery, Buffalo; 'The Perplexities of Security', Watson Institute for International Studies, Providence; 'What? A Tale of Free Images', Memlingmuseum, Brugge; Whitney Biennial, Whitney Museum of American Art, New York

Selected Bibliography: 2002 Alan Gilbert, 'Walid Raad's The Atlas Group Project', *Bomb Magazine*, Fall; Steven Humblet, 'Inheemse portretten', *De Fomamcoeel-Economische TIJD*, 8 May; John Menick, 'Imagined Testimonies: an interview with Walid Raad', www.thing.net/ ~johnmenick/ writing/raad.html, 25 March; Kobena Mercer, 'D11', *frieze*, September; Walid Raad, 'Sweet Talk', *Interarchive*, Verlag der Buchhandlug Walther König, Cologne; Walid Raad/Akram Zaatari, 'Mapping Sitting', *Camera Austria*, No. 78; Sara Rogers, 'Forging History, Performing Memory: Walid Raad's The Atlas Project', *Parachute*, Winter

WALID RAAD / THE ATLAS GROUP

Walid Raad is a storyteller. In his elusive practice, which combines performance art, photography, video, installation and media art, he plays with the paradoxes and ambiguities of speech, authorship and history, never revealing his true identity or clarifying what he actually does. His projects are ongoing bodies of work that explore the trauma of history, as well as the ways in which collective memory and fears are engendered and constructed.

Born in Lebanon, to which he returns for short visits each year, Raad now lives in New York, where he teaches at Cooper Union. He belongs to a generation of artists who began their practice when the Conceptualists of the 1960s and 1970s had become the 'official' artists of our time. However, his work is perhaps more accurately described as an academic art than a form of Conceptualism. Conversant with cultural studies, psychoanalysis and critical theory, he uses these fields as material for art, rather than as tools for its analysis.

One strand of Raad's practice takes the form of lectures, in which he describes the findings of the fictitious Dr Fadl Fakhouri, whom he claims was a historian of the Lebanese civil wars. On his death in 1993 Fakhouri allegedly bequeathed his notebooks in English and Arabic, as well as images and short films, to Raad's 'organization', the Atlas Group. This material, which continues to proliferate, can be found on the Atlas Group website (www.the atlasgroup.org). His research is grouped into files and can be presented in various formats – photographic displays, videos, texts and documentation shown in installations, always under the 'authorship' of the Atlas Group.

Raad mimics the documentary form, but not in order to be ironic. He creates an archive of documents and facts to write the history of contemporary Lebanon while revealing the problematic nature of how knowledge and history are legitimized, accepted as factual and 'truthful', in our digital world of constructed imagery and prosthetic bodies. He tests the limits of memory and the boundaries between memories of actual experience and the narratives they generate.

The Atlas Group's files suggest something covert, at times dangerous. The recent *My Neck is Thinner Than a Hair* (2001–2), for example, collects all the engines used in car bomb attacks in Lebanon from 1975 to 1991. In the file *Secrets in the Open Sea*, the Atlas Group claims to have found small black and white group portraits of men and women discovered dead in the Mediterranean Sea between 1975 and 1990, and deeply embedded them in large blue photographic prints – beautiful, blue expanses in which to project, scrutinize and lose yourself. Carolyn Christov-Bakargiev

Description of the Winning Historian:

He is not merely miserable. He is brilliant at it.
There seems no event, no matter how trivial that
does not arouse him to a frenzy of self-mortification

Historians' Initials and Bets:

1. KS -717
2. MM +830
3. FF +729
4. PH -222
5. HG +311
6. RO +001
7. AB -921
8. SK -112

Winning Historian / Time:

PH - 222

Race Distance:

1000 m.

Winning Time:

1:10

Average Speed:

50.5 km/hr.

*Distance Between Horse
and Finish Line:*

- 18

Missing Lebanese Wars, 1996–2002
colour photograph, 53 x 43 cm

Secrets in the Open Sea, 1998–2000
colour photograph, 109 x 183 cm

AG_AGA_AGP_Neck: 020788S

front back

Date: 2 July 1988
Archive: As-Safir (Beirut) / The Atlas Group | Photographer: Unknown
Notes: Lebanon - Crimes and Criminals - Explosions - 1988 - Beirut

My Neck is Thinner Than a Hair, 2001–2
black and white photograph, 23 x 46 cm

Plate 59

Chevrolet
Brown or Burgundy
August 17, 1985
11:45
Antelias Highway, Jal El Deeb
45 or 62 killed
120 or 122 injured
250 kg. of TNT
Hexogen
4 m. X 1.5 m. crater

Plate 60

Toyota or Subaru
Celica or unknown
Red or Blue
August 18, 1985
12:30
Beirut
4 killed
7 injured
50 kg. of TNT
Some mortar shells

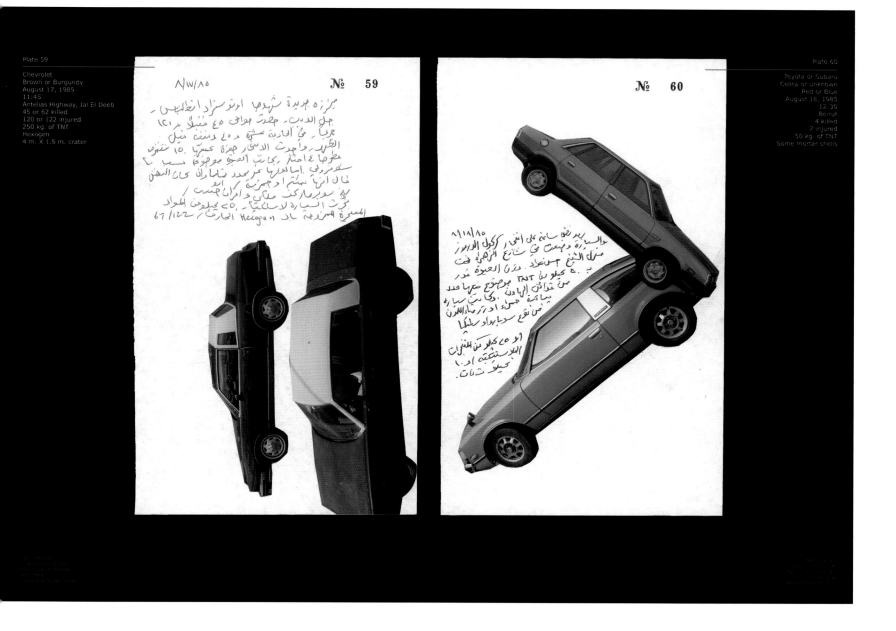

Already Been in a Lake of Fire, 1999–2002
colour photograph, 109 x 150 cm

Born Reken, Westfalen, Germany, 1964 Lives and works in Cologne, Germany

THOMAS RENTMEISTER

Thomas Rentmeister's sculptures are frequently moulded in polyester, dipped in 'appetizing' colours – chocolate, a delicate nougat or a creamy shade of caramel – and often polished to such a degree that viewers can see themselves reflected in their surfaces. This gives them a hyper-realistic, mysterious quality, a sense of physical transience enhanced by the fact that they seem to be melting.

'The key to my highly polished polyester sculptures is their surface', Rentmeister has commented. 'I would prefer to … leave the sculptures lying around in real space like virtual envelopes or soap bubbles with infinitely thin walls. That's impossible of course, so I try to make them look hyper-artificial and alien to reality by intensive crafting, so that at least it isn't difficult to imagine a virtual body.'

Rentmeister is one of the few artists who have gone back to sculptural, three-dimensional forms in this digital and virtual age. His sculptures occupy the space almost as though they belong there naturally, seductively smooth and perfect, apparently crawling across the floor. His earlier works – beginning with variations on the theme of coffee – established the consistent and highly personal artistic position that he has increasingly adopted since.

Rentmeister's work belongs within the rich historical trajectory of three-dimensional work that began on an unspecified day in antiquity and moved through classical modernism down to our media age. His examination of Minimalism plays a key role. In *Whiteware* (2002) he shaped a block made up of several refrigerators covered with greasy baby cream into an even monolith, reminiscent of a work by Robert Ryman. Again, the tactile surface was central to this work. Visitors couldn't keep their hands off it, and could be seen slipping away covered in cream, vainly feigning innocence.

In 2001 in the exhibition 'Brown', at the Kölnischer Kunstverein, Cologne, Rentmeister showed only works in various shades of that colour. The principal means of catching the viewer's eye was a large-scale floor work made of liquid nougat crème. For the first time, Rentmeister added a temporal dimension to his works by making their lifespan dependent on the material's use-by date.

Udo Kittelmann

Untitled, 1999
plastic shelves, Nutella (choclate-nut spread), 60 x 60 x 22 cm

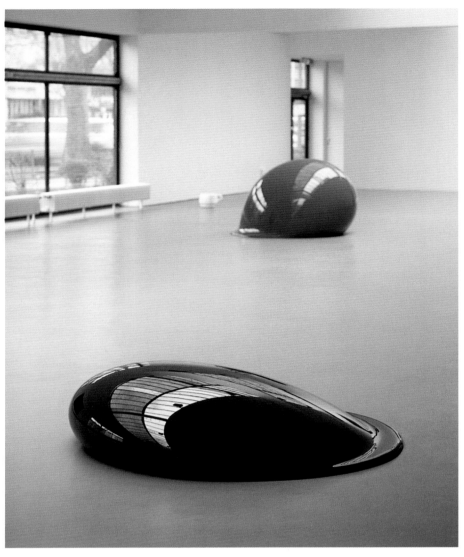

foreground **Untitled**, 1994, polyester resin, 38 x 160 x 149 cm
background **Untitled**, 1993, polyester resin, 107 x 177 x 161 cm
Installation 'Brown', Kölnischer Kunstverein, Cologne, 2001

Untitled (*detail, right*), 2001
Nussenia (chocolate-nut spread), approx. 35 x 1600 x 600 cm
Installation 'Brown', Kölnischer Kunstverein, Cologne, 2001

Untitled, 1985
porcelain cups, coffee, milk, 7.68 m

Milk Cup, 2001
polyester resin, milk, 24 x 24 x 32 cm

Born Seoul, South Korea, 1971 Lives and works in Seoul

Selected Solo Exhibitions: 1998 'Feet Trip', CoCA, Anyang, Korea 2001 'Comfort Tools', Habitat Exhibition Space, London

Selected Group Exhibitions: 2000 'New Comtemporaries 2000', Milton Keynes Gallery/Cornerhouse, Manchester/Inverleith House, Royal Botanic Gardens, Edinburgh 2001 'Fantasia', Space Ima, Seoul/Contemporary Art Centre, Beijing/Tokyo Opera City

Selected Bibliography: 1998 Eun-Joo Park, 'Feet Trip', *Hankook ILBO Daily Newspaper*, 26 November 2000 Dave Beech, 'New Contemporaries 2000', *Art Monthly*, No. 24 2002 Charles Esche, 'Warming and Humidifying', *Artists' Book*, June

JEWYO RHII

Jewyo Rhii makes work about her problems as a 'small, weak and emotionally repressed' woman. Her art often places her initially in a peculiarly dependent and needy position, from which she then proceeds to extract herself with wit, humour and intense displays of energy. Her series of 'screaming devices', made for a recent exhibition in Beijing, is a perfect example of her production. The homemade style of the work is in itself charming, fragile and slightly fey, while the modesty of the proposal – finding a quiet place to scream – could be seen, through Western eyes, as typically Asian. Yet the act of yelling in a gallery breaks all the rules of engagement with art and hints not only at desperation but at anger towards the codes of artistic consumption.

Rhii's work extends from such installations to drawings and books that all offer a measure of practical advice on how to be comfortable, relaxed and content. Never without humour, her works can be read literally as useful guides for the cold, weak or lonely, as well as beautifully creative proposals to reclaim and personalize the material world. They always contain a measure of homespun invention, such as her humidifiers made of materials taken from garden furniture or from the kitchen cupboard. The irony of the work is that such 'cuteness', which can be read as satisfying another Western cliché of Asian women's art, is aimed at a sensual and erotic experience of the world. Her book *Two* (2001) collects drawings of two bodies in a series of close encounters that can either be read as illustrating an inexpensive way of achieving comfort, as Rhii proposes, or in much more overtly sexual terms. This ambivalence is what provides the work with its charge, further complicated by the fact that she has also made a video in which she and another woman adopt some of the same poses suggested in the book.

Other subjects addressed by Rhii include 'Warming & Humidifying', the topic of another self-published book project of 2002. In this case, she suggests solutions to the problems of a cold body and dry skin, again with an ironic twist that leaves the reader considering the book both as a practical instruction manual and a document of obsession. The artist's drawings and photographs build up an increasingly elaborate series of proposals for transforming everyday things into effective therapeutic tools for life indoors, all seemingly drawn from real experiences with the climate in Seoul, London and Philadelphia. It also includes ways to warm up through the use of various body parts, either alone or with someone else, gradually forming a poetic reflection on the absurdity of our normal bodily needs.

As a young Korean artist struggling with the demands of a Westernized art world, Rhii stands out for the metaphorical honesty of her work, as well as for her clear desire to make small improvements to our everyday existence. Charles Esche

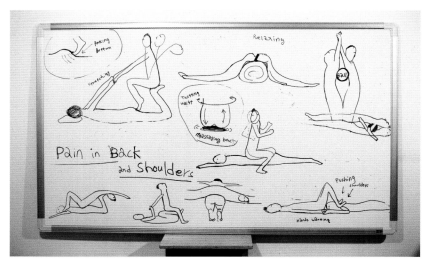

Two (*detail on white board below*), 2001
installation using various household items, dimensions variable
Installation 'Two', Shinsegae Gallery, Incheon, 2001

Back Warming with Friends, 2001
from 'Warming & Humidifying', 2002
drawing, 23 x 30cm

313

Extra long trousers which can be transformed into feet warmer, 2000
from 'Warming & Humidifying', 2002

Back & Hip Warming in Winter Vacation, 2001
from 'Warming & Humidifying', 2002
various household items, dimensions variable

Sound Proof
Head set

FREE RANGE EGGS

above, right and lower right
Screaming Headset, 2001
from 'Scream', 2001
egg cartons, foam and string, dimensions variable

Can I
shout? Sure.

Can I Shout?, 2001
from 'Scream', 2001
drawing, 23 x 30 cm

315

Born Lisbon, Portugal, 1975 Lives and works in Lisbon

Selected Solo Exhibitions: 1998 'Costa da Caparica', Praia da Nova Vaga, Lisbon 1999 'Space Between Characters', Film and Video Auditorium – SAIC, Chicago 2000 Centro Cultural de Belém – Project Room, Lisbon 2001 'Jarre Live', Home Project Calçada do Lavra, Lisbon 2002 '3DTV/ Covende em Paraduça', Lugar Comum Fábrica da Pólvora, Barcarena; 'SlowMotion: Nuno Ribeiro', ESTGAD, Caldas da Rainha

Selected Group Exhibitions: 1998 'LH 4665', Landen Gallerie, Munich; 'Pankow Park Bibliothek', Pankow Park Bibliothek, Berlin 1998 'Nove + X', Vila do Conde Auditorium; 'Rehersal', Ritz Club, Lisbon 2000 'On Location', Dan Peterman's Studio/Monk Parakeet, Chicago 2001 'Video Artists from Chicago', O. Gallery – Top-S, Tokyo 2002 'Interpress: Exhibit A', Interpress Building, Lisbon

Selected Bibliography: 2002 Miguel Wandschneider, 'Notes on Narrative, Reception and Process in an Installation of Nuno Ribeiro', *From Work to Text – Dialogues onn Practice and Criticism in Contemporary Art*, Centro Cultural de Belém, Lisbon

NUNO RIBEIRO

The artist in a fake beard dancing in front of a mirror or singing in the shower; a nocturnal aerial view of Chicago; the interior of a plane; the artist, again, sitting on a sofa zapping through TV channels, or shaving while wearing a wig and fake teeth; a suburban scaled-down replica of the leaning tower of Pisa in a US mini-mall; the artist fiddling with a remote control; a nocturnal snowstorm in Chicago; an American couple in an info-mercial … Nuno Ribeiro's video *Barbalake* (2001) is a succession of seemingly disconnected, often humorous fragments, shot during his graduate studies at the Art Institute of Chicago. Experimentation and discovery, both in terms of the form (video) and the site (America, though there are also images of Ribeiro's native Lisbon here), are recurrent themes, as is an emphasis on the interface between the artist, the medium and the subject matter. The traditional notion of narrative with a beginning, middle and end is continuously questioned, yet the work itself evokes a traditional literary genre – the *Bildungsroman*, or coming-of-age novel. The cryptic title – *barba* means 'beard' in Portuguese – evokes the name of some sort of pirate, perhaps a character in this fragmented *Bildungsroman*.

Ribeiro also works with video in the context of intricate installations. *3DTV* (2002) was a window installation in which a mock 'three-dimensional television' was advertised. It was displayed along with a number of other gadgets under the logo 'TRANSOM – Solutions in home audio and cinema systems', the company that loaned the equipment to the artist in exchange for such singular publicity. *Covende em Paraduça*, a black and white video shown on the two-monitor 3DTV, displayed images of the artist wearing a wetsuit, performing nonsensical acts on a road and the surrounding fields. The title, which refers to an untranslatable expression commonly found in graffiti in Portugal after the 1974 revolution, underlines the work's play between the nonsensical and the political.

Perhaps Ribeiro's most ambitious work, his installation at Lisbon's Centro Cultural de Belém held in 2000, also juxtaposed a wide range of fragments and narratives: video, audio and text on the theme of flying. Five videos were on display: one showing the launching of a balloon; another presenting bird's-eye-view images of Lisbon; the third shot from the inside of an aeroplane, with the sound of the in-flight channel interrupted by the pilot's voice; a fourth of two people's legs shot from a ski lift; the last of a young American woman painfully attempting to read a text in Portuguese. The installation was set in a lounge scenario, with sofas and coffee for visitors, and a soundtrack recorded at a bus station. A choice of diverse reading material downloaded from the Internet included instructions on how to build a small plane, and the absurd story of Larry, who made a fourteen-hour flight attached to forty-five helium balloons. Perception, recording, translation and understanding, never definitely or precisely articulated, are filtered through representation. Ribeiro offers us many clues to these obscure or cryptic elements; ultimately it is up to us to take them up, discovering and following our own paths through his work. Adriano Pedrosa

Barbalake, 2001
video, 42 min., colour, sound

3DTV, 2002
2 TV monitors, 2 DVD players, subwoofer, 2 speakers, glass
Installation '3DTV', Lugar Comum Fábrica da Pólvora, Barcarena, 2002

Covende em Paraduça, 2002
video, 12 min., black and white, sound

Installation Centro Cultural de Belém – Project Room, Lisbon, 2000

Liftchair, 2000
video, 25 min., black and white, sound

Helium balloon launch, 2000
video, 9 min., colour, sound

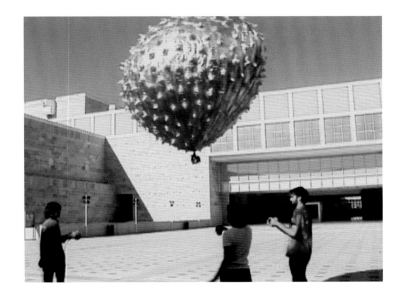

Ascending balloon view over Tagus river, 2000
video, 45 min., black and white, silent

Jeroen de Rijke born Brouwershaven, The Netherlands, 1970, Willem de Rooij born Beverwijk, The Netherlands, 1969 Live and work in Amsterdam, The Netherlands

Selected Solo Exhibitions: 1999 Galerie Daniel Buchholz, Cologne; Städtisches Museum Abteiberg, Münchengladbach 2000 Kunsthaus Glarus; Stedelijk Museum Bureau, Amsterdam 2001 Regen Projects, Los Angeles 2002 Galerie Daniel Buchholz, Cologne; Institute of Contemporary Arts, London; Villa Arson, Nice

Selected Group Exhibitions: 1998 'h:min:sec', Kölnischer Kunstverein, Cologne; Manifesta 2, Casino Luxembourg, Forum d'Art Contemporain, Luxembourg 2000 'Still/Moving', National Museum of Modern Art, Kyoto 2001 1st International Triennale of Contemporary Art, Yokohama; 'Casino 2001', Stedelijk Museum voor Actuele Kunst, Gent; 'Neue Welt', Frankfurter Kunstverein, Frankfurt; 'Squatters', Fundacao de Serralves, Porto 2002 'Die Kraft der Negation', Theater der Welt, Schaupielhaus, Cologne/Volksbühne, Berlin; 'Tableaux Vivants: Lebende Bilder und Attitüden in Fotografie, Film und Video', Kunsthalle Wien, Vienna; 'View Master', New International Cultural Centre, Antwerp

Selected Bibliography: 1998 Christoph Blase, 'Luxemburger Pluralismus: Zur Manifesta 2', *Kunst Bulletin*, No. 9 1999 Lars Bang Larsen, 'Off the silver screen', *nu: The Nordic Art Review*, No. 1 2000 Veit Loers, 'Observations on de Rijke/de Rooij's "Of Three Men"'/Vanessa Joan Müller, 'Non Fiction', 'Forever and a Day', 'Vision in Motion', 'Post-minimal Projections (inside and outside the frame)'/Nicolaus Schafhausen, 'Interview with de Rijke/de Rooij: If only all Rooms could so clearly fulfill their purpose', *Jeroen de Rijke/Willem de Rooij – After the Hunt*, Lukas & Sternberg/Frankfurter Kunstverein/Museum Abteiberg, Frankfurt; Sven Lütticken, 'The Fictions of de Rijke/de Rooij', *De Rijke/De Rooij Bantar Gebang*, Stedelijk Museum Bureau, Amsterdam 2001 Ina Blom, 'Director's Cut (Beauty Operations)'/Lars Bang Larsen, 'What Beauty Saves the World?', *De Rijke/De Rooij: Director's Cut*, catalogue of the exhibition 'Jeroen de Rijke and Willem de Rooij: Three films', The National Museum of Contemporary Art, Oslo 2002 Martin Herbert, 'The glossy untruth', *tema celeste*, October

DE RIJKE / DE ROOIJ

Jeroen de Rijke and Willem de Rooij produce films and, more rarely, photographic works that take their images and composition principles from the history of painting, and from contemporary cinema and video. The artists link these characteristics with elements from the commercial image industry, and with the formal and aesthetic features of contemporary art.

The films are shot on 16 mm or 35 mm film, and are shown only in spaces that comply with the canonic presentation criteria of visual art. In terms of installation, de Rijke and de Rooij control their work's reception down to the last detail. The exhibition space is treated like a sculpture, defined by the technical apparatus and the seating. This creates a hybrid space somewhere between a cinema and an exhibition, present as minimal sculpture, even when the film is not being shown.

The works themselves constitute reductive, concentrated, precisely positioned pictorial worlds that unsentimentally re-activate the way in which we perceive reality, pre-determined cultural definitions and notions of beauty. Camera movement, length of shot and rhythm scarcely change, while the films are reduced to a few images that the artists see as central to the particular theme. The soundtrack is usually separate from the action in the film, with no sense of narrative cinematic development. The camera may make an extended journey, for example, along a chain of icebergs (*I'm Coming Home in Forty Days*, 1997), or focus on a butterfly among the greenery of a deciduous forest (*Voor Bas Oudt*, 1996) or on a couple's dialogue among exotic rhododendron blossoms in a botanical garden (*Chun Tian*, 1994).

By compelling viewers to concentrate with intensified attention on perceiving minimal changes and differences, de Rijke and de Rooij address social themes: central to these films is the presentation of familiar images of cultural identity and difference. *Of Three Men* (1998), for example, shows the interior of a Neo-Romantic church in Amsterdam that is now used as a mosque. The details of the images and the camera perspective are reminiscent of church interiors by the Haarlem painter Pieter Saenredam (1597–1665), whose chief stylistic characteristics are off-centre perspective and the handling of light. The only 'plot' elements are the shift from audio to visual perception, the changing sunlight through the windows, the camera's slow circling of large, low-hanging chandeliers, and the occasional movements of three men sitting on the floor. One's sensory organs become tuned to these minimal events, and one begins to perceive differences both in form and in pictorial interpretation in the course of the film, initiating a discourse about the culturally shaped reading of images.

This experience is repeated in two films shot in India, *Bantar Gebang* (2000) and *Untitled* (2001), which present concentrated shots of daybreak in a slum or a cemetery. Ideas of beauty, the exotic, nature and artificiality are made visible in this film, a tribute to the quality of perception in all its forms.

Beatrix Ruf

Installation Casino Luxembourg, Forum d'Art Contemporain, Luxembourg, 1998

'Shirwan', The Point of Departure, 2002
35 mm film, 26 min., colour, sound

Fatih Mosque, Amsterdam, 1998, location still for **Of Three Men**, 1998
35 mm film, 10 min., colour, sound

Born Mexico City, Mexico, 1973 Lives and works in Mexico City

Selected Solo Exhibitions: 1996 'R.S.V.P', Galería OMR, Mexico City 1998 'La Laguna de las Ilusiones', Arena Mexico, Guadalajara 2000 'All the Best Names Are Taken', Greene Naftali Gallery, New York 2001 Kevin Burke Fine Arts, Miami; Galeria Alberto Peola, Turin 2002 'Ricas y famosas', Casa de America/PhotoEspaña02, Madrid; 'Third World Blondes Have More Money', Greene Naftali Gallery, New York

Selected Group Exhibitions: 1997 'InSITE 97: New Projects in Public Spaces by Artists of the Americas', InSITE, San Diego/Tijuana 1998 'No Soy Chino', Art & Idea, Mexico City; 'Six Contemporary Artists from Mexico City', Jack Tilton Gallery, New York; 'Super Freaks – Post Pop & the New Generation, Part I: Trash', Greene Naftali Gallery, New York 1999 'Lontano da dove?', Galleria Alberto Peola, Turin 2000 'I Saw Stars', Momenta Art, New York; 'Policies of Difference: Iberoamerican Art at the Turn of the Century', Pinacoteca do Estado de São Paulo; 'Superpredators',

CRP Gallery, New York 2002 'Mexico City: An Exhibition About the Exchange Rates of Bodies and Values', PS.1 Contemporary Art Center, New York; 'Mexico: Common Objects and Cosmopolitan Acts', San Diego Museum of Art; 'Sublime Artificial', La Capella, Barcelona

Selected Bibliography: 1999 Rubén Gallo, 'Mexican Photography from Chiapas to Fifth Avenue', *Flash Art*, May–June 2000 Holland Cotter, 'I Saw Stars', *The New York Times*, 19 May; David Hunt, 'Daniela Rossell: Rich and Infamous', *art/text*, August–October; 'Superpredators', *The New Yorker*, 11 December; Naief Yehya, 'Profile: Daniela Rossell', *ArtNexus*, August–October 2001 Hilarie M. Sheets, 'Material Girls', *ARTnews*, February 2002 Vince Aletti, 'Photo: Daniela Rossell', *Village Voice*, 1 May; Holland Cotter, 'Daniela Rossell', *The New York Times*, 26 April; Martha Schwendener, 'Daniela Rossell', *Time Out New York*, 25 April

DANIELA ROSSELL

Daniela Rossell was given her first solo show in 1993, when she was barely twenty. It was held at Temístocles, Mexico City's most lively alternative space, housed in a condemned mansion in the ritzy neighbourhood of Polanco. She showed portraits of various female family members posing in the garish bedrooms, terraces and gardens of their suburban villas, located for the most part in Las Lomas, Mexico City's answer to Beverly Hills.

Rossell's parents both came from families associated with the PRI – the political party that emerged from the Mexican Revolution, then degenerated into what Octavio Paz once called a 'philanthropic ogre', and ruled the country from 1929 to 2000. Her photographs provide a fascinating glimpse into the private lives of the rich and powerful.

Looking at these pictures, one is immediately struck by a certain gender imbalance: men are, for the most part, absent. We find traces of their existence – a silver-framed snapshot on a mahogany table, a painting dedicated to a certain Don Manuel, a stuffed-lion hunting trophy – but we soon realize that this is a world largely created and inhabited by women – the wives and daughters of mighty politicians and opulent businessmen. This feminine realm is characterized by what seems to be a fierce compulsion to fill every square inch with gilded mirrors, blackamoor sconces, crystal chandeliers, baroque self-portraits, lace curtains, Persian rugs, silver tea-sets and many other *tchochkes*.

In contrast to the exuberance of their surroundings, however, most of these women appear to be lacking something. They are not arrogant or haughty, snobbish or even wholly self-assured.

On the contrary, it seems that they are suffering from an intense *horror vacui*, as if trying to fill an internal void through this compulsive accumulation of objects. Their wistful gazes betray a certain emptiness … is it loneliness? Boredom? Existential angst?

Inge, for example, a twenty-something aspiring model, appears in front of a pastel-coloured, turreted mansion, posing next to a statue of Don Quixote. She seems completely unaware of the pathological excesses that surround her; ignorant of the fact that the family's fortune might have less-than-respectable origins, that a 100,000-foot house is an anomaly in a third-world country.

Though most critics have read Rossell's photos as critiques of the ills afflicting Mexican society – political corruption, social and racial inequity – it is perhaps more interesting to examine them within the context of Mexican photography. Since the 1920s, it has been dominated by an ethnographic tendency: photographers from Manuel Alvarez Bravo to Graciela Iturbide have turned an exoticizing eye towards the countryside, documenting the lifestyles of impoverished peasants in the remote hills of Chiapas or the deserts of Sonora. Ironically, these photographs have become prized commodities, adorning the living rooms of rich Mexicans like those depicted in this series. Rossell's pictures use many of the same ethnographic strategies – she poses her subjects in their native environments, and documents their daily habits and rituals. The difference, however, is that she focuses on those who until now had been excluded from the history of photography: the urban elite that is to blame for the sorry lot of the impoverished – but picturesque – rural masses.
Rubén Gallo

above and overleaf
Untitled, from 'Rich and Famous', 1999
Cibachrome prints, 76 x 101.5 cm

Born Tirana, Albania, 1974 Lives and works in Paris, France

Selected Solo Exhibitions: 2000 De Appel, Amsterdam; 'Intervista', Galerie Rüdifer Schöttle, Munich; 'Nocturnes', MAMCO, Geneva 2001 'Anri Sala: Nocturnes', Delfina Project Space, London; 'It Has Been Raining Here', Galerie Chantal Crousel, Paris 2002 'Concentrations 41', Dallas Museum of Art; Galerie Hauser & Wirth & Presenhuber, Zürich; IKON Gallery, Birmingham; 'Missing Landscape and Promises', Trans>Area, New York 2003 Kunsthalle Wien, Vienna; 'The Moderns', Castello di Rivoli, Museo d'Arte Contemporanea, Turin

Selected Group Exhibitions: 1999 47th Venice Biennale; 'After the Wall', Moderna Museet, Stockholm/ Ludwig Museum, Budapest 2000 Manifesta 3, Ljubljana; 'Voilà – Le Monde dans la Tête', Musée d'Art Moderne de la Ville de Paris 2001 1st International Triennale of Contemporary Art, Yokohama; 1st Tirana Biennale; 49th Venice Biennale; 'Uniform: Order and Disorder', PS.1 Contemporary Art Center, New York; 'Unpacking Europe', Haus der Kultur der Welt, Berlin/Museum Boijmans van Beuningen, Rotterdam 2002 XXV São Paulo Biennale; 'ForwArt 2002, a choice', Mont des Arts, Brussels; 'Kusammenhägen herstellen', Hamburger Kunstverein, Hamburg; 'Viewmaster', NICC, Antwerp

Selected Bibliography: 1999 Edi Muka, *After the Wall: Art and Culture in Post-Communist Europe*, Moderna Museet, Stockholm 2000 Ronald Jones, 'After the Wall: Art and Culture in Post-Communist Europe', *Artforum*, March; Emmanuelle Lequeux, 'Passage Comme ses Images', *Le Monde (Aden)*, 13–19 December; Jan Verwoert, 'Manifesta 3', *frieze*, No. 55 2001 'Anri Sala, Darren Almond', *Le Monde (Aden)*, 10–16 January; Arnaud Eshayes, 'Anri Sala – La mémoire fictive', *Beaux Arts*, October; *The Gift, generous offerings, threatening hospitality*, Palazzo delle Papesse, Sienna; Martin Herbert, 'Anri Sala', *tema celeste*, Summer; 'Hans Ulrich-Obrist on Anri Sala', *Artforum*, January; Daniel Soutif, 'Pick to Click', *Artforum*, September; Elisabeth Véndrenne, 'Anri Sala', *L'Oeil*, June 2002 *ForwArt 2002, a choice*, Mont des Arts, Brussels; Soren Grammel, 'Finding the Words', *Afterall* No. 5; Jörg Heiser, 'Anri Sala: Reverse of the Real', *The Hugo Boss Prize 2002*, Guggenheim Museum, New York; Jan Verwoert, 'Mother Country', *frieze*, No. 67

ANRI SALA

When Anri Sala emigrated to Paris from his native Tirana in 1996, his first body of work contemplated the sense of dislocation he experienced in both geographical and temporal terms. Though originally trained as a painter, he turned to film – specifically invoking the documentary genre – to relay his stories of half-remembered truths and nearly forgotten landscapes.

In *Intervista – Finding the Words* (1998), Sala returns home to confront his mother with an old film reel that showed her being interviewed on the occasion of an international congress of Communist youth during the reign of dictator Enver Hoxha. Because the soundtrack to this found footage had been lost and Sala's mother could not remember her comments, the artist set out to reconstruct the dialogue. Along the way he interviewed various people originally involved in such propaganda productions, including a former sound engineer at the national television station, who is now a taxi driver. In his search for his mother's own voice, Sala engaged the assistance of deaf-mutes who lip-read and transcribed her speech.

Sala's exploration of the disjunction between words and (visual) memory is also manifested in *Byrek* (2000), which focuses on the hands of an elderly woman preparing the traditional Albanian bread of the title. The footage is projected onto an enlarged version of a letter that the artist received from his grandmother expressing her concern for his health and diet, along with the family recipe for *byrek*. The camera lingers nostalgically over the dough, pausing only to follow the trajectories of aeroplanes flying overhead, as if to capture metonymically the division between a remembered past and the intrusions of the present.

Nocturnes (1999) also rehearses tensions between personal memory and empirical reality through the confessions of two insomniacs living in the nightmares of their own secluded universes. Jacques obsessively collects predatory fish to the exclusion of an external life. Dennis, a former peacekeeper from the Balkans, tries to ease his conscience about the bloodshed he has committed through the mind-numbing effects of video games.

Sala's approach to his subject is always oblique. He omits key information, allowing the quiet poetry of an image to emerge. In *Uomoduomo* (2000), for instance, the identity of an old man sleeping in the Milan cathedral is never revealed. During the fragile few minutes that comprise this video, it is impossible to know if this vulnerable-looking, Beckett-like figure is homeless or merely resting. In *Naturalmystic* (1998), a young man in a recording studio whistles softly into a microphone, raising and lowering the pitch of his voice to simulate the sounds of falling tomahawk missiles. What is not explained is that he is imitating from memory an attack he experienced in Sarajevo. *Blindfold* (2002), a two-screen video projection, is premised on absence. It shows two views of the sun setting behind a blank, aluminium billboard atop a building. As the sun lowers in the sky an aura of light seems to emanate from the empty sign, its brilliance masking out the quotidian activities on the street below.

Nancy Spector

Blindfold, 2002
double-projection video, 15 min., loop, sound

Uomoduomo, 2000
video, 1 min., 34 sec., colour, silent

Untitled, 2002
colour photograph, 110 x 157 cm

Naturalmystic (Tomahawk #2), 1998
video, 2 min., 8 sec., colour, sound

Christmas Tree, 2002
colour photograph, 110 x 157 cm

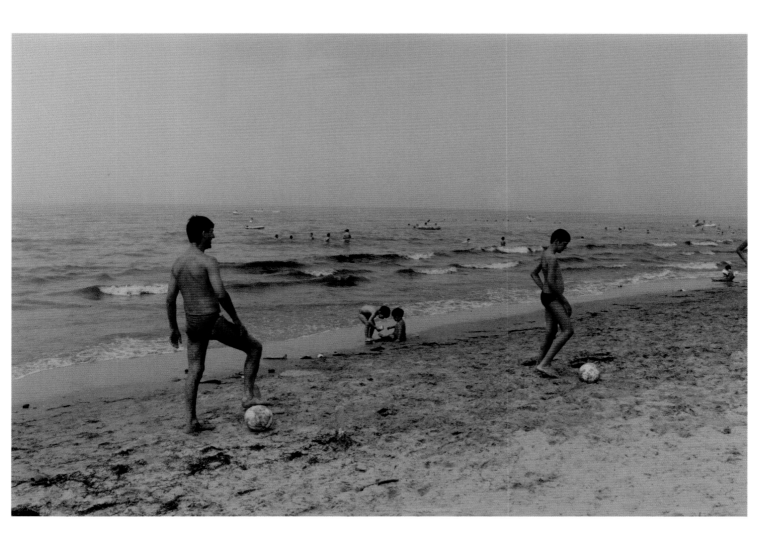

We have other concerns, 2001
colour photograph, mounted on aluminium, 77 x 115 cm

Born Torrance, USA, 1971 Lives and works in Los Angeles, USA

Selected Solo Exhibitions: 2001 'He Sang the Soundtrack to my Life: Too young to reason, too grown-up to dream …', Galerie Hohenlohe & Kalb, Vienna; 'Too young to reason, too grown-up to dream …', LOW, Los Angeles 2002 'Boys in my Bedroom', Taka Ishii Gallery, Tokyo; 'Statements', Art 33 Basel

Selected Group Exhibitions: 1999 'Good Vibrations', Tomio Koyama Gallery, Tokyo 2000 'Urban Hymns', Luckman Gallery, CalState LA, Los Angeles 2001 'Andere Raume', Kunstverein Hamburg; 'Bystander', Andrea Rosen Gallery, Space 2, New York; 'L.A. on My Mind: Recent Acquisitions', Museum of Contemporary Art, Los Angeles; 'Inframince', Cabinet, London; 'Majestic Sprawl: Some L.A. Photography', Pasadena Museum of California Art; 'Nachgemacht: reproduzierte Naturlichkeit-simulierte Natur', Kunstraum Innsbruck; 'Scenes', Henry Urbach Gallery, New York; 'Song Poems', Cohan, Leslie & Browne, New York; 'Two Friends and So On …', Marc Foxx Gallery, Los Angeles

Selected Bibliography: 1998 Bill Arning, 'Honcho Featured Artists: Dean Sameshima, Glen Ligon, Adriano Pedrosa, Matts Liederstam', HONCHO, October 1999 Claudine Ise, 'Articulating Grief Through the Art of Loss', Los Angeles Times, 16 April 2000 Martin Prinzhorn, 'Conceptualism with a Splash of Cranberry', Camera Austria, No. 71 2001 Bruce Hainley, 'Dean Sameshima: Review', Artforum, May; Laurence A. Rickels, 'Dean Sameshima: Secret Agency', art/text, February–April 2002 Stuart Comer, 'Dean Sameshima', i-D, May; Holland Cotter, 'Review: Bystander', The New York Times, 12 July; Yilmaz Dziewior/Katrin Sauerlander, Andere Raume, Kunstverein Hamburg; Susette Min, 'Remains to be Seen: Reading the Works of Dean Sameshima and Khan Vo', Loss: The Politics of Mourning, University of California Press, Berkeley; Dean Sameshima, Hysteric Glamour Books, Tokyo

DEAN SAMESHIMA

Roland Barthes once remarked that erotic pleasure arises from the tension between what is seen and what is left to the imagination, and that the secret to a successful striptease lies in showing but never revealing too much, whetting the viewer's appetite for more but never quenching his desire. In this sense, Sameshima's work – the sexiest Conceptual photography ever – resembles the ideal Barthesian striptease: it presents us with a few sparse hints – an unmade bed, the entrance to a bathhouse, an isolated country nook – evoking the aftermath of seduction, but he leaves the meatier aspects of the narrative to be construed by the erotic imagination.

A series of untitled photographs of nondescript Los Angeles buildings features low-rise structures as banal as strip malls and fast-food joints. These images of boring suburban structures appear, like the works of Dan Graham and Edward Ruscha, to comment on the architectural monotony permeating American cities. But the *punctum* of Dean's photos lies elsewhere, as the subtitles suggest. One, for example, reads *Untitled (12 stalls, 1 leather bunk bed, outdoor garden, 1 water fountain, 1 barber's chair, glory hole platform, Chinese décor, 1995)*, while another is more succinct: *Untitled (older men, 1995)*. They are all images of gay sex clubs and bathhouses in LA, and nothing could be more distanced from these unremarkable, grey exteriors than the steamy, salacious action that they serve to conceal. A similar strategy is adopted in *Untitled (Palos Verdes, 1996)*, a series depicting a cruising area full of abandoned bunkers on the hills above the Pacific Ocean. We could stare at these photos for hours without finding a single hint of the world

that lies on the other side of these walls; we have either to read the title or be in the know.

What is hidden from view, however, is not always erotic – even when what is concealed is the interior of a sex club. The series *Inbetween days (without you, 1997)*, for example, groups together fifteen photos of a room in a sex club; each shows the same narrow bed, but in one picture the sheets are ruffled while in another they are spotless and untouched. Sameshima made this series after breaking up with his first boyfriend; as a ritual of mourning, he visited his local sex club for fifteen days and documented the state of his room at the end of each visit. These photos elicit a mood of melancholy, loneliness and longing accentuated by the starkness of the red light. Ultimately, they seem to suggest, the interior of a sex club can be as barren and nondescript as its facade.

Café Bleu, another series from 2000, documents a brighter aspect of gay life: club culture. Here, Sameshima began by selecting a cute guy at this straight club, and proceeded to photograph him until he either looked back at the camera or left. Playful, delightfully adolescent and even bashful, these photographs constitute a minute-by-minute documentation of flirtation, although only from Sameshima's point of view. The perspective of these boys – and the thoughts that ran through their minds upon finding themselves targeted by Sameshima's camera – must be left, in a gesture that Barthes would certainly applaud, up to our imagination. Rubén Gallo

Café Bleu, November 5, 1999, 2000
5 Fuji-Flex prints, each 10 x 15 cm

Inbetween days (without you, 1997), 1997
6 of 15 colour photographs, each 25 x 30.5 cm

Untitled (15 rooms, 1 locker room, 3 bathtubs, 2 leather slings, 1995)
1995–6
1 of 7 colour photographs, each 16.5 x 35.5 cm

Untitled (older men, 1995), 1995
1 of 7 colour photographs, each 16.5 x 35.5 cm

DEAN SAM

Untitled (Palos Verdes, 1996), 1996
nos 1, 4, 5, 6 of 7 colour photographs, each 28 x 35.5 cm

Born Cruzton, San Juan Chamula, Mexico, 1975 Lives and works in Chiapas, Mexico

Selected Solo Exhibitions: 1998 'Creencias', Mexican Cultural Institute, New York; 'Creencias de Chamula', Centro Cultural San Angel, Mexico City; 'Maruch Sántiz-Gómez. Creencias', Galería OMR, Mexico City 2001 'De la serie creencias', MUCA, Mexico City

Selected Group Exhibitions: 1998 'Looking at the 90s: Four Views of Current Mexican Photography', Fotofest '98, Vine Street Studios, Houston; 'Mayan photographs: indigenous images from Chiapas', Reykjavik Arts Festival 1999 1st Liverpool Biennial 2000 'Versiones del sur. Más allá del documento', Museo Nacional Centro de Arte Reina Sofía, Madrid; 'Visiones', Museo Na Bolom, San Cristóbal de las Casas, Chiapas; 'Visiones indígenas de Chiapas', Instituto de Cultura de la Ciudad de México, Mexico City 2001 'AbseeD', Anthony Reynolds Gallery, London; 'Lifestills', Galerie Carousel, Paris; 'ReMediated Memories', Australian Center for Photography, Sydney 2002 'Geld und Wert – Das letzte Tabu', Expo.02, Biel; 'Magische Expeditionen. Streifzüge mit rätselhaften Empfindungen', Museum Folkwang, Essen

Selected Bibliography: 1994 Hermann Bellinghausen, 'Caligrafía de las cosas', *Luna Cornea*, No. 5 1998 Yishai Jusidman, 'Maruch Sántiz-Gómez: Galería OMR', *Artforum*, September 1999 Carlota Duarte, 'Interview with Maruch Sántiz-Gómez', *Aperture*, Winter; Rubén Gallo, 'Mexican Photography from Chiapas to Fifth Avenue', *Flash Art*, Vol. 32, No. 206 2000 Carinne Chavarochette, 'Croyances et Photographes, les communautés indiennes du Chiapas à l'aube de XXIe siècle', *Histoire et Sociétés de l'Amérique Latine*, No. 11; Charles Merewether, 'Perturbacion en el archivo', *Versiones del sur. Más allá del documento*, Museo Nacional Centro de Arte Reina Sofía, Madrid 2001 Eduardo Pérez Soler, 'Arte mexicano reciente. Reflexivo, irónico, posrelacional', *Lapiz*, May; Madlenn Schering, 'Leben in Chiapas aus der Innenperspektive. Indígenas hinter der Kamera', *Lateinamerika Nachrichten*, December 2002 Necmi Sonmez, '"Es hängt vom Text ab, von dem, was meine kommende Arbeit sagt", Ein Gespräch mit der Maya-Fotografin Maruch Sántiz-Gómez'/Michael M. Thoss, 'Maruch Sántiz-Gómez', *Magische Expeditionen. Streifzüge mit rätselhaften Empfindungen*, Museum Folkwang, Essen

MARUCH SÁNTIZ-GÓMEZ

Maruch Sántiz-Gómez lives far away from the bustling art scene of Mexico City, in the mountains of the southern state of Chiapas, a region that attained world fame after the Zapatista uprising of 1 January 1994. At a time when Mexico had just signed the North American Free Trade Agreement and city dwellers basked in dreams of an imminent transition into the first world, the Zapatista revolt reminded us that there was another, forgotten Mexico, embodied in the country's Indian minority concentrated in remote regions like Chiapas. While middle-class Mexicans celebrated their ability to acquire computers, cell phones and the latest imported gadgets, hundreds of thousands of rural people lacked plumbing, running water and other basic necessities.

Sántiz-Gómez lives in a poor region inhabited mostly by the Mayan-speaking Tzotzil people. Since 1993 she has worked on *Beliefs*, a Conceptual project that documents the sayings and traditions of her village by juxtaposing photographs of simple objects – pots or water gourds – with short, succinct texts (in Tzotzil) describing the popular beliefs associated with them. A photograph of an earthenware pot, for example, accompanies a text warning viewers that if you eat directly from the pot, you risk becoming a glutton; another photograph depicts a *comal*, the round griddle used to cook tortillas, and advises that 'You shouldn't drink the water used for washing hands while making tortillas, or you might end up grinning like a madman.' Yet another cautions against the potentially lethal consequences of nocturnal vanity: 'It is bad to comb your hair at night because it is said that your mother might die.'

Though Sántiz-Gómez is an outsider to the art world (her aim is to pass on these beliefs to the children in her community), her simple yet eloquent combinations of texts and images brings to mind the work of Conceptual artists like Dan Graham and Hans Haacke: photography has been freed from the formalist concerns privileged by high modernism, reduced to its most elemental, documentary function of conveying information to the viewer. Sántiz-Gómez's photographic series, however, focuses on experiences that are absent from the work of most Conceptual artists: she documents a world that is not only Indian, but also feminine, since many of her objects – from cooking utensils to grooming accessories – are used almost exclusively by women. By adopting Conceptual strategies to represent a feminine realm, Sántiz-Gómez's series recalls Martha Rosler's *Semiotics of the Kitchen* (1975), another work that relies on the systematic yet humorous classification of women's 'stuff'.

By far the most important aspect of Sántiz-Gómez's work – and one that firmly grounds it in the lineage of Conceptual art – is its engagement with her country's political reality. At a time when the tension between the city and the country, the modern and the Indian Mexico, threaten to explode into a fully fledged confrontation, *Beliefs* serves the urgent purpose of documenting and disseminating the traditions of the country's Indian minority. Rubén Gallo

K'uxi ta metz'tael mi oy toj muk'tik
yak' li bote: ta jtzobtik oxlajunbej,
chich' juch'el ta cho', ja' no'ox ma'uk
sk'ob chtunc jalamtc' tzk'obin.

To prevent large hailstones from falling, 1994
silver gelatin print and text in Tzotzlil, 57.5 x 47.5 cm
'A secret to prevent large hailstones from falling: collect three hailstones and
begin to grind them on the grinding stone, using the stick used for weaving'

Mu xtun jlapojtik jtz'is jk'u'tik,
yu'un ta la xijpas ta jkotkovil; ja'
la ti buy xijlok' xij'och ta na'etikc.

Sewing clothes, 2000
colour print and text in Tzotzlil, 78 x 64 cm
'You should not sew clothes while wearing them because you may become a nomad'

Li isak'c mu xtun jchobc spat
jipbetik, yu'un mi mo'oje,
mu xa la xch'i ku'untik.

Potatoes, 2000
colour print and text in Tzotzlil, 78 x 64 cm
'If potato peelings are thrown in the field, the next harvest will not be very good'

K'alal mi oy buch'u kaki bakil choy
ta snuk'e, ta xich' sa'el jkot ik'al sup,
ta xich' mesel oxmesel ti ta nuk'ile;
va'I jech la ta xlok'tal ti bakil choyc.

Black cat, 2000
colour print and text in Tzotzlil, 78 x 64 cm
'If a fish bone gets caught in someone's throat, pass a black
cat over the neck three times and the bone will come out'

Li ololetike mu xtun stibik li
yakan yuye, yu'un ti k'alal
xtakeik batel ta mantale mu la
suj sbaik mu xanavik ta anil.

Mushroom, 2000
colour print and text in Tzotzlil, 78 x 64 cm
'Children should not eat mushroom stems because, while on an errand, they will not hurry'

Li tzebetike mu xtun slajetsik li sk'ak'etal
ve'lil ta xalteme, li ta binc, yu'un k'alal mi
staik antzilale, xchi'uk k'alal mi sta
sk'ak'alil chkolik ta alajele, ja' la mu xyal li
sme' olole, tey la pak'al ta xkom, ti
xal xcham o ti mi mu yaltalele.

Frying pan, 2000
colour print and text in Tzotzlil, 78 x 64 cm
'Girls should not eat food stuck in the frying pan. If they eat it, when they are older and they are going to give birth, although the baby will be born well, the placenta might not come out and the mother could die'

Mi chij'ak'bat vunal tak'ine, ja'lek, yu'un
mi oy buy li jbat ta sa' abtele, ta xkilbetik
jutuk sat tak'in. Yanuk mi ta xkak'tik
batel jtak'intike, yu'un me chijpas ta me'on
un bi, yu'un ja' la ti laj yich'ik
batel ti xch'ulel tak'ine.

Paper money, 2000
colour print and text in Tzotzlil, 78 x 64 cm
'If in a dream we are given bills and one day we go out looking for work, we will receive little money. If we give our money to someone, it means surely we will be poor. They say the spirit of money has taken our wealth'

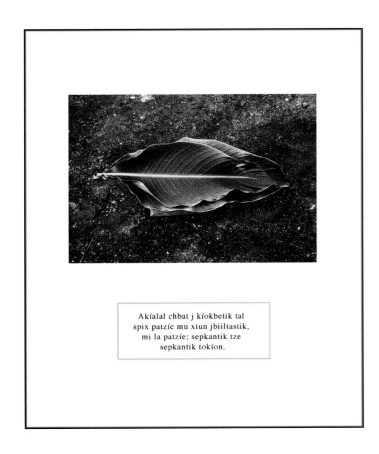

Akíalal chbat j kíokbetik tal
spix patzíe mu xtun jbiiltastik,
mi la patzíe; sepkantik tze
sepkantik tokíon.

Do not mention the name of the *bejao* leaf when you make tamales, 1994
silver gelatin print and text in Tzotzlil, 61 x 51 cm
'When the *bejao* leaf is cut to make tamales, it is not good to mention its name because then the tamales do not cook well; some pieces will be cooked and others raw'

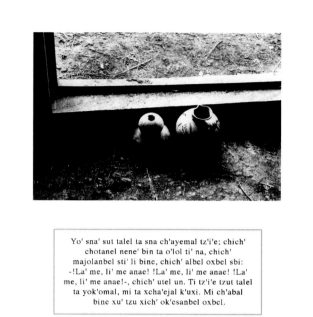

Yo' sna' sut talel ta sna ch'ayemal tz'i'e; chich'
chotanel nene' bin ta o'lol ti' na, chich'
majolanbel sti' li bine, chich' albel oxbel sbi:
-!La' me, li' me anae! !La' me, li' me anae! !La'
me, li' me anae!-, chich' utel un. Ti tz'i'e tzut talel
ta yok'omal, mi ta xcha'ejal k'uxi. Mi ch'abal
binc xu' tzu xich' ok'esanbel oxbel.

Mu xtun jmes jnatik ta bat
k'ak'al, chch'ay jve'ebtik chijpas
ta mc'on mi ja'uk xa jtatik tak'in.

Do not sweep the house in the afternoon, 1994
silver gelatin print and text in Tzotzli, 57.5 x 47.5 cm
'It is such bad luck to sweep the house in the afternoon that you can lose all your money'

How to call back home a lost dog, 1994
silver gelatin print and text in Tzotlil, 57.5 x 47.5 cm
'To call back home a lost dog, you place a small clay jar in the middle of the doorway, and tap the
mouth of the jar, saying the name of the dog three times: "Come, here's your house! Come, here's
your house! Come, here's your house!" is what you say. The dog will come back the next day or the
third day. If you don't have a jar, you can blow into a gourd three times'

Akíalal chichí likel lokíel ta
kíokí li semete, mu xtun jkíeltik
li slebe, ta xchí ta jsatik jaí
la tzlokíta li butumtike.

Mu xtun xkuch'tik apubil, mi
la kuch'tike chijpas la ta tze'etel
risano ko'ol xchi'uk
chijpas ta chuvaj xkaltik.

Do not look at the sparks from the griddle when you take it off the fire, 1994
silver gelatin print and text in Tzotzli, 78 x 64 cm
'When you take the griddle off the fire don't look at the little sparks it makes because pimples will
appear on your face just like the ones seen on the griddle'

Do not drink the water used for hand washing while making tortillas, 1994
silver print and text in Tzotzlil, 78 x 64 cm
'You shouldn't drink the water used for washing hands while making tortillas or you might end up
grinning like a madman'

Born Tarnow, Poland, 1972 Lives and works in Tarnow

Selected Solo Exhibitions: 1999 'The Hundred Pieces', Galeria Zderzak, Krakow; 'Painting', Contemporary Arts Centre, Ujazdowski Castle, Warsaw 2000 'Board Game', Galeria Potocka, Krakow 2001 'Cars and Men', Foksal Gallery Foundation, Warsaw; 'Everyday Life in Poland between 1999 and 2000', Galeria Raster, Warsaw 2002 'PHO', Galerie Johnen + Schöttle, Cologne; 'Show on your Hands – Look – Come Closer', Foksal Gallery Foundation, Warsaw/Parel, Amsterdam 2003 Sadie Coles HQ, London; Anton Kern Gallery, New York; Kunsthalle Zürich; MUKHA, Antwerp; Sommer Contemporary Art, Tel-Aviv; Westfälischer Kunstverein, Münster

Selected Group Exhibitions: 1997 'Seven Young Painters', French Cultural Institute, Krakow 1999 'What you see is what you get', Medium Gallery, Bratislava 2000 '100% Painting', BWA Gallery, Poznan, Poland; 'Scena 2000', Contemporary Arts Centre, Ujazdowski Castle, Warsaw 2001 1st Tirana Biennale; 'Bureaucracy', Foksal Gallery Foundation, Warsaw; 'The Good', Galeria Raster, Warsaw; 'In Between', Chicago Cultural Center; 'Painter's Competition', Galeria Bielska BWA, Bielsko-Biala 2002 4th Gwangju Biennale; 'Painting on the Move', Kunsthalle Basel; 'Urgent Painting', Musée d'Art Moderne de la Ville de Paris

Selected Bibliography: 2001 Adam Szymczyk, *Tirana Biennale* 2002 Ralf Christofori, 'Wilhelm Sasnal's Realisms', *Kunst-Bulletin*, September; Charles Esche, 'Just Pictures Anyway', *Urgent Painting*, ARC, Paris; Igor Zabel, *Vitamin P*, Phaidon Press, London

WILHELM SASNAL

The titles of Wilhelm Sasnal's works are soberly direct: *A Drug on White Saucer*, *Airport at Night*, *Black Thing*, *UFO with Date*, *Two Men Throwing Bombs from Balloon* ... But the images he produces – depicting everything from the domestic refrigerator to the nuclear threat – represent an intricate, physically and psychologically complex process of appropriation. Though he also produces films and comics, more frequently he uses the subjective medium of painting to depict objective fact, making the familiar eerie, and exploring the relationship between reality, imagination and representation.

Almost all of Sasnal's images are plucked from the context of the omnipresent mechanisms that mediate reality, defining and generating our perception of the world. These may be images from the mass media (the Boeing jet exploding over Lockerbie, Concorde taking off with its engine on fire, pictures of atomic bombs and sporting events, subjects from magazines like hunters, views of the moon, UFOs), or his own photographs (portraits of friends, everyday utensils and consumer objects). They may take art-historical sources as their subject matter (portraits from photographs by Rodchenko; Robert Smithson sitting in a chair or photographing *Spiral Jetty*; Joseph Beuys handing over a work of art in Poland, etc.), or they may be appropriated from specialist literature like botanical or zoological picture books (monkeys, sea grasses, fungi). He has also borrowed from advertising, comics (Art Spiegelmann's books, for example, or more recent children's cartoons), record covers (for Sonic Youth, Stereolab, The Clash) or book jackets (a series from the 1960s and 1970s, created by Polish designers).

Sasnal reproduces these 'things' and visual layouts in a succinct, flat style that takes its cue from the style of the image he appropriates. Thus his paintings can look like enlarged black and white graphics from a comic, or they can be visually exciting, masterly and meticulous translations into paint of, for example, a historical black and white photograph. He can also adapt banal compositions of colour and form, evoke sentimental and atmospheric colour moods, or allude to abstract image creation processes. Whatever the original source material, his pictures are always disturbing or distracting, or perhaps even disappointing, somehow falling short of the familiar language we recognize from the deluge of media illustrations to which we are constantly exposed. His images create a gap in our perception that refuses to accept the interpretations we would normally attribute to them, even making them seem threatening through the subjectivity and intensity of his vision. In this way he returns these images to reality, and thus returns reality to the viewer.

Beatrix Ruf

Adam, 2002
oil on canvas, 150 x 150 cm

Church, 2002
oil on canvas, 120 x 110 cm

Gonzales, 2002
oil on canvas, 27 x 35 cm

Jeff Wall – Figures and Places, 2002
oil on canvas, 30 x 40 cm

Artificial Leather, 2002
oil on canvas, 30 x 40 cm

WILHELM

Maus, 2001
oil on canvas, 90 x 190 cm

Untitled, 2002
ink on paper, 29 x 21 cm

Untitled, 2001
oil on canvas, 50 x 60 cm

Born Düsseldorf, Germany, 1962 Lives and works in Düsseldorf

Selected Solo Exhibitions: 1996 Kölnischer Kunstverein, Cologne; Städtische Galerie, Wolfsburg 1997 Lehmann Maupin, New York; Musée d'Art Moderne da la Ville de Paris 1998 Mai 36, Zürich; Portikus, Frankfurt 2000 'Kat. 55/Architektur', Kat. 55/Architektur, New York; Galerie Wilma Tolksdorf, Frankfurt 2001 'Arbeiten am Bild', Kunsthalle Bremen; Lehmann Maupin, New York 2002 Mai 36, Zürich; Galerie nächst St Stephan, Vienna; Galerie Wilma Tolksdorf, Frankfurt

Selected Group Exhibitions: 2000 'Contemporary Positions on Architectural Photography', Museum Ludwig, Cologne; 'Hybrid', Fotomuseum, Winterthur, Switzerland; 'Photography from the 20th Century', The Ann and Jürgen Wilde Collection, Kunstmuseum Bonn; 'Transformer', Raum aktueller Kunst, Vienna 2001 6th Lyon Biennale; 'Image a New', Bard College for Curatorial Studies, Annandale-on-Hudson; 'Distance and Proximity', Nationales Fotomuseum, Copenhagen; 'Nature in Photography', Galerie nächst St Stephan, Vienna; 'Ohne Zögern – Without Hesitation', The Olbricht Collection, Neues Museum Weserburg, Bremen 2002 'heute bis jetzt', Museum Kunst Palast, Düsseldorf; 'Malerei ohne Malerei', Museum der bildenden Künste, Leipzig; 'Traumwelten.

Imagination und Wirklichkeit', Städelsches Kunstinstitut, Frankfurt 2003 'Jeanne Dunning, William Eggleston, Luigi Ghirri, Thomas Greenfield, Diego Perrone, Jörg Sasse', Galleria Massimo de Carlo, Milan; 'Moving Pictures', Solomon R. Guggenheim Museum, New York

Selected Bibliography: 1992 Thomas Lange, 'Zur Sache, Sehen', *Jörg Sasse – 40 Fotografien*, Schirmer/Mosel, Munich 1995 Matthias Lange, 'Komprimierte Bildmodelle', *Pakt: Fotografie und Medienkunst*, No. 7 1996 Udo Kittelmann, 'Wird es sie erfassen', *Jörg Sasse: Kölnischer Kunstverein – Kunsthalle Zürich*, Hatge Cantz, Stuttgart 1997 Berhard Bürgi, 'Rideau/Curtains', *Jörg Sasse*, Musée d'Art Moderne de la Ville de Paris, Paris 1998 Iris Cramer, 'Jörg Sasse', *Das Versprechen der Fotografie*, Prestel, Munich 1999 Christoph Blasé, 'Jörg Sasse', *Art at the Turn of the Millennium*, Taschen, Cologne; Ursula Zeller, 'Jörg Sasse', *Zoom: Ansichten zur deutschen Gegenwartskunst*, Hatje Kantz, Stuttgart 2001 Andreas Kreul, 'Arbeiten am Bild', *Jörg Sasse: Arbeiten am Bild*, Schirmer/Mosel, Munich

JÖRG SASSE

Jörg Sasse's work reveals photography to be what, strictly speaking, it has always been: a deception. Only at first glance do his images seem to be an analogue image of reality.

Photographers have always imposed certain subjective constraints on their material when deciding how an image should turn out – either through their choices in cropping or their selection of shots. It may be true to a certain extent that the camera captures reality, but photographs are really just as much an interpretation of the world as paintings and drawings have traditionally been.

Sasse's images are based on amateur and found photographs. They seem innocuous at first, but when the viewer's mind engages with them they start to develop strong powers of suggestion. The photographic models for his images have been purloined, confiscated, appropriated, perhaps even stolen, but incorporated in his works they present a completely new view. They are not doubles, nor a simple repetition of the source material; they embody a completely fresh, original image. As Sasse himself has said: 'It is not the question of what is depicted with reference to reality that makes a photograph autonomous, it's the question of how it is depicted. And the "how" question is not just about the conditions of the medium, it is also about the choice of the medium itself.'

In the age of computer-manipulated images, Sasse inevitably uses technical image-manipulation programmes for his pictorial finds and inventions. But the fact that his images appear as they do is not entirely due – as many people might think – to the computer. In fact, he devises the images in his head, so that he can then transfer them onto a two-dimensional surface with a digital brush, just like a painter. Here nothing is reactive: the image-maker is an active designer of his image of the world.

A key feature of Sasse's work is that when manipulating his pictures he is less concerned with their function as vehicles for meaning than with their properties in two dimensions. Another question his works ask is whether or not this really is photography in the classical sense. But one thing can be said for certain about his pictures: they force us to investigate more thoroughly what images are, what they consist of, how they work, and what they communicate. They tell stories that can involve us in what is represented, showing that any image is made up of an infinite number of other images – and that the world still dreams in colour. Udo Kittelmann

8246, 2000
Lambda print mounted behind acrylic glass, 103 x 160 cm

7988, 2002
Lambda print mounted behind acrylic glass, 105 x 180 cm

2957, 2002
Lambda print mounted behind acrylic glass, 105 x 180 cm

5671, 1996
Lambda print mounted behind acrylic glass, 103 x 180 cm

1000, 2002
Lambda print mounted behind acrylic glass, 100 x 150 cm

8298, 2000
Lambda print mounted behind acrylic glass, 99 x 160 cm

6478, 2000
Lambda print mounted behind acrylic glass, 123 x 200 cm

9800, 2001
Lambda print mounted behind acrylic glass, 99 x 190 cm

JÖRG

5127, 1995
Lambda print mounted behind acrylic glass, 116 x 90 cm

4251, 1994
Lambda print mounted behind acrylic glass, 124 x 90 cm

7515, 1995
Lambda print mounted behind acrylic glass, 45 x 58 cm

Born Rheydt, Germany, 1969 Lives and works in Rheydt

Selected Solo Exhibitions: 1997 'Totes Haus ur 1985–1997, Rhedyt', Portikus, Frankfurt 1999 Galeria Massimo de Carlo, Milan; Kabinett für aktuelle Kunst, Bremerhaven; Kunsthalle Bremerhaven 2000 Foundation Galeria Foksal, Warsaw; 'Gartenlaube', Museum Haus Esters, Krefeld; Douglas Hyde Gallery, Dublin; Secession, Vienna 2001 49th Venice Biennale 2002 'Gregor Schneider: Fotografie und Skulptur', Museum für Gegenwartskunst, Siegen

Selected Group Exhibitions: 1997 'Niemandsland', Museum Haus Lange/Haus Esters, Krefeld 1998 'The Confined Room', De Waag, Amsterdam 1999 53rd Carnegie International, Carnegie Museum of Art, Pittsburgh; 'Anarchitecture', Stichting de Appel, Amsterdam; 'German Open', Kunstmuseum Wolfsburg; 'The Invisible City', Centrum Beeldende Kunst, Maastricht 2000 'Wonderland', The St Louis Art Museum 2001 'The Museum, the Collection, the Director and his Loves', Museum für Moderne Kunst, Frankfurt

Selected Bibliography: 1992 Ingrid Bachér/Raimund Stecker, *Impulse 17: Gregor Schneider, 1985–1999*, Galerie Löhrl am Abteiberg, Mönchengladbach 1995 'Gregor Schneider. Arbeiten 1985–1994', *Herausgegeben Kunstmuseum*, Krefelder Kunstmuseum, Krefeld 1997 Brigitte Köelle/Veit Loers/Ulrich Loock/Adam Szymczyk, *Gregor Schneider. Totes haus ur/Dead House ur/Martwy Dom ur 1985–1997*, Portikus, Frankfurt/Foksal Gallery Foundation, Warsaw/Städtisches Museum Abteiberg, Mönchengladbach 1999 Noemi Smolik, *Gregor Schneider. Keller, herausgegeben von*, Secession, Vienna 2001 Udo Kittelmann/Elisabeth Bronfen/Daniel Birnbaum (eds.) *Gregor Schneider: Venice Biennale 2000*, Hatje Cantz, Ostfildern 2002 Bice Curiger/Renate Puvogel/Ulrich Loock, *Parkett*, No. 63

GREGOR SCHNEIDER

Gregor Schneider builds rooms. He places walls in front of walls, walls behind walls, rooms within rooms, rooms around rooms, corridors in rooms, corridors in corridors, walls in front of corridors, doors in front of doors behind walls, walls in front of windows in front of windows … Since the mid-1980s, he has been subjecting an ordinary terraced house in Rheydt near Düsseldorf to a constant process of transformation, calling the result *Haus ur*. Walls are constructed and then pulled down, rooms are enlarged and then reduced in size, new floors are inserted while others disappear. Due to these perpetual changes, it is no longer possible to visualize what the building originally looked like.

Schneider's contribution to the 2001 Venice Biennale provided a first opportunity for viewers to gain a comprehensive impression of how he works. In previous gallery shows he has reconstructed single rooms from *Haus ur* in the exhibition space. Here, he transferred as many as twenty, enclosing this huge installation inside the confines of the German Pavilion.

Immediately on entering *Haus ur*, one is not only confronted with the building itself, but also enveloped in and captured by its general atmosphere. This is not like the precious aura of an artwork, which isolates it from the reality of the world; it connects the visitor to that reality. A tour of *Haus ur* requires the visitor to engage more with the situation itself than with aesthetics and designed objects. Spending time in this house with its many rooms awakens moods and senses, and is therefore primarily an emotional rather than a rational encounter. With *Haus ur*, Schneider has created for himself a mainly self-reflexive living space, although its form is always influenced by his moods and emotions.

Our living space consists of more than one room – it is a room within a room within a room, and each space has its own logic, its own being, its own time. Correspondingly, our complex existence can be compared to a building and its different rooms, each with its own function. Yet it is only in geometry that internal and external space possess the same quality. In human existence, the inner psyche has its own sense of reality, allowing the emergence of new worlds and idiosyncrasies, and with them a sense of 'self'. Viewed as a work of art, Schneider's mutated house is a representation of an individualistic reality, with its own spaces, times and configurations, its own being-in-the-world. To put it in old-fashioned terms, Schneider is building a house for his soul, a vessel, even a body. The individual rooms can thus be regarded both as vital internal organs – brain, heart, lungs – and as the germ cells of compulsive drives and fantasies.

Udo Kittelmann

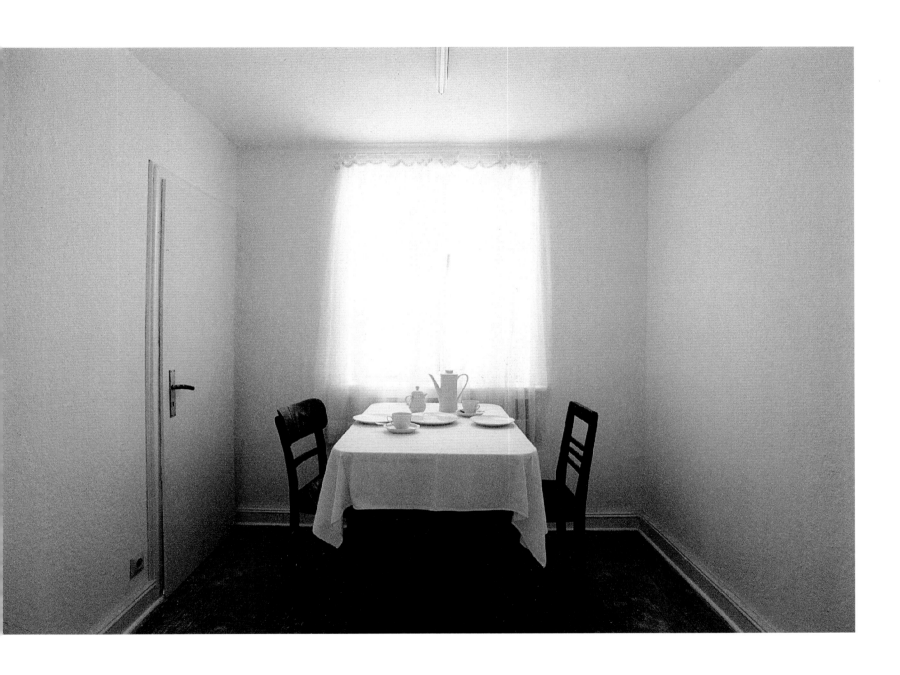

ur 10, 1993
Rotating Guestroom, Rheydt

ur 14, 1995
The Last Hole, Rheydt

ur 14, 1999
The Last Hole, Milan

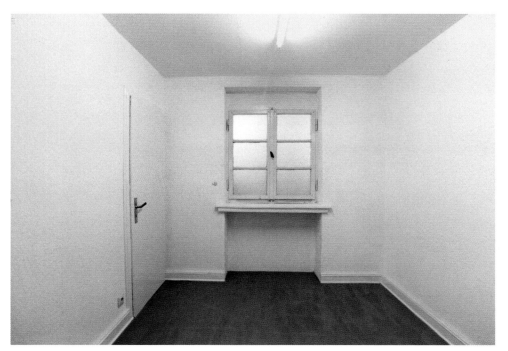

ur 3, 1998
Rheydt

ur 3 A, 1994
Berlin

GREGOR SCH

ur 12, 1995
Totally Isolated Guestroom, Rheydt

Born Tallinn, Estonia, 1969 Lives and works in Tallinn

Selected Solo Exhibitions: 1997 'Video Installations', Gallery Vaal, Tallinn 1998 'Breathing Circle', Gallery Sebra, Tartu 1999 Rotermann's Salt Storage Arts Centre, Tallinn 2000 'Here', Rotermann's Salt Storage Arts Centre, Tallinn; 'Oasis', Begane Grond, Utrecht 2002 'Four Works', Presentation House Gallery, Vancouver; Tallinn Art Hall

Selected Group Exhibitions: 2000 'Inverse Perspectives', Edsvik Gallery, Stockholm, Manifesta 3, Ljubljana; 'PICAF 2000', PICAF, Seoul 2001 49th Venice Biennale; 'BAC-Presence Balte', Ileana Tounta Contemporary Art Centre, Athens; 'The Baltic Times', Museum of Contemporary Art, Zagreb; 'Looking at You', Kunsthalle Fridericianum, Kassel; 'Vertigo', Ursula Blickle Stiftung, Kraichtal-Unteröwisheim 2002 ARCO 2002, Madrid; 'Attitude 2002', Contemporary Art Museum, Kumamoto, Japan; 'Basic Elements', Rauma Biennale Balticum, Finland; 'OPEN 2002, Imaginaire Feminin', Venice Lido; 'The Video Lounge', Fondazione Adriano Olivetti, Rome

Selected Bibliography: 2000 'Has the title stolen the show? Three views of Manifesta 3 from three different European ports', *nu: The Nordic Art Review*, Vol. II, No. 5 2001 Anders Härm, '*Ene-Liis Semper*', 49th International Exhibition of Contemporary Art, Venice; Raimundas Malasauskas, 'Venice Biennale/Ene-Liis Semper', *tema celeste*, summer; Heie Treier, 'Provoking the Subconscious, Ene-Liis Semper/Marko Laimre', *49th International Exhibition of Contemporary Art*, Centre for Contemporary Arts, Tallinn; 'Ene-Liis Semper', *nu: The Nordic Art Review*, Vol. 3, No. 2/01

ENE-LIIS SEMPER

Ene-Liis Semper's art can be placed at the crossroads of performance and video art. The actual presence and bodily involvement of the artist is an essential aspect of her work. We are consistently aware when watching her videos that we are seeing Semper herself, and that her actions are real, not mere cinematic illusion. This is emphasized by her direct emotional involvement with her material, such as her tender relationship with a rat in *Into New Home* (2000), as well as a strong physical engagement. The strange way in which she moves along a staircase in *Stairs* (2000), for example, seems to alter our own perception of our bodies. In some works, this involvement reaches an extreme. In *Licked Room* (2000–2) she licked the entire gallery before the audience arrived, and in *Fundamental* (1997), she got extremely drunk, slurringly attempting to read out texts whilst obviously having no conception of their meaning.

This foregrounding of Semper's own body is connected to her search for reality. In an interview she stated: 'What matters for me is the presence of reality, or its straightforward recognition … Pure original reality … stands in front of your eyes unchanged, and you traverse it hundreds of times without noticing it. The moment when it suddenly swims into focus is astonishing.' The way in which she approaches her medium, however, seems at first to be at odds with this pursuit. Her video works are far from being the mere documentation of performances. Although sparse and ascetic in their use of technology, they are made with careful consideration of the medium's possibilities and demands. The complex structure of *FF/REW* (1998), which moves back and forth from one theatrically staged simulation of suicide to another, reflects this. Its form is based on the seemingly banal fact that technology makes it possible to look at a video not only forwards, but backwards too.

The obvious theatricality of this work might seem to distance it from others in which Semper's activities are less artificial. However, the combination of immediacy and theatricality only makes 'the presence of reality' more complex and strongly felt. Behind the self-irony of the staged suicides, one can sense actual traumas, fears and fantasies. In a sense, the work presents a theatrical staging of reality.

Semper's works, then, attain their particular effect not just through her immediate bodily presence and involvement, but also through its transformation into emotional and poetic images, and a tense, sometimes uncanny, play of presence and reminiscence, reality and vision. *Oasis* (1999), for example, in which a flower is literally planted in her mouth, is not just an example of radical body art. The action has a poetic, emotionally charged dimension that somehow transcends the basic gesture of filling the artist's mouth with soil, without concealing it or ameliorating its directness. The dimension of the real is never present in Semper's bodily engagement alone; it is provoked by the relationship between the artist, the image and the viewer. Igor Zabel

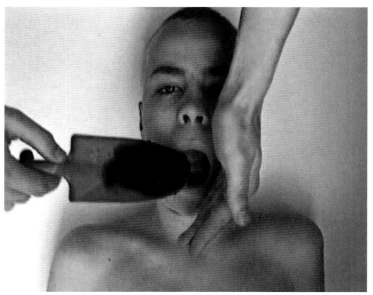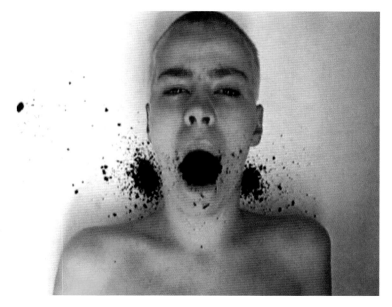

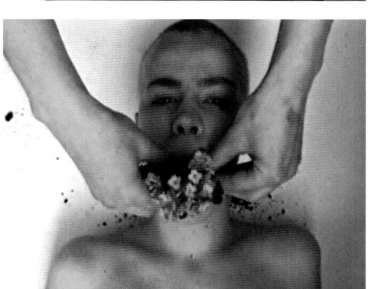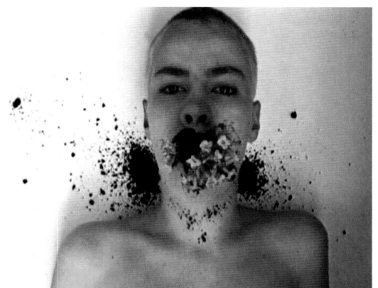

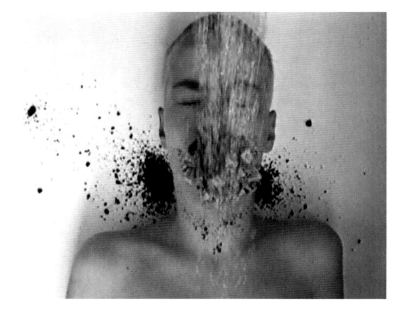

Oasis, 1999
video installation, 3 min., 6 sec., loop, colour, sound

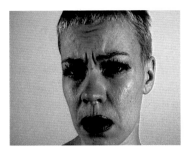
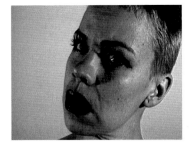
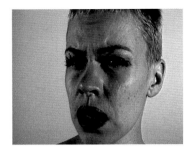

Fundamental, 1997
video installation, 17 min., loop, black and white, sound

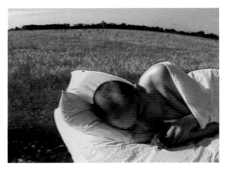
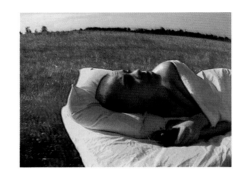

Into New Home, 2000
video installation, 8 min., 36 sec., loop, colour, sound

Stairs, 2000
video installation, 6 min., loop, black and white, sound

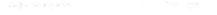

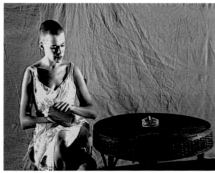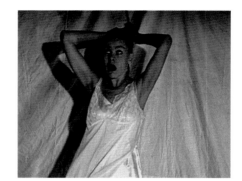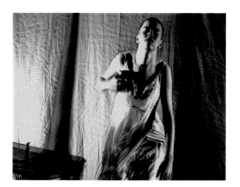

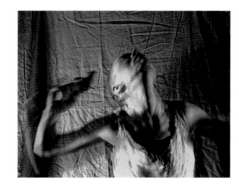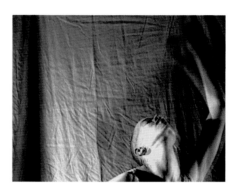

FF/REW, 1998
video installation, 7 min., 8 sec., loop, sound

Licked Room, 2000–2
video, duration variable, loop, silent
Installation 49th Venice Biennale, 2001

Born Madrid, Spain, 1966 Lives and works in Mexico City, Mexico

Selected Solo Exhibitions: 2002 Carlier/Gebauer, Berlin; Deitch Projects, New York; Foksal Gallery Foundation, Warsaw; Fundacíon NMAC/Ikon Gallery, Birmingham; Galeria Enrique Guerrero, Mexico City; Galerie Peter Kilchmann, Zürich; Galleria Claudio Poleshi Arte Contemporanea, Lucca, Italy; Vejer de la Frontera, Cadiz

Selected Group Exhibitions: 2001 49th Venice Biennale; 'Loop', Kunsthalle der Hypo-Kulturstiftung, Munich/P.S.1 Contemporary Art Center, New York; 'Marking the Territory', Irish Museum of Modern Art, Dublin; 'Transsexual Express: A Classic for the Third Millenium', Centre d'Art Santa Monica, Barcelona 2002 'Art & Economy', Deichtorhallen, Hamburg; 'Axis Mexico: Common Objects and Cosmopolitan Actions', San Diego Museum of Art; 'Coartadas/Alybis', Centre Culturel du Mexique, Paris; 'Cut, pulled & burnt', Hyde Park Art Center, Chicago; 'Mexico City: An Exhibition about the Exchange Rates of Bodies and Values', P.S.1 Contemporary Art Center, New York/Kunstwerke, Berlin; 'Spanish Contemporary Art', Borusan Art Gallery, Istanbul

Selected Bibliography: 1997 Adriano Pedrosa, 'Santiago Sierra', *Artforum*, September 2000 Cuauhtémoc Medina, 'Crónica del Sudor Ajeno, Una ación de Santiago Sierra', *CURARE*, July–December 2001 Natasha Hébert, 'Versiones del sur: l'invasion de l'Amérique latine', *ESSE Arts + Opinions Magazine*, Autumn; Taiyana Pimentel, *Santiago Sierra*, Galerie Peter Kilchmann/Galeria Enrique Guerrero, Germany 2002 Pamela Echeverria, 'Santiago Sierra Minimum Wages', *Flash Art*, July–September; Arne Ehmann, 'Point of Sale', *FRAME Magazine*, Summer; Uta Grosenick/Burkhard Riemschneider, *Art Now: 137 Artists at the Rise of the New Millenium*, Taschen, Cologne/Berlin; Audrey Mascina, 'Petrium Doloris', *BLAST*, July–August; Graciela Speranza, 'Arte de la Cotización', *Mil palabras, letras y artes en revista*, Autumn; Pierluigi Tazzi, *Santiago Sierra*, Claudio Poleschi Arte Contemporanea, Lucca, Italy

SANTIAGO SIERRA

Thousands of miles and countless degrees of economic status separate Spain and what is arguably its most important former colony, Mexico. It is interesting to note how two similar models and systems (economic, political, cultural, social) have developed into such disparate manifestations in contrasting though historically related settings across the Atlantic. Born in Spain but now based in Mexico City, Santiago Sierra has made the opposite trip to that embarked on or wished for by so many Mexicans, leaving the wealthy metropolis for the huge, harsh and chaotic third-world megalopolis. Much of the art produced today takes into serious consideration the context in which it is produced and exhibited. Sierra takes the notion of site specificity to new grounds, exploring charged social, political, economic and cultural contrasts, the painful and critical points where different systems in different fields and regions reveal their frictions, contradictions and shortcomings.

In Mexico, Sierra gave eleven Tzotzil women two dollars each to say a phrase in Spanish ('I am being paid to say something whose meaning I ignore'). In Spain, four addicted prostitutes were paid the equivalent of a shot of heroin to have a line tattooed on their backs. In Cuba, ten men were given money to masturbate in front of a video camera. In Korea, sixty-eight people were paid twice the country's minimum wage of $1.50 per hour to block the entrance at the inauguration of Busan's Museum of Contemporary art. At P.S.1 in New York, a man was paid $10 an hour to remain isolated and secluded for two weeks behind a wall constructed in the middle of the gallery, and fed through a small hole close to the ground. As Katya García Anton has remarked, Sierra's actions relate to Marx's notion of the value of labour: 'The product of a worker's labour serves him solely as exchange value. But it can only acquire universal validity by being converted into money.'

Sierra's work has pushed way beyond the limits of what is legal, democratic, social, humanitarian. What is crudely radical here is not so much the work itself, but the systems and models that it poignantly represents. His work is huge, harsh, chaotic. It is also ugly – not due to its stripped down, no-frills aesthetic, but because of the scary scenes and situations it reveals, provokes and engenders. Sierra's work will never please you or make you feel comfortable, it will never offer aesthetic delight. But to turn away from it would somehow be like avoiding the real world. Adriano Pedrosa

Wall ripped from a gallery and inclined at a 60 degree angle, sustained by five people, 2000
chromogenic print, 217 x 150 cm; action at Acceso A., Mexico, 2000
A gallery wall was pulled out of place and then buttressed by five workers at an angle of 60 degrees from the
floor for four hours over five days. Working in shifts, four held up the wall while a fifth checked that the
inclination was correct. Each charged about $65.

10-inch line shaved on the heads of two junkies who received a shot of heroin as payment, 2000
chromogenic print, 150 x 224 cm
Action at Calle Fortaleza 302, San Juan, Puerto Rico

160 cm line tattooed on four people, 2000
chromogenic print, 150 x 217 cm
Action at El Gallo Arte Contemporáneo, Salamanca, Spain
Four drug-addicted prostitutes were hired and tattooed for the price of a shot of heroin (about $67).

Gallery burned with gasoline, 1997
chromogenic print, 189 x 150 cm
Installation Galería Art Deposit, Mexico, 1997
For the opening of a new gallery space, the walls and ceiling were burned with a torch.

Two cylinders of 250 x 250 cm each made of ripped billboard posters, 1994
chromogenic print, 220 x 150 cm
Installation Espacio 'P', Madrid, 1994
Layers of billboard posters were ripped from the walls of empty stores and construction sites in the streets of Madrid over the course of a week. With this material two cylinders were formed, which occupied almost all the space, making it difficult for the public to circulate around them.

Person remunerated for a period of 360 consecutive hours, 2000
chromogenic print, 150 x 217 cm
Action at P.S.1 Contemporary Art Center, New York, 2000
A brick wall was built in the middle of the space to isolate a person who was fed through a hole that had been left just above floor level. He remained isolated for 360 consecutive hours (three weeks), and was paid $10 an hour.

Born Lübeck, Germany, 1961 Lives and works in Düsseldorf and Karlsruhe, Germany

DIRK SKREBER

It is becoming apparent that it is utter nonsense to continue asserting that painting is dead; the medium is currently celebrating a glorious resurrection. The way in which painting has constantly postponed its presumed demise, and is enjoying a repeated renaissance, is by 'assimilating the concepts and media used by its supposed murderers', as an art magazine once put it. A new generation of young painters is treating us to a magnificent demonstration of all the things that painting can be in the twenty-first century.

One of the most outstanding of these artists is Dirk Skreber, who treads a highly individual path between figuration and abstraction. In fact, he is not even a newcomer: he has been applying painterly strategies consistently ever since the 1980s. Seen in this light, and especially when we look at his paintings in detail, it is possible to view him as a kind of father figure for the younger German painters who are now being so hyped.

Skreber's painting constantly and rigorously ignores the rules of both figurative and formal approaches. It is never 'correct', but 'faulty' in some way, emphasizing the uncertain nature of the image. Skreber himself has this to say about his paintings: 'I simulate a landscape with the simplest devices available to me. I convey an ideal of something that lost its authenticity centuries ago.' Doing this means using destructive forms, or painting in a way that is destructive by nature.

Skreber is aware that the categories of representational and abstract have started to crumble in his work, and is thus playing a crafty game with these classifications. It is precisely this ambivalence that creates such enormous tension in his canvases. Despite their representational quality, his landscapes, buildings and trains become pure painting, while completely abstract areas begin to seem figurative. Narrative structures develop and are suppressed at the same time; everyday, familiar locations are represented, but are charged in such a way that they are transformed into mysterious, eerie crime scenes. And is it up to the viewer to discover the stories, often dramatic, that lie behind these images. Udo Kittelmann

o.T., 2002
oil and tape on canvas, 280 x 400 cm

o.T., 2002
oil and tape on canvas, 280 x 400 cm

o.T., 2000
oil on canvas, 290 x 170 cm

o.T. (Andrew), 1999
oil and tape on canvas, 145 x 180 cm

o.T. (Shoa), 1999
oil and tape on canvas, 140 x 400 cm

o.T., 2000
oil on canvas, 280 x 420 cm

o.T., 2000
oil and tape on canvas, 290 x 170 cm

o.T. (Ultra Violence), 1999
oil on canvas, 235 x 335 cm

Born Virginia Beach, USA, 1972 Lives and works in Berlin, Germany

Selected Solo Exhibitions: 2001 Galerie Chantal Crousel, Paris 2002 Galerie Neu, Berlin

Selected Group Exhibitions: 1998 1st Berlin Biennale; 'Junge Szene', Secession, Vienna; Manifesta 2, Luxembourg 1999 'Ars Viva 98/99', Portikus, Frankfurt; 'Cities on the Move', Kiasma, Helsinki 2000 'Another Place', Tramway, Glasgow; IASPIS Galleriet, Stockholm; 'Negociations', Centre Régional d'Art Contemporain, Sète; 'No Swimming', Kunstverein Munich 2002 4th Gwangju Biennale; 'Centre of Attraction', Baltic Triennial of International Art, Contemporary Art, Lithuania; 'Haunted by Detail', De Appel, Amsterdam; 'Sean Snyder/Christian Jankowski', Künstlerhaus Bethanien, Berlin 2003 'Living Inside the Grid', New Museum of Contemporary Art, New York

Selected Bibliography: 1998 Daniel Birnbaum, 'All Together Now', *frieze*, September–October; Sven Luetticken, 'Apes on the Rocks in Luxembourg', *Archis*, September 1999 Sean Snyder, 'Museum in Progress', *Der Standard*, 26 August 2000 Kentaro Itchihara, 'Very New Art, 2000', *Bijutsu Techo*, January; Krystian Woznicki, 'Image Problem City', *Camera Austria*, April 2001 Ele Carpenter and Graham Gussin (eds.), *Nothing*, Birkhauser Verlag, Basel; Philippe Dagen, 'Vrais et faux paysages', *Le Monde*, 12 December; *re: songlines*, Halle für Kunst, Lueneburg 2002 Charles Esche, 'The Slobozian Question', *Afterall*, October; Hans-Peter Feldmann/Hans Ulrich Obrist/Diethelm Stoller/Beatrice von Bismarck/Ulf Wuggenig, *Interarchive*, Verlag der Walther König, Cologne; Park Chan-Kyong, 'Ryugyong', *Forum A*, October; Francesco Poli, 'Review', *tema celeste*, January; Jan Vervoert, 'Jump Cut Cities', *Afterall*, October

SEAN SNYDER

'Today the US corporations, through their physical presence in cities, try to define a global value system in which a Tex-Mex restaurant in Baku appears exactly the same as one in Cincinnati', Sean Snyder has noted. 'We can even see a corollary with early settlers in the American West who staked out claims by importing physical structures reminiscent of those where they had come from. However, the difference between colonized and colonizer has become less clear. Given the alternatives, citizens in Baku are probably not unhappy about the Tex-Mex restaurant and want a share in its values – at least up to some, as yet, undefined point.'

Snyder's move from America to Europe when he was nineteen seems to have provoked a perverse commitment to understanding the culture of his home country. Along sometimes tortuous but always fascinating routes through various unlikely buildings, proposals and urban sites, he leads us to an understanding of the new imperial model that is the US today.

Some are now claiming that the USA's duty is to behave as a grown-up empire, rather than a liberated colony. Snyder takes this a stage further, accepting America's imperial identity and travelling to its farther outposts to see where and how this identity might break down. Just as Rudyard Kipling documented the British Empire in poems that were both mournful and critical of the Raj at the height of its power, Snyder seeks the same ends in terms of the US.

His work often presents the details of everyday urban environments, concentrating on the organization of space and the ways in which these sites are used or occupied. For instance, his discovery of an abandoned replica American suburb, built in 1998 on the outskirts of Shanghai, led to *Shanghai Links, Hua Xia Trip* (2002), where he parallels it with the European colonial heyday of Shanghai. Using video, text and photographs, the story of this luxury housing scheme unfolds against the background of 1920s Shanghai documentaries.

Also in 2002, Snyder responded to an invitation from the Gwanju Biennale by excavating what little is known to the outside world of the North Korean capital Pyongyang. For this video work he showed pictures of the city using the few records that exist outside the Stalinist country, presenting them in a slow fade from one static image to the next. The extraordinary unreality of the city, where everything appears to be staged for the photographer, becomes animated through this process.

Snyder has also looked closely at the multifarious effects of capitalism on Romania, from Ceaucescu's monumental redesign of Bucharest, to the extraordinary story of the soya-bean magnate and *Dallas* obsessive Ilie Alexandru. The latter rebuilt the ranch from the TV soap opera in the Romanian countryside, successfully invited George W. Bush to his wedding, and was finally arrested and sent to prison for bankruptcy.

All these stories, retold in films and installations that formally emphasize the fractured nature of the original, ultimately test that 'undefined point' described by Snyder above. When, he seems to ask, might rejection of the US model set in, and what will take its place?

Charles Esche

Pyongyang, 2002
video, 5 min., 37 sec., colour, silent

from Bulgaria, Romania, Nigeria."
Larry King: Why did it work Larry?

version of the Southfork Ranch in Slobozia, on the main
road between Bucharest and the Black Sea.

above and right
Dallas Southfork in Hermes Land, Slobozia, Romania, 2001
video, 4 min., 37 sec., colour, silent, subtitles

above and right
Dallas Southfork in Hermes Land, Slobozia, Romania, 2001
C-prints, each 50 x 70 cm

McDonald's, Shenzhen SE, 1998
35 mm slide projection

McDonald's, Oslo, 1999
35 mm slide projection

above and right
Shanghai Links, Hua Xia Trip, China, 2002
C-prints, each 57 x 84 cm

Born Los Angeles, USA, 1968 Lives and works in Los Angeles

Selected Solo Exhibitions: 2001 'Gestus Maximus (Gold Standard)', Galerie Christian Nagel, Cologne; 'Grisly Notes and Tones', Le Consortium, Centre d'Art Contemporain, Dijon 2002 'Five Economies (big hunt/little hunt)', Hammer Museum, University College, Los Angeles; 'Five Economies (big hunt/little hunt)', The Renaissance Society, Chicago 2003 Wadsworth Atheneum, Connecticut

Selected Group Exhibitions: 1998 'Still and Otherwise', Margo Leavin Gallery, Los Angeles 2000 'L.A. ex', Museum Villa Stuck, Munich

Selected Bibliography: 1997 Justin Hayford, 'Dad's Ham', *Chicago Reader*, 7 May 1998 Albert Williams, 'Alien Hand, or Let the Right be a Vision of the Left', *Chicago Reader*, 12 June 2001 Sebastian Egenhofer, 'Theater und Gewalt Oder: was wird hier eigentlich gespielt', *Texte zur Kunst*, September 2002 Stèphane Pichelin, 'l'ours montré qui nous montre', *L'Humanité*, 10 December, Paris; James Yood, 'Catherine Sullivan Renaissance Society', *Artforum*, September

CATHERINE SULLIVAN

'The success, even the survival, of the arts has come increasingly to depend on their ability to defeat theater.' These fighting words were issued in defence of modernist painting by the art critic Michael Fried in his famous essay, 'Art and Objecthood' of 1967. He articulated in crystalline form one of modernism's central features: a desire for medium specificity. Fried was one of modern painting's most rabid proponents. For him, what made painting worthy of consideration as a 'modern' discipline was that its properties (colour, surface, support) were unique to it as an art form. Arguing as a purist, Fried defined theatre negatively, as something 'between the arts', a hybrid activity into which modernist art forms could only degenerate. He characterized the struggle to avoid such a fate as 'war'.

The work of Los Angeles-based artist Catherine Sullivan demonstrates which side won that war. After receiving a BFA in acting from the California Institute of the Arts, Sullivan worked in numerous stage productions including a stint at Chicago's Trapdoor Theater. In 1997 she received a Masters Degree in Fine Art from Art Center College of Design in Los Angeles. Although she has worked in a variety of media, Sullivan's primary focus has been creating original theatre and video works that lay bare dramaturgical conventions and the mechanics of expression. Her true media are performers or agents of expression, be they actors, dancers or musicians. Sullivan refers to her performances as 'second-order drama'. They consist of re-staged moments of dramatic or performative tension taken from sources as disparate as Ted Nugent lyrics and Yvonne Rainer's choreography.

Five Economies (big hunt/little hunt) (2002) is a two-part work whose main component, *Big Hunt*, is a fifteen-minute, five-part video projection. Screened along a single wall, the silent, black and white footage consists of re-staged and choreographed scenarios based on a variety of sources including several popular films. The question relevant to all Sullivan's staged performances is, how does expression work? How does a performer literally inhabit emotional memory? What are the formal characteristics that allow for the transmission of expressive or emotive content? But Sullivan is less interested in deconstructing theatrical conventions than in reconfiguring codified forms of expression to explore, in her words, 'the body's capacity for signification'.

Five Economies (big hunt/little hunt) is a particularly elaborate work drawing on scenes from films as diverse as Arthur Penn's *The Miracle Worker* (1962), Peter Brook's *The Marat/Sade* (1966), Ingmar Bergman's *Persona* (1966) and Robert Aldrich's *Whatever Happened to Baby Jane?* (1962). It also features imagined episodes from the true story of Birdie Jo Hoaks, a twenty-five-year-old woman who tried to cheat the welfare system by passing as an orphaned thirteen-year-old boy. There are several mise-en-scènes (lounge, dance floor, stage, sunroom, kitchen), each containing a different permutation of characters performing simultaneously. The drama is reduced to movement and facial expression steeped in emotional excess. The emphasis on non-verbal gesticulation extends the performance into the realm of dance. The result is a baroque, hybrid theatre for which the term 'postmodern' is an understatement. Hamza Walker

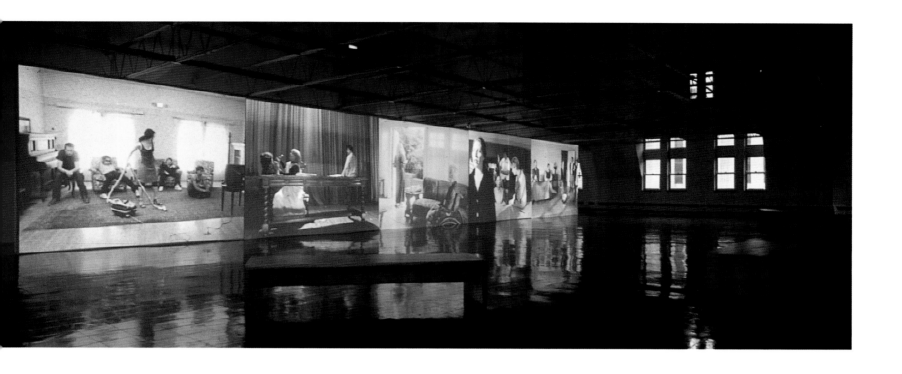

Big Hunt, 2002
5-channel video projection, transferred from 16 mm film, 22 min., black and white, silent
top Installation The Renaissance Society, Chicago

Little Hunt, 2002
single-channel video, 15 min., 30 sec., colour, silent

CATHERINE SU

'Birdie Jo Hoaks (Baby Jane Infusion)'
from **Big Hunt**, 2002
5-channel video projection, transferred from 16 mm film, 22 min., black and white, silent

'Helen (Birdie Jo Hoaks/Baby Jane Infusion)'
from **Big Hunt**, 2002
5-channel video projection, transferred from 16 mm film, 22 min., black and white, silent

'Helen, Annie, and Gunman (Amusement Infusion)'
from **Big Hunt**, 2002
5-channel video projection, transferred from 16 mm film, 22 min., black and white, silent

'Baby Jane (Birdie Jo Hoaks Infusion)'
from **Big Hunt**, 2002
5-channel video projection, transferred from 16 mm film, 22 min., black and white, silent

Born Belo Horizonte, Brazil, 1958 Lives and works in São Paulo, Brazil

Selected Solo Exhibitions: 1982 'Objetos e Interferências', Piacoteca do Estado de São Paulo 1986 'Running Wall', Superior Street Gallery, Chicago 1996 'Rotatórias', Galeria Millan, São Paulo 1997 'Porta Pampulha', Museu de Arte da Pampulha, Belo Horizonte 1998 'Relax'o'Visions', Museu Brasileiro da Escultura, São Paulo 2000 'Estação II', Centro Universitário Maria Antonia, São Paulo 2001 'Middelburg Airport Lounge with Parede Niemeyer', De Vleeshal, The Netherlands

Selected Group Exhibitions: 1984 1st Havana Biennale 1987 XIX São Paulo Biennale; 'Modernité, Art Bresiliènne du XX Siècle', Musée d'Art Modern de la Ville de Paris 1991 XXI São Paulo Biennale; 'Arte Brasileña: La Nueva Generación', Fundacion Museo de Bellas Artes, Caracas 1993 'Ultramodern: the Art of Contemporary Brazil', National Museum for Women in the Arts, Washington D.C. 2000 7th Havana Biennale; XXVI Pontevedra Biennale 2001 7th Istanbul Biennale; 'Políticas de la Diferencia: Arte Iberoamericano fin de Siglo', Museo de Arte Latino Americano de Buenos Aires 2002 'Artecidadezonaleste', Sesc Belenzinho, São Paulo

Selected Bibliography: 1990 Bernardo Carvalho, 'Escultura seduz e castiga o olhar com boas intenções e perversão', *Folha de São Paulo*, 27 November; Tadeu Chiarelli, 'Ana Maria Tavares e o Cerco de Arte', *Arte Internacional Brasileira*, Lemos-Editorial, São Paulo 1993 Paulo Herkenhoff, 'Brazilian Contemporary Art: A Theoretical Construction'/Susan Fisher Sterling, 'Ultramodern: The Art of Contemporary Brazil, an Introduction', *Ultramodern: The Art of Contemporary Brazil,* The National Museum for Women in the Arts/Expert/Brown, Richmond 1997 Martin Grossman, 'Visões de Pampulha', *O Estado de Minas*, 18 October; Bill Hinchberger, 'Ana Maria Tavares: Impractical Practices', *Art News*, June 1999 Lisette Lagnado, 'Carriers', *Panorama 1999*, Margraf Editora, São Paulo 2000 Martin Grossman, 'El Arte en Permanente Transformación: La Obra de Ana Maria Tavares', *XXVI Bienal de Arte de Pontevedra*, Pazo da Cultura de Pontevedra 2001 Yuko Hasegawa, 'VII International Istanbul Biennial: Hagia Eirene', *VII Istanbul Biennial*; Anna Tilroe, 'The Promise', *The Thinking Matter: Looking for a New Utopian Vision*, Querido Publishers, Amsterdam

ANA MARIA TAVARES

The work of Ana Maria Tavares is strongly influenced by Oscar Niemeyer and other utopian modernist Brazilian architects. Her sculpture is made of metallic materials taken from building interiors and product design, sliding along the border between design and fine art. Airports and departure lounges are a recurrent theme in her work, places that symbolize exit from everyday life, getting ready to depart, floating, meditating, and the co-existence of the real and the virtual. *Strategies for Enchantment* (2001), which was created by placing a piano, mirrors and seats in a glass-walled room, and *Middelburg Airport Lounge with Parede Niemeyer* (2001), in which Tavares used mirrors and video projection to transform De Vleeshal in the Netherlands into a futuristic airport lounge, are examples of how she has transformed sites while making the most of their features.

For the installation *Exit II (Rotterdam Lounge) with Parede Niemeyer* (2001), a 14.5 x 4.5 metre mirror was installed on the stage in the Hagia Eirene Church in Istanbul so that it reflected almost the entire interior of the church. Installed roughly at the centre of the stage was a set of silver steps of the type one might use when boarding an aircraft. Visitors took turns to climb this staircase to the little platform at the top, where they put on headphones and looked at themselves reflected in the centre of the mirror. Through the headphones they could hear traffic information broadcast from a helicopter flying above São Paulo. At first issued one after the other, these bulletins gradually started to overlap, becoming a jumble of noise. In the background passionless easy-listening music played. The viewer's own standpoint became lost in this excess of 'useful' information, exacerbated by the figurative anticipation of boarding a plane and flying, the view of one's self and the vast space surrounding it reflected before one's eyes. Tavares illustrates with dazzling sharpness the loss of self amid the activity and information that are the symbols of globalism.

Numinosum (2002) is a cool, minimalist installation that allegorically expresses a capitalistic scene. An octagonal 'spring', made of mirror-like stainless steel is surrounded by four fences. These seem to be devices against which on can lean one's body, or inside which one can peer or lose oneself. The surrounding white walls are imprinted with silver words representing devices created to allow us to escape from the stress of everyday life: 'sparkling water', 'credit card', 'Relax'o'visions'. Additionally, a soundtrack broadcasts dizzying stock-exchange dealings symbolizing a future world. Tavares has said that the origin of this work lies in the acknowledgement that what is shared by both the art world and the system that fuels the capitalist world is the notion of the abstract, along with projections and speculation about the future.

Tavares' use of sounds, reflective surfaces and other elements that can be interpreted in multiple ways as appropriations from reality, draws the viewer into a poetic meditation while at the same time reflecting the realities of our society, institutions and systems.

Yuko Hasegawa

Middelburg Airport Lounge with Parede Niemeyer, 2001
stainless steel, mirror, glass, leather, headphones, video projection, music, 432 m²
Installation De Vleeshal, Middelburg, The Netherlands, 2001

Cityscape, 2001
stainless steel with engraving, steel, sensors, music, 180 m²
Installation 'Bienal 50 Anos', Brazilian Pavilion, XXV São Paulo Biennale, 2002

Visiones Sedantes (partial view), 2002
stainless steel, mirror, glass, lounge seats, carpet, grand piano, vase with flowers, music, 120 m²
Installation 'Strategies to Enchant', Museu de Arte Contemporânea da Universidade de São Paulo, Brazil, 2002 **ANA MARIA T**

Gambling, 1999
stainless steel, mirror, wood, 60 m²
Installation 'II Semana Fernando Furlaneto – Fotografia', Teatro Municipal de São João da Boa Vista, São Paulo, 1999

Exit II (Rotterdam Lounge) with Parede Niemeyer, 2001
stainless steel, headphones, mirror, music, 120 m²
Installation 7th Istanbul Biennale, Hagia Eirene, 2001

Numinosum, 2002
stainless steel, coloured stainless steel, music, 86 m²
Installation Galeria Brito Cimino, São Paulo, 2002

Born Dubrovnik, Yugoslavia, 1964 Lives and works in Dubrovnik

Selected Solo Exhibitions: 1989 'Entry', Art Workshop Lazareti, Dubrovnik 1991 Galerija PM, Zagreb 1994 'Bubo – Bubo Maximus', Galerija Zvonimir, Zagreb 1998 'Four and a Half Tones', Moderna galerija, Zagreb 1999 'Cinema "Jadran"', Galerija Otok, ARL, Dubrovnik 2000 'Space/ Relation', Kunsthalle Bremen 2001 '11.09.2001', Moderna galerija/Mala Gallery, Ljubljana 2002 'One Year Later', Brno Art Museum, Czechoslovakia

Selected Group Exhibitions: 1993 'Place and Destiny', Art Workshop Lazareti, Dubrovnik; 'Tower of Babel/Food for Survival', MUU-ry, Helsinki 1995 'Checkpoint', Moderna galerija, Zagreb 1997 Documenta X, Kassel 1997 'Performance week – Public Body – Community Spirit in Action', SCCA-Zagreb 1999 'Who by fire', A Kortars Muveszeti Intezet – Dunaujvaros & Art radionica Lazareti, Dunaujvaros; 'After the Wall', Moderna Museet, Stockholm 2000 '2000 + Arteast Collection', Moderna galerija, Ljubljana 2001 'Body and the East – performance Globalization', Exit Art, New York/Moderna galerija, Ljubljana; 'Nothing', Northern Gallery for Contemporary Art, Sunderland 2002 'Here Tomorrow', Moderna galerija, Zagreb

Selected Bibliography: 1990 Mario Kopic, 'Art radionica Lazareti', *Moment*, November 1994 Antun Maracic, 'Sova I grad', *Bubo-Bubo Maximus*, Galerija Zvonimir, Zagreb 1995 Janka Vukmir, 'Intersticij', *Checkpoint*, SCCA Zagreb 1996 Ivica Zupan, 'Slaven Tolj', *SCCA Quarterly*, January 1997 Janka Vukmir, 'Odraz grada', *Simposium Otok/island*, SCCA Zagreb/Visual Arts Library, Zagreb; Janka Vukmir, *Perceptual Art – Slaven Tolj*, SCCA Zagreb/Visual Arts Library, Zagreb 1998 Alfred Nemeczek, '2 lampen' Documenta X, Kassel 1999 Jeroen Laureyns, *Slaven Tolj*, University of Gent 2000 Ana Devic, 'Permanent Vacation', *A Small Country for a Big Vacation*, Galerija SSKUC, Ljubljana 2002 Hrvoje Ivankovic, 'Slaven Tolj: Radical approach is just a language adequate to its time', *Frakcija – magazine for performing arts*, Winter; Silva Kalcic, 'Art at the border of existence', *Zivot umjetnosti – casopis za suvremena likovna zbivanja*, Institute of Art History, Zagreb

SLAVEN TOLJ

Children often play tennis in the square near Dubrovnik cathedral. From time to time a ball gets stuck in the baroque decoration of the facade, interrupting the game. This is the subject of Slaven Tolj's *Interrupted Games* (1993), a work that exists neither as an intervention (since the tennis balls were not placed there by the artist), nor through its documentation in photographs. Rather, it is a conceptual work, drawing attention to Tolj's particular perception and interpretation of this occurrence. The work is subtitled *Pax. Vobis. Memento Mori Qui. Ludetis Pilla* ('Peace be with you. Remember that you are mortal, you who play ball here'), a phrase inscribed on the cathedral wall by a sixteenth-century priest who was annoyed by people playing in the square and took the opportunity to remind them of the fragility of life. His words took on a sinister new meaning in the context of the war and the siege of the city, when playing on the square could be fatal.

Interrupted Games is key to Tolj's art. Firstly, it is an essential example of what the critic Janka Vukmir has described as his 'perceptual work' – a simple found situation, transferred into a new context. This process of displacement makes visible the inherent richness of meanings, the network of connections and emotional content of the original source. In *Untitled* (1997), he literally displaced two simple lights from a Dubrovnik church to the Kultur-bahnhof in Kassel. In their new site, these humble objects not only evoked their original context, but also took on a strong metaphorical value, their manner of installation evoking issues such as separation and connection.

Tolj's hometown, Dubrovnik, is also essential to his art. This ancient city was severely damaged in the war, during which several of his friends were killed. More recently, his references to the war have become less frequent, but the idea of the fragility of life has remained strongly present. This has resulted in an even stronger intensity in perceiving found situations, charged with multi-layered meanings, and the discovery of beauty even in banal, every-day situations. Another frequent presence is a resigned sense of mortality. The performance *Community Spirit in Action* (1997), for example, in whch Tolj lay motionless under a sheet on the floor of a peepshow while a dancer performed her act, could be read as an unequivocal *memento mori*.

Tolj often uses his own body in his works. In the action *Untitled: In Expectation of Willy Brandt* (1997) he drank a mixture of two sorts of brandies, one from Bosnia, the other from Dalmatia. In this act he 'distilled' his emotions about Sarajevo and Dubrovnik, two cities of intimate importance to him, both victims of war and destruction. In 2001, when participating in a show of Eastern European artists in New York, he performed a parallel action (*Globalization*). Here, he attempted to overcome cultural division by drinking a mixture of whisky and vodka. The action almost cost him his life.

The involvement of Tolj's body and the particular role of the city indicate his strong personal presence in his art. We can always sense private meanings and metaphors in the situations he discovers. In the video *11.09.2001* (2001), the peeling and cutting of a heart-shaped potato obviously refers to strong, hidden emotion. This date has a personal value for Tolj, and the reference to the tragic event in America is a coincidence. It does, however, contribute a strong additional meaning. The work becomes a metaphor for the impossibility of social and intercultural communication, for impotence and frustration, and for its bitter consequences. Igor Zabel

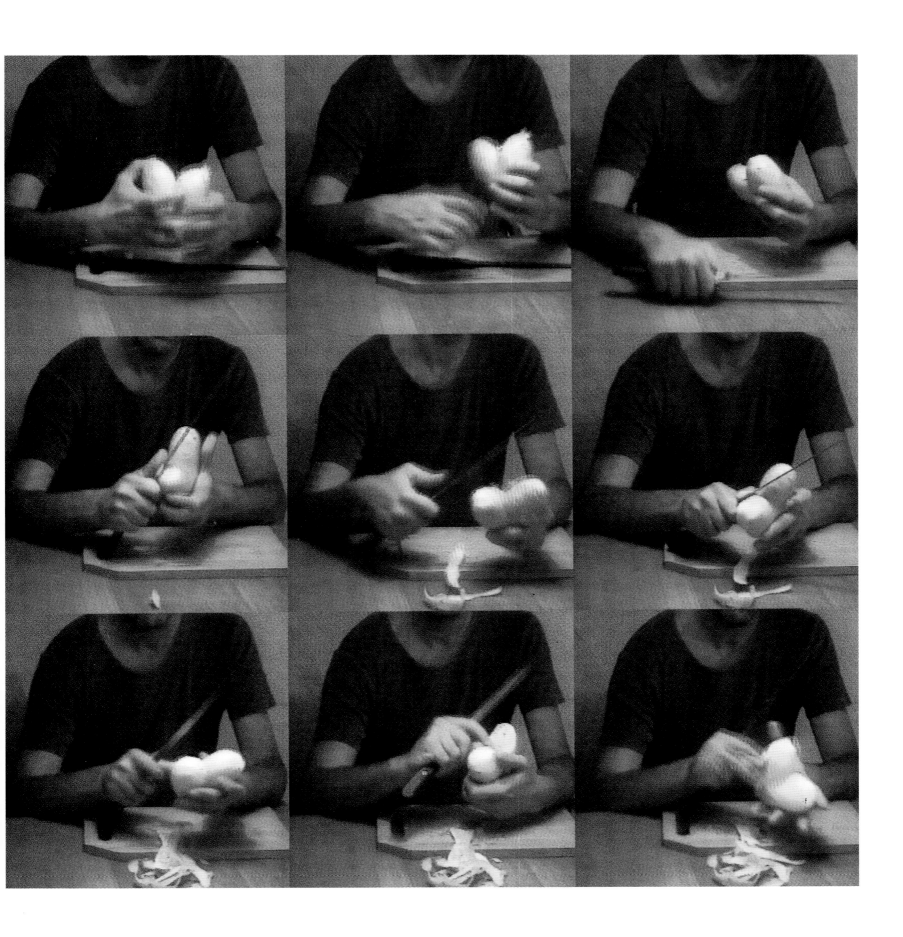

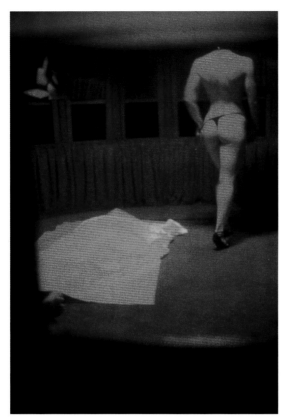

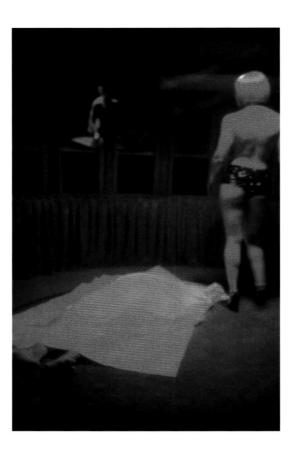

Community Spirit in Action, 1997
Performance at 'Performance Week – Public Body', SCCA Zagreb, 1997

Untitled, 1999
2 flags, each 3 x 1.20 m
Installation 'After the Wall', Moderna Museet, Stockholm

SLAVEN

Untitled, 1997
2 lamps from the Jesuit church, Dubrovnik, dimensions variable
Installation 'Documenta X', Kassel, Germany

Space/Relation, 2000
2 reflectors with sensor, metal tetragonal tubes, h. 2 m
Installation Kunsthalle Bremen, 2000

Interrupted Games, 1993
tennis ball lodged in decorative stonework of Dubrovnik cathedral

Born Brussels, Belgium, 1958 Lives and works in Brussels

Selected Solo Exhibitions: 1991 '27 mai 1991 28 mai 1991... (la date du jour)', Centre d'Art Contemporain, Lausanne 1995 'A-exposition', Opus Operandi, Gent 1996 Galerie des Beaux-Arts, Brussels 1999 'Nieuwe Projecten D.D.', Museum Dhondt-Dhaenens, Deurle; 'this book, LIKE A BOOK', FRAC Campagne-Ardenne, Reims/Stedelijk Museum voor Aktuele Kunst, Gent 2000 'Audio and Visual Days – journal de jours', Argos, Brussels 2001 'A Stretch Museum Scale 1:1 (proposition for a streched walk in a compact museum)', Bonnefantenmuseum, Maastricht 2002 'Drawings', Stella Lohaus Gallery, Antwerp; Hyper Space, Brussels; 'In real time', South London Gallery

Selected Group Exhibitions: 1995 'Tekeningen en tekeningen', Galerie van Gelder, Amsterdam 1996 'NowHere', Louisiana Museet, Humlebaek, Denmark 1997 'Inside the Visible', The Art Gallery of Western Australia, Perth/Whitechapel Art Gallery, London/Institute of Contemporary Art, Boston/ National Museum of Women in the Arts, Washington 1998 'The Fascinating Faces of Flanders', Centro Cultural de Belèm, Lisbon 1999 'Trouble Spot, Painting', MUHKA, Antwerp 2000 Manifesta 3, Ljubljana 2001 'Sous les ponts, le long de la rivière', Casino Luxembourg, Forum d'Art Contemporain, Luxembourg 2002 Documenta 11, Kassel

Selected Bibliography: 1994 Mark Kremer, 'A Sweet Iconoclasm, the Work of Joëlle Tuerlinckx/ Joëlle Tuerlinckx, 'Notes d'exposition', *Witte de With Cahier # 3*, Richter Verlag, Düsseldorf 1996 Frank Vande Veire, 'Something about a Tuerlinckx Machine Traverses the Exhibition Machine', *Inside the Visible*, M.I.T. Press, Boston 1998 Ilse Kuijken 'The Oeuvres of Joëlle Tuerlinckx and Honoré d'O are not Complementary', *Fascinerende Facetten van Vlaanderen. 58/98 Twee uur breed of twee uur lang*, Stad Antwerpen, Antwerp 1999 Joëlle Tuerlinckx, *this book, LIKE A BOOK*, Vol. 0, SDZ, Gent 2000 Moritz Küng, 'Ways of Worldmaking', *ORBIS TERRARUM*, Ludion, Gent/Amsterdam; Joëlle Tuerlinckx, *autour de film. cinéma EXPOSITIONS. PROJECTIONS*, Argos, Merz, Brussels/Gent 2001 Joëlle Tuerlinckx 'A Stretch Museum Scale 1:1 Invitation to a stretched walk 1:1 in a compact museum'*, Bonnefantenmuseum, Maastricht 2002 Luc Derycke, 'The Archaeology of the fluid', *Janus*, Summer; *Documenta 11– Platform 5*, Hatje Kantz, Ostfilden

JOËLLE TUERLINCKX

Joëlle Tuerlinckx works with materials and situations that are simply self-evident. Her formally austere installations may just as easily refer to their immediate context as to an observation taken from a quotidian aspect of her life. They feature a sculptural component often based on the aesthetics of display (vitrines, lightboxes) accompanied by numerous slide projections and rows of video monitors placed throughout the exhibition space. These components can consist of any strain of Conceptual art, be it institutional critique, an examination of language, a formal investigation into the properties of a given medium, or video documentation bearing witness to a fleeting thought. As grandiose as this may sound, it is offset by Tuerlinckx's love of life's ephemera.

Having reduced aesthetics to a matter of facts, Conceptual art allowed for the greater mingling of art and life. Tuerlinckx's work, however, suggests that Conceptualism's formal structures – the systems, seriality and analytic propositions used to generate its forms – remain empty. Within her visual vocabulary, books, vitrines, video monitors, indeed the gallery spaces themselves, are sculptural volumes; Tuerlinckx takes pleasure in their existence simply as formal structures, using them as occasions to point, to count, to measure. In short, her quirky installations use the exhibition as a time and a space when life – no matter how meagre or ephemeral the object under scrutiny – can assume a new factual certainty.

Some of Tuerlinckx's slide projections investigate the transition from the second to the third dimension; others feature bits of found language. All display the emphasis on ideas rather than objects that is the hallmark of Conceptual art. Her installations are matter-of-fact both in the way in which they refer to their immediate gallery context and in their off-handed quotations of the movement's leading practitioners (Sol LeWitt, Niele Toroni, Hannah Darboven, Mel Bochner, Joseph Kosuth, Lawrence Weiner). Whereas Conceptual art is often characterized as cold or clinical in its approach to its subject, Tuerlinckx's work is quirky if not outright absurd. In one work, for example, she simply labelled walls and doors as such, in contradistinction to the famous painting by her Belgian compatriot René Magritte that features the words *Ceci n'est pas une pipe*.

It is this type of wit, not to mention an interest in the relationship between language and objects, that also lends her work an affinity with that of another Belgian artist, Marcel Broodthaers, who believed that poetry and the visual arts had been reduced to an impoverished semiotics of mere words and pictures capable only of serving as an illustration of each other, as in advertising. Tuerlinckx's demonstrative labelling is proof that Broodthaers' prognosis has come to pass. Empty egg and mussel shells were to him what vitrines, books and monitors are to Tuerlinckx. Her use of dots, although alluding to the painted brushmarks of Toroni, also reads as an ellipsis declaring an omission. Her work, however, is permeated less with a sense of loss than of deferral. 'Later, Later' and 'After Me, After Me' are phrases appearing in two of her videos, suggesting that we are not so much faced with questions about art's fate after Conceptual art, but with what remains of life after Conceptual art.

Hamza Walker

ENTER
HERE

THE ROOM OF THE NIGHT

or how to see the night by day

Night Cabin (*exterior, interior and detail*), 2002
worksite cabin, automatic door, solar film, adhesive lettering
Installation 'In Real Time', outside Tate Modern, London, 2002

A Proposal for a Room in the Fridericianum, with 2 doors and 1 open window, 15 foot 7 inches x 22 museal steps, 2002
22 steps around the found sentence *Acqui Havia Historia-Cultura Agora O* (Here There was Cultural History Now Nothing)
film compilation, video, 15 min., 7 sec., colour, silent
Installation Fridericianum Museum, Documenta 11, Kassel, 2002

JOËLLE TUERLINCKX

Space Parts 21 Elements® + Extras, 2002
Plexiglas, fabrics, photocopies on box, wooden container, cash registers in painted covered boxes, fluorescent
paint, pigment from objects found on site (red and green Victorian books), postcards, cut-outs, found
materials, electric dimmer with varying intensity of light, turntables, electric device creating random speeds
dimensions variable
Installation 'In Real Time', South London Gallery, London, 2002

Born Kaduna, Nigeria, 1967 Lives and works in New York, USA

Selected Solo Exhibitions: 2000 'At the Meat Market', Art + Public, Geneva; 'At the Water Tap', Greene Naftali Gallery, New York; 'Fusion Cuisine', The Kitchen, New York 2001 'Celebrations', Galeria Joao Graça, Lisbon 2002 'Changing Spaces', Art Production Fund, New York; 'Conveyance', Art + Public, Geneva; 'Mama Na', Long Island University, The Avram Gallery, Southampton College

Selected Group Exhibitions: 1997 2nd Johannesburg Biennale 1999 6th Istanbul Biennale; 'Beyond Technology', Brooklyn Museum of Art, New York 2000 'EuroAfrica', 3rd Gwangju Biennale 2001 24th Biennale of Graphic Art, Ljubljana; 'Mujeres que Hablan de Mujeres', Centro de Fotografia, Tenerife 2002 'Empire/State: Artists Engaging Globalization', Whitney Museum of American Art, New York; 'Fusion Cuisine', Deste Foundation, Athens; 'Tempo', The Museum of Modern Art, New York; 'Young with FIA', The V Salon CANTV Jovenes con Feria Iberoamericana de Arte, Venezuela

Selected Bibliography: 1994 Peter Plagens, 'School is Out, Far Out', *Newsweek*, 24 January 1997 Benita Munitz, 'Go With Me and I Will Go With You', *Cape Times*, 31 October 1998 Rose Arthur, 'Fatimah Tuggar: Picture In Progress', *Art Byte, The Magazine of Digital Arts*, June–July 2000 Kim Levin, 'Fusion Cuisine', *Village Voice*, 24 October 2001 Laurence Hazout-Dreyfus, 'La Recette de Fatimah Tuggar Masa: Mix + Match', *Beaux Arts*, June; Elizabeth Janus, 'Fatimah Tuggar, Art & Public', *Artforum*, January; Carol Kino, 'Fatimah Tuggar at Greene Naftali', *Art in America*, September; Franklin Sirmans, 'Fatimah Tuggar', *Time Out New York*, 28 December–4 January 2002 Paulo Herkenhoff/Roxana Marcoci/Miriam Basilio, *Tempo*, The Museum of Modern Art, New York; Yates McKee, 'On Counterglobal Aesthetics', *Empire/State: Artists Engaging Globalization*, Whitney Museum of American Art, New York; Alondra Nelson, 'Afrofuturism', *Social Text*, Duke University Press, Summer

FATIMAH TUGGAR

Fatimah Tuggar's art is powered by a drive to expose the racially inscribed divide between the 'first' and 'third' worlds through an examination of their respective access to technological advancements. Born in Nigeria and educated in England and the United States, Tuggar has witnessed these separate cultures first-hand, directly experiencing their differences as well as their common concerns. Accordingly, her artistic method is one of juxtaposition. In her photographs and videos, she fuses disparate imagery to create hybrid untruths, cultural mélanges in which Western goods infiltrate remote African villages, or their residents inhabit modern, suburban track houses. In a spirit akin to the work of John Heartfield and Hannah Höch (two Dadaists whom she cites as sources), Tuggar creates potent computer-generated photo- and videomontages that address the uneven flow of capital in an increasingly global world.

In her video *Fusion Cuisine* (2000) Tuggar intercuts footage from 1950s films espousing the utopian promises of the well-equipped, technologically advanced kitchen with domestic scenes shot in Africa – children playing in the dust, women preparing food with the most rudimentary utensils, etc. She has taken to new heights Martha Rosler's pivotal, feminist-inspired video *Semiotics of the Kitchen* (1974) – in which a cooking demonstration turns into a rant, arguing that feminism must encompass all social and economic inequities. In one of the video's 'Western' sequences, a metal-clad robot prepares a meal in its kitchen-of-the-future. For the photomontage *Robo Entertains* (2001) Tuggar transposed this robotic servant into a waiter at a Nigerian restaurant where people wearing traditional Islamic attire dine on shrimp cocktail and soda pop. In another, earlier picture, *Robo Makes Dinner* (2000), she positions this mechanical assistant in a village courtyard, complete with cutting board, kitchen trolly and Calphalon pots. Ironically, the robot resorts to archaic cooking methods by using an open, outdoor fire, its shiny remote control rendered useless in the process.

The video *Conveyance* (2001) enlists transportation tropes – factory production of new, streamlined cars and the advent of roadside advertising – to examine the impact of new technologies on global culture. As before, Tuggar juxtaposes found footage from propaganda films about the American dream with what appears to be home movies, African style. She further confounds the mix by interjecting replicas of her own provocative photomontages onto billboards seen alongside highways and urban boulevards. The presence of these Nigerian-based images (albeit doctored to include Western commodities like fax machines, Sony Trinitrons and Disney characters) serves as a constant reminder that the exoticized Other is never really a separate, distanced entity.

Nancy Spector

Working Woman, 1996
computer montage, 129 x 122 cm

Robo Makes Dinner, 2000
computer montage, 115 x 274 cm

Big Lorry, 2001
computer montage, 101 x 243 cm

Shaking Buildings, 1996
computer montage, 51 x 58 cm

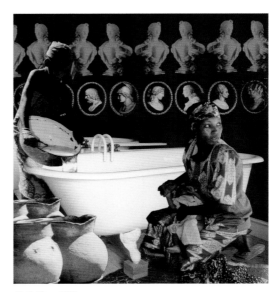

Bath Time, 1999
computer montage, 133 x 121 cm

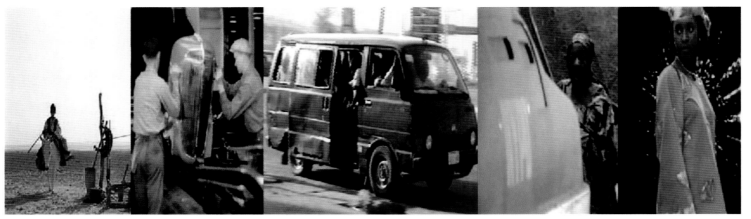

Conveyance, 2001
video collage, 3 min., 12 sec., colour, sound

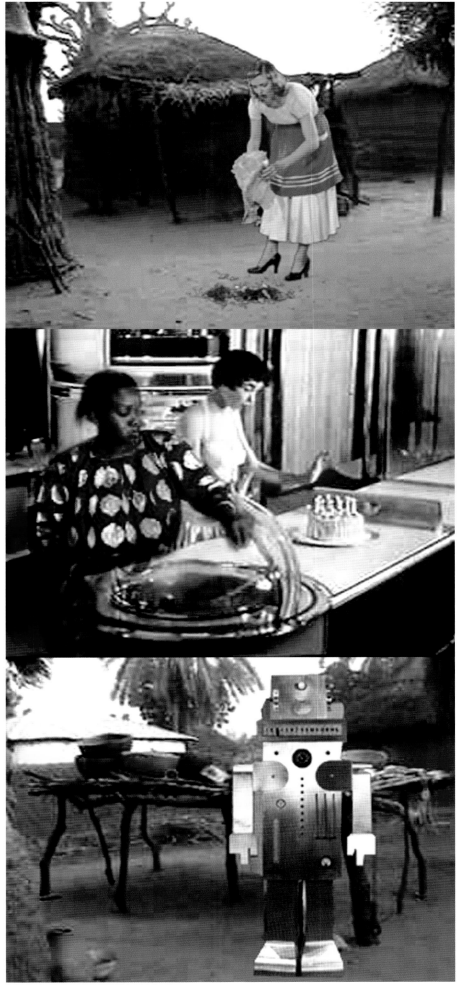

Fusion Cuisine, 2000
video collage, 15 min., 56 sec., colour, sound

Born Ulverston, Cumbria, UK, 1969 Lives in Brighton, works in London, UK

Selected Solo Exhibitions: 1995 'From the Artmachine', Anthony Reynolds Gallery, London 1996 David Zwirner Gallery, New York 1997 Galerie Georges-Philippe Vallois, Paris 1999 Delfina, London; 'Molecular Compound 4', Kleineshelmhaus, Zürich 2000 'One of Each', Galerie Ursula Krinzinger, Vienna 2002 Kunsthalle Zürich; 'Supercollider', South London Gallery, London

Selected Group Exhibitions: 1995 'Institute of Cultural Anxiety', Institute of Contemporary Arts, London 1997 'Private Face – Urban Space', Gasworks, Athens/L. Kanakakis Municipal Gallery of Rethymnon, Crete 1998 'Seeing Time: Selection from the Pamela and Richard Krammlich Collection of Media Art', San Francisco Museum of Modern Art 2000 'Over the Edges', Stedelijk Museum voor Actuele Kunst, Gent 2001 2nd Berlin Biennale; 49th Venice Biennale; 'Century City: Art and Culture in the Modern Metropolis', Tate Modern, London; 'l'effet Larsen-associative networks', OK Centrum fur Gegenwartskunst, Linz/Casino Luxembourg, Forum d'Art Contemporain, Luxembourg 2002 XXV São Paulo Biennale; 'Reality Check – Recent Developments in British Photography and Video', 14 Wharf Road, London/Moderna galerija, Ljubljana/House of Artists, Zagreb/Gallery Rudolfinum, Prague/ Bunkier Gallery, Krakow/Mucsarnok Kunsthalle, Budapest; 'The Turner Prize 2002', Tate Britain, London

Selected Bibliography: 1995 Adrian Searle, 'Keith Tyson', *Time Out*, 12–19 July 1999 Michael Archer, 'Keith Tyson – Kleins Helmhaus', *Art Monthly*, October; Kate Bush/Jeremy Millar, *Keith Tyson*, Delfina Studios, London; Simon Morrissey, 'Keith Tyson', *Contemporary Visual Arts*, No. 23 2000 Judith Palmer, 'Hubble, Bubble, Toil and Trouble', *The Independent on Sunday*, 6 April 2001 Rachel Withers, 'A Thousand Words: Keith Tyson Talks about his Seven Wonders of the World', *Artforum*, April 2002 Michael Archer, 'Keith Tyson – South London Gallery', *Artforum*, March; Michael Archer/Kate Bush/Jeremy Millar/Beatrix Ruf, *Keith Tyson*, Kunsthalle Zürich; Keith Tyson, *Supercollider*, South London Gallery, London

KEITH TYSON

Keith Tyson's universe of objects, paintings, photographic works and installations addresses through a diversity of artistic styles the way in which we construct reality and create models such as literature, science, philosophy or mathematics to explain it.

His works are hybrid forms, mechanisms that are intended to unfold these familiar models. Language plays a central role in his art: as a coded system, as a medium of representation, but also as a device that brings together conditions that cannot usually be united – real and imaginary, near and far, chaos and order, thinkable and unthinkable, possible and impossible. Tyson's laboratory places the viewer in a variety of landscapes, confronting us, for instance, with Jorge Luis Borges' 'Library of Babel', or with images of the nervous system, the Internet, Marcel Duchamp's Conceptual and scientific strategies, or taking us on a wild ride along the boundaries of science and science fiction.

Since the early 1990s, Tyson has been creating works by means of his 'Art Machine', a computer able to access an unlimited number of sources in order to generate linguistic proposals for the creation of artworks. Tyson attempts to execute these as faithfully as possible, without imposing a personal style. While the 'Art Machine' works relate to a potentially infinite network of information resources, *Random Tangler (Recursive Transition Knot)* (2001) deals with a potentially infinite network of individual subjects, and with the variations, transformations and vagaries of subjectivity. This large

board game similarly offers verbal concepts for works of art, and can be played by any number of people, who create the artworks themselves based on these instructions. Systems and freedom, chance and intention, authorless definition and individual interpretation combine to allow all conceivable styles and manifestations to emerge simultaneously.

Tyson's language games also weave their complex realities in a series of panel pictures. *Supercollider* (2001) – its name derived from the nickname for the CERN particle accelerator in Geneva – combines texts and images on a bright yellow ground, listing a disparate collection of events and actions. *Table Top Tales No. 4*: *8 Dukes Mews, Centre of the Multiverse* (1998) – part of a series using found surfaces – is executed on Tyson's studio floorboards, removed from their original building. Here, a set of random ink blots is transformed into an elaborate metaphysical chart.

For the 49th Venice Biennale (2001), Tyson installed his 3-metre high sculpture *The Thinker (after Rodin)* (2000) alongside his *Studio Wall Drawings*, which covered the entire wall surface. Part of the series 'Seven Wonders of the World', *The Thinker* attempts to embody the phenomenon of thought. Somewhere between black box and abstract sculpture, it is a hermetic block containing a computer that both visually and metaphorically shuts away its internal processes. By contrast, the *Studio Wall Drawings* radically reveal Tyson's artistic thoughts and actions. Beatrix Ruf

Supercollider, 2001
paint, ink and liquid chalk on paper on aluminium, 388 x 481 cm

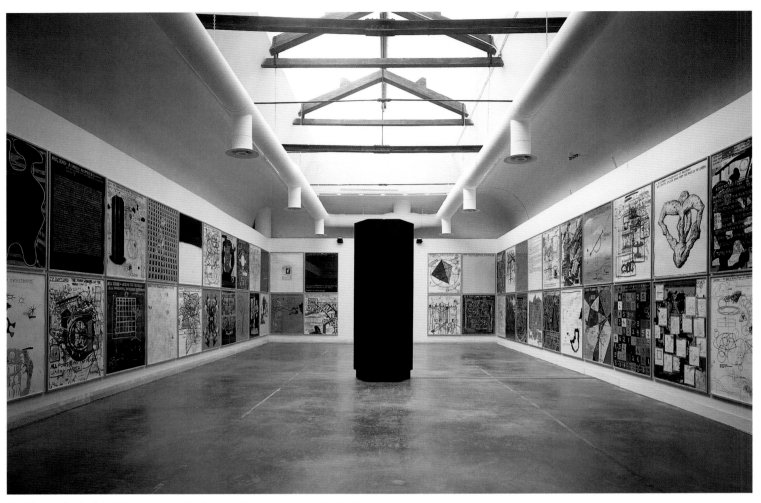

The Thinker (after Rodin), 2000, enamel-sprayed aluminium, steel, computers, software, 3 x 1.2 x 1.1 m
Studio Wall Drawings (1999–2001), mixed media on paper, each 157 x 126 cm
Installation 'Drawing and Thinking', 49th Venice Biennale, 2001

Monument to the Present State of Things, 2000
steel and newspapers, 3 x 1.1 x 1.1 m

An Open Lecture About Everything That Was Necessary to Bring You and This Work Together at This Particular Time, 2000
acrylic, emulsion paint and permanent marker pen on MDF, amp, mini-disc player, 2 speakers, signed mini-disc, 2.4 x 4.8 m

KEITH

Artmachine Iteration AMCHII-CCLXXXV: An Emergency Meeting of the Doughnut Assembly, 1997
Perspex, rubber, steel, glass, fluorescent lights, fibreglass resin, wooden 'dumpling ballot', pour channels, funnels, 35 gallons of paint, dimensions variable
Installation Galerie Georges-Philippe Vallois, Paris, 1997

Window on an Infinite Cellular Blanket, 2001–2
acrylic on aluminium, 4.2 x 13.2 m

A Universal Cooling within the Everyday Photographic Array, 2000–1
mixed-media assemblage consisting of 54 elements x 2 (108 elements in total), dimensions variable

Born Caulonia, Italy, 1960 Lives and works in Milan, Italy

Selected Solo Exhibitions: 1993 'Misure Dratiche', Care/Of, Milan 1994 'Incroci di Voci', Viafarini, Milan 2002 'Prospect', Gallery Placentia Arte, Piacenza; 'You'll Never Walk Alone', Artopia, Milan

Selected Group Exhibitions: 1994 'Oriente Mediterraneo', University of Helwan, Cairo 1999 1st Melbourne Biennale; 4th Milan Triennale; 'Molteplicitta', Fondazione Adriano Olivetti, Rome; 'Public Art', Viafarini, Milan; 'Subway', Milan subway 2000 'Fuori Uso: The Bridges', Art on the Highway, Pescara; 'Ironic', Trevi Flash Art Museum 2002 'Last Minute', Ospedale Soave, Codogna; 'Open House', Casino Luxembourg, Forum d'Art Contemporain, Luxeumbourg; 'Utopie Quotidiane', Museum PAC Padiglione d'Arte Contemporanea, Milan

Selected Bibliography: 1991 Giulio Ciavoliello, 'Enzo Umbaca', *Journal Juliet*, June 2000 Domenico Papa, *Geografie del Lontanovicino*, Turin; Michele Robecchi, 'Ironic (Giovane arte Italiana)', *Catalogue Collana/Flash Art*, No. 30 2002 Emanuela de Cecco, *You'll Never Walk Alone*, Artopia, Milan; Daniela Lotta, 'Reviews: Enzo Umbaca', *Flash Art*, May–June, Milan; Roberto Pinto, *Open House*, Casino Luxembourg, Forum d'Art Contemporain, Luxembourg; Maria Rosa Sossai, *Artevideo: Storie e culture nel video d'arte in Italia*, Silvana, Milan

ENZO UMBACA

Enzo Umbaca's work deals with what we might call the 'politics of leisure'. This Milan-based artist has devoted much of his work to commenting on the wider social significance of modern forms of entertainment, ranging from soccer to chamber music. These are the games that adults play in modern society, and – as the French writer Roger Caillois has pointed out – sports like soccer draw such large crowds because they allow spectators and participants to escape reality for the duration of the match. During the ninety or so minutes in which two teams compete against one another, viewers forget about politics, about the economy, about their work; their attention is entirely focused on the trajectory of the ball. It is not surprising, then, that totalitarian states have used sports to distract their citizens from disturbing political realities: both Hitler and Stalin staged elaborate athletic competitions to divert people's attention away from the historical urgency of the moment.

Umbaca's work attempts to unveil the political reality that lies behind soccer matches and other modern games. In 1998 he visited the impoverished village of Caulonia in South Italy, where he discovered a curious political manipulation of sports: for years the local government had been promising to provide a public soccer field, but for one reason or another – the official word was that land around the village was too rough and rocky – it was never built. Umbaca decided that an artistic intervention – *Out of Play* – was in order. Surveying the rocky hills surrounding the village he used the Renaissance technique of anamorphosis (painting an image that appears to change shape when looked at from different angles, like the famous skull in Holbein's *The Ambassadors* of 1533), to create what from a distance looked like a perfect soccer field. Upon approaching the field, however, visitors discovered that the white borders, which had appeared so smooth and straight, were actually rough and bumpy, like the terrain that served as their support. This duplicitous piece is an apt metaphor for the local politicians, whose seemingly generous, straightforward promises become 'bumpy' – unrealizable and plagued by technical difficulties – as soon as the elections are over.

In other works like *On the Dark Side of the Street* (2001) and *Musicians Street* (2002), Umbaca addresses the political context in which music, the most abstract of all forms of entertainment, is produced. The first of these performances, broadcast by Milan's Radio Popolare, featured an improvised, raucous orchestra of accordionists, fiddlers, clarinetists and guitarists playing various kinds of folk tunes. At one point the radio announcer interrupted the concert to inform listeners that the orchestra was made up of gypsy musicians who habitually played for money in the Milan subway. This made the lifestyle and working conditions of the musicians – facts generally irrelevant to the enjoyment of music – key components of the concert.

Sigmund Freud once wrote that 'the opposite of play is not what is serious but what is real'; Umbaca's art is about bringing reality back into the game.

Rubén Gallo

Out of Play, 1998
chalk powder, 35 x 90 m
Caulonia, Italy

Camouflage, 2000
straw, burnt straw, grass, earth, 60 x 40 m

Love is Colder Than Death, 2002
C-type print on aluminium, 250 x 400 cm
Installation 'Open House', Casino Luxembourg, Forum d'Art Contemporain, Luxembourg, 2002

You'll Never Walk Alone, 2002
Lambda print mounted on aluminium, 100 x 70 cm

Kick Off, 2002
video, 10 min., colour, sound

Born Bonn, Germany, 1942 Lives and works in Cologne, Germany and Corberon, France

Selected Solo Exhibitions: 1996 'Günter Umberg, six paintings and a room', Stark Gallery, New York 1998 'Günter Umberg, En shrijdt behoedzaam voort van der hemel doorheen de wereld naar de hel! Günter Umberg met …', Museum Dhondt-Dhaenens, Deurle 1999 Palazzo Municipale, Morterone (with Elisabeth Vary) 2000 Galerie alleArt, Remise Bludenz; 'Body of Painting', Museum Ludwig Köln, Cologne 2001 Galerie Evelyne Canus, Paris; Galeria Elvira Gonzalez, Madrid 2002 Galerie Rolf Ricke, Cologne

Selected Group Exhibitions: 1996 'Mark Rothko, Adrian Schiess, Phil Sims, Günter Umberg, Ulrich Wellmann', Galleria Nazionale dell'Umbria, Perugia; 'Le Voyage Extraordinaire 2', Musée d'Art Contemporain, Lyon 1997 'Helmut Federle, Mark Grotjahr, Ingo Meller, Günter Umberg', Antony Meier Fine Arts, San Francisco; 'Licht Raum … Schwarz', Kunsthaus Palais Thurn und Taxis, Bregenz 1998 'Das Jahrhundert der künstlerischen Freiheit', Secession, Vienna/Helsingfors stads Konstmuseum, Helsinki 1999 'abstract', Galerie Evelyne Canus, Paris; 'special offer', Kasseler Kunstverein, Kassel 2000 'Voici, 100 ans d'art contemporain', Palais des Beaux-Art de Bruxelles 2001 'Degrees of separation', Jensen Gallery, Auckland; 'Delicious', Galerie Rolf Ricke, Cologne/Roger

Smith Gallery, New York 2002 'The Museum, the Collection, the Director and his Loves', Museum für Moderne Kunst, Frankfurt

Selected Bibliography: 1985 Hannelore Kersting/Joseph Marioni, *Günter Umberg*, Klaus Gallwitz, Frankfurt 1991 Rolf Hengesbach/Richard Hoppe-Sailer/Jochen Poetter, *Günter Umberg*, Jochen Poetter, Baden-Baden 1993 *Günter Umberg, Arbeiten auf Papier 1973–76*, Städtisches Museum Abteiberg, Mönchengladbach 1994 Nicola von Velsen/Eva Schmidt/Friedrich Meschede, *Günter Umberg – Raum für Malerei*, Nicola von Velsen, Ostfildern/Stuttgart 1996 Christian Besson/Odile Biec, *Devant et derrière la lumière, Günter Umberg face à …*, Espace de l'Art Concret, Mouans-Sartoux 1997 Michael Engelhard/Carlo Invernizzi/Giovanni Maria Accame, *Günter Umberg*, A arte Studio Invernizzi, Milan; *Günter Umberg*, Harvard University Art Museums, Cambridge, Massachusetts 1998 Luk Lambrecht/Peter Nisbet/Günter Umberg, *Günter Umberg – En schrijdt behoedzaam voort van de hemel doorheen de wereld naar de hel! Günter Umberg met …*, Museum Dhondt-Dhaenens, Deurle 2000 *Günter Umberg – Body of Painting*, Bildern aus Kölner Sammlungen/Museum Ludwig Köln, Cologne 2001 *Günter Umberg*, A arte Studio Invernizzi, Milan

GÜNTER UMBERG

Painting is more difficult than any other artistic discipline. It takes a great deal of courage to add something fundamentally different to the vast number of paintings that have been made since the beginning of art history – and it takes even more courage if those paintings are monochromes.

Günter Umberg has been addressing the phenomenon of painted colour for decades, tending to make black the central colour in his works. Few other painters since the 1960s have so persistently examined a single tone and the infinite number of possible variations on it. When Umberg talks about his paintings, he extends their 'nature-given' quality by adding in the complex tissue of relationships between the presence of the image in the space and the way in which the image is sensed and experienced by its viewers. He is not trying to make his images more emotional, however; that would detract from the enormous importance of their material qualities. 'The sensuous phenomenon must not become autonomous', he insists, nor 'detach itself from its material cause and exert a merely uncontrolled effect, as a mood stimulant. Painted colour must free itself from its materiality and yet eliminate any doubt in the viewer that it can be traced back to its materiality as its anchor. The "logic" of the phenomenal appearance must not actually transcend the "logic" of materiality to become a "logic" of emotion. Given that, the picture stands across from me, and in a state of "alertness", I face the Other.'

It is not possible simply to glance at Umberg's images; one must take one's time if they are to be experienced physically as well as visually – time that we are perhaps no longer inclined to spend on a painted image. Thus Umberg is quite consciously working against the non-spiritual nature of the modern age. It is only by consciously approaching these works and then distancing ourselves again that we can see and experience the full nature of Umberg's images. Essentially they are defined by their spatial effect and by the way in which they relate to space, and this is further enhanced by the different supports that Umberg has developed over the years. For example, aluminium supports fitting almost flush to the wall give a sense of unity between image and wall, while wooden supports help the colour to take over the space. Furthermore these pictures must be seen in the flesh, since any reproduction can be little more than an appetizer. Umberg's painting challenges its viewers at a time when so many images are created, while thoughtful looking is largely left behind.

Udo Kittelmann

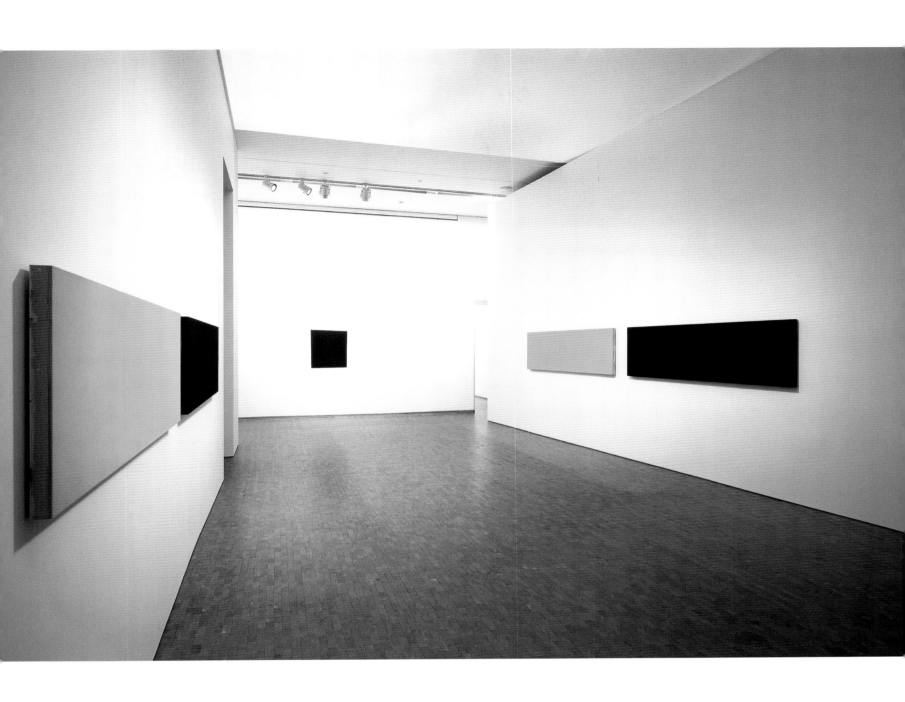

Installation 'Günter Umberg – Body of Painting', Museum Ludwig Köln, Cologne, 2000

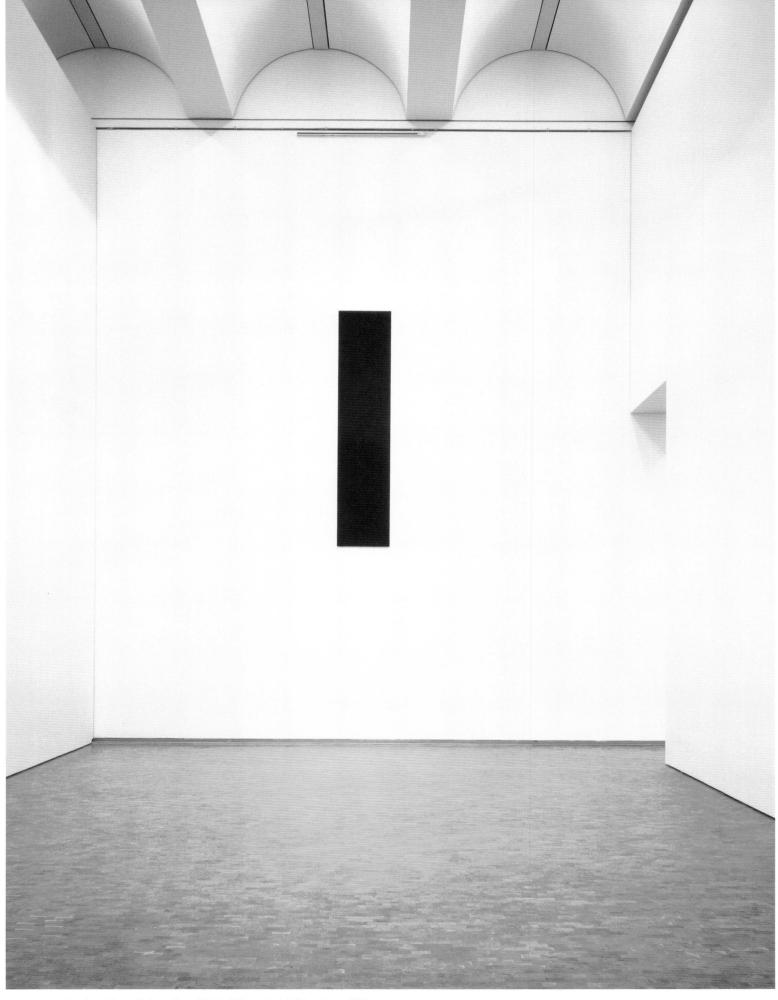

Installation 'Günter Umberg – Body of Painting', Museum Ludwig Köln, Cologne, 2000

Installation Burnette Miller Gallery, Los Angeles, 1993

Installation Busch-Reisinger Museum, Cambridge, Massachusetts, 1997

Born Bangkok, Thailand, 1970 Lives and works in Bangkok

Selected Solo Exhibitions: 2001 'Narratives', Intercross Creative Centre, Sapporo 2002 'Second Love In Hong Kong', Plastic Kinetic Worms, Singapore

Selected Group Exhibitions: 2000 'Alien (Gener) ation', Chulalongkorn University Gallery, Bangkok; 'Euro-Visions', Silpakorn University Gallery, Bangkok; 'Made in Thailand', Moulden Art Project, Darwin 2001 1st Tirana Biennale; 7th Istanbul Biennale; 'Traversée', Musée d'Art Moderne de la Ville de Paris 2002 4th Gwangju Biennale; 'Videotrafic', Cinema Lumiere, London; 'What? A Tale in Free Images', Memlingmuseum, Brugge

Selected Film Festivals: 1996 'World Views', Chicago Cultural Center 2000 Rotterdam International Film Festival 2001 Anthology Film Archive, New York; Singapore International Film Festival 2002 Cannes Film Festival/Toronto International Film Festival

Selected Bibliography: 1999 Chalida Uabumroongjit, 'Alien Filmmaker', *Thai Film Quarterly*, July 2000 Myriam van Lier, 'Mysterious Object at Noon', *Vision du Reel*, Vision du Reel Film Festival, Nyon; Chuck Stephens, 'Siamese Spin', *Filmmaker*, Spring 2001 Kim Ji Seok, 'A Crusader for Experimental Films', *New Thai Cinema*, Busan International Film Festival; Elvis Mitchell, 'From Thailand, Adventures in Collective Storytelling', *The New York Times*, 1 November; Siwaporn Pongsuwan, 'Unconnected Continuity', *Sarakadee*, September 2002 Philippe Azoury, 'Extase Thai', *Liberation*, 17 May; Ulrike Kremeier, 'Levelled Narratives: Films by Apichatpong Weerasethakul', Editions de l'œil, Berlin; Thunska Pansittiworakul, 'Blissfully Yours', *Movie Time*, May; Jonathan Rosenbaum, 'Collected Consciousness', *Chicago Reader*, 22 March; Thomas Sotinel, 'Un moment de bonheur arrache a la jungle', *Le Monde*, 18 May

APICHATPONG WEERASETHAKUL

Apichatpong Weerasethakul pursues the possibilities of a type of film that incorporates both fiction and non-fiction, the two intersecting and supporting each other. His intention is not so much to create an innovative new method of storytelling, as to develop a natural process by which a third reality is gradually constructed. He does this by providing the actors in his films with an environment and conditions totally different from those of their everyday lives.

Mysterious Object at Noon (2000) is a 35 mm film that developed when Weerasethakul travelled from the north of Thailand to the south. Using a single, fictional story as his point of departure, Weerasethakul asked the villagers whom he encountered to pick up the story and spin from this common source their own totally unrelated and fantastic tales, which were then joined together to form a chain. Later Weerasethakul returned to Bangkok, where he had a group of residents act out the story. He then edited together the two different types of footage, alternately weaving documentary recordings of conversations amongst the villagers with the awkwardly acted-out original tale of a disabled boy and his young female teacher. The story develops in a totally unexpected, surrealistic manner – even Weerasethakul had no idea what the final outcome would be.

In the video work *Haunted Houses* (2001) Weerasethakul asked sixty-six people from six Thai villages to re-enact in their own houses the roles played by popular soap-opera stars. How would these ordinary people rise to the challenge of becoming movie stars in the mundane environment of their homes? The script is based on two typical episodes dealing with issues surrounding love and wealth, while the noble heroine is played by a lower-class housewife who would normally be condemned to the role of servant. The actors' embarrassment and discomfort, their absorption in placing themselves in the role of these characters, and their tenuous sense of self is captured with humour and subtle camera work. Weerasethakul screened the soap opera at 8 o'clock every night, creating a sense of community and shared dreams as the villagers were projected into strange new environments, becoming the characters of their dreams.

Blissfully Yours (2002), shot on 35 mm film, began with a simple plot of lovers going into the forest for a picnic lunch. As Weerasethakul found out more about the actors involved, fragments of his observations were gradually incorporated into the story, capturing the process by which the imaginary characters and the actors themselves gradually blended into one. The underlying methodology was that the performers are co-conspirators in the making of the film. Meanwhile, the silent video works *Masami is a PC Operator/Fumiyo is a Designer* (2001) were formed as an open narrative in which viewers offer a range of diverse stories.

Weerasethakul's method of filmmaking gently prises open the subject of his work to incorporate each and everyone involved – a quietly unassuming and yet incomparably radical strategy.

Yuko Hasegawa

Golden Ship, 2002
from 'Haunted Houses'
2 rear projections, gold wood frames, video, 12 min., loop, colour, silent

Blissfully Yours, 2002
35 mm film, 12 min., colour, sound

Second Love in Hong Kong, 2002
video (for cinema version), 23 min., colour, sound
Collaboration with Christelle Lheureux

Mysterious Object at Noon, 2000
35 mm film, 83 min., black and white, sound

APICHATPONG WEERASET

Haunted Houses, 2001
video, 60 min., colour, sound

Born Llanelli, UK, 1958 Lives and works in London, UK

Selected Solo Exhibitions: 1996 'Immerse, Reverse, Perverse', White Cube, London 1997 Deitch Projects, New York 1998 Gallery CCA, Kitakyushu 2000 'Cleave 00', Tate Britain, London; Galerie Neu, Berlin 2001 Galerie Daniel Buchholz, Cologne; 'Has the Film Already Started?', Georg Kargl, Vienna; Kunsthaus Glarus

Selected Group Exhibitions: 1995 'General Release', XLVI Venice Biennale 1996 'Life/Live', ARC, Museé d'Art Moderne de la Ville de Paris 1997 'Material Culture', Hayward Gallery, London; 'Sensation', Royal Academy of Art, London 1998 'From the Corner of the Eye', Stedelijk Museum, Amsterdam 1999 'Retrace your Steps Remember Tomorrow ...', Sir John Soane Museum, London 2000 British Art Show 5, touring throughout Britain; 'The Greenhouse Effect', Serpentine Gallery, London 2001 1st International Triennale of Contemporary Art, Yokohama 2002 Documenta 11, Kassel; 'ForwArt 2002, a choice', Mont des Arts, Brussels

Selected Bibliography: 1990 Michael O'Pray (ed.), *Andy Warhol: Film Factory*, British Film Institute, London; *Sign of the Times*, Museum of Modern Art, Oxford 1996 *Live/Life*, Musée d'Art Moderne de la Ville de Paris/Centro Exposicones do Cultural de Belem, Lisbon; Mark Sladen, 'Cerith Wyn Evans', *frieze*, September 1998 *Close Echoes, Public Body and Artificial Space*, City Art Gallery, Prague/ Kunsthalle Krems, Austria; *From the Corner of the Eye*, Stedelijk Museum, Amsterdam; *Cerith Wyn Evans*, Centre for Contemporary Art, Kitakyushu 1999 Francesco Bonami/Hans Ulrich Obrist, *Dreams*, Fondazione Sandretto Rebaudengo per l'Arte, Turin; Jennifer Higgie, 'Cerith Wyn Evans', *frieze*, Summer; Greg Hilty, 'We go Round and Round in the Night and are Consumed by Fire', *Parkett*, No. 56; Gilda Williams, 'Cerith Wyn Evans', *art/text*, No. 66; *Young British Art: The Saatchi Decade*, Booth Clibborn Editions, London 2000 Isabelle Graw, 'Cerith Wyn Evans', *Texte zur Kunst*, November; *The Greenhouse Effect*, Serpentine Gallery, London

CERITH WYN EVANS

Cerith Wyn Evans, a key figure in British art films since the 1980s, has worked from the 1990s onwards with installations, video, photography and pieces using fireworks and neon. All these resources enable him to introduce cinematic elements into three-dimensional, real spaces. The chief characteristic of his work is its network of intellectual 'collaborations', which shift the act of artistic quotation into a different dimension.

Wyn Evans' tableaux incorporate fragments, elements and borrowings from films, literature, art and philosophy in the form of sound, image and text. These create a highly resonant and individualized portrait of the sources evoked, capturing the mood of a historical moment, or the intellectual-historical dimensions of a work of art. Just as film music can influence – or even reverse – the way in which we perceive the scene on the screen, Wyn Evans reorganizes and transforms familiar images, stories, narratives, sound and perceptions through found footage and 'sampling'. Identifiable historical dates and events play an important part in these poetic repeat performances, questioning rules and chance, building up an ambivalent charge, and amalgamating objectivized facts with individualized perceptions. Reversals, juxtapositions of positive and negative, palindromes, interference and friction create a labyrinth of non-linear narratives.

Wyn Evans often refers in his works to the radical founder of the Situationist International, Guy Debord, and to his criticism of the 'Society of Spectacle', with its fixation on cyclical repetitions and systems. In a richly layered installation of 2002 at the Kunsthaus Glarus, entitled *Dreamachine* (which has appeared in various versions since 1996), he referenced Debord's 1978 film *In Girum Imus Nocte et Consumimur Igni* (*We Go Round and Round in the Night and Are Consumed by Fire*). This palindrome had earlier inspired Wyn Evans to create both a circular neon work and a 40-foot-long wall text spelt out in fireworks. Juxtaposed with this was a reconstruction of Brion Gysin's visual apparatus *Dreamachine* – a spinning, flickering cylinder designed to be experienced through closed eyes in order to access one's inner visual capacities. The installation also included a screening of Gil Wolman's experimental film *L'Anti-Concept* (1952), combined in a loop with Willard Mass' documentation of Andy Warhol's *Silver Clouds* (1966), an installation of helium-filled balloons that Wyn Evans has also reconstructed. The accompanying soundtrack was an audio collage compiled from over 100 sound sources, in the spirit of Jean-Luc Godard's *Histoire(s) du Cinéma* (1989–98), a homage to all the audio and visual things in the world.

In *Cleave 00* (2000) language was used to orchestrate the presence and absence of light: texts by William Blake were translated into Morse-code signals that regulated light projections onto a disco ball. The mirrored sphere bathed the space in star-like reflections and projected an image of a solar eclipse onto the wall.

Beatrix Ruf

In Girum Imus Nocte et Consumimur Igni, 1997
neon, h. 18 x Ø 140 cm

Cleave 00, 2000
mirror ball, lamp, shutter, computer, text by William Blake, plants, dimensions variable
Installation Tate Britain, London, 2000

...later on they are in a garden, he remembers there are gardens.
They walk in the park and come across a display showing a section
cut through the trunk of a giant sequoia tree. They study its rings
of growth marked with historical dates, she pronounces an English
word he doesn't understand. He indicates a point in space outside the
circumference of the tree trunk and, as if in a dream- hears himself
say: "This, is where I come from..."

406 **Silver Clouds (after Andy Warhol)**, 2001
plastic, helium, air, dimensions variable
Installation Galerie Daniel Buchholz, Cologne, 2001

Before the Flowers of Friendship Faded, Friendship Faded, 2001
mirror-coated Perspex, wire and stainless-steel rod, dimensions variable

Firework Text (Pasolini), 1998
Super-16 mm film, 15 min., colour, silent

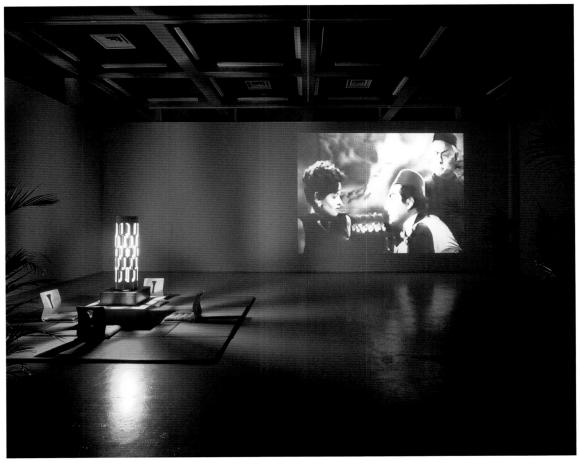

Dreamachine, 1998
'Dreamachine' constructed after plans by Brion Gysin, table, tatami mats, chairs, cushions, potted plants, video projection
of Orson Welles' *Lady from Shanghai*, 6 different films from Guy de Bord's *Society of Spectacle*, various soundtracks
Installation Centre for Contemporary Art, Kitakyushu, 1998

Born Peja, Kosovo 1970 Lives and works in New York, USA

Selected Solo Exhibitions: 1999 Galleria Placentia Arte, Piacenza 2000 Foundation Olivetti, Rome 2001 Aarhus Kunstmuseum, Denmark; Galleria Laura Pecci, Milan; Project Room, Kunsthalle Bern; Swiss Cultural Institute, New York 2002 Deitch Projects, New York; Galleria d'arte moderna e contemporanea, Bergamo; Galleria Laura Pecci, Milan; Teseco Foundation, Pisa

Selected Group Exhibitions: 1997 XLVII Venice Biennale; 'GAME', Galleria d'Arte Moderna, Bologna 2000 'Anna Zero', Fondazione Pistoletto, Biella; 'Ironic', Trevi Flash Art Museum; Manifesta 3, Ljubljana; 'Over the Edges', Stedelijk Museum voor Actuele Kunst, Gent; Galleria Laura Pecci, Milan 2001 1st Tirana Biennale, Albania; 7th Istanbul Biennale; 'Casino 2001', Stedelijk Museum voor Actuele Kunst, Gent; 'Chinese Whispers', Apex Art, New York; 'Finale di Partita, Endgame, Fin de partie', Istituto Francese, Giotti Bottega Veneta, Chiostro di Ognissanti, Florence; 'Georgia', Grassy Knoll Productions, Belfast; 'Le tribù dell'arte', Galleria communale d'arte moderna e contemporanea, Rome; 'Uniform', P.S.1 Contemporary Arts Center, New York 2002 4th Gwangju Biennale; 'Big Turin Biennale of Emerging Artists'; Casino Luxembourg, Forum d'Art Contemporain, Luxembourg; 'Emotional Site', ShugoArts, Tokyo; National Gallery, Copenhagen; Palais de Toyko, Paris; Statens Museum for Kunst, Copenhagen

Selected Bibliography: 2000 Francesco Bonazzi, 'Sislej Xhafa', *Juliet*, No. 100; Guido Molinari, 'Interview with Sislej Xhafa', *Premio Querini-Furla per l'Arte*, December; Giacinto de Pietrantonio, 'Going Underground', *Janus*, No. 6 2001 Tiziana Casapietra, 'Life is Not Las Vegas', *Nu: The Nordic Art Review*, Vol. 3, No. 6; Massimiliano Gioni, 'Strangers in New York: Adel Abdessemed, Sislej Xhafa', *Flash Art*, No. 218; Luca Legnani, 'Il fattore G', *Avant Garde*, No. 3; Edi Muka, 'Aperto Albania: Sislej Xhafa, Anri Sala, Adrian Paci', *Flash Art*, No. 216; Daniele Perra, 'Sislej Xhafa', *tema celeste*, March–April; Giancarlo Politi (ed.), 'Sislej Xhafa', *Escape, Tirana Biennale I*; Giorgio Verzotti, 'Openings: Sislej Xhafa', *Artforum*, Vol. 39, No. 9; Marcia E. Vetrocq, 'Italy: New and Improved', *Art in America*, January 2002 Teresa Macrì, 'Il Gigante Notturno di Sislej Xhafa', *Manifesto*, July; 'Sislej Xhafa – Artist Statement', *Project 1 Pause: Conception*, Gwangju Biennale

SISLEJ XHAFA

Sislej Xhafa, an Albanian from Kosovo, has lived in various European cities. He bases his work on his contact with different cultures and people, on illegality and taboos, and on the issues of inequality that stem from being an immigrant.

In *Unofficial Albanian Pavilion* at the 1997 Venice Biennale, Xhafa walked through the various pavilions wearing a soccer uniform, ball in hand, and carrying a backpack from which blared a recording of a match between Portugal and Italy. He was willing to play ball with anyone who would approach him, after which he would continue on his wanderings. As a result of this action, observers were made aware of the fact that many countries such as Albania had no pavilion of their own. Xhafa's method of expression, neither an aggressive nor an illegal intervention, took a form that resulted in acceptance and inclusion rather than opposition or exclusion.

The video work *Stock Exchange* (2000) symbolizes Xhafa's directness and sense of irony. The artist is shown in front of the arrivals and departures board at a train station, gesticulating wildly like the traders on the floor of the stock exchange, shouting out instructions such as: 'Go, go, go! Leave! Buy! Sell!' The mass movement of people resulting from globalization, he suggests, which forces people to move elsewhere for a better chance of survival, can be likened to the Wall Street stock market, except that here, people are the commodity. Racism and xenophobia in Europe are on the rise as a result of this increase in the number of migrants from Muslim nations, Asia, and the ex-Communist countries. Xhafa's strong physical presence creates enormous tension, drawing attention to these issues in only four minutes of footage.

In *Pleasure of Flower* (2000*)*, Xhafa turned the waiting room of a police station – normally an arena of bureaucracy and detention for immigrants – into an elegant room decorated with Louis XVI furniture, where drinks were served. The work is a proposal for a welcoming setting that would bring comfort to those in an uncertain and insecure situation.

Tourism is another major factor in the movement of communities, and a product of Western culture. The people of Turkey, afflicted by this cheap, fake economy, must work towards attracting tourists to their country. The performance *Elegant Sick Bus* (2001), which took place in Sultanahmet Square, Istanbul's main tourist attraction, symbolically represented this. Xhafa asked twenty-five rural labourers, who had come to the city to find work, to push a bus clad in mirrored material around the square. The vehicle not only reflected back the spectacular tourist site, but also the poverty of those pushing this industry along.

As Xhafa has stated, his work 'deals with institutions, sociopolitical and economic issues, tourism, integration, immigration and criminality'. He incisively comments on these issues by courageously throwing himself at his subject, using irony and the displacement of conventions as his tools, while employing a poetic, utopian mode of expression.

Yuko Hasegawa

Stock Exchange, 2000
video of performance at Manifesta 3, Ljubljana, 30 min., loop, colour, sound

Pleasure of Flower, 2000
furniture, carpets, chandelier, curtains, mirrors, bookshelves, champagne bottles, plants
Installation 'Over the Edge', police station, Gent, 2000

Benvenuto–Welcome, 2000
carved wood embedded in earth, 70 x 900 m
Installation 'Arte all'Arte', Casole d'Elsa, Tuscany

Unofficial Albanian Pavilion, 1997
Lambda print of performance at XLVII Venice Biennale, 1997, 160 x 110 cm

Elegant Sick Bus, 2001
Mercedes bus covered with mirrored material
Performance at 7th Istanbul Biennale, 2001

Born Buenos Aires, Argentina, 1973 Lives and works in São Paulo, Brazil

Selected Solo Exhibitions: 2000 'Desenhos', Adriana Penteado Arte Contemporânea, São Paulo 2001 'Desenhos', Fundação Joaquim Nabuco, Recife; 'Restauro', Centro Cultural São Paulo 2002 'Belvedere', Torreão, Porto Alegre; 'Fortuna', Museu de Arte da Pampulha, Belo Horizonte

Selected Group Exhibitions: 1997 Heranças Contemporâneas, Museu de Arte Contemporânea da Universidade de São Paulo 2000 VII Bienal de Santos 2001 Panorama da Arte Brasileira, Museu de Arte Moderna, São Paulo/Rio de Janeiro/Bahia 2002 Caminhos do Contemporâneo, Paço Imperial, Rio de Janeiro; 'Contemporáneos Brasileños', Centro de Arte Contemporáneo Wilfredo Lam, Havana

Selected Bibliography: 2000 Katia Canton, *Novíssima Arte Brasileira: um guia de tendências*, Iluminuras: FAPESP, São Paulo 2001 Rodrigo Moura, 'Panorama vê circuito como problema', *Folha de S. Paulo*, 25 October; Carla Zaccagnini, 'Panorama', *Livro Panorama da Arte Brasileira 2001*, Museu de Arte Moderna de São Paulo 2002 Ricardo Basbaum, 'Anos 2000–2002', *Caminhos do Contemporâneo*, Paço Imperial, Rio de Janeiro; Ricardo Basbaum/Eduardo Coimbra, 'Conversações: projeto da artista Carla Zaccagnini', *Item: Revista de Arte*, February; Maurizio Cattelan/Bettina Funcke/Massimiliano Gioni/Ali Subotnick (eds.), *Charley 01*, January; Adriano Pedrosa/Rodrigo Moura, *Projeto Pampulha: Carla Zaccagnini*, Museu de Arte da Pampulha, Belo Horizonte

CARLA ZACCAGNINI

Carla Zaccagnini is an artist who also works as a critic and curator in São Paulo. These interrelated activities have led her to take the approach of institutional critique, combining different media in works centring around the museum and its activities.

Exhibition Contour (2001), shown at the city-run Centro Cultural São Paulo, outlined in pencil the contours of all the works included in the previous exhibition there, a selection from the museum's classical art collection. These drawings traced the memory of the permanent historical collection through temporary, almost invisible, contemporary means. For *Restoration* (2001), Zaccagnini arranged for the professional restoration of an important painting in the same collection, Almeida Junior's *Head* (1882). This project marked her constructive approach to institutional critique, and spoke about the lack of resources in Brazil's art institutions.

Whilst working as a curator at the Museu de Arte Moderna, São Paulo, Zaccagnini made the work *Panorama* (2001) for the museum's biennial exhibition of the same name. This piece dealt with the difficult relationship between the museum and the neighbouring Pavilhão Lucas Nogueira Garcez (OCA), previously the Museu da Aeronáutica, and now taken over by BrasilConnects, a powerful organization that promotes mega art shows in Brazil and abroad. Zaccagnini exhibited images of Museu da Aeronáutica's poorly kept collection in its new site, the Centro Municipal de Campismo, as well as enlarging some of the beautiful bird's-eye-view period photographs in its collection. She also made a window in the museum wall through which one could see a view of OCA.

Fortune (2002) was funded by the Museu de Arte da Pampulha. Zaccagnini embarked on a trip to Mar del Plata in her native Argentina to find a casino founded the same year as the defunct Cassino da Pampulha, formerly housed in the museum's building, an Oscar Niemeyer landmark of 1942. Her exhibition consisted of documentation of the trip, from air ticket and receipts to the complete correspondence with the curators, as well as photographs of landscapes and interiors taken during the trip, and of the installation process itself, all arranged in a chronological grid. Establishing a play between different memories – of her trip, of her native country, of the two buildings – Zaccagnini reopened the museum's Memory Room, containing images and relics of the Cassino da Pampulha. This room also housed a sound installation of recordings made at the Mar del Plata Casino.

Other works include *Seats* (2002), retractable stools designed by Keila Costa placed in front of selected works in group shows, and *Bibliography* (2002), an ongoing project involving the donation of Brazilian art publications to Centro de Arte Contemporáneo Wilfredo Lam in Havana.

Artists working as critics or curators are not a novelty, but the conflict of interests that often arises tends to restrict one activity whilst privileging the other. Zaccagnini has managed to develop all three roles fully, feeding one activity into the other; thus her work in criticism takes on creative tones, and her art is informed by her critical and curatorial approach. Adriano Pedrosa

Bibliography, 2002
selection of books on Brazilian art theory and history donated to the library of Centro de Arte Contemporáneo Wilfredo Lam, Havana (work in progress)

Fortune (memory), 2002
Memory Room of the Museu de Arte da Pampulha, with period objects and photographs of architects Burle Marx and Oscar Niemeyer
sound recording made at the Casino Central, Mar del Plata, Argentina
Installation 'Fortuna', Museu de Arte da Pampulha, Belo Horizonte, 2002

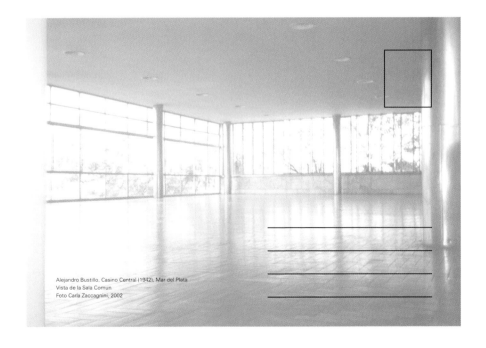

Alejandro Bustillo, Casino Central (1942), Mar del Plata
Vista de la Sala Comun
Foto Carla Zaccagnini, 2002

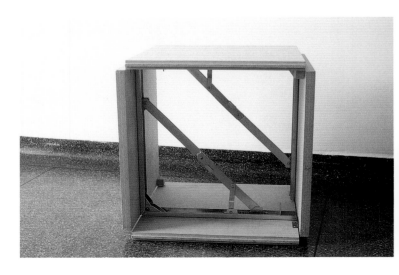

Fortune (postcard), 2002
double-faced postcard showing on one side the interior of the Casino Central, Mar del Plata, Argentina
and on the other the interior of the Museu de Arte da Pampulha, Belo Horizonte, offset print on paper,
1,000 distributed to the public, 13 x 18 cm

Seats, 2002
foldable, modular seat designed by Keila Costa in collaboration with the artist for
institutions housing temporary exhibitions, 40 x 40 x 40 cm

CARLA ZACCA

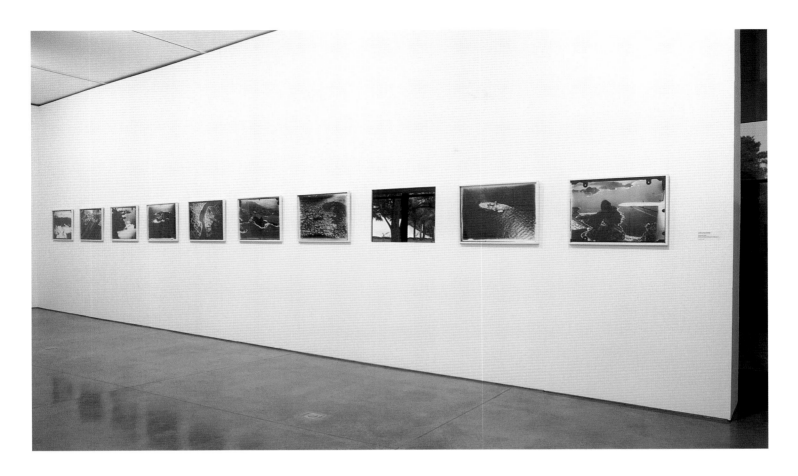

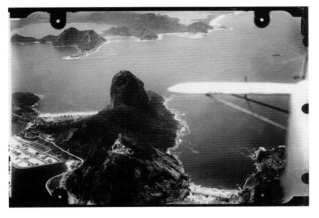

Panorama (*details below*), 2001
photographic enlargements of glass-plate negatives belonging to the Museu da Aeronáutica de Fundação
Santos Dumont; window on the Pavilhão Lucas Nogueira Garcez; facsimile of headline in 'Illustrada', insert
of the newspaper *Folha de São Paulo*, 24 May 2000; photographic studies by Alice Vergueiro
each photograph 54 x 74 cm, window 54 x 74 cm
Installation 'Panorama da Arte Brasileira 2001', Museu de Arte Moderna de São Paulo, 2001

Born Duschanbe, USSR, 1959 Lives and works in Moscow, Russia and Cologne, Germany

Selected Solo Exhibitions: 1995 'Der letzte Spaziergang durch die Elysischen Felder', Kölnischer Kunstverein, Cologne 1996 'Funny and Sad Adventures of a Foolish Pastor', Atopic Site, Tokyo; 'Stories of the Black Widow', National Academy of Fine Art, Oslo 1997 'Deadend of Our Time' (with S. Anufriev), Institute of Contemporary Arts/Obskuri Viri/TV Gallery, Moscow; 'Pastor Zond Edition', Art Cologne 1998 'Letzter punkt desVerlegers Pastor Zond. Verlegerstatigkeit 1992–98', Galerie Hohenthal und Bergen, Berlin 1999 'Psychedelics of Choice', Academy of Fine Art in Odense, Denmark 2001 'Cults, Prophets, Image', TV Gallery, Moscow

Selected Group Exhibitions: 1996 'Artists for Nature', Kunst und Ausstellungshalle der BRD, Bonn 1997 'Fort! Da! Cooperations. 20 internationale Künstler innen im Dialog mit der Sammlung', Gegenwartskunst der Staatsgalerie, Stuttgart/Villa Merkel Galerie der Esslingen 1998 'Someone else with my Fingerprints', SK Stiftung Kultur, Cologne; 'vollkommen gewönlich', Kunstverein Freiburg im Marienbad/Germanische Nationalmuseum Nürnberg, Nuremburg/Kunstverein Braunschweig/ Kunsthalle Kiel 1999 'Zeitwenden: rückblick und ausblick', Kunstmuseum Bonn/Museum Moderner Kunst, Vienna 2000 'L'Autre Moitié de l'Europe', Galerie Nationale du Jeu de Paume, Paris; 'Bons Baisers de Russie', Festival Garonne 2000, Toulouse 2001 49th Venice Biennale; 'ARS 01', Museum of Modern Art, Helsinki 2002 'BABEL 2002', National Museum of Contemporary Art, Seoul; 'Bangkok meets Cologne', Art Centre Silpakorn

Selected Bibliography: 1997 *2000 minus 3. ArtSpace plus Interface*, Steirische Herbst, Graz; *Deadend of Our Time* (with S. Anufriev), Institute of Contemporary Arts/Obskuri Viri/TV Gallery, Moscow; *Fort! Da! Cooperations!*, Cantz Verlag, Stuttgart; *Mystical Correct*, Salon Verlag, Cologne; *Zeichen und Texte aus der russischen Postmoderne*, Via Regia, Blätter für internationale kulturelle Kommunikation, Erfurt 1998 *Präprintium, Moskauer Bücher aus dem Samizdat*, Edition Temmen, Bremen; *Someone else with my Fingertips*, Salon Verlag, Cologne; *volkommen gewönlich*, Kunstverein Freiburg in Marienbad/Germanische Nationalmuseum Nürnberg, Nuremburg/ Kunstverein Braunschweig/Kunsthalle Kiel/Kunstfonds e.V., Vienna/Cologne 1999 *Zeitwenden, rückblick und ausblick*, Kunstmuseum Bonn 2000 *AMNESIA*, New Museum Weserburg, Bremen; *L'Autre Moitié de l'Europe*, Galerie Nationale du Jeu de Paume; *Bons Baisers de Russie*, Festival Garonne 2000, Toulouse; *Le Fou Dédoublé, l'idiotie comme stratégie*, Château d'Orion, France 2001 49th Venice Biennale; *Milano Europa 2000, The End of the Century*, Electa, Milan

VADIM ZAKHAROV

Vadim Zakharov brings together a variety of activities. He works as an artist, archivist, compiler of photographic and video document-ation, collector, magazine publisher and editor for a children's lib-rary. His artistic work can never be pinned down to unambiguous, definite interpretation, even when his subject matter is intimately familiar. By constantly mingling the dimensions of text, image, stage action and film he is able to make multiple cross-references between his various artistic activities. Everything he depicts could be something else when looked at another way.

Zakharov started work as an artist in the context of the Moscow Conceptualists' Circle in the 1980s, coming into contact with Ilya Kabakov and Erik Bulatov. Since, he has developed an approach in which his works are interlinked 'episodes'. Thus a cast of fictitious characters crops up over and over again in his work – the pirate, the man with an elephant's trunk, the gardener with an eyepatch on his right cheek, the dwarf with a an eyepatch over his mouth, Madame Sluice with an eyepatch between her eyes, the Marquis, Alda and more recently Pastor Zond of Cologne. Each fig-ure in this group is allotted a particular function and task, entering into dialogue with the others through the various strands of the plot. It is this highly individual way of quoting from and making references to his own work without insisting on completion or fin-ality that distinguishes him from the older generation of Muscovite Conceptual artists.

Transferring his artistic activities to territory that is alien to art – for example an exhibition in the form of a real park with lawns, trees, flowers and butterflies – initiates an exchange bet-ween reality and illusion. This exchange always involves deliberate deception, shaped by Zakharov's Soviet origins, when external restraints prevented him from expressing himself directly.

Zakharov's narrative style takes up a link between liter-ature and art that is largely alien to the West, winding a humorous path through a labyrinth of enigmatic images, mysterious words and ambiguous stories, such as Pastor Zond battling with watermills or Sumo wrestling. This network harmoniously and democratically combines all forms of artistic expression (text, drawing, painting, sculpture, installation, video and computer graphics) to form an experimental artistic model. 'My system', Zakharov once noted, 'is an iceberg. The part above water develops from and is dependent on the part under water. It is a coherent organism.' Udo Kittelmann

Funny and Sad Adventures of a Foolish Pastor – No. 7
'Theological Conversations', 'Atopic Site, Tokyo Seaside Fiesta', 11 August 1996
Performance; photographs; video, 3 min., colour, sound

Funny and Sad Adventures of a Foolish Pastor – No. 6
'Encounter with a Biker on Christ's Grave in Schingo Village (Aomori Province)'
Schingo Village, 5 August 1996
book; photographs; video, 20 min., colour, sound
Cover and page from magazine *Mr. Bike*, presented and dedicated to the artist by the biker
featured in it, after meeting on Christ's Grave

Funny and Sad Adventures of a Foolish Pastor – No. 1
'How the Pastor Died or How Hens Pecked Out His Intellect in Moscow'
Fabrichnaya Village, Russia, 14 May 1996
performance; book; photographs

Funny and Sad Adventures of a Foolish Pastor – No. 3
'In Search of the Knight of the Rueful Countenance'
El Toboso, Campo de Criptana, Toledo, Spain, 9–14 July 1996
performance; book; photographs

10 SOURCE ARTISTS

422 **Elastic Net**, 1974
 net made from elastic bands
 Performance at Université de Paris-Sorbonne, 1974

opposite **Monument in all Situations**
aluminium, 40 x 40 cm

LYGIA CLARK

Born Belo Horizonte, Brazil, 1920 Died Rio de Janeiro, Brazil, 1988

The work of Brazilian artist Lygia Clark is now increasingly acknowledged as fundamental to understanding the art of the 1960s and 1970s. Her 'experimental exercise of freedom', as the critic Mario Pedrosa expressed it in 1970, unfolded into groundbreaking works whose legacy can be spotted in much of the most radical contemporary productions, from interactive to interdisciplinary works.

Along with Lygia Pape and Hélio Oiticica, Clark was part of the Neoconcrete tradition, a rich artistic strand originating in Rio de Janeiro that confronted the pureness and rigour of mid-century geometric abstraction with bodily or quotidian themes and ideas. A key concept here is that of anthropophagy (cannibalism), a Brazilian modernist notion according to which local artists and writers would devour foreign ideas and movements (from Constructivism and concretism to modernist architecture and literature), digesting them and subsequently regurgitating them in their own works (one could call it an early form of postmodernism). Another key concept was life itself.

Clark's highly coherent trajectory begins in the early 1950s with abstract geometric paintings, and unfolds later in that decade and early in the next with a formal break from the frame, the pictorial plane and two-dimensionality. Her first radical works are the 'Beasts', a series of articulated geometric abstract sculptures made of hinged metal sheets, which Clark started in 1960. Despite their highly figurative title, these have no fixed or final existence – it is up to the viewer, now turned participant, to determine the temporary configuration of the artwork. Roland Barthes'

1968 notion of the 'death of the author' comes to mind. Other key concepts are process, touch, interactivity and the open, incomplete, fragmented work. An important piece in this series is *Monument in all Situations* (1964), a humble, plinthless and utterly unstable sculpture that plays with the classical notion of the monument.

It was in Paris in 1972, working with a group of students at the Sorbonne, that Clark would start to bring the human body into her experiments. In *Elastic Net* (1974), a group fabricated a net from elastic bands, and later intertwined their own bodies within and through it in playful, erotic ways. This work exemplifies further key concepts in Clark's practice: the 'collective body', participation and *vivência* (living experience). A reference to geometric abstraction also unexpectedly reappears here through the pliable grid, now contaminated by the agitated human bodies.

Clark's close rapport with psychoanalytic theory and practice led her to develop therapeutic experiments in 1976. She did so through her concept of 'Structuring of the Self' and her 'Relational Objects' – masks, shells, plastic bags, cushions and stones that only become significant when related to an individual, their meaning shifting from person to person. This anticipates Nicolas Bourriaud's recent notion of 'relational aesthetics'.

Clark's late work is the most challenging and polemical, and will perhaps only be fully understood in the future. It was at this stage that she started to distance herself altogether from that old, used and abused concept: the art object. Adriano Pedrosa

Canoe-Lake, 1997–8
oil on canvas, 200 x 300 cm

Echo-Lake, 1998
oil on linen, 229 x 359 cm

opposite **Untitled**, 200
oil on canvas, 186 x 19

PETER DOIG

Born Edinburgh, UK, 1959 Lives and works in London, UK

Peter Doig presents variations on a range of similar pictorial motifs and themes. His archive of parallel, thematically continuous images demonstrates how addressing identical subjects in varying moods or versions is a basic contemporary experience. This is achieved both via his familiar subject matter and through the adoption of recognizable painting styles and techniques.

At first glance Doig's paintings are 'illustrative'; they represent intelligible scenes and occurrences, or evoke the familiar genre of landscape painting. They frequently operate at the eerie interface between man and nature, culture and wilderness, depicting woodland scenes, lake and alpine landscapes, outdoor leisure, residential areas and street scenes. And yet no concrete landscape, no precise location is intended. These pictures are sampled from the general cultural archive, the arsenal of our mediated reality. Doig's own photographs or images from art history, cinema, pop culture, music, architecture or sport are used as triggers rather than specific models, generating an idea of the present as an accumulation of places, times, ideas and styles.

Doig's techniques take advantage of every trick from the history of painting, along with other image-producing methods from photography and film: perspective, scale, long-shots etc. But his painting always stresses its own triviality, assumes a thin-skinned quality, blurs outlines or conceals itself. The colour in these works seems both unnatural and non-synthetic – it may be informed by the photographic, video or film images on which it draws, or by the numerous Impressionistic, Expressionistic, realistic or surreal means that painting has adopted, but these in turn draw on the real world with its strange vagaries of light and colour.

Most of Doig's paintings are divided into three areas or structural fields, frequently organized as horizontal stripes. Appearing in the form of parallel planes, these trigger parallel speeds, readings, narratives, functioning as linear movements in time. In other pictures they are organized in layers, creating a simultaneity of readings between the foreground, middle ground and background, thus taking the temporal experience away from the linear towards the spatial depth of a single point. In both versions, cinematic movement is referenced in the static field of painting. The sense of narrative progression evokes the viewer's individual 'films' in the form of memories and echoes of present experience.

There is a fictitious quality inherent in painting: its images are always clearly fabricated and can thus assert subjectivity as a quality. This idea is updated in Doig's pictures without sentimentality, with no romantic or nostalgic ideas of an alternative world. His paintings draw attention to a link with reality that must constantly be redetermined in the imagination of both the painter and the viewer.

Beatrix Ruf

Untitled (Portrait of Ross in L.A.), 1991
multicoloured candies individually wrapped in cellophane, endless supply
ideal weight: 175 lb, overall dimensions variable

opposite **Untitled (Lovers – Paris)**, 1993
15-watt lightbulbs, porcelain light sockets, extension cords
2 parts, each 12.49 m with 6.09 m of extra cord, overall dimensions va

FELIX GONZALEZ-TORRES

Born Guaimaro, Cuba, 1957 Died Miami, USA, 1996

When the Guggenheim Museum organized a survey exhibition of Felix Gonzalez-Torres' work in 1995, he spoke passionately about the artists who most influenced him, as if paying back a debt for the examples they provided. Citing the appropriationist strategies of Barbara Kruger, Louise Lawler, Sherrie Levine, Richard Prince and Cindy Sherman, he aligned himself with their postmodernist (and in some cases feminist) critiques of representation. He too expropriated existing aesthetic styles, infusing allegedly neutral Minimalist sculpture and Conceptual text-based work with both political and autobiographical content, and not distinguishing between the two. His was an art of infiltration and subversion, seducing with great formal beauty to introduce commentary on critical cultural issues such as equal rights and the efficacy of democracy. The catalogue accompanying the Guggenheim retrospective positioned Gonzalez-Torres' work as an extension of 1980s postmodernist art. While this genealogy remains true today, in retrospect his unique practice functions as much, if not more, as a bridge to the art of the 1990s that directly engages its audiences.

Best known for his infinitely replenishable sculptural stacks of imprinted paper and endlessly refillable mounds of edible sweets, Gonzalez-Torres created works that exploit systems of mechanical reproduction and distribution. They also explore the ever-eroding distinctions between privacy and publicity, while speaking metaphorically of the socially disenfranchised. An openly gay man, Gonzalez-Torres also infused his art with poetic references to both homosexuality and the tragedy of loss endured by a generation scarred by the AIDS epidemic. His premature death at the age of thirty-nine ended what promised to be a brilliant artistic career, although the impressive body of work he completed during his brief life has proved profoundly important to a generation of younger artists investigating methods of distribution, audience participation and process-oriented aesthetic strategies.

Singularly generous, Gonzalez-Torres literally gave his art away. The sheets of coloured paper or photographs from his stacks flow like a virus outward from the gallery or museum into the community at large to spread intimate messages of love and loss, or heated missives against the National Rifle Association, inadequate healthcare and the like. This munificence parallels the open invitation Gonzalez-Torres offered his viewers to interpret the work as they wished, in recognition that meaning is always contingent on the context in which it is encountered.

Clues to Gonzalez-Torres' own references are often embedded in the parenthetical subtitles he assigned to each 'untitled' work. For example, a coiled pair of identical, illuminated light strings subtitled *Lovers – Paris* (1993) subtly suggests a same-sex couple. Diagonal lines on sheets of graph paper subtitled *Bloodwork* (1989) become ciphers for one's mortality. And a festive, 175-pound, corner spill of brightly wrapped candy subtitled *Portrait of Ross in L.A.* (1991) transmutes into a depiction of the artist's boyfriend before he succumbed to AIDS. Through such allusions, Gonzalez-Torres reintroduced what was sublimated in much postmodernist art – erotic desire, visual pleasure, vulnerability with a potent but quiet poignancy.

Nancy Spector

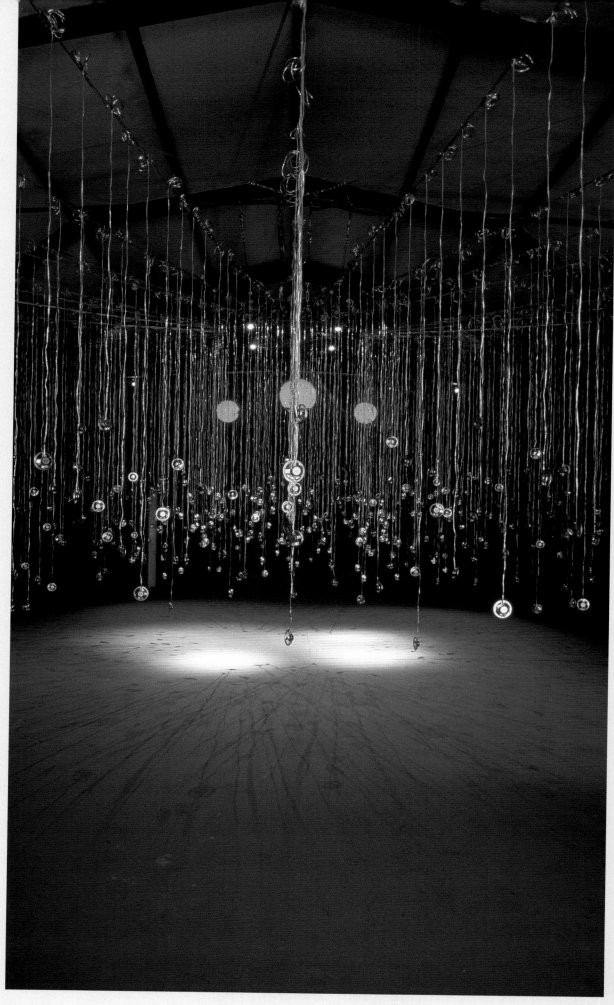

428 **Witness**, 2000
audio sculpture, 400–600 hanging speakers, 10 soundtracks, CD players, lighting
dimensions variable
Installation 'Witness', Artangel commission, The Chapel, London, 2000

opposite **Dedicated to the Unknown Artists** (*detail*), 1972–6
postcards, charts, map, on 14 panels with accompanying book of ima[...]
(*Rough Sea*) and brochure of notes and tabulations
each panel 66 x 104 cm, overall dimensions variable

SUSAN HILLER

Born Carson City, USA, 1942 Lives and works in London, UK

For Susan Hiller, art practice is a way to visualize 'certain chinks or holes through which it is possible to sense an enormous potential reality … I believe that art can function as a critique of existing culture and as a locus where futures not otherwise possible can begin to shape themselves.'

Hiller has consistently produced work that speaks directly about those experiences of life that we recognize but are often too shy or puzzled by to share. Her work draws from life – its irrationality, absurdity and wondrousness – and captures aspects of it that cannot be explained away within a scientific, rationalist worldview. Instead, she offers them up as evidence of other ways of imagining the world and its mechanisms of cause and effect. In the above quotation, from twenty-five years ago, she defines issues about art-making that are yet to be fully acknowledged within the art system. What she speaks about is an art that is both analytical and speculative, grounded in real things and events but containing the immanent possibility of transforming them.

In *Witness* (2000), for instance, Hiller presents an archive of those who claim to have experienced extra-terrestrial encounters. Tiny suspended loudspeakers emit the stories in their original languages. A strange vulnerability is elicited as the quiet sincerity of the narrations and their delicate purchase on 'truth' chimes with the fragility of the sculpture and its whispering soundtrack. An early piece, *The Sisters of Menon* (1973–9) places the artist herself in a vulnerable position. She acts as a medium for a narrative of female solidarity through the device of automatic writing. The piece could be seen as confessional, evidence of psychological disturbance, or just plain weird, but in reality it defeats categorization to become palpable evidence of an event.

In works ranging from seminal pieces such as *Dream Mapping* (1974) to the most recent video and installation works like *PSI-Girls* (1999) and *Witness*, the presence of alternative systems of knowledge serves as evidence of the potential of reality not only to surprise us but to awaken new understandings.

As an anthropologist turned artist, Hiller talks about phenomena that lie outside the scientific or cultural mainstream as 'social facts', things that we recognize but for which we cannot offer an undisputed explanation. In her explorations of the power and motivations behind collections, she sheds light on hidden rationales, while in other works she raids historical artefacts and combines them with oral narratives to offer nuanced and individualized readings of the past. Her entire oeuvre, stretching over thirty years, comprises an extraordinary investigation into art's potential as an engine of imaginative possibility that provides us all with the means to see and think about things differently.

Charles Esche

10.OKT.1991, 1991
from *Today*, 1966–
liquitex on canvas, 25.5 x 33 cm

opposite **I Got Up**, 19
rubber-stamped post
each 10.5 x 15 cm

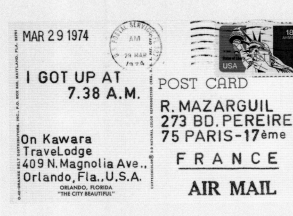
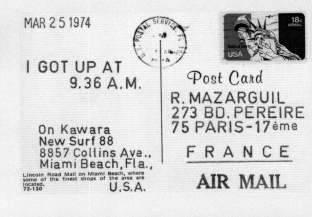

ON KAWARA

Born Kawira, Japan, 1933 Lives and works in New York, USA

On Kawara produces the most minimal of objects – detached records of the passing of time.

His ongoing *Today* series contains the *Date Paintings*, begun on 4 January 1966. Every day since then, Kawara has made a canvas on which he simply inscribes the date in the language of the country in which it is made. Other works include *I Read* – clippings from the newspapers he has read each day; *I Met* – a list of the names of every person he has encountered; *I Went* – maps tracing where he has been; and *I Got Up* – postcards informing two different acquaintances each day of the time he awoke.

For *I Am Still Alive*, Kawara has been dispatching telegrams confirming his existence since 1970. Although on the face of it an optimistic message, this phrase in fact brings the presence of death closer, even suggesting to the recipient a ghostly message from beyond the grave. This is emphasized by the choice of the telegram as medium – an outmoded method of delivering messages that frequently conveys news of emergencies, accidents or death. Thus – in keeping with Buddhist notions of life and death – this confirmation of continuing life makes one sense more vividly one's own inevitable mortality.

Equally paradoxically, through Kawara's exclusive use of 'I' in these works, he sharpens our own sense of self, sharing his individuality in a universal relationship with all viewers. His project of turning moments into objects is not an attempt to capture for eternity the temporal experience of an individual, but rather a bold effort to liberate the self from time.

One Million Years (Past and Future) (1969–99) takes the form of a number of books containing typed lists of every year from the past (998,031 BC to 1965 AD) to the future (1996 AD to 1,001,995 AD). At Documenta 11 (2002), this work was exhibited in the form of a performance during which a man and woman, sitting in a glass recording booth, read out the list of dates. Thus aeons of 'time' flowed through the air in the form of sound, reverberating into the future.

Pure Consciousness, which began in Sydney in 1998 and has already travelled to five continents, demonstrates a new direction for Kawara. For this project he installed seven *Date Paintings* – 1–7 January – on the walls of a kindergarten, giving the students no explanation as to their origin. By bringing about this purely physical encounter between these works and their young observers, Kawara transcends traditional theories of intellectual understanding and artistic boundaries. It is an encounter in which the viewers themselves melt into the work and touch it, not with their sense of sight, but with the edges of their consciousness.

Yuko Hasegawa

Untitled, 1980
projection of Fritz Lang's *Metropolis* onto the body of a black man seated at a grand piano

432 **What is Fascism?**, 1971
Performance at Galleriea Nazionale d'Arte Moderna, Rome, 1994

opposite **Pieces of soap**, 1971
wood, soaps, paper, 32 x70 x 7 cm
Installation 'Jewish Person', Galleria Barozzi, Venice, 1

FABIO MAURI

Born Rome, Italy, 1926 Lives and works in Rome

Fabio Mauri's radical, anarchic art investigates the dark side of European culture that began to emerge with the end of World War II. The lifting of censorship surrounding the war revealed immeasurable European cruelties, epitomized by the Holocaust, and marked an acute awareness of the relationship between spectacle and manipulation in Fascist society. Ever since his early Expressionist drawings of the 1940s, Mauri's art has always been political, revealing structures of power and oppression, contemporary ideological apparatus and related processes of dehumanization in the contemporary mediated world. While for much of his career the main object and subject of US culture was the consumer product – the Coca-Cola bottle of Pop art – Mauri believed that the object and subject of European culture was ideology itself, and that ideology was not something abstract, but a concrete reality that had marked the best and the worst of European civilization.

Mauri was born in Rome into a family of book publishers. His father developed the first modern book-distribution company in Italy, importing comic strips such as 'Mickey Mouse' and 'Flash Gordon' as early as the 1930s. In the late 1930s and early 1940s in Bologna, Mauri was friends with writer/filmmaker Pier Paolo Pasolini, taking part in after-school literary clubs and participating in cultural competitions organized by the Fascist party. It was one of these competitions, staged in honour of Hitler's visit to Florence in 1938, that would become the primary source for Mauri's later performance *What is Fascism?* (1971).

After the war Mauri turned his attention, in collages and paintings, towards thinking about the meaning and impact of the media – his daily acquaintances since childhood. Starting with his white, shaped canvases, *Screens*, in 1957–8, he became concerned with the connections between photography and its sister art, film, the beginnings of television in the post-war era, and the rise of authoritarian political systems. His ideas about television and its impact on thought formed a parallel with the development of semiology.

These issues would also inform Mauri's 'ideological' performance/installations, begun in 1971. Focusing on the theme of subliminal persuasion, these were made with the intention of revealing a form of collective psychic removal whereby Italian society in the late 1960s and early 1970s seemed to have forgotten its alignment with Fascism less than thirty years earlier. The complex theatrical props also function as autonomous sculptural elements once the performances are over, while the 'sets' remain as silent exhibitions laden with the memory of the action.

Mauri's artworks merge fact and fiction in a documentary style that pre-dates much recent Conceptual/documentary art by decades. Working at the juncture of visual art, theatre, writing and theory, however, he has remained on the sidelines of international contemporary art. He may not have been a conscious 'source' artist for many, and his art is not generally directly known by younger artists internationally, but it certainly forms a dialogue with much of what is going on today. Carolyn Christov-Bakargiev

Mirrors, 1969
mirrors installed in the landscape, each approx. h. 1 m

opposite **Pop Items (Bottles),** 196
plaster casts of plastic bottles
each approx. h. 5–25 cm

OHO GROUP

Group formed 1966 Disbanded 1971

The OHO Group was the most active, daring and innovative phenomenon in Slovene art during the 1960s. Combining strict Conceptualism and open play, drawing on and transforming diverse influences, and inventing original forms and approaches, it developed a highly interesting, rich, heterogeneous but coherent body of work. The group still enjoys a legendary status in Slovene art, cited as an important predecessor by many contemporary artists.

In a relatively short time OHO went through many transformations in its structure, interests and ways of working. Its history can be divided into three main periods. Although it was never formally established, 1966 is considered its date of birth, when the book *OHO* and what became known as the 'OHO Manifesto' were published. (However, an interesting pre-history goes back as far as 1962.) In its initial period (1966–8) OHO was essentially a movement. It had no formal membership, and its core figures – Marko Pogacnik, I.G. Plamen, Milenko Matanovnic, Ales Kermavner, Andraz Salamun, David Nez, Naski Kriznar – collaborated widely with others. Conceptually, OHO's work at that time was based on the notion of 'Reism'. This term, based on the Latin *res* ('thing'), described an attempt to reach beyond the human-centred world into a realm of things where all objects would be on the same hierarchical level, since they are all unique. Activities ranged from literature, visual poetry and artists' books to film, actions and objects. The latter were called *pop artikli* ('pop items'; the prefix 'pop' was understood literally, as 'people's art'), indicating that a work of art is a thing, not an auratic, precious object. To minimize the artist's individual expression, inappropriate in a Reistic world, OHO often used impersonal techniques such as casting and printing, working in series or with mathematical programmes.

By the second period (1969–70) OHO had dwindled to six members. They produced works influenced by such tendencies as Arte Povera, performance, Body, Land and Process art, but their works were based on OHO's own ideas and specific circumstances. Their Land art, for example, was essentially different from American 'Earthworks' – produced in a cultivated landscape, by simple means, always ephemeral, ecological and spiritual. Conceptualism was also a strong tradition for OHO.

In its brief last period (1970–1) OHO developed into a 'community' of four, who became progressively interested in the relationships within the group itself, seeing it as a microcosm of wider society. They attempted to develop an ideal, harmonious balance both within the group and with nature, culture, the world and the whole cosmos, even through such unusual approaches as telepathy (described as 'Transcendental Conceptualism'). In this final year, the group was beginning to receive some international recognition. Yet the members decided that the only step forward was to abandon the isolated field of art and attempt a full integration of art and life.

Igor Zabel

Andrea Carrano, 1996
C-type print, 96.5 x 76 cm

opposite left **Stardust No. 2**, 2001
acrylic lacquer on canvas, 183 x 244 cm

opposite right **Like Paris in the Rain on Second Avenue**, 1
plastic, iron, steel, chrome and paint, 170 x 147 x 8 cm

JACK PIERSON

Born Plymouth, USA, 1960 Lives and works in New York, USA

Jack Pierson began showing his photographs of (mostly naked) men in the late 1980s. Like other artists of his generation, including Nan Goldin and Mark Morrisroe (who was Pierson's lover), he used photography to document the underground world of urban gay life. But if Goldin produced film-like photographs that seem to form a narrative of drug use, self-abuse and solitude, Pierson's sober portraits of men are laden with personal feeling. At first sight, his works seem far more sedate than those of Goldin or Morrisroe – there are no syringes, no blood, no violence – but eventually we discover that the strength of Pierson's work lies in the strong emotions with which he has invested his photographs: he looks at his subjects with a melancholy gaze that fuses desire and longing, pleasure and pain. It is this ability to create artworks that integrate a political dimension (through the representation of scenes from underground culture) with a poignant reflection on the contradictions of gay desire that distinguishes him from his peers.

Pierson's work is also fraught with comments on and revisions of canonical photography. In the late 1990s, he began producing a series of 'back' portraits: photographs of nude men facing away from the camera (these were often combined with matching photos of the men's torsos in poses that showed their genitals but concealed their faces). Some of these works – like *Chris's Back* (1998), which shows the model sitting on a stool, the cleavage between his round buttocks forming the *punctum* of the photograph – bring to mind the classic nudes of high modernist photography that also show the model from the back – Edward Weston's nude portraits of Tina Modotti from the 1920s, for example. But unlike Weston's pristine, sculptural nudes, in which the female body acquires the impeccable sheen of a marble sculpture, the beauty of Pierson's nudes is always subverted by an element that introduces a hint of an ugly world that is miles away from the aesthetic perfection of modernism: a cheap gold chain around the model's neck, a scar suggesting a violent episode, a body that lacks the flawlessness to which fashion advertisements have accustomed our eyes. These anti-aesthetic elements subvert the modernist quest for beauty by hinting at the ugly face of American society – the historical context in which they were produced – with its inner-city violence, racial tensions and even homophobia.

Although the subjects of Pierson's photographs vary widely – he has produced hundreds of portraits of nude men, including porn stars and hustlers, but he has also created many photos depicting flowers and landscapes – the one constant in his work is his melancholic way of looking. Whether his camera turns to the nude body of a young man or a palm tree swaying by the ocean, his images are invariably bittersweet, always hinting that behind the glitter of beauty lies a dark realm of pain, frustrated desires and lost hopes. His is a sadness that defies description: all-encompassing, yet always accented by the sparks of libidinal force.

Rubén Gallo

Scottie's Bedroom, 1992
headboard, footboard, lamp, side table, robe, bed and bedding
painting #297, 1989–91, oil and alkyd on linen
video with digital insertion of #297 into Alfred Hitchcock's *Vertigo*, dimensions variable
Installation 'You look good in blue', Kunstmuseum St Gallen, Switzerland, 2001

DAVID REED

Born San Diego, USA, 1946 Lives and works in New York, USA

'We see painting differently today because of film and video', David Reed has said. He builds on our experience of these media, which has taught us to see moving pictures as narratives. Films are an inexhaustible source of inspiration for him, and his abstract compositions correspond to the complexities of cinematic presentation. His canvases are unusually long and narrow, thus relating to the Cinemascope format. Several overlapping geometric colour fields, some transparent, some opaque, are painted next to and on top of each other. Since viewers cannot take in everything that is going on in these works at once, they are forced to concentrate closely on single images within them; while their attention is focused on one point, the other elements seem to be on the move.

However, in a departure from the processes of classical painting, the pictorial surface is not created simply by adding layers of colour. Reed also subtracts pigment as one of his fundamental working principles. Like an archaeologist, he gradually uncovers old layers of paint, adding new ones at the same time. Thus generous sweeping brushstrokes are arranged alongside lavish sets of curves, but also underneath each other and intermeshed. These loop and thrust out over the background in a movement akin to writing, sometimes breaking off abruptly and starting again in a different place. The same theme may be taken up with a different rhythm and in different colour tones in the next picture in the series. All

this gives Reed's paintings a three-dimensional quality, but also endows them with a two-dimensional pull that compels viewers to plunge into and out of a particular work.

Reed perceives his non-representational art as being entirely within the tradition of the Old Masters. He is particularly fascinated by the transparent colours and simultaneous representation of Italian painting, as well as the dramatic handling of light found in Baroque works. His pictures exude a disturbing sensuality in their interplay of stasis and movement, tension and reflection, physical action and the smooth application of paint. His express aim is to make his pictures objects of 'intimacy and day-dreaming'.

As a metaphor for the desired personal relationship between image and viewer, Reed chooses to speak of 'bedroom pictures', in contrast to the publicly displayed images in a museum. He sees the bedrooms in Hitchcock's *Vertigo* (1958) as magic locations for the fusion of fiction and reality. This has led to a series of installations that include both beds and videos of *Vertigo*, into whose scenes of rooms his pictures have been digitally incorporated.

The critic Katy Siegel recently put her finger on Reed's contribution to the evolution and future of abstract painting when she wrote: 'Newman, Richter and Reed find common cause: making the single frozen image matter in a world that never stops moving.'

Udo Kittelmann

440 **Bend Over**, 2001
oil on canvas, 60 x 60 cm

LUC TUYMANS

Born Mortsel, Belgium 1958 Lives and works in Antwerp, Belgium

'Pictures, if they are to have effect, must have tremendous intensity of silence, a filled silence or void', the Flemish artist Luc Tuymans has said. 'The observer should become motionless before the picture [and] freeze [in] a kind of picture-terror. I show pictures with a direct intention. The effect they should have on the viewer resembles an assault that he or she does not experience directly, but from a distance, initially. When he or she comes closer, this assault should loom again, but on a different level. Something quite unmistakable then triggers certain emotions, makes certain demands. This can only come about in a certain silence, [like] the silence before a storm. It is not about developing feelings of melancholy, but about a certain form of déjà vu.'

Before turning to painting, Tuymans was a filmmaker; perhaps his decision to change media was for the sake of silencing his images. The silence of Tuymans' paintings is extreme, like that of a corpse. Indeed, his works seem more dead than alive, resurrecting the ghosts of past histories that are themselves shrouded in silence, such as Nazism or Belgium's colonial past. Elsewhere Tuymans revives the cloudy, forgotten details of personal memory, for example in the patterns of a kitchen towel, the illustrations of a medical handbook, or the recollections of a play that Tuymans attended with his parents in the 1970s. His pictures are

discomforting, as if diseased, and yet their delicacy and connection with the past call to mind gentle memories of childhood, of partial glimpses into an adult world of hushed secrets.

'Painting is utterly soundproof', Tuymans has said. 'It does not make noise, or remind one of music.' His work does not stray into simulating other media but remains very deliberately confined to what painting does best: it is utterly mute, still and flat. It functions through genres: landscape, portrait and still-life. The colours are faded, like a whisper, while his choice of images borders on the indecipherable; his is neither a random nor fully understandable choice of subject matter. 'Everything could be painting', says Tuymans, 'Or, in fact, everything just is painting.'

No discussion of contemporary painting is complete without referring to Tuymans' work. Throughout the 1990s up to the present he has, perhaps more than any other recent painter, kept alive the possibility of painting as a viable art form whilst admitting to its position on the 'peripheral outskirts of the art world'. 'Painting should mute its image, deny its real proportions and colour, and be difficult in terms of being memorized', he has said. His silent pictures cannot be memorized, yet remain unforgettable.

Hamza Walker

10 CURATORS

CAROLYN CHRISTOV-BAKARGIEV is a curator and writer based in Turin and New York. She is currently Chief Curator at the Castello di Rivoli, Museo d'Arte Contemporanea, Turin. In her previous post as Senior Curator at P.S.1 Contemporary Art Center in New York (1999–2001), she organized numerous group and solo shows, including 'Around 1984' (2000), 'Animations' (2001) and 'Janet Cardiff' (2001). Her publications include *Arte Povera* (1999) and *William Kentridge* (1998). Interested in curatorial collaboration, she has co-curated a number of projects, including 'On Taking a Normal Situation' (Antwerp, 1993) with Iwona Blazwick and Yves Aupetitallot; and 'La Ville, le Jardin, la Mémoire' (Villa Medici, Rome, 1998–2000) with Laurence Bossé and Hans Ulrich Obrist.

RUBÉN GALLO teaches Latin-American literature and cultural studies at Princeton University and writes regularly on contemporary art for various publications including *Flash Art*, *artpress*, *Poliester* and *TRANS>arts.culture.media*. His research focuses on aesthetic responses to modernization in post-revolutionary Mexico, and he teaches courses on the avant garde and material culture. He has recently completed *Technology as Metaphor*, a study of how five artifacts – radio, cement, the typewriter, the camera and stadiums – emerged as the dominant symbols of a new art transformed by technological inventions in the 1920s. He is also the author of *The Mexico City Reader* (2003).

CHARLES ESCHE is a curator and writer based in Copenhagen. Since 2001 he has been Director of the Rooseum Centre for Contemporary Art, Malmö. He is also Editor of *AFTERALL*, an art journal published by Central St Martins College of Art and Design, London and CalArts, Los Angeles, and a Research Fellow at Edinburgh College of Art. In 2002 he co-curated the 4th Gwangju Biennale in South Korea. From 1993–7 he was Visual Arts Director at Tramway, Glasgow. He was co-curator of the UK section of ARCO 2001, Madrid, and in 2000 he co-curated two large-scale shows: 'Intelligence – New British Art' at the Tate Gallery, London, and 'Amateur – Variable Research Initiatives' at Konstmuseum and Konsthall, Göteborg. He is also the author of numerous catalogues and magazines.

YUKO HASEGAWA has been Chief Curator at the 21st Century Museum of Contemporary Art, Kanazawa (due to open in 2004) since 1999. Previously she was Curator of the Contemporary Art Gallery at the Mito Arts Foundation, during which time she was awarded a visiting curatorship at the Whitney Museum of American Art, New York. She was also appointed as Curator at Setagaya, Tokyo. In 2001 she was Artistic Director of the 7th International Istanbul Biennale, and the following year co-curated the Shanghai Biennale. She is the Commissioner for the Japan Pavilion at the 50th Venice Biennale (2003). Recent exhibitions include 'Fancy Dance' at Sonje Art Museum, Kyonju and Sonje Art Centre, Seoul (1999) and 'Shirin Neshat' at Kanazawa Citizens' Art Centre (2001). She teaches art history at Tokyo National University of Fine Arts and Music.

UDO KITTELMANN worked as a freelance curator until 1993, when he became Director of the Könischer Kunstverein, Cologne. He is now Director of the Museum für Moderne Kunst, Frankfurt, a position he has held since 2002. In 1991 he was appointed Commissioner of the German Pavilion at the 49th Venice Biennale, which was awarded the Golden Lion for the best national contribution. His recent exhibitions and accompanying publications have included 'Michel Majerus' (2000), 'Cildo Meireles & Lawrence Weiner' (2000), 'Anna Gaskell' (2001), 'Fabian Marcaccio' (2001), 'Gregor Schneider' (2001), 'Martin Boyce' (2002), Hans-Peter Feldmann (2002), 'The Museum, the Collection, the Director and his Loves' (2002) and 'Hélio Oiticica' (2002).

ADRIANO PEDROSA is a curator and writer based in Rio de Janeiro and São Paulo. Currently he is Curator at Museu de Arte da Pampulha, Belo Horizonte, and Co-curator of 'InSite 2005', San Diego/Tijuana. He has published in *Artforum*, *frieze*, *Poliester*, *ArtNexus*, *art/text*, *Lapiz*, *Flash Art*, among others. He was Adjunct Curator and Publications Editor of the XXIV São Paulo Biennale (1998), Co-curator of 'F[r]icciones' (Museo Nacional Centro de Arte Reina Sofia, Madrid, 2000–01) and Senior Editor, São Paulo, of *TRANS>arts.culture.media*. Solo exhibitions he has curated have showcased Franklin Cassaro, Iran do Espírito Santo, Laura Lima, Beatriz Milhazes, Rivane Neuenschwander, Rosângela Rennó, Valeska Soares, Edgard de Souza and Carla Zaccagnini.

BEATRIX RUF is Director/Curator at the Kunsthalle Zürich. From 1998 to 2001 she was Director of the Kunsthaus Glarus, and prior to that Curator at the Kunstmuseum des Kantons Thurgau. Since 1995 she has been Curator of the Collection Ringier. Her many publications and exhibitions have featured Marina Abramovic, Eija-Liisa Ahtila, Emmanuelle Antille, Knut Asdam, Monica Bonvicini, Olaf Breuning, Angela Bulloch, Clegg & Guttmann, Verne Dawson, Peter Doig, Michael Elmgreen & Ingar Dragset, Urs Fischer, Sylvie Fleurie, Liam Gillick, Jenny Holzer, Fabrice Hybert, Joseph Kosuth, Peter Land, Kristin Lucas, Christian Philip Müller, Muntean/Rosenblum, Paul Pfeiffer, Richard Prince, de Rijke/de Rooij, Ugo Rondinone, Daniel Roth, Keith Tyson, Cerith Wyn Evans and Rodney Graham.

NANCY SPECTOR is a writer and curator based in New York. She is currently Curator of Contemporary Art at the Solomon R. Guggenheim Museum, New York, where she has organized exhibitions on Conceptual photography, Felix Gonzalez-Torres and Matthew Barney's *Cremaster* cycle. She was Adjunct Curator of the 1997 Venice Biennale and co-organizer of the 1st Berlin Biennale in 1998. Under the auspices of the Deutsche Guggenheim, Berlin, she has initiated special commissions of work by Andreas Slominski, Hiroshi Sugimoto and Lawrence Weiner. She is the author of numerous books and essays on contemporary visual culture.

HAMZA WALKER has served since 1994 as Director of Education for The Renaissance Society, Chicago – a non-collecting museum devoted to contemporary art. Prior to this position he worked as a Public Art Co-ordinator for the Department of Cultural Affairs. He has written articles and reviews for such publications as *TRANS>arts.culture.media*, *New Art Examiner*, *Parkett* and *Artforum*. For several years he served on the board of Randolph Street Gallery and is also on the boards of *Noon*, an annual publication of short fiction, and Lampo, a non-profit presenter of new and experimental music. He has been a member of numerous panels and was the recipient of the 1999 Norton Curatorial Grant.

IGOR ZABEL is Senior Curator at the Moderna galerija, Ljubljana. He has curated a number of exhibitions with Slovene and international artists, and has published two books of essays on contemporary art. Magazines for which he has written include *Art Journal*, *artpress*, *Index* and *Moscow Art Magazine*. He has also recently contributed to the publications *Words of Wisdom* (2001); *Ausgeträumt ...* (2002); *Critical Writing on Critical Art in East-Central Europe: A Primer* (2003); *Vitamin P* (2003). He is a member of the curatorial team for the 50th Venice Biennale (2003). Other recent projects include 33rd Zagreb Salon (1998); '2000+ – The Arteast Collection', Moderna galerija, Ljubljana (2000); 'Aspects/Positions', Museum of Modern Art, Vienna (2000); Manifesta 3, Ljubljana (2000); 'The Eye and Its Truth', Moderna galerija, Ljubljana (2001).

INDEX

ACKNOWLEDGEMENTS

Special thanks are due to the artists in *Cream 3*

We would like to thank the following for their help:
21st Century Museum of Contemporary Art, Kanazawa; 303 Gallery, New York; Air de Paris, Paris; De Appel, Amsterdam; Artangel, London; Gallery Artopia, Milan; ArtPace, San Antonio; Art + Public, Geneva; Galeria de Arte Ruth Benzacar, Buenos Aires; BintaZarah Studios, New York; Blum & Poe, Santa Monica; Tanya Bonakdar Gallery, New York; Ilaria Bonacossa; Galerie Daniel Buchholz, Cologne; Cabinet, London; Luis Campaña, Cologne; Galleria Massimo De Carlo, Milan; Casino Luxembourg, Forum d'Art Contemporain, Luxembourg; Cheim & Read Gallery, New York; Galeria Brito Cimino, São Paulo; Family Clark Collection, Rio de Janeiro; Contemporary Art Centre, Art Tower Mito, Tokyo; Contemporary Fine Arts Galerie GmbH, Berlin; Charles Cowles Gallery, New York; Galerie Chantal Crousel, Paris; Deitch Projects, New York; Laurent Delaye Gallery, London; Galerie EIGEN + ART, Berlin/Leipzig; Fabric Workshop and Museum, Philadelphia; Foksal Gallery Foundation, Warsaw; Galeria Fortes Vilaça, São Paulo; Marc Foxx Gallery, Los Angeles; Fredericks Freiser Gallery, New York; Stephen Friedman Gallery, London; Gagosian Gallery, London/New York; Annet Gelink Gallery, Amsterdam; The Felix Gonzalez-Torres Foundation, New York; Galerie Karin Guenther, Hamburg; Galeria Enrique Guerrero, Mexico; Dejan Habicht; Galerie Hauser & Wirth & Presenhuber, Zürich; International Graphics Centre, Ljubljana; Irish Museum of Modern Art, Dublin; Galerie Johnen + Schöttle, Cologne; Jay Jopling/White Cube, London; Casey Kaplan, New York; Anton Kern Gallery, New York; Kent Gallery, New York; Kick the Machine, Bangkok; Nicole Klagsbrun Gallery, New York; Klosterfelde, Berlin; Robert Koch Gallery, San Francisco; Gallery Koyanagi, Tokyo; Andrew Kreps Gallery, New York; Kurimanzutto, Mexico City; La-Ong Dao Limited, Bangkok; Lisson Gallery, London; Stella Lohaus Gallery, Antwerp; LOW, Los Angeles; Maccarone Inc., New York; Mai 36, Zürich; Milenko Matanovic; Galerie Gabrielle Maubrie, Paris; Memlingmuseum, Brugge; Burnett Miller Gallery, Los Angeles; Victoria Miro Gallery, London; Mizuma Art Gallery, Tokyo; Moderna galerija, Ljubljana; The Modern Institute, Glasgow; Museu de Arte da Pampulha, Belo Horizonte; Museu de Arte Moderna de São Paulo; Museum für Moderne Kunst, Frankfurt; Museu Nacional Centro de Arte Reina Sofia, Madrid; Joanna Mytkowska; Galerie Christian Nagel, Berlin; Nanjo & Associates, Tokyo; David Nez; Galerie Neu, Berlin; New Museum of Contemporary Art, New York; Galleria Antonella Nicola, Turin; Pacific Film Archive, Berkelely; Public Art Development Trust, London; Galleria Laura Pecci, Milan; P-House, Tokyo; Gallery Placentia Arte, Piacenza; Marko Pogacnik; The Project, New York; Max Protetch, New York; The Renaissance Society, Chicago; Anthony Reynolds Gallery, London; Meyer Riegger Galerie, Karlsruhe; Sammlung Ringier, Zürich; Anna Sanders Films, Paris; Galerie Schipper & Krome, Berlin; Secession, Vienna; SCAI the Bathhouse, Tokyo; Peter Simon Family Trust, London; Galeria Luisa Strina, São Paulo; Studio Guenzani, Milan; Ssamzie, Seoul; Taka Ishii Gallery, Tokyo; Museo Rufino Tamayo, Mexico City; Tate Britain, London; Tokyo Opera City Art Gallery, Tokyo; Galerie Wilma Tolksdorf, Frankfurt; Tomio Koyama Gallery, Tokyo; Trauma, Posadas; University of California Berkeley Art Museum; Henry Urbach Architecture, New York; Wadsworth Atheneum Museum of Art, Connecticut; Galleri Nicolai Wallner, Copenhagen; Walker Art Center, Minneapolis; Galerie Krobath Wimmer, Vienna; Barbara Wittwer; Hanna Wróblewska, Zacheta Gallery, Warsaw; Zeno X Gallery, Antwerp

Photographers:
Gaël Amzalag; Everton Ballardin; Petra Bauer; Jörg Baumann; Boris Becker; Rodrigo Benavides; John Berens; Bruno Blasone; Christian Bretton-Meyer; Danny Bright; Luigi Briglia; A. Burger; Jenny Carter; Jan B. Christensen; Ruth Clark; Dennis Cowley; Andrew Cross; Boris Cvetanovic; Anny de Decker; Alan Dimmick; Mirjana Djordjevic; Marc Domage; Erma Eastwick; Eduardo Eckenfels; Carsten Eisfield; Tom van Endye; Harrell Fletcher; Brian Forrest; Arte Fotografica; Edouard Fraipoint; Jacek Gladykowski; Bob Goedewaagen; Mitsuru Goto; John Groo: Wolfgang Günzel; Amy Haberlan; Carlos Hahn; Frank Hans-wijk; Serge Hasenböhler; Pez Hejduk; Jörg Hejkal; Matthias Herrmann; Hideki Hiromoto; Peter Hunkeler; Yoon Hyung-moon; Aaron Igler: James Isberner; Rhee Jae-yong; Werner Kaligofsky; Ahlburg Keate; Christopher Kern; Carlos Kipnis; Knut Klaßen; Arthur Kleinjan; Borut Kranjc; Achim Kukulies; Masakazu Kunimori; Gabriel Kuri; Igor Lapajne; Manne Lindwall; Orestes Locatel; Bernd Lohaus; Dante Lomazzi; Jon Lowenstein; Gustavo Lowry; Brenton McGeachie; Eoghan McTigue; Rubens Mano; Martin Marencin; Jacek Markiewicz; Andrea Martiradonna; Isabella Matheus; Cuauhtémoc Medina; Vicente de Mello; Mariusz Michalski; Lado Mlekuz; Vegar Moen; Dave Morgan; Joerg Mohr; Henry Moore Selder; Kenji Morita; Ernst Moritz; Maria Mulas; João Musa; Peter Muscato; Masato Nakagawa; Fredrik Nilsen; Ana Opalic; Jina Park; Matija Pavlovec; Pascal Petignat; Johan Phillips; Marin Polák; David Quintas; Ian Reeves; Ludger Paffrath; Elwa Rabinovich; Adam Reich; Mauro Restiffe; José Augusto Ribeiro; C. Rotoli; Bent Ryberg/Planet Foto; Jerzy Sabara; Bojan Salaj; Lothar Schnepf; Hoelger Schnars; Axel Schneider; Christian Schwager; Howard Sheronas; Darko Simicic; Oren Slor; Roberto Caldeyro Stajano; Andreas Szlavik; Yasunori Tanioka; Giorgio Tellini; Sergio Tornaghi; Piotr Trzebinski; Jesús Sánchez Uribe; Mario Valente; Martin Vargas; Alice Vergueiro; D.K. Walla; Uwe Walter; Paul Warchol; Joshua White; Stephen White; Gareth Winters; Muammer Yanmaz; Jens Ziehe

Translator:
Texts by Udo Kittelmann and Beatrix Ruf translated from German by Michael Robinson.

All works are in private collections or the artist's collection unless otherwise stated.

Phaidon Press Limited
Regent's Wharf
All Saints Street
London N1 9PA

Phaidon Press Inc.
180 Varick Street
New York, NY 10014

www.phaidon.com

First published 2003
© 2003 Phaidon Press Limited
All works are © the artists

ISBN 0 7148 4311 3

A CIP catalogue record for this book is available from the British Library.

Commissioning Editor: Gilda Williams
Project Editor: Melissa Larner
Assistant Editor: Swapna Tamhane
Editorial Assistant: Christian Aldridge
Designer: Miles Murray Sorrell FUEL
Production Controller: Sarah McLaughlin

Printed in China